HAUNTED BAUHAUS

HAUNTED BAUHAUS

Occult Spirituality, Gender Fluidity,
Queer Identities, and Radical Politics

Elizabeth Otto

The MIT Press
Cambridge, Massachusetts
London, England

Designed by Jarrett Fuller.
Printed and bound in the United States of America.

Library of Congress Cataloging-in-Publication Data

Names: Otto, Elizabeth, 1970- author.
Title: Haunted Bauhaus : occult spirituality, gender fluidity, queer
 identities, and radical politics / Elizabeth Otto.
Description: Cambridge, MA : The MIT Press, 2019. | Includes bibli-
ographical references and index.
Identifiers: LCCN 2019007765 | ISBN 9780262043298 (hardcover :
alk. paper)
Subjects: LCSH: Bauhaus--Faculty--Psychology. |
 Bauhaus--Students--Psychology. | Lifestyles--Germany--History--
20th century.
Classification: LCC N332.G3 O88 2019 | DDC 700/.455--dc23 LC
record available at https://lccn.loc.gov/2019007765

10 9 8 7 6 5 4 3 2 1

For Sascha.

LIST OF ILLUSTRATIONS

ACKNOWLEDGMENTS

My work on *Haunted Bauhaus: Occult Spirituality, Gender Fluidity, Queer Identities, and Radical Politics* has been animated by support, conversation, and kindness from many quarters. Grants permitted travel to archives, libraries, and scholarly forums where I learned to see a very different Bauhaus and received invaluable feedback as I worked. Fellowships gave me time, that essential ingredient for writing. Ideas for this book were germinated during a Faculty Fellowship from the University at Buffalo's Humanities Institute, an Early Career Residential Fellowship at the University of Pittsburgh's Humanities Center, and a visiting fellowship at the Center for Advanced Studies of the Ludwig-Maximilians-Universität, Munich, where Burcu Dogramaci kindly hosted my stay. Essential short-term funding came from a Library Research Fellowship at the Getty Research Institute, and from UB's Gender Institute; the Alexander von Humboldt Foundation supported several research trips. Above all, *Haunted Bauhaus* came together during my tenure as the Frank Kenan Fellow at the National Humanities Center for 2017–2018, where I had the great fortune to be part of an extraordinary group of scholars and to experience the unparalleled research and intellectual support of the NHC's dedicated staff. I am also very grateful for the support of an Ailsa Mellon Bruce Senior Fellowship from the Center for Advanced Study in the Visual Arts. Two Deans of the College of Arts and Sciences at UB, Bruce Pitman and Robin Schulze, granted essential leaves and generously provided a subvention for rights and reproductions. Behind the institutional names of archives, libraries, and museums that dot these pages are many wonderful archivists, librarians, and museum professionals whose expertise has been invaluable to this project.

The book also owes its existence to a wonderful crew who supported it at many stages. The members of the brilliant and creative team at MIT Press have been the perfect partners to bring it to light. Victoria Hindley's belief in my vision was absolutely critical to my being able to complete this book—as the *right* book—in time for the Bauhaus centenary. I am grateful for the generous feedback provided by anonymous peer reviewers and by my own editor, Jonathan Smit. The book's designer, Jarrett Fuller, immediately apprehended the aesthetic approach that *Haunted Bauhaus* needed and has been a dream to work with. I also wish to thank Andrew Barron and Jordan Troeller for research support, and Nicola King, who provided the index.

I was fortunate to be able to publish a small amount of the book's material elsewhere in advance. Chapter 1 draws on a co-authored essay with Allison Morehead, "Representation in the Age of Mediumistic Reproduction, from Symbolism to the Bauhaus," in *The Symbolist Roots of Modernism*, edited by Michelle Facos and Thor Mednick (2015), and "Bauhaus Spectacles, Bauhaus Specters," in *Spectacle*, edited by Jennifer Creech and Thomas O. Haakenson (2015). Part of chapter 2 appeared in a substantially different form as "Designing Men: New Visions of Masculinity in the Photomontages of Herbert Bayer, Marcel Breuer, and László Moholy-Nagy," in Jeffrey Saletnik and Robin Schuldenfrei's *Bauhaus Construct: The Object of Discourse* (2009). In chapter 3, my discussion of Brandt's work draws in part on material published in 2013 as "Neue Frau oder weibliche Konstrukteur? Marianne Brandts Suche nach einer Bauhausidentität," in *Gespiegeltes Ich: Fotografische Selbstbildnisse von Frauen in den 1920er Jahren*, edited by Gerda Breuer and Elina Knorpp.

Over the years, many more friends and colleagues than I can mention here have given freely of thought-provoking conversation and moral support, but I would like to express my particular gratitude to a few of them. Daniel Magilow read and gave feedback on each chapter as I wrote it, and Patrick Rössler was an extraordinary collaborator and sounding board. Additional inspiration and camaraderie came from Deborah Ascher Barnstone, Marcia Brennan, Megan Bryson, Tim Dean, Magdalena Droste, Susan Funkenstein, Randall Halle, Sabine Hartmann, Paul Jaskot, Juliet Koss, Barbara McCloskey, Allison Morehead, Vanessa Rocco, Robin Schuldenfrei, Angelique Szymanek, Andrés Zervigón, and the 2018–2017 NHC Fellows. Jen Read and Jill Murray were steadfast friends along the road. At my home institution, I am grateful to many colleagues including David Castillo, Miriam Paeslack, Erik Seeman, and Maki Tanigaki, and to the intellectual collective of Jonathan Katz, Jasmina Tumbas, and our extraordinary graduate students of the Visual Studies PhD program. A number of mentors and now friends have shaped my scholarship including Mark Antliff, Matt Biro, Kathleen Canning, Patricia Leighten, Helmut Puff, and Betsy Sears. Patricia Mathews inspired a generation of art historians at Oberlin College and left us too soon in 2018; her fierce feminist spirit lives on in our work.

Considering the *Bauhäusler*, a kind of family by choice, makes me think about how lucky I am in the family I was born to—my parents, Mary and David Otto, and my sister Susan Goodell—and my own family of choice with Tobias and Sascha Westermann. Everyone has helped to maintain good cheer while I kept my head down to finish this book, and I am grateful for their love and encouragement. Sascha, thank you for caring about this project and for understanding why I wanted to finish it—and for always being a model of the fact that play is just as important as work. This book is for you.

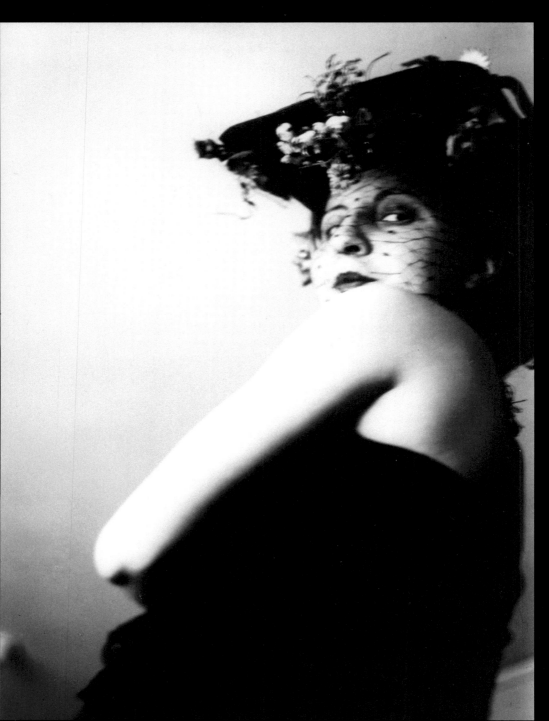

BAUHAUS UTOPIAS

FIGURE INTRO.1. Gertrud Arndt, Mask Photo No. 22, c. 1930, gelatin silver print. 9.4 x 4.5 in. (23.8 x 11.5 cm). Bauhaus-Archiv Berlin © 2019 Artists Rights Society (ARS), New York / VG Bild-Kunst, Bonn.

century, and Spiritism in Europe, which embraced it by the 1870s.[3] Adherents of these movements believed that the soul was immortal, and that ghosts of the dead had the potential to appear and to intervene in our world, albeit in limited ways.[4] Among these interventions was the possibility of spirit communication through an array of what Jeffrey Sconce has dubbed "haunted media," including spiritual telegraphy, in which predominately female mediums transmitted voices from the dead in a manner akin to the electromagnetic telegraph.[5] Photography became central to Spiritualism in the 1860s, when, during the American Civil War, William Mumler began creating spectacular images of the living with spirit figures. Initially the novel result of a technical mistake with reused wet plates, the resulting photographs spoke to both grieving family members and adherents of Spiritualism, and the images began to circulate widely as authentic proof of spirits' existence.[6] Photography provided credible records of Spiritists' increasingly spectacular experiences, including levitating tables, flowers or fruit gifted from the other side, and of course, contact with actual spirits.[7] Over subsequent decades and well into the twentieth century, its prevalence as documentation only increased as new photographic technologies meant that even amateurs were able to snap pictures in the low-light environs of a séance. In the 1920s, photography continued to be employed on behalf of the interest in Spiritism that persisted among both the public and occult researchers at universities including the Sorbonne.[8]

A spirit photograph contemporaneous with the photograph of the Breuer chair shows the medium Marguerite Beuttinger seated in a very un-Bauhaus chair (figure 1.3). Standing, she is blurred and translucent, and, but for her face and hands, in such an advanced state of dematerialization that she appears almost of a piece with the curtain behind her.[9] The unknown creators of both the Breuer and Beuttinger photographs used the same method; with the camera focused on one scene, they exposed the film twice, so that elements that were only present during one of the exposures appear only faintly. In the Bauhaus spirit photograph, a modern man—evidently a white-collar worker and member of the new group of "salaried masses" chronicled by Siegfried Kracauer—is the ghostly figure conjured by this chair.[10] The man and the chair are kindred spirits emerging into modernity.

In light of the fact that the Bauhaus is so often imagined to have unrelentingly pursued a rationalized approach to art and design, how could this Bauhausian iteration of a spirit photograph have come to exist? In fact, the image alludes to a very different Bauhaus than the one we know, one profoundly invested in exploring the spiritual within and beyond. In his landmark *Specters of Marx*, Jacques Derrida remarks that, "Even though...every period has its ghosts (and we have ours), its own experience, its own medium, and its proper hauntological media...this complication ought not to forbid an historical inquiry on this subject....

FIGURE 1.2. Marcel Breuer, *a bauhaus film: five years long*, portion of a page from *Bauhaus* 1 (1926): 3. 5.5 x 4.3 in. (14 x 10.8 cm). Obtained from Monoskop.org © Estate Marcel Breuer.

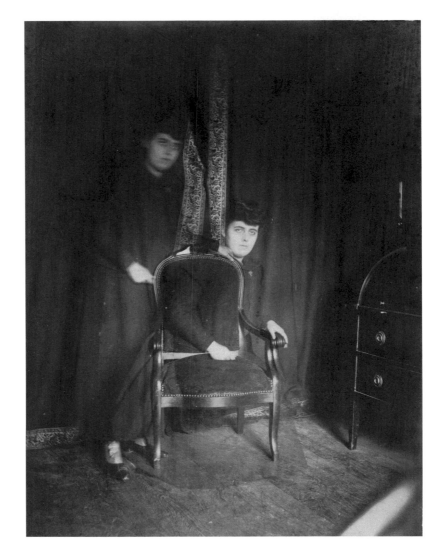

But one must not fail to reinscribe it in a much larger spectrological sequence."[11] Following Derrida's charge, this chapter will propose that the ghosts, spiritual experiences, and hauntological media of the Bauhaus shaped its art and design in ways not always readily apparent to the naked eye, and that they tie the institution to a broader, exploratory cultural continuum of its time.[12] Scholars have done important work on the spiritual in the Bauhaus's early years, particularly during the tenure of Johannes Itten, but rarely is it understood as a motivator for nearly the whole of the fourteen years of the school's existence. As I argue, the objective, *neues*

Chapter 1

Sehen (New Vision) approach of the Bauhaus's middle and later years was not nearly as divorced from spiritual seeking as is often presumed. Many at the Bauhaus continued to probe the realm of the spiritual even as the school publicly projected rationalization as its mission. In a society in which links to traditional organized religions began to loosen, the era's experimental religions and new philosophies offered the promise of healing from the ills of the past, righting a society in crisis, and charting a meaningful future. Early twentieth-century Germany, where many were reacting against what they saw as mechanistic natural science that had "disenchanted" the world, was particularly alive to the paranormal and to demonstrable aspects of the occult.[13]

Contemporaries perceived spirit photography as just one of any number of powerful new visual technologies that revealed previously unseen truths and yielded new understandings of time, space, scale, the body, and even life and death. German scientists were part of a lively international community of scientific experimentation and intellectual exchange that resulted in such advances as August Köhler's 1893 method of illuminated microscopy, which opened up new realms of visible detail in specimens, and Wilhelm Röntgen's startling 1895 discovery of the x-ray's ability to reveal the body's interior.[14] Research into a spatial fourth dimension suggested that our world might be but the shadow of another. Advances in photographic technologies resulted in shorter exposure and development times, and new types of cameras brought immersive media like the stereoscopic view and the cinema to a broad and enthralled public.[15] The First World War introduced numerous new technologies: advanced weaponry, trench warfare, poison gas, and new forms of communication for military command and control, as visual propaganda campaigns engaged and managed soldiers and publics. That war also left 9.5 million soldiers dead, and its survivors with the most egregious injuries ever seen.[16]

In addition to Spiritualism and the influences of new sciences, a third movement is essential to understanding the Bauhaus's context: the nineteenth-century *Lebensreform* or "life reform" movement, which received a new impetus with the understandable ambivalence about technology that many felt in the wake of the war. *Lebensreform* stood in staunch opposition to the negative aspects of industrialization and modernization.[17] It emphasized what contemporaries considered "natural" in lifestyle, food, medicine, clothing, movement, and spirituality. In 1924, Adolf Koch, founder of nudist camps and exercise schools that would soon spread throughout Germany, wrote that, "The misery of our times, the monotony of work, the world war and its legacies have made us into disturbed human beings, both internally and externally."[18] Many who sought change through a broad range of reforms, philosophies, and life experiments held this belief.

Because of its general goal to help to create a better world, the Bauhaus can be counted among these reform movements. Before

matriculating, many *Bauhäusler* had already participated in aspects of *Lebensreform*, most commonly the *Wandervogel* (Hiking Birds) scouting and youth movement, whose members embraced youth independence, trekking, and outdoor living as a part of a broader counterculture.[19] As *Bauhäusler*, they participated in a vast array of life experiments in which art and design functioned as soft sciences to probe occult and mystical phenomena in inquisitive, futuristic, and playful modes. This chapter examines how these ideas and themes manifested in teaching, living, play, and creating by visiting the experiments of six influential Bauhaus teachers within this broad field of new spirituality and occultist science—Walter Gropius, Johannes Itten, Gertrud Grunow, Paul Klee, Wassily Kandinsky, and László Moholy-Nagy—as well as the work of their students and collaborators.

UTOPIAN COMMUNITIES, SPIRITUAL EXPERIMENTS: GROPIUS, ITTEN, AND THE FOUNDATIONS OF THE WEIMAR BAUHAUS

The early Bauhaus's program of guest speakers, readings, and musical performances gives a keen sense of its engagement with *Lebensreform* and spiritually oriented eclecticism.[20] Some of these events were what one might have expected, as when architect Bruno Taut spoke about glass architecture in April 1920, or even when art historian and Werkbund member Adolf Behne gave his "Towards a Cosmic Perspective on Art" talk that same month, and Dadaist Kurt Schwitters came to tell fairytales in January of 1925, just as the Weimar Bauhaus was closing.[21] But the majority of talks and speakers, particularly during the first two years, concerned religious experimentation and *Lebensreform*. In the fall of 1919 and again at the start of 1920, Magdalene Trenkel performed Classical Gymnastics, an energetic form most often done in the nude.[22] The prominent *Wanderprediger* (Wandering Preacher)—one of the early Weimar period's so-called *Inflationsheiliger* (Inflation Saints)—Ludwig Christian Haeusser spoke on the topic of "Christ, Spartacus, Sexualism, and Goethe-Schiller" late in 1920, and he took a group of students, most of them women, with him when he left.[23] Sufi Master Inayat Khan presented on "The Nature of Art," in English in October of the following year; that same month Otto Rauth's "Lecture on the Teachings of Mazdaznan" treated the most significant new religion for the Bauhaus.[24] The influential art historian and medical doctor Hans Prinzhorn spoke in the spring of 1922 on "Drawings of the Mentally Ill."[25]

Gropius himself was strongly oriented to the eclectic and symbolic-spiritual at the start of the Bauhaus. When his 1919 "Program of the State Bauhaus in Weimar" called for artists and craftsmen to unite and create a "new structure of the future" that would "rise toward heaven from the hands of a million workers like the crystal symbol of a new faith," he

intended his impact to be much more than merely theoretical.[26] Gropius was fascinated with Freemasonry, a secret society of initiates based on the medieval guild system and infused with its own occult rituals and mystical symbolism.[27] This helps to explain why Gropius selected Lyonel Feininger's expressionist woodcut of a cathedral radiating light as the cover of the "Program" and his choice of the name "Bauhaus"—a twist on the term for a guild lodge, *Bauhütte*—since both were understood to relate to the guild system. As Annemarie Jaeggi tells us, already when he took up the leadership of the Workers Council for Art (*Arbeitsrat für Kunst*) in March of 1919, Gropius proposed reconvening this large, radical group as a small, tightly knit, and secretive collaborative with its own private symbols, ceremonies, and even cult robes.[28] His hope was that the assemblage of artists, architects, sculptors, musicians, and poets would work together to create a cult house or building (*Kulthaus*) in which they could meet and celebrate. This too he addresses in the "Program," when

FIGURE 1.4. Walter Determann and collaborators, photograph of the Bauhaus settlement model (site plan), c. 1919, gelatin silver print. 6.3 x 8.4 in. (16 x 21.4 cm). Klassik Stiftung Weimar, museum collection, Weimar. Photographer: Roland Dreßler.

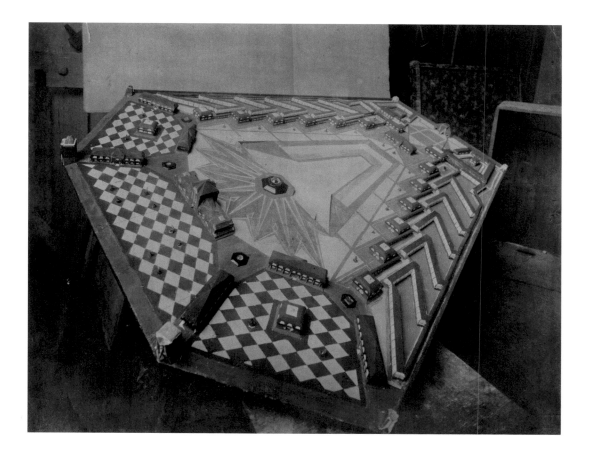

he calls for cult buildings (*Kultbauten*) among the collective, specifically "utopian" projects that the Bauhaus collective will undertake.[29]

The very month the Bauhaus opened, Gropius wrote to Ernst Hardt, director of Weimar's theater, of even grander utopian plans for Bauhaus building: a settlement.

> I imagine that in Weimar a grand settlement should be created at the foot of the Belvedere Hill, centered around buildings for the people, theaters, concert hall, and, as the ultimate goal, a cult building, and that large festivals for the people will take place there every summer, at which the best in contemporary theater, music, and art will be offered. I am determined to create and propagate, initially on paper, great plans in this direction with the help of the masters and students at my art institute.[30]

Gropius lost no time deputizing student Walter Determann to lead a collective working group—additionally comprised of Toni von Haken, Elfriede Knott, Maria Rasch, and Lotte Schreiber—to design the settlement. In June of 1919, at the first exhibit of student work held at the Bauhaus, they presented their detailed plans, views, and a model of the settlement (figure 1.4).[31] The Determann group's site plan—which appears more Wiener Sezession than Bauhaus in its aesthetic approach—describes a perfectly functioning commune and looks as if it were located on an island, which is just how Thomas More, inventor of the term "utopia," situated his early sixteenth-century imagined community. Determann and his colleagues gave their plan a surprising amount of architectural specificity; zig-zagging diagonal shapes along the edges are houses and workshops surrounded by gardens; the model's centrally located, large building—shown to the photograph's left—is for administration.[32] The site plan is crowned in the middle by that very "crystal symbol of a new faith" that Gropius signaled as the Bauhaus's symbol at the conclusion of the Bauhaus manifesto, which also appears to be the cult building he mentions in both the manifesto and his subsequent April letter. The Determann plan centers on an open space for theater and sporting events, the very type of festival space of which Gropius wrote.[33] Toni von Haaken worked tirelessly to complete a plaster model specifically for another key part of the plan, the House of Bodily Education, which ties the project to Trenkel's Classical Gymnastics presentations and emphasizes the centrality of movement as well as spirituality—evoked by the cult building—to the Bauhaus.[34]

Gropius's enthusiasm for the idea of a Bauhaus settlement (*Bauhaussiedlung*) lingered for several years and clearly inflected several of the school's projects. In 1920, writing to Adolf Behne, he expressed his hope that this settlement could serve as an example and a way to approach, "the totality of life, that is *Siedlung* [settlement], children's education, fitness, and still other things."[35] The space for gymnastics, festivals,

FIGURE 1.5. Georg Muche
(design) and Benita Otte
(drawing), *Four Color Print:
Single-Family Home in
the Exhibition of the State
Bauhaus* (*Vierfarbendruck:
Einfamilienwohnhaus auf
der Ausstellung des Staatl.
Bauhauses*), 1923, color plate
XI in *Staatliches Bauhaus in
Weimar, 1919–1923* [165].
9.6 x 9.8 in. (24.5 x 25 cm).
Obtained from Monoskop.org.
© Bauhaus-Archiv Berlin © v.
Bodelschwinghsche Stiftun-
gen Bethel.

and cult buildings would not end up being concretized in a major building project; after all, these were lean, post-war years of rebuilding. Yet ideas that were central to the settlement, including collective production of all arts and crafts, and even such elements of the visual iconography as the room line, went into the drawings and execution of the Haus Sommerfeld villa, the Bauhaus's first collective project, designed and built under the direction of Gropius and Adolf Meyer from 1920–1922.[36]

The enduring Bauhaus-settlement dream even appeared in the 1923 *Staatliches Bauhaus in Weimar 1919–1923* exhibition catalogue, in which Gropius completes his outline of the "Idea and Organization of the State Bauhaus" with a section titled "Bauhaus Canteen and Bauhaus Settlement," in which he describes the Haus am Horn as the first part of a settlement and references an isometric drawing by Benita Otte (figure 1.5). "Adjacent to the garden land, one of the most beautiful areas of Weimar will be developed into a settlement compound, upon which single and group houses will be built as living quarters for members and friends of the Bauhaus. The construction of the houses is to be led by the Bauhaus and will thus provide the workshops with corresponding contract work."[37] That Gropius conceived of the Haus am Horn, designed by Bauhaus master Georg Muche and constructed in four months, in relation to a Bauhaus *Siedlung* is rarely mentioned.[38] Instead, with its straight lines and flat roof, the small building is taken as a prime example of the hard turn to "Art and Technology, A New Unity." Interpreted in the context of the *Siedlung* project, however, the luminous color and interlocking forms of Otte's drawing of a building floating in white space can also be taken as the base unit for a larger, communal, perhaps even Freemasonic settlement that would foster the Bauhaus collective. That the Bauhaus would be forced out of Weimar and move to Dessau during the next three years would, ironically, provide Gropius the chance to finally realize aspects of this ideal settlement in the form of the Dessau Bauhaus campus.

Gropius's was not the only vision to shape the Bauhaus in its early years; Oskar Schlemmer later remarked that, "Itten was the secret director."[39] Johannes Itten, the influential founder of the Bauhaus's preliminary course, was at the heart of another, highly influential spiritual movement at the Bauhaus, Mazdaznan, which held the body as the key site for spiritual self-improvement (figure 1.6). Bauhaus student Helmut von Erffa, writing about his experience of the Bauhaus's early years from the U.S. in 1943, recalled Itten's teaching as an unorthodox mixture intended to offer a new experience of art making:

> He had [the students] use Indian clubs to gain physical relaxation; then he had them draw…. "Draw a thistle, make it as sharp as you can." "Draw a feather and make it soft." One's creative ability was tested by drawing with charcoal the abstract *feeling* of rain, the *feeling* of spring or winter. After a masterful analysis

HAUNTED HISTORIES

Long celebrated for its unadorned design and embrace of the technical and commercial, Germany's Bauhaus (1919–1933) was arguably the twentieth century's most influential art institution. In contrast to the so-called irrational modernisms of Dada and surrealism—movements now widely held to have embraced "messy, subjective, and disorderly practices"—the Bauhaus is often viewed as the paradigmatic movement of rational modernism.[1] In this line of thought, the Bauhaus's revolution is defined almost exclusively by its elevation of sleek and rectilinear design.[2] Further, its most important contributions have been ascribed to a small cadre of innovative artists, designers, and architects.

In this book, however, I propose that the Bauhaus—through anti-utilitarian experiments in occultism and spirituality, communal and individual expressions of unorthodox conceptions of gender and sexuality, and radical politics—was equally engaged with a specific range of ideas that controvert this paradigm of rationality, and that these ideas were central to its project and yet have been systematically overlooked or relegated to the margins. The irrationalities of non-Taylorized bodies and non-normative sexualities haunt the margins of the Bauhaus, as do more familiar haunters: ghosts, spirits, and mysticism.[3] While emergent democracy and capitalism are generally viewed as formative in shaping Bauhaus ideology and design, the significance of radical leftist and utopian political projects has largely been written out of the school's histories—as have its ties to fascism.[4] These haunting elements permeate the Bauhaus and its objects: metal, ceramics, furniture, and fabric designs; architecture and interiors; and figural work in painting, photography, photomontage, and graphic design.

In resurrecting the school's intense engagement with spirituality, the body sexed and gendered, and radical politics, *Haunted Bauhaus* stakes a claim for a vastly more diverse and paradoxical Bauhaus than that put forward by many histories of its tenure. Through an engagement with the terms evoked by its subtitle—*Occult Spirituality, Gender Fluidity, Queer Identities, and Radical Politics*—this book argues that the Bauhaus's legacy rests as critically in the life experiments it nurtured as in the objects and architecture

generated by its members. My analysis springs from the premise that we can understand the school's significance only by taking into account many more of the 1,253 *Bauhäusler*—the students and masters who passed through its doors—and its women in particular, who made up over one-third of the institution's membership, 36.9%.[5] The work of these artists, designers, and architects challenges us to revise the now almost axiomatic notion that the Bauhaus was fundamentally committed to the rational and the normative, by restoring its spectral other to its history.[6]

My approach to rereading this *Haus* as haunted begins with an examination of repressed and uncanny motivators at the Bauhaus that transcend the impetus to produce goods for a capitalist market. I reclaim trauma and desire as well as the so-called *Life Reform* (*Lebensreform*) movement, spiritual seeking, emergent ideas about gender identity and same-sex desire, and political convictions as vital stakes in Bauhaus artists' and designers' work. In *Ghostly Matters: Haunting and the Sociological Imagination*, a text I turn to at several points in this book for its rich explorations of the ghostly in gender, politics, and memory, Avery Gordon uses the term *haunting* to illuminate how content that is repressed or unresolved can escape and manifest obliquely despite the systems that usually contain it. She asserts, "haunting and the appearance of specters or ghosts is one way…we are notified that what's been concealed is very much alive and present, interfering precisely with those always incomplete forms of containment and repression ceaselessly directed toward us."[7] At early and formative points following the shuttering of the Bauhaus in 1933, various repressive forces that dominated cultural discourse made a lasting impact on the school's members and its historiography. These forces include normative ideas about gender and sexuality under Nazism (National Socialism) that disproportionately negatively impacted the careers of women; post-war notions of genius that continued to accrue almost exclusively to male artists; and the persistence of anti-gay laws in Europe during that period, as well as the homophobic "lavender scare" in the 1950s US that likewise propelled heteronormative perceptions of the Bauhaus and its artists. The Cold War years, when Communist content in art was seen as dangerous or, at best, deeply misguided, also shaped scholarly responses to leftist elements of Bauhaus thought and practice. In recent decades, with the growth of a powerful art market in which skyrocketing values are linked to work by a limited number of sought-after names, the Bauhaus's complex history and diverse membership have often been distilled to suit the protocols of the point of sale. In part because many Bauhaus members who fled Nazi Germany carried their technical and philosophical outlook with them to the myriad nations to which they immigrated, the impact of the Bauhaus's ideas and innovations has been global and continues to reverberate today. Yet our inherited Bauhaus histories have circumscribed our apprehension of the

full scope of the institution's relevance in terms of both its historical context and our contemporary cultural landscape.[8] This book returns to look at and listen to the Bauhaus's eerie echoes in order to apprehend it anew.

HAUNTED BAUHAUS

In *Haunted Bauhaus,* I reject the delimiting and often politicized components of the school's historical reception in favor of relying on new sources and the empirical ground of the archive. This reorientation is most evident in the book's understanding of Bauhaus women as central to the movement, an essential readjustment based on the fruits of recent scholarship: despite facing higher admission standards, women not only made up over one-third of the institution's members, but they were active in every workshop and class at the school, without exception.[9] Bauhaus women also appeared frequently as the institution's public face in brochures and splashy articles in the popular press.[10] Avery Gordon writes that one aspect of haunting is the moment "…when the people who are meant to be invisible show up without any sign of leaving."[11] The objects and images produced by Bauhaus women, in an institutional context in which they were often deliberately marginalized, have usually been viewed as ancillary to the school's history, if they are taken into account at all. Recent years have seen a welcome increase in exhibitions, books, and articles on Bauhaus women, but these have tended to focus on the necessary recovery work of investigating individual women's lives and establishing the scope of their work, rather than integrating them into a synthetic history of the Bauhaus.[12]

Haunted Bauhaus widens the lens in general on the Bauhaus, so that each of the following chapters includes a number of both female and male *Bauhäusler* whose work has predominantly been characterized as out of sync with received notions of the school's essential mission, and accordingly relegated to the sidelines. Their presence haunts the school's historiography to the same measure that their activities complicate the standard narratives. As this book reveals, if we reorient and broaden the scope of scholarly inquiry with a view to reintegrating these ghostly presences, the art and design produced by more famous *Bauhäusler* gain a startlingly expansive resonance, as does the institution as a whole.

Instead of providing an overview of the school, a number of which are widely available, *Haunted Bauhaus* sets out to complicate our understanding of the stakes of the school and its members.[13] The concept of the *Bauhäusler* is central to the book, as it reflects the institution's egalitarian striving—a kind of Bauhaus citizenship—more accurately than formulations such as "masters and students," which mask the fluidity of these categories at the school.[14] As a word, *Bauhäusler* is both singular and plural. It was likely in circulation at the school by 1923 at the latest.[15] But, even before there was a word for this shared identity, with the

school's founding document, the April 1919 "Program of the Staatliche Bauhaus in Weimar," Walter Gropius laid out a vision of the Bauhaus as a collective, stating in a list of the school's "Principles" on the first page of the "Program," that "there will be no teachers or pupils in the Bauhaus but masters, journeymen, and apprentices." In the same list, he evokes the concept of utopia and describes what might anachronistically be called team-building exercises, the "encouragement of friendly relations between masters and students outside of work; therefore plays, lectures, poetry, music, costume parties. Establishment of a cheerful ceremonial at these gatherings."[16]

The first students met Gropius's team spirit with their own by organizing an inaugural party (*Einführungsfest*) on June 5, 1919, during which student representative Hans Groß gave a speech recognizing Gropius's "Program" as describing a new kind of relationship between the students and their leader. "I no longer believe that one hundred and fifty are still against one; rather all are now anxious to do their utmost to support and realize this idea."[17] As the school developed, divisions between masters and students were even further eroded, as students taught students and former students became masters.[18] This collective impulse developed as a subculture along with the parallel, increasing use of the word *Bauhäusler* under the subsequent directorships of the leftist Hannes Meyer (1928–1930) and, perhaps more surprisingly, the more conventional and heavy-handed Ludwig Mies van der Rohe (1930–1933).[19] *Bauhäusler* Irena Blühová joined in the fall of 1931 and later wrote of the school, "I found much evidence that a high level reigned not only in the fields of art and subject pedagogy, but also in the areas of humanity, compassion, solidarity…. At the Bauhaus give and take were reciprocal."[20]

Haunted Bauhaus's investment in a larger Bauhaus populated by many more members of the *Bauhäusler* collective is paralleled by its consideration of Bauhaus production in the broadest sense—to include art, design, photography, performance, and life—which also allows us to finally free the institution from the lingering impression that architecture was the most central aspect of the school's pedagogy or production. Although all three of its directors were architects, no workshop or department for architecture was housed within the school until 1927.[21] Prior to that time, selected students could attend relevant courses, and some received training by working with Gropius in his private practice and on Bauhaus projects like Haus Sommerfeld.[22] Of the 1,253 students who enrolled in workshops over the life of the school, only 261 of them did so in architecture, or 20.8%. It is worth noting that, at least by the numbers, given that they made up 36.9% of the student body, women at the Bauhaus were a much more significant presence than architecture students, although some of those student architects—forty, in fact—were female.[23] The shadow of architecture may in part loom so large because of its students' impact; the Bauhaus trained them to think conceptually about design problems in

harmony with emerging technical and scientific ideas for a new society, a contrast to the largely practical instruction offered contemporaneously at building academies and universities.[24]

In its five chapters, *Haunted Bauhaus* recounts the Bauhaus movement as a series of life experiments; in each, I take the objects produced by the school's members as traces of ideas as much as ends in themselves. Chapter 1, "Bauhaus Spirits," retells Bauhaus history as a *Geist* story—referring both to "ghosts" but also to the word's rich connotations in German Idealism of "mind and spirit."[25] From the school's 1919 opening in Weimar, *Bauhäusler* passionately embraced diverse expessions of religiosity by seeking novel spiritual experiences and flirting with the occult. Alongside their work in art, design, and architecture, students and masters created representations of séances from inkblots and double-exposed "spirit photographs." They practiced aspects of the *Lebensreform* movement including breathing exercises and nudist gymnastics; they wore reform clothing and took mandatory courses in "harmonization" for spirit and body. Above all, they practiced Mazdaznan, the neo-Zoroastrian religion that dominated Bauhaus philosophy, art, and even diet. While the school's 1922–1923 turn from its early soulful expressionism to the new motto of "Art and Technology, a New Unity" has been read to signal a complete retreat from the spiritual, in this chapter I show that the break was only partial and that the shift entailed instead a migration of Bauhaus members' utopian aspirations to new conceptions of technology's potential to liberate modern spirituality. I argue that the experience-centered works imagined by László Moholy-Nagy and other *Bauhäusler* proposed a less dogmatic way to continue earlier Bauhaus members' search for spiritual transformation, rather than embodying a turn to a mere uncritical embrace or fetishization of technology.

As much as the spirit, the body was at the center of a range of transformative ideas during the Weimar Republic, a period that spanned the years 1919–1933 and thus was largely coterminous with the Bauhaus. In the words of historian Erik Jensen, "health and fitness movements proliferated in Weimar Germany, and most of these promoted some idea of remaking one's body and oneself."[26] Most significant to my investigation are the period's public legal, scientific, and popular-culture discourses on gender identity and sexuality. War, revolution, and the dawn of the new republic often impacted men and women differently. The war wrought disproportionate devastation on young male bodies, and many male citizens of the republic had ongoing struggles with their corporeal and psychological health.[27] Meanwhile, the 1919 Weimar constitution legislated equal rights for women for the first time, rights for which they had long fought.[28] As the young democracy unfolded, for both men and women, the 1920s witnessed a new openness to ideas far beyond traditional, normative understandings of gender, sex, and sexuality at institutions such as Magnus Hirschfeld's Institute of Sexual Science in Berlin, likewise founded

in 1919, where researchers developed the scientific field of "sexology" and posited a spectrum of sexual identities and behaviors as natural to humanity.[29] These discussions came to the Bauhaus through publications and guest speakers as well as via the travel of cosmopolitan *Bauhäusler* to big cities, Berlin above all, where this acceptance and even celebration of experimentation with identity and sexuality seemed to be everywhere evident, on the streets and in cafés, clubs, and cinemas. *Haunted Bauhaus's* three middle chapters unpack the impact of these central, long suppressed aspects of gender and sexuality to argue that the body at the Bauhaus was haunted by repression, experimentation, and desire.

Chapter 2, "New Visions of the Artist: the Artist-Engineer and Shadow Masculinity," focuses on two competing male types as through-threads in Bauhaus imagery. The first is the optimistic and technologically savvy artist-engineer, and the second is that sunny type's doppelgänger, the lurking avatar of a war-torn or traumatized man that gave the lie to conventional masculine ideals. The artist-engineer was an ideal solution to Gropius's declared end of "salon art," painting as commodity, and a novel masculine type who offered a changed role for the artist in an increasingly technologized society.[30] The second type shadowed the first with its uncanny expression of the masculinity of the male body doubled, mocked, undercut, or impotent. Not limited to Bauhaus works, these haunting doubles appeared contemporaneously in the broader context of interwar visual culture, especially in avant-garde paintings and in numerous films about murderous sleepwalkers, soul-stealing devils, and serial killers.[31] As *Bauhäusler* sought to design and build the new society and to construct novel ideal types for the artists of the future, they also produced a critical visual discourse on masculinity that explored its dark sides, created space for male vulnerability, and provided an inoculation against the heroization of right-wing masculine types that persisted throughout the years of the Weimar Republic. In a way, these figures functioned as sublimations of traumatized male psyches and, in that sense, they are also akin to what Sigmund Freud referred to as *unlaid ghosts.* "In an analysis… a thing which has not been understood inevitably reappears; like an unlaid ghost, it cannot rest until the mystery has been solved and the spell broken."[32] Specters troubled these attempts to articulate a new man with haunting visions that evoked a disturbing past and gestured towards a fascist future.

My inquiry into gendered representation continues in chapter 3, "Bauhaus Femininities in Transformation," which considers new forms of female identity designed at the Bauhaus. Like their masculine counterparts, Bauhaus women's art and design as well as their figurative photographs often served as proposals for new ways of being in the modern world through emergent Bauhaus femininities. These corresponded to the new life possibilities in a post-war society that promised women full equality, and they contested the often unameliorated limits on women's creativity.

It was in secret that, before the first year of the Bauhaus was over and in direct contradiction to its open proclamations of the school's gender equality, Gropius and the masters' council raised the admissions standards for female applicants in order to eventually reduce their numbers to a maximum of one third of the student body. Henceforth, admitted female students who completed the preliminary course (*Vorkurs*) were to be strongly encouraged to enter the weaving workshop, for a time dubbed "the women's class."[33] As this chapter argues, despite these challenges—and perhaps even because of them—not only did Bauhaus women master new technologies to design functional objects and interiors that included clothing, ceramics, metal, lighting design, and home-industrial kitchens, many of these women were also leaders in the school's pioneering approach to adaptable design. I argue that, in their lives and work, female *Bauhäusler* were engaged in a sustained if largely unarticulated project of defining modern femininity and investigating how emerging forms of womanhood could best be expressed in a society recovering from war and revolution, moving through the upheavals of the Weimar period, and then descending into fascism and eventually brutal armed conflict in the 1930s and '40s. Parallel to these designs, Bauhaus women created photographic images that challenged mainstream perceptions of New Women as mere embodiments of superficial consumer culture. Artists including Marianne Brandt used the medium to create novel mashups of the New Woman and the artist-engineer or to model femininity as a masquerade; this latter concept was contemporaneously theorized by the psychoanalyst Joan Riviere, who asserted that "womanliness…could be assumed and worn as a mask, both to hide [a woman's] possession of masculinity and to avert the reprisals expected if she was found to possess it."[34] Gertrud Arndt exploited the same medium to very different ends; whereas Brandt's self-portraits represent her as a technologically savvy constructor, Arndt, an extremely accomplished weaver, renounced her craft and instead made photographs of herself excessively costumed and demonstratively idle, a performative eschewing of the Bauhaus's future-oriented mission. As this chapter demonstrates, like their contemporary Claude Cahun and long before Cindy Sherman, Bauhaus women turned to portraiture and self-portraiture to perform and probe their own eerie psychological interiors, and to adopt and adapt a range of malleable, transformative identities.

Chapter 4, "Queer Bauhaus," delves into the previously unexplored question of sexuality and gender fluidity at the Bauhaus by focusing on *Bauhäusler* who queered the school's aesthetics in order to disrupt gender conventions, represent gay and lesbian subjectivities, and picture same-sex desire—a move not without risk under a regime that criminalized homosexuality. This chapter again makes apparent Gordon's "people who are meant to be invisible," in this case *Bauhäusler* who we would now call gay, lesbian, bisexual, and transgender, people whose identities were life

experiments on a par with others at the Bauhaus, although their presence at the school has been all but erased. Gordon also writes of haunting as a state in which "repressed or unresolved social violence is making itself known, sometimes very directly, sometimes more obliquely."[35] In addition to arguing for the vital importance of coming to grips with gay and lesbian *Bauhäusler*'s work because it directly and obliquely evinces the traces of such social violence, this chapter engages objects that invite queer readings—interpretations centered on same-sex desire—regardless of their makers' sexual orientation. By queering the Bauhaus, this chapter further debunks the myth of the Bauhaus as dryly objective (*sachlich*) and upends the institution's presumed heteronormativity by arguing that a queer approach to objects and imagery was fully in keeping with Bauhaus experimentation.

Given the republic's repressive anti-homosexual laws, it is not surprising that the gender politics of many of these works are, as I assert, *coded*, so that, through medium and content, artists often evoked conventional norms of gender and sexuality only to simultaneously overturn them, creating images and objects that could be read in multiple ways. Florence Henri turned to photography to create her iconic images that herald new forms of independent, modern femininity. Henri also made seductive female nudes that functioned dually: lesbian desire haunts the photographed model, yet these images also fit readymade into the mainstream soft-core pornography industry, where they provided Henri with needed income. Other works were much more overt in their embrace of queer content, such as Max Peiffer Watenphul's campy photographs of men in female drag that pair imagery from Weimar's gay and lesbian subcultures with Bauhaus aesthetics. This chapter argues that certain Bauhaus works invite queer double vision as manifestations of what has come to be called "queer hauntology," which calls up ghosts from the past to trace queer lineages and asks, in the words of Carla Freccero, how might "an openness to haunting guide…our historiographic endeavors?"[36]

To paraphrase Karl Marx and Friedrich Engels's *Manifesto of the Communist Party,* a specter of Communism itself also haunts the Bauhaus—and so does fascism. This book concludes with chapter 5, "Red Bauhaus, Brown Bauhaus," named for the colors associated with each of these political movements; it traces the Bauhaus's experiments to its later years, when the institution became highly politicized. Much of this political activity was Communist, particularly when, starting in 1927, students organized themselves into a political cell called the Kostufra or Communist Student Faction. In 1930, they founded their own alternative *bauhaus* journal, a low tech, largely text-based affair that they produced secretly and as a collective.[37] Parallel to this movement and arguably in reaction to it, the Bauhaus was home to a nationalist and even National Socialist faction as well. While the numbers lay with the leftists, reports from the school's last years in Dessau detail sharp polarization, with even

the territory of the school's canteen divided up between right- and left-wing students.[38]

This chapter reintroduces an array of politically inflected Bauhaus art and design from the school's later years and its immediate aftermath in order to probe the limits—extremes of the political left and right—of its experiments in change. In focusing on both political extremes at the Bauhaus, I make two arguments. First, that the school's three-year, intensely Communist period from 1928 through 1931 was a kind of fruition of a promise made at its start, namely that art and design could change the world. Charges of Bolshevism were leveled against the Bauhaus from its earliest years in Weimar, but Communism only became a significant motivating force during the Dessau period. By the school's later years, the change Bauhaus work conjured was no longer spiritual and individual; it sought to instill a new consciousness in its viewers and users and to lay the ground for world revolution. Communist *Bauhäusler* of this period joined the party, worked as activists and spies, and put their skills into the service of that revolution. These later Bauhaus members moved increasingly away from the precious object and instead designed agitprop wagons for workers' rights parades, items that could be mass-produced to offer easier and more efficient everydays to everyone, and affordable housing for workers in the dreamed of Soviet society. They made photographs in the realist idiom of Worker Photography *(Arbeiterfotografie)* to expose the plight of society's marginalized, and often worked in representational forms that had little financial value compared with traditional fine arts, but which were easily reproduced, disseminated, and understood by a broad public. Serbo-Croatian *Bauhäusler* and Communist Ivana Tomljenović created the only extant film that shows the Dessau Bauhaus building itself, a rough experimental short that was a signal Bauhaus-constructivist work. This film illuminated a new direction that, had this Communist phase not been cut so decisively short, might have realized a mission already set for the Bauhaus by Moholy-Nagy in Weimar: to make experiential art for a new world rather than commodity fetishes for museums and collectors—ironically what many Bauhaus objects have become today.

The second argument that arises in this final chapter on late- and post-Bauhaus art and design in relation to politics is that the political orientation of this work was not a foregone conclusion. The nationalists and National Socialists at the Bauhaus were more subdued and less organized, so there is not a specific body of work from the school's tenure with obvious right-wing content. However, a wealth of material from *Bauhäusler* who were victims and perpetrators of the Holocaust—sometimes both—connects them to Nazism in significant and surprising ways, as this chapter reveals.

By concluding the book with an exploration of how Communist and Nazi politics relate to the school, *Haunted Bauhaus* comes full circle

to contend that we cannot understand the Bauhaus's arc without engaging its striving to remake the world as the *Bauhäusler* knew it. Its members explored the margins and the leading edges of culture and experience even as they consistently interacted with the mainstream, in a kind of dialectical movement that obviates constructed polarities between the rational and the irrational. *Haunted Bauhaus* argues that Bauhaus works are best understood as artifacts of life experiments aimed at profound change that moved from the interior worlds of spirit and mind; through the body, gender, and sexuality; and outwards to reimagine society as a whole. Above all, what haunts the Bauhaus and unifies it is its sometimes obscured, but never abandoned, search for utopian solutions to the entrenched inequities of its historical moment.

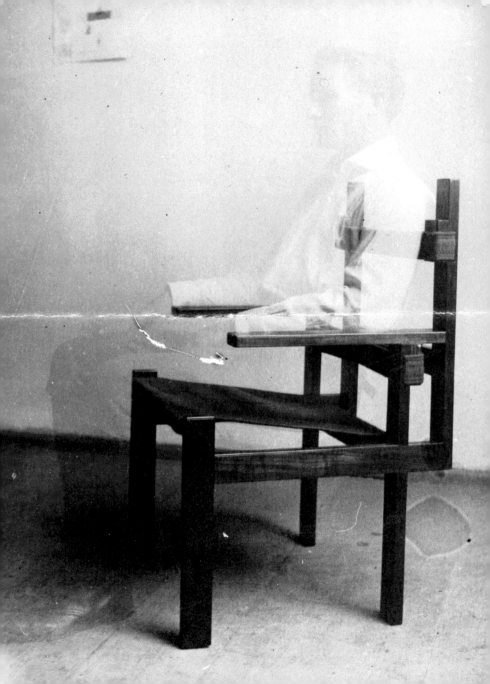

BAUHAUS SPIRITS

FIGURE 1.1. Unknown photographer, Untitled (disappearing figure seated on Marcel Breuer chair, later titled *ti 1a*), n.d., c. 1922–1928, gelatin silver print. 3.9 x 2.7 in. (9.8 x 6.9 cm). Getty Research Institute, Los Angeles.

DOUBLE VISION

A box at the Getty Research Institute containing Bauhaus student work includes a small photograph of a wooden slat chair—model *ti 1a*, designed in 1922 by the young Hungarian student Marcel Breuer (figure 1.1). Combining interlocking wooden L shapes, cantilevered arms, and a sparse frame draped with strips of hand-woven Bauhaus fabric, the *ti 1a* unites elements of the school's craft-centric beginnings with the markers of that year's shift toward a pared-down, machine aesthetic, as articulated in the new Bauhaus slogan, "Art and Technology, a New Unity."[1] Under the banner of this catchphrase, the school aimed to generate prototypes for industrial manufacture, rather than produce individual objects for sale. While Bauhaus was never a style, per se, its aesthetic approach begins to look increasingly sleek from this point forward. Breuer's chairs—particularly those in bent metal—are now iconic. With their simple, rectilinear frames banded with strips of fabric, they exemplify the school's functionalism.[2] They were meant to be easy to manufacture, care for, and transport, all without obstructing views of their architectural environments. Breuer impishly proposed his chairs as markers of human social evolution in a film mock-up he created in 1926 (figure 1.2). Marked with an uncertain date, its final frame shows a woman seated on an invisible "elastic column of air." One day, he suggests, we will free ourselves from objects entirely.

The Getty photograph is memorable for more than its prescient chair. Comprised of two composited exposures, it seems haunted by a ghostly figure. Surely his transparent form is there to demonstrate that, stiffly rectilinear though this chair may appear, it is also well designed and comfortable. Yet the man's spectral presence eerily contrasts with the clean objectivity of Breuer's design. It brings the practical and the mystical into unsettling, even uncanny, proximity. The chair photograph's sober composition and ostensible subject place it clearly in the tradition of the Bauhaus. But it also suggests another lineage: spirit photography, an immensely popular visual form in wide circulation beginning in the later nineteenth century.

Photographs of spirits and mediums were part of a movement centered on the possibility of communicating with the dead that was called Spiritualism in the United States, where it arose in the mid-nineteenth

ein bauhaus-film

fünf jahre lang

autor:
das leben, das seine rechte fordert

operateur:
**marcel breuer, der diese rechte
anerkennt**

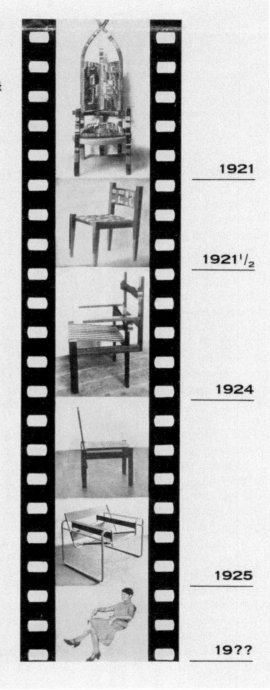

1921

1921¹/₂

1924

1925

19??

es geht mit jedem jahr besser und besser.
am ende sitzt man auf einer elastischen luftsäule

of Sung paintings, he told us that the Chinese artist had felt the landscape he painted, not copied it from nature but produced it because he was one with nature. While we put the charcoal on paper we were to be filled with the feeling of rain or snow. After that we proceeded to the drawing of materials. This had a double purpose. First it would enhance our tactile sense, then it was to bring us in harmony with the material we were to work with…. There was the theory current that unless you had a mystical relationship with your material you could not get the most out of it.[40]

In addition to evoking Itten's eclecticism, von Erffa's text also suggests the awe that he inspired in his students.

In his diary, Itten elaborated on another means with which he started class, a practice he began even prior to his Bauhaus time, when he was teaching in Vienna; the goal was to "enable the body to express itself, to experience things, to awaken these things in it. First one has to experience. For that reason, I needed gymnastic exercises, to experience, to feel, to unleash chaotic movements…. Only then did the harmonization exercises follow."[41] Clearly Itten drew upon a broad range of esoteric ideas in order to reshape the process of forming young artists; far from the copying of models or even life drawing, Itten's preliminary course aimed at giving Bauhaus students *experiences* from which to create from within.

Experimental spirituality at the early Bauhaus revolved to a great extent around Mazdaznan, a hybrid religion founded by Otoman Zar-Adusht Hanish as the Mazdaznan Temple Association of Associates of God in Chicago in 1890. Little is known about his origins, but he was likely a German immigrant originally named Otto Hanish.[42] This syncretic religion combined Zoroastrianism, ayurvedic medicine, tantric Hinduism, Christianity, and Ancient Egyptian philosophy, and drew on early twentieth-century mysticism including Spiritism and Helena Blavatsky's Theosophy movement. The central practice of Mazdaznan was to strive towards light, which was associated with good and happiness, and it stressed morality and personal responsibility. Mazdaznan prescribed a strict vegetarian diet, extended fasting, breathing exercises, hot baths, singing, smiling, creative movement, and a training of the mind uniquely towards positive thoughts.[43] Practitioners could learn about the future by deciphering ancient texts written in cuneiform or Egyptian hieroglyphics but also from what Hanish called the "Open Book of Nature," which included all observable natural phenomena such as clouds, sunlight, wind, and water.[44] In Mazdaznan, the body is considered the living god's temple, so that it must be brought into harmony in all realms, intellectual, spiritual, and physical.[45] Via Hanish's disciple David Ammann, the movement reached Germany in 1907. Key texts were published in German, among them a cookbook to guide initiates' transition to the sect's vegetarian diet, and *Atemlehre,* a translation of Hanish's *The Power of Breath* that instructed

readers in, among other things, "Egyptian Exercises."[46] The religion had vociferous critics, including the U.S. muckraker Upton Sinclair, who, in his 1918 treatise against the immoralities of numerous religious movements, *The Profits of Religion*, listed Mazdaznan under the grouping, "The Church of the Quacks."[47] And yet to many who were seeking spiritual and bodily renewal, it offered new methods for mindfulness and an updated moral code that they embraced, often with fervor.

Mazdaznan took the Bauhaus by storm when Gropius hired Itten to begin teaching in fall 1919. Itten arrived from Vienna with sixteen students, who were likewise Mazdaznan converts.[48] As the preliminary course instructor, Itten set the tone for the entire school since all students had to pass his class and prove that they understood a set of fundamental principles before they could specialize in one of the workshops. Among these students was Paul Citroen, who came to the Bauhaus in 1922 after his participation in *Der Sturm* and Berlin Dada, and promptly became a convert of Mazdaznan. He later reported that the religion profoundly shaped the school's daily life, including the offerings of the canteen, which conformed to a Mazdaznan diet. Citroen described practices such as the fasting required at regular intervals and for as long as three weeks, which transported its Bauhaus Mazdaznan adherents—many of whom were already malnourished in the early Weimar Republic's ongoing period of shortage and financial crisis—into altered states. He wrote of, "the unique, unforgettable experience we had during and because of the fasting. The bodily changes and transformations gave rise to unexpected moods, opened unknown regions of feeling. I would never have thought it possible to attain such 'transparency,' to become so receptive to otherwise hardly noticeable spiritual vibrations. In the end it was a pity to have to leave this exalted, almost unearthly state."[49] Citroen also had a sense of humor about the limits to which Mazdaznan's regimes pushed the body; a 1922 drawing titled *Mazdaznan Regime* shows practitioners shaking, defecating, vomiting, and wrapped in bandages.[50]

Painful as it sometimes was, Mazdaznan gave its practitioners a feeling that they could decipher others they encountered as part of nature's open book. Citroen notes, "when we shook someone's hand we could tell more about him from the handshake, the dryness or dampness of his skin, and other signs than he would find comfortable. His vocal pitch, his complexion, his walk, every one of his involuntary gestures gave him away. We thought we could see through any person, because our method gave us an advantage over the unsuspecting."[51] In addition to this sense of omniscience, Mazdaznan made its members feel privileged because they would not, as Citroen put it, "like the others, collapse in the great chaos."[52]

Works produced during the early Bauhaus show the influence of Mazdaznan's theories of color, light, and spirituality. Drawings of Mazdaznan leaders (Citroen completed one of Hanish), designs for utopian sculptural structures, and photographs of life at the school are all evidence of

Chapter 1

Bauhaus members' connections to Mazdaznan and the belief that spiritual learning was essential to the school's quest. Shortly after Itten arrived at the Bauhaus, he began work on perhaps his most significant work, his *Tower of Light*, an architectural sculpture that rendered his engagement with astrology and the theosophical writings of Charles Webster Leadbeater and Annie Besant—who both inspired Kandinsky as well—and with theories of the fourth dimension from Claude Bragdon's 1913 *Primer of Higher Space*.[53] In a move associated more with László Moholy-Nagy's so-called *Telephone Pictures (EM 1-3)* of the following year, which he later claimed to have ordered over the telephone from a technician, Itten dematerialized his relationship to the sculpture by having it manufactured by a local stained-glass workshop, rather than making or assembling it himself.

Itten was above all a teacher, and works of his students, including Friedl Dicker, who came with him from Vienna, are examples of Itten's philosophies and theories of spirituality embedded in simple abstraction (figure 1.7). Essential to the preliminary course was Itten's theory that perception occurs through contrasts: "The *chiaroscuro* (brightness-darkness) contrast, the material and texture studies, the theory of forms and colors, the rhythm and the expressive forms were discussed and demonstrated in terms of their contrast effect," he later recalled of his teaching.[54] The most important of these pairs, true to the Mazdaznan doctrine's focus on light as a symbol of spiritual goodness, was the *light-dark contrast* exercise, which taught students to see subtle gradations of tone in order to heighten their senses and perceptive abilities, and to think of them akin to musical chords.[55]

Student works reveal not only the influence of Itten's Mazdaznan but of the heady mixture of other spiritual ideas in the air at the Bauhaus. In his ink wash, watercolor, and pen and ink picture *Spiritist Séance*, Citroen materializes two indistinct, glowing figures out of the darkness (figure 1.8). Like Bauhaus members' multi-faceted mysticism, *Spiritist Séance* is an amalgam of otherworldly methodologies that engages with mediumistic forms of reproduction in distinct registers. With its balance of light and darkness, the picture generally suggests the enlightenment and transparency of Mazdaznan. More specifically, it appears as a record of an otherworldly scene, as if Citroen—with uncharacteristic awkwardness as opposed to his normally precise work—witnessed it and quickly jotted it down as a Spiritist picture in ink and watercolor akin to the more famous spirit photographs. As, according to its title, a representation of a séance, it is not entirely clear what we are witnessing. It could document an interaction between a researcher and a medium, scenes of which were captured by contemporaneous occult scientist Albert Schrenck-Notzing and published in his 1914 *Phenomena of Materialization*.[56] The indefinite character of the female figure's face and upper body and the male figure's arm also evoke a laying on of hands or the presence of an ectoplasm, a

FIGURE 1.7. Friedl Dicker (Friedl Dicker-Brandeis), *Study of Form and Tone (Form und Tonstudien)*, 1919, chalk on black paper. 12.8 x 8.9 in. (32.5 x 22.5 cm). Getty Research Institute, Los Angeles.

stringy substance that emerged from a medium's bodily orifices during spirit possession and often looked remarkably like cheesecloth.[57] But Citroen's could also be a picture of the ghostly, conjured figure of an "extra" at the left—the kind that appeared in Mumler's photographs—here hovering over the seated medium.[58] Lastly, Citroen's séance image functions as a seeming direct trace of a spirit presence, with passages of abstract watercolor and dripped forms that recall Spiritist inkblots, the so-called *Kleksographien* of Justinus Kerner that circulated widely in publications in the later nineteenth century as manifestations of actual spirits.[59] Kerner "enhanced" the emerging forms to allow others to see them, and Citroen uses a similar technique of adding lines to define details of faces and bodies from within the abstract forms of dripped ink and watercolor. In its complex amalgamation of the range of experimental religions on offer at the Bauhaus, *Spiritist Séance* embraces a wide array of Spiritist thought and image making; it is profoundly Bauhaus, in ways that challenge conventional understandings of the school.

The rediscovery of spirituality was a serious matter for Bauhaus members such as Citroen, but an often missed but essential element of this and other Bauhaus images is humor. Citroen's *Spiritist Séance* evokes multiple currents of occult thought in a manner that could poke fun at these quickly passing fads. It suggests numerous paths to enlightenment, but in the end, it is merely a low-tech image that shows two amorphous figures surrounded by darkness. While Citroen initially immersed himself in the Mazdaznan religion, by 1924 he clearly had distanced himself from it, and these layers of belief and skepticism shine through the murky multidimensionality of *Spiritist* Séance. If taken in play, it could also be a device to offer his fellow *Bauhäusler* the simple yet transformative release of laughter. This work is both a profound and layered meditation on the ongoing unfolding of multiple otherworldly possibilities at the Bauhaus, and, at the same time, a picture that suggests its own opposite: the shabby charlatanism of upstart cults or tricks of the Spiritist trade that relied upon visions only partially revealed in darkness.

SPIRITUAL APPROACHES: GRUNOW, KLEE, AND KANDINSKY

Beyond Gropius's Masonic, communal foundational thinking and Itten's Mazdaznan-eclectic theories, three more Bauhaus teachers' work and pedagogy were critical vehicles of the time's new spiritualities: Paul Klee, Wassily Kandinsky, and an instructor who numbers among the most central figures of the early Bauhaus but has all but been written out of its history, Gertrud Grunow. Klee and Kandinsky have been studied extensively, so less attention to them is required here, but the part that they played in conveying new ideas on religion and spirit in their work and teaching is essential for understanding Bauhaus spiritualities.[60] All three of these artists' engagements with emerging theories of spirit, body, and reform predate

Spiritistische Séance Weimar III.24

O Citroen

their time at the Bauhaus and were among the attributes that led Gropius to invite them. Although their approaches were different, Klee and Kandinsky were friends and had both been members of the expressionist Blue Rider (*Blaue Reiter*) group in Munich prior to the First World War. Grunow's training was as a musician in her native Berlin, where she studied with composers, conductors, and pianists including Hans Guido von Bülow and the brothers Philipp and Xaver Scharwenka. She became a vocal teacher and, during the period of the First World War, developed her own theoretical approach, which she began teaching at the Bauhaus as the Practical Harmony Course (*Praktische Harmonisierungslehre*) at Gropius's request, in the fall of 1919.

Initially a contracted instructor at the Bauhaus, Grunow came to be considered one of the school's masters of form, who, in contrast to the masters for practical workshop instruction, were responsible for art, theory, and intellectual leadership and whose numbers included Kandinsky and Klee, as well as Feininger, Itten, Moholy-Nagy, and Gropius himself.[61] While a few other women held leading positions at the school over the course of its fourteen years, the titles changed somewhat over time, and Grunow was the only woman ever to attain this highest title for a teacher during the school's early years.[62] Furthermore, as the notes of the masters' council meetings attest, Grunow's judgments about students' preparedness to progress from the preliminary course to one of the workshops often decided their fates.[63]

Grunow's theories survive only in fragmentary form, since, after her death, a former student reworked her most major treatise and destroyed the original.[64] Still, other writings have survived, and it is clear that her teaching and methods were compatible with Itten's, who first invited her to visit the Bauhaus.[65] Contemporaneous records also indicate Grunow's

FIGURE 1.9. Unknown photographer, assistant during Gertrud Grunow's class (possibly Hildegard Nebel-Heitmeyer), n.d. (c. 1917 in Berlin or 1922 in Weimar), gelatin silver print. 4.3 x 3.3 in. (11 x 8.5 cm). each. Bauhaus-Archiv Berlin.

centrality to the school; writing in the 1923 catalogue for the *Staatliches Bauhaus* exhibition, Gropius described her course, "During the entire curriculum a practical course in the fundamental relationships of sound, color, and form is followed, designed to harmonize the physical and psychic qualities of the individual."[66] In the accompanying diagram representing the school's curriculum, the Harmony Course (*Harmonisierungslehre*) is a solid strip at the base that undergirds all other classes.

Grunow's Practical Harmony Course was based in the idea that elements of the natural world, as well as musical tones, shapes, and poses of the body, are perceived universally, that is, in the same way by all people. Moreover, according to Grunow, the experience of perceiving these primary elements and understanding their interconnected nature has a balancing and even healing effect on individuals. By concentrating on these equivalent elements and reproducing prescribed movements that were in harmony with them, individuals learn to find equilibrium within themselves.[67] Thus, as for Kandinsky and others at the Bauhaus, synesthesia, the experience of perceiving across senses, was essential to Grunow's teaching. Sound was also central for Grunow; not only was she most familiar with it, as a musician, but she believed that the ear's location directly next to the brain, our most important perceptive organ, gave it primacy over other senses. In a series of photographs, Grunow's assistant holds three of the prescribed poses (figure 1.9). From left to right they are: the notes E, E#, and E and the color white; the notes A#, E#, and A and the color blue-violet; and, finally, the note E paired with green-blue.[68]

Another principal element of Grunow's teaching was the *Circle of Balance* (*Gleichgewichtskreis*), which students were assigned to create for themselves to explore how colors corresponded with other elements. These were colored circles or other shapes arranged and glued in a circular layout, because Grunow considered the circle to be the most basic of all forms.[69] In Grunow's most prominent publication from her Bauhaus period, "The Creation of Living Form through Color, Form, and Sound," her contribution to the 1923 *Staatliches Bauhaus* catalogue, she explains the ideas that animate the *Circle of Balance* concept and her over-all theories.[70] As a universal, ordering force experienced by all, gravity impacts the natural world and its apprehension through the senses. Thus, the circle is the most universal form because it represents a center of gravity and equilibrium. Colors are not merely appearances to the eye but "living force"; their true order cannot be derived from intellectual calculation, but is likewise the result of gravity, and thus can be understood subconsciously by all. Gravity serves as a guide to seeking equilibrium, so that colors, forms, and the human body sense instinctively their order within their own spectrum and in relation to each other, just as musical notes proceed from lowest to highest. Thus, the proper order of colors "is found subconsciously and spontaneously by anyone because of the gravitations within the living and active body."[71] The *Circle of Balance*

exercise was thus a heavily coded, abstract representation of these theoretical ideas and a way for students to understand their bodies as perceptive instruments.

For Grunow, perceiving these relationships was the most significant creative act, more important, one senses from her writing, than any work of art or design that might be produced through such an experience. She wrote of the school that,

> In a place where all endeavors are directed toward reconstruction and companionship in liveliest reciprocation with the world, as in the Bauhaus, the cultivation of independence, born in the subconscious, will, as beginning and constant aid, not be dispensable. For, only from such independence can a renewal, an intensification, and a strengthening of sensitivity and receptivity originate in the purist and most thorough way, [and] can expressiveness develop which is living, pure, thorough, and rich.[72]

In Grunow's theories, such expressiveness—the creation of art and design at the Bauhaus—then is the "living" sign of the artist's own renewal, and cultivating this as well as the "independence" that nourishes it are the Bauhaus's clear goals. That very independence comes from balance achieved through her methods of experience and perception. As in Gropius's goal of creating "the totality of life" through the idea of a Bauhaus settlement or Itten's equally eclectic embrace of Mazdaznan's life rules, Grunow's teaching was bent almost exclusively on Life Reform and renewal.

Lothar Schreyer, himself a master of form, later recalled that Grunow "appeared to us to be like one of the great intellectuals of antiquity. The intellectual connections between color, form, and tone arose to her from an inner clairvoyance. Thus, she brought people inwardly and outwardly into 'balance.'"[73] Still, with Itten's departure and after the exhibition closed in September of 1923, Grunow's influence declined. After a long discussion during a meeting that same fall, the masters' council decided by a six-to-two majority that the Practical Harmony Course was no longer necessary, as Grunow's methods seemed to have had no impact.[74] In the spring of 1924, Grunow left the Bauhaus for good. But her four and a half years there had a significant impact on many; through movement, music, and what might best be considered a form of soul searching, she taught students the importance of thinking synthetically, creatively, and abstractly and provided them with a methodology for integrating their ensuing discoveries into their work.

In contrast to Grunow, Paul Klee's spiritual influence at the Bauhaus has received more attention. Prior to teaching there, Klee was based in Munich, and the early critical reception of his work tended to place him as a mystic, a logical conclusion given his subjects and his studies with

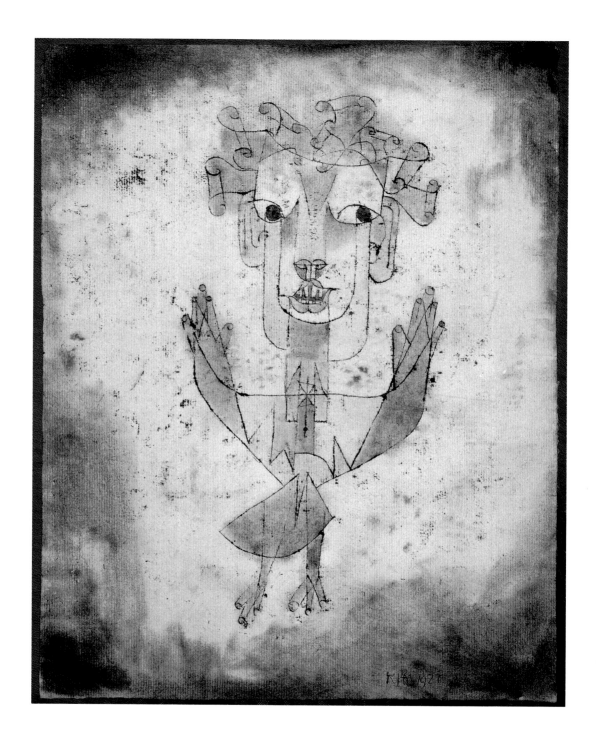

symbolist Franz von Stuck. Yet Klee saw himself otherwise and long but unsuccessfully strove to rid himself of this reputation, even as he continued to pursue mystical subjects in his work.[75] This tension is evident in Klee's Bauhaus-era art and teaching, which engages mysticism but also playfully makes space to critique the more doctrinaire ideologues at the school. Klee began at the Bauhaus after Grunow, in the spring of 1921, two years into its existence. He and Grunow lived in the same house for a time and, he periodically sought her advice on the abilities of newer students.[76] Yet, in the fall of his first year, he wrote to his wife about Grunow's methods in a dismissive manner: "Grunow came down in the evening, finding evidence of her approach in my presentations. Of course, I cannot judge it. I am red, my material is wood, now you know it. She's already lurking now to see how it will continue on Monday."[77] While composer Grunow and Klee—himself an accomplished musician—would seem to have had common interests, this anecdote suggests that he was suspicious of her rather strict doctrines, which were very different than his own approach to the spiritual. He was open to new ideas but displayed an almost allergenic aversion to serious occultism. While he embraced the otherworldly in his art, Klee never adhered to any organized religion, traditional or otherwise, and his works seem at times to even caricature his contemporaries' Spiritism.[78]

Klee's quickly rising international stature as well as his complex approach to both abstraction and the spiritual were surely essential factors in his appointment to the Bauhaus, a post he held for a decade, until April of 1931. Inspired by folk, non-Western, and children's art, Klee's often extremely abstracted forms gesture toward the mystical, as do the titles of his works. He was strongly influenced by Wilhelm Worringer's 1908 *Abstraction and Empathy*, which argues that a culture's use of abstraction signals a period of anxiety or intense spirituality, things that both Worringer and Klee saw reflected in their own time.[79] Through his eclectic approach to spirituality, Klee tapped into the tradition of primitivism within German romanticism and expressionism, but with a complexity that drew the attention of his contemporaries in other avant-garde movements. The Zurich Dadaists were avidly discussing Klee's work already in 1915.[80] And, perhaps because of the strange and open-ended nature of his imagery, Klee was the first Bauhaus artist associated with surrealism, a movement that would, over time, come to influence several *Bauhäusler* with its uncanny engagement with the ghostly and psychological. Initially a purely literary movement when it was founded in the early 1920s, surrealists held their first art exhibition in 1925 and included Klee's work among others' as representative of the movement's ideas.[81]

A number of magical and mystical motifs appear in Klee's work, such as astrology, oracles, and divining rods; and spirit figures including ghosts, witches, fairies, elves, and demons haunt his pictures.[82] Perhaps Klee's most famous otherworldly figure was his 1920 oil transfer and watercolor

Angelus Novus, purchased by Walter Benjamin and a great source of inspiration to him (figure 1.10).[83] Klee's angel has an oversized head compared to its bird body, which is rendered in sparse line drawing to show a hybrid figure emerging in a cloud of light. The figure appears at once childlike—almost mischievous—and all knowing. The Angel's large, searching eyes, typical of Klee's figures, stare off into a distance that we cannot see. The face is haloed with scroll-like curls, and his lips are parted as if in a moment of annunciation. For Benjamin, writing in "On the Concept of History" in exile in 1940, this is the angel of history whose face is turned toward the past, where he sees the unending wreckage of catastrophes, not in their details but as one continuum. The angel cannot act on what he sees in front of him, for a storm from paradise is blowing him backwards and propelling him to the future, "while the pile of debris before him grows toward the sky. What we call progress is *this* storm."[84] For Benjamin, living through the catastrophes of Germany's embrace of Nazism and the ongoing Second World War, in exile from his homeland—but not separated from this artwork that meant so much to him—Klee's mystical angel could embody a range of contradictory associations, past and future, divinity and damnation, history as catastrophe.[85]

Klee was the originator of the oil-transfer drawing technique that he used to make the *Angelus Novus* and other, related compositions.[86] These figures' otherworldly nature is paralleled by their medium. To make them, Klee placed a special type of paper coated with oil-based pigment on top of plain paper and drew on top. He would not have been able to see the final image as it emerged on the second piece of paper that, once removed, revealed lines and smudges produced by the pressure of Klee's pen and hands. After the picture was achieved through this invisible drawing, Klee added definition in watercolor, a technique that, like his student Citroen's picture, recalls Justinius Kerner's *Klecksographen*. Defined through a line drawing, this ghostly angel materialized through a process that involved more than the usual distance between the artist and the picture, and thus allowed for unexpected elements to appear. And as Annie Bournouf has shown, Klee gave this work a ghostly, hidden, double countenance, for he mounted the drawing on an engraved, nineteenth-century portrait of the religious reformer Martin Luther.[87]

Rather than use his art and teaching as conduits to a specific mystical path, or base them in a set of practices intended to lead to self-improvement, Klee was interested in the spiritual as imagined space or evoked feeling. Conjuring also served as a slightly irreverent metaphor for his creative process. He spoke of "calling spirits" in order to make his work, an activity usually reserved for Spiritist séances.[88] As Bourneuf has argued, it is at the conjuncture of the visual and the verbal that Klee created a new model of sequential, contemplative, and private viewing akin to reading; this was his own way of responding to the avant-garde call for a new kind of relationship between artwork and viewer.[89] Klee's quirky titles and

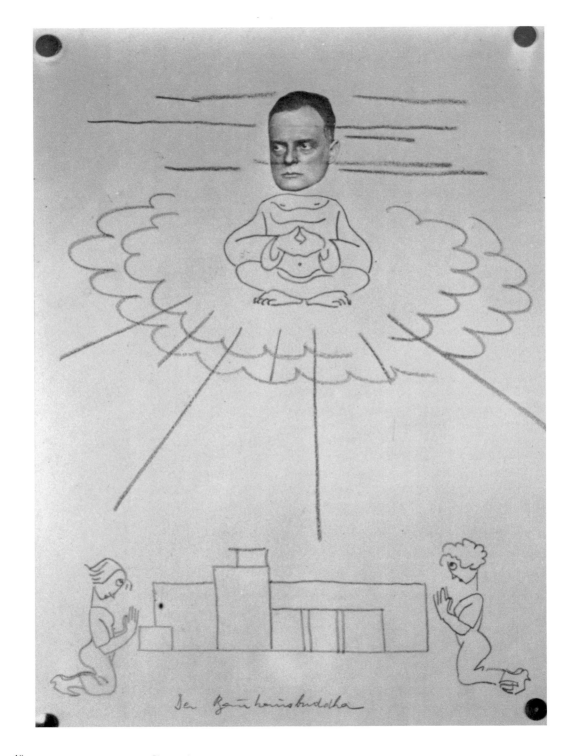

Der Bauhausbuddha

imagery are often playful, but his engagement with spirituality is a through thread, an ongoing search, in his work.

FIGURE 1.11. Ernst (Ernő) Kállai, caricature of Paul Klee as *The Bauhaus Buddha* (*Der Bauhausbuddha*), photograph of a lost drawing and photo-collage, 1928 or 1929. 2.8 x 2 in. (7 x 5 cm). Bauhaus-Archiv Berlin.

The seriousness of Klee's unorthodox spirituality and its impact on his Bauhaus teaching is attested to by the reverence with which many of his former students recalled him. Marianne Ahlfeld-Heymann describes how, as a young student in the textile workshop where Klee was master, she and the others perceived Klee during his lectures. "While the words fell haltingly, we students experienced a transformation. We suddenly saw what we never saw before. Each of his words opened our eyes to never-before-seen perspectives. In spite of the apparent dryness of his presentation, his being radiated that suggestive spirit that also captivates us in his paintings."[90] For Ahlfeld-Heymann and others, Klee spoke to them from another, more spiritual realm. This was a widely held impression that inspired a caricature in the late 1920s by art theorist and *Bauhaus* journal editor Ernst Kállai (figure 1.11). The picture shows Klee's photographed head montaged onto a portly body in a seated lotus position, levitating above a stylized image of the Dessau Bauhaus. *The Bauhaus Buddha* (*Der Bauhausbuddha*) is bookended by bobbed-haired female Bodhisattvas on the ground below who bow their heads in reverence.[91] Gropius wrote of Klee as "a figure of moral authority at the Bauhaus," and art historian Will Grohmann reported that many *Bauhäusler* jokingly referred to him as "dear god."[92]

The last of these spiritually influential teachers who strongly impacted the Bauhaus's early period and beyond is Klee's friend and fellow painter, Wassily Kandinsky. When he arrived at the Bauhaus in 1922, Kandinsky was already famous as the author of *On the Spiritual in Art*, and his abstract work was the result of decades of interaction with both new religions and experimental psychology. In Moscow, Kandinsky grew up in the circle of his second cousin Victor Kandinsky, a medical doctor and pioneer of psychiatry and psychopathology. After experiencing a psychotic break, Victor Kandinsky took his own symptoms—which he termed "mental automatism" and included telepathy, mind reading, and delusions that one's thoughts or motor movements were externally influenced—as the subject of his research.[93] In addition to exposing his relative to psychopathology and the occult, Victor's work helped Wassily to develop his ideas about synesthesia, or sensory transference. Through Wassily Kandinsky's subsequent reading of theosophists Rudolf Steiner and Franz Freudenberg as well as Russian theorist A. Zakharin-Unkovsky, he came to believe that synesthesia was a sign of being "spiritually unusually developed," a phrase he underlined in one of Freudenberg's texts, and it became a mode of perceiving he sought to cultivate in himself and others.[94]

In 1896, Kandinsky gave up his legal and academic career in Russia and moved to Munich to become an artist. There he became integrated into the mystically influenced circles connected to the Munich Secession.[95] He immersed himself in the emerging body of established research

on the occult, including Carl du Prel's 1891 *Studien aus dem Gebiete der Geheimwissenschaften* (Studies from the Field of the Secret Sciences), Alexander Aksakow's *Animismus und Spiritismus* (Animism and Spiritism), issues of the scientific-theosophical research journal *Sphinx*, and the study of spirit photographs. This research was undertaken in preparation for writing *On the Spiritual in Art,* published in 1911.[96] In *On the Spiritual in Art*, Kandinsky argued that the artist must work to spiritually elevate others in society, a message that resonated widely, and the book circulated to great acclaim throughout Europe as did his painting and other writings.[97] *On the Spiritual in Art* also solidified a broadly understood link in the minds of many artists and members of the public between abstraction, expressionism, and mysticism. Meanwhile, Germany expelled the Russian national Kandinsky with the outbreak of the First World War in 1914; he returned to Russia and participated in the radical experiments in art and life enabled by the 1917 Soviet Revolution. Eventually rejected by his fellow Soviets as too bourgeois, Kandinsky left Russia and took up his post at the Bauhaus in 1922. He became a source of continuity until the school's closure in 1933.

Above all, Kandinsky's teaching explored the potential for abstraction to convey new forms of meaning. In 1913, Kandinsky had begun to paint in nearly pure abstraction; by the time he was at the Bauhaus, he had thoroughly considered what the open spaces of abstract pictures could do. Already in 1913, Kandinsky wrote of his realization "that objects harmed my pictures," although this understanding brought on "a terrifying abyss of all kinds of questions, a wealth of responsibilities stretched before me.... Most important of all: What is to replace the missing object? The danger of ornament revealed itself clearly to me."[98] Yet in this same text, Kandinsky reports that he found answers to these questions, namely to paint from forms that arose from his unconscious and that these should be generated through emotion rather than logic. It is worth noting here then that the work and pedagogy of one of the most influential Bauhaus masters is centered around *anti* rationality, a strong contrast to stereotypes of the Bauhaus. Kandinsky wrote, "Every form I ever used arrived 'of its own accord,' presenting itself fully fledged before my eyes, so that I had only to copy it, or else constituting itself actually in the course of work, often to my own surprise. Over the years I have now learned to control this formative power to a certain extent...to bridle the force operating within me, to guide it."[99]

By the example of his writings, painting, and lessons, Kandinsky taught Bauhaus students that artistic expression resulted from turning inward and tapping into the purity of one's thoughts and emotions. Further, he systematized his approach to abstraction through neurasthenic explanations—for example the sounds of various forms and colors—and passed these ideas on to his students.[100] The contents of Kandinsky's library suggest that he discovered a new esoteric interest once he was at the Bauhaus:

astrology, a topic on which he purchased almost a dozen books in German that were published between 1919 and 1931. Additionally, Kandinsky's library includes books from this period on esoteric topics including magic squares, suggestion and autosuggestion in hypnosis, and—through Emil Mattiesens' *Jenseitiger Mensch* (Otherworldly Man) of 1925—the newest research on aura, astral bodies, telepathy, and other mystical topics. Kandinsky also was clearly interested in philosophical questions of metaphysics, which, in its grappling with the nature of reality and being, would have been essential for his painting and teaching.[101]

In a 1924, Kandinsky published an article titled "The Bauhaus Question," in the feature section of the *Leipziger Volkszeitung*, in which he characterized the Bauhaus's struggle with its naysayers as embodying an age-old truth, namely, that when "a cart [Karre] is pulled up the hill by courageous people, at the same moment, there will inevitably be others who pull the brakes."[102] The saving grace is that there are "many strong hands that try to release the brakes again. But these hands belong to spiritual minds. Sooner or later, the cart *will* make it up the mountain. And when it does makes it, the people who pulled the brakes today will clap. Weimar will certainly participate."[103] Essential here is not only Kandinsky's characterization of the Bauhaus's town-gown struggle as a battle for spiritual elevation, but his consciousness of it being a collective effort among the *Bauhäusler.*

One of his Bauhaus students, the filmmaker, photographer, and designer Erna Niemeyer—better known by a name she adopted after she left the Bauhaus, Ré Soupault—later remembered the deep anticipation with which she and her fellow students awaited the arrival of the famous artist and theorist Kandinsky.[104] Awestruck by his work and his journey to abstraction, she later wrote, "We were fascinated by the ideas that he developed in [*On the Spiritual in Art*]. We could talk with him, ask him questions."[105] Niemeyer would take Kandinsky's abstraction into the realm of film. And she is also typical of Bauhaus students in that she was influenced by the range of teachers with whom she worked from her arrival in the spring of 1921—the manifestations in her work of what she learned with them was also unpredictable. Next to Kandinsky's, she particularly recalled Itten's influence, "…with Itten, something happened that freed us. We did not learn to paint, but learned to see anew, to think anew, and at the same time we learned to know ourselves."[106] Through her studies with him, she became so interested in Mazdaznan that she bicycled weekly to the university in nearby Jena to study Sanskrit, and wove Sanskrit words into one of her early works in the weaving workshop.[107]

On a trip to Berlin in 1923, she met the Swedish experimental filmmaker Viking Eggeling; the two became romantically involved, and Niemeyer took a leave from her Bauhaus studies. With Eggeling, she learned the ropes of filmmaking and, over the course of the year, helped him to complete *Symphony Diagonal*, now celebrated as one of the most

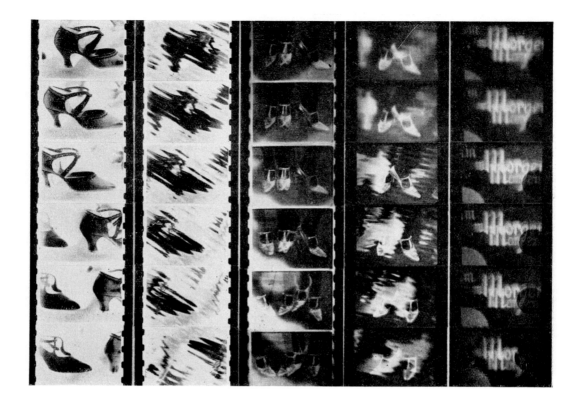

FIGURE 1.12. Renate Green (born Erna Niemeyer; later Ré Soupault), *Film Frames from a Fashion Film, Dancing Shoes Doing the Charleston* (*Teile aus einem Modefilm: Tanzschuhe beim Charleston*), c. 1925. Reproduced in Hans Hildebrandt, *Die Frau als Künstlerin*, 1928 [174]. 4 x 5.5 in. (10.2 x 14 cm). © 2019 Artists Rights Society (ARS), New York / VG Bild-Kunst, Bonn/Manfred Metzner.

significant abstract films, something Soupault later called—in a clear reference to Kandinsky's synesthesia—"optical music."[108] After Eggeling's death in 1925, Niemeyer—by this time also working as a journalist under the professional name "Renate Green"—maintained the small film studio in his apartment and made her own films including what she called a *Modefilm* (Fashion Film). One of the earliest publications of her work was in the art historian Hans Hildebrandt's *Die Frau als Künstlerin* (The Woman as Artist) in 1928, a picture comprised of extracted frames from the fashion film to make a new kind of image (figure 1.12).[109] When we examine the frames from left to right, first, fashionable but empty shoes appear to move forward into motion and abstraction, and they subsequently are fleshed out with feet and legs as they traverse into the darkened film frames of evening. There, they light up the night until *"Morgen"* (morning), as the last strip of film indicates, its letters blurry and doubled as if viewed by a dancer in motion—perhaps one who has had a few cocktails.

Taken together, the spiritual theories and teachings of Grunow, Klee, and Kandinsky enabled students to fully reassess the world around them and to engage and represent their experiences in traditional and new

media. Grunow's synesthetic philosophy was perhaps the most unique and ultimately the hardest to defend. Yet it provided students with a structure for understanding their spirits in harmony with the world around them. Klee was much more eclectic in his spiritual influences while also modeling a serene skepticism of the fervent embrace of emerging theories and religions. As a contrast, his works offered open-ended mysteries that could inspire—including Benjamin's angel of history—and allow students to explore the more secular categories of the uncanny and the surreal. Kandinsky, certainly one of the most famous painters of his day, continued to infuse his work with new mystical material of a quasi-scientific nature that informed his lectures, even as he publicly declared himself just one member of the Bauhaus and *Bauhäusler* collective, whose collaborative project was spiritual elevation.

LIGHT TRACES: MOHOLY–NAGY AND BAUHAUS SPIRITUALITY IN THE AGE OF ART AND TECHNOLOGY

> The presence of equally strong intellectual and emotional powers may have a particular and evenly distributed harmonious effect on one specific professional field, that of art. This is confirmed above all by Venus as the mistress of the tenth house (for profession and reputation). The interaction of the more receptive…and more active-creative…qualities characterizes a comprehensive and strong artistic personality that, because [specific stars and planets] are located in Scorpio, will champion everything new in art, and combine the ability to produce one's own creative work with a talent for teaching.[110]

Moholy-Nagy's eighteen-page horoscope from 1926 contains many such officious statements about his gifts and the rightness of his chosen profession, from an astrological perspective. This is one of three, extremely thorough horoscopes still held in his personal archive; that the other two are from later dates, the period when he was with his second wife, suggests that this was a personal and enduring interest of his.[111] The reading in fact offered some insights that would certainly come true in Moholy-Nagy's future: "The professional life, as well as the entire life of this person, will be accompanied by manifold events of at times profound change and travel. But, on the whole, these [professional and personal lives] will be happy and successful, although the ascent will not be easy."[112] In its very existence, this horoscope attests to the endurance of an openness to esoteric beliefs, philosophies, and religions at the Bauhaus, well beyond its supposed hard turn away from the spiritual during 1922 and 1923 and the departures of Itten and Grunow in 1923 and 1924, respectively.

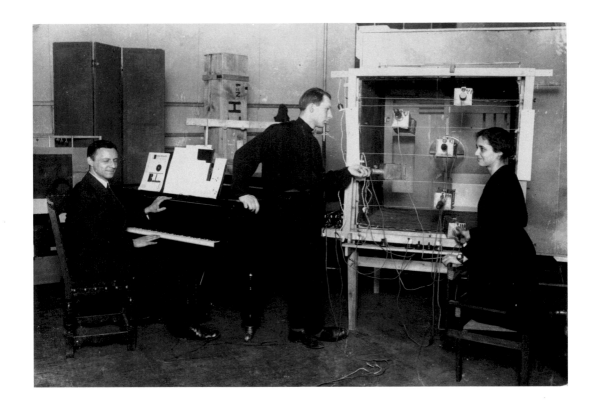

FIGURE 1.13. A. & E. Frenkl, Ludwig Hirschfeld-Mack at the piano during a performance of *Color Light Play* with F.W. Bogler and Marli Heimann, Staatliches Bauhaus, 1924, gelatin silver print. 7.1 x 9.4 in. (18 x 24 cm). Courtesy of Kaj Delugan.

Indeed, even in its focus on "Art and Technology, a New Unity," the Bauhaus's engagement with the spiritual clearly persisted. Not only did Klee and Kandinsky continued to teach and Gropius to lead until 1928, but many students of the early years stayed on and some even became junior masters and took on other leadership positions. And there continued to be many aspects of the Bauhaus that specifically drew faculty members and students with utopian interests. Even Hannes Meyer—the school's director starting in 1928, who is often remembered for promulgating practical design that could improve life for the working classes—was reportedly influenced by anthroposophy and theosophy.[113] In place of the eclectic, Mazdaznan-centered spirituality, as Linda Henderson has pointed out, "Einstein, Relativity Theory, and the new model of 'space time'" took hold as informing principals.[114] The visual realm became increasingly a laboratory space for testing out ideas— but these included ideas about abstract spiritual experiences. This new Bauhaus was fascinated with hard science and technology, but, as much as these were aimed at mass producing modern design, they were often explored for their potential in offering transformative experiences

that might expand and renew vision and even society.

That that spirit was not, in fact, dead at the Bauhaus is evident in experiments carried out by many *Bauhäusler* as they continued to engage with their new age in *Lebensreform*-related practices and in a range of expansive media, with a sense of experimentation and often play. Many at the Bauhaus, particularly those who had been there in the early years, continued to actively incorporate aspects of their spiritual inquiry into their work. Not the least of these were Kandinsky and Klee, the later of whom stated in 1929, "we construct and construct and yet intuition is still a very good thing."[115] Ludwig Hirschfeld-Mack began his Bauhaus studies with Itten and Grunow in 1919, and their lessons would be crucial for his later experiments. Hirschfeld-Mack remained at the school until 1925 and later recalled of the "mixed crowd" at the Bauhaus that "all united in one aim, the seeking of a new way of life, a new architecture and a definite negation of all those forces which had caused the First World War. Thus, every kind of tradition became questionable, not only the traditional way of building… but also education, clothing, food, everyday habits, even the manner of greeting each other, and so on."[116] Beginning in 1921, Hirschfeld-Mack would spend two years at the Bauhaus developing experimental light compositions and a complex apparatus that could project them, accompanied by live music and operated by four students who likewise played their parts from a score (figure 1.13). "The music was written to form a unity with the rhythmic movements. Yellow, red, and blue in glowing intensity, blended with light silvery gray colors, moved about in varying tempi on the dark background of a transparent screen. They appeared at one movement as angular forms, triangles, squares, polygons; then as curved shapes, circles, arcs, and wavelike patterns; they joined and created overlappings and color blendings as a result."[117] These *Reflected Light Compositions* were produced for a broader public first in Weimar for the August "Bauhaus Week" of the *Staatliches Bauhaus* exhibition in 1923, where their hybrid status as both a new form of painting and as related to film earned a mention in a review in the *Bremer Nachrichten* newspaper.[118] Subsequent showings in theaters in Leipzig, Berlin, Hamburg, and Vienna, over the next two years, made them a significant public example of the experimental nature of Bauhaus work.[119] In 1930, Hirschfeld-Mack reunited with Grunow to participate in The Second Convention for Color-Sound Research, held in Hamburg, and published an essay on his *Color Light Play.*[120]

Photographic experimentation only accelerated over the course of the Bauhaus's existence. Posing his friend Marcel Breuer and other *Bauhäusler* in Dessau in 1925, Xanti Schawinsky made a "spirit photograph" with ghostly figures haunting the school's objective and utterly unadorned architecture (figure 1.14). A pensive figure sits on a simple café chair, his legs crossed and his raised right hand likely holding a cigarette. Behind him, a dramatically posed spirit appears to manifest almost as if the

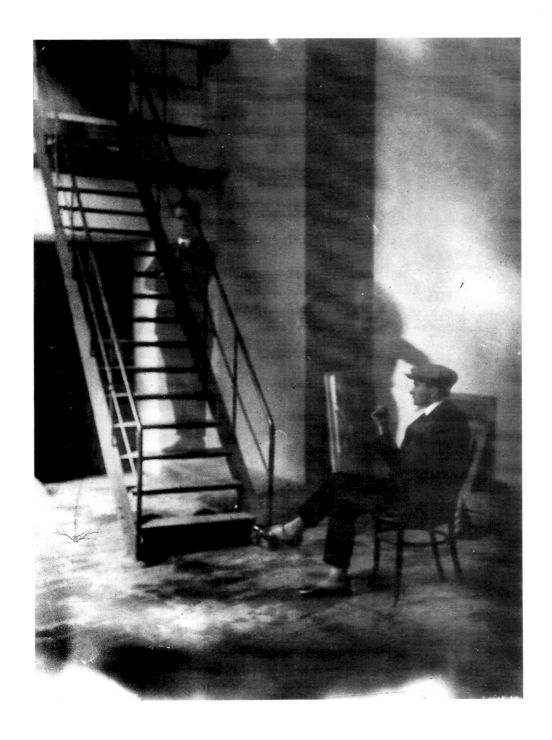

Chapter 1

cigarette smoke has taken form. Staring out impassively at the viewer with his arms crossed in a serious pose on the stairs, the ghost of Breuer dominates the scene. In 1925, the Bauhaus was still in flux, not yet settled into its new building, which would only be fully complete late in 1926. Yet Schawinsky already brought the sense of play and spiritual experimentation with the other worldly to the new location. Performing new ideas about spirit in relation to body would continue to be important in Dessau; in 1927, T. Lux Feininger made a photograph of *Bauhäusler* leaping crazily about in a field, their now-complete school building tiny in the distance. He titled it *Eurythmy*, as if to indicate that these madcap students—along with gymnastics instructor Karla Grosch, who appears in the picture as well—were caught up in Rudolf Steiner's theosophically inspired movement system.[121]

The body as a vessel for the spiritual was imaged too by Joost Schmidt, perhaps most surprisingly, since he is remembered largely for his strict and rational approach to design and teaching.[122] Schmidt came to the Bauhaus as a student in 1919 and became a junior master for typography and advertising. Recent archival finds have revealed that his Bauhaus lectures up until the school's closing in 1933 included information for health and creativity from the philosophy of yoga (figure 1.15). In a drawing from approximately 1930 or '31, kept in a folder Schmidt had labeled "lesson preparation," he displays a substantive understanding of the chakras, with each one carefully labeled in both Sanskrit and German on a perfectly proportioned male torso. He renders each chakra as a whimsical pinwheel of distinct color to indicate its composition and function. This lesson was also not singular in his teaching; as Lutz Schöbe demonstrates, the relationships among emotions, bodily systems, and creativity were central to Schmidt's teaching until the end of the Bauhaus.[123]

The man hired to replace Itten, the one who was to embody the school's profound shift in orientation to the technological, arrived in April of 1923: Moholy-Nagy, the subject of the astrological predictions that I quoted earlier. From the first mention of him in the masters' council meetings, he is nearly always identified as a young "constructivist," to emphasize his fitness to move the school away from expressionism.[124] Constructivist that he was, like the school he was joining, Moholy-Nagy was also a mixture of the technologically oriented and the experimental-spiritual. Prior to coming to the Bauhaus, he too was caught up in Europe's transcendentalist spirituality and the *Lebensreform* movement. His wife and collaborator Lucia Moholy had been an adherent of Mazdaznan as well as a Communist. Together, the two of them spent extended periods at the Loheland and Schwarzerden women's communes that taught expressionist dance and reformist heath and healing.[125]

It was likely at the Loheland commune through the work of Bertha Günther that Moholy and Moholy-Nagy first encountered the photogram

FIGURE 1.14. Xanti Schawinsky, Ghost of the Stairs (Treppenspuck), Dessau, 1925, silver gelatin print. 6.3 x 4.5 in. (16 x 11.4 cm). Reproduced from Ronald and Roger Schmid and Eckhard Neumann, ed. *Xanti Schawinsky Foto* (Bern: 1989) [23], with kind permission of Daniel Schawinsky.

technique that became a defining medium for the latter's work; early on he called these, "light compositions," a name that emphasizes their ability to capture the ephemeral.[126] Moholy-Nagy also came into contact with the chaotic forces of Dada in Berlin during the early 1920s; he shared a studio with Kurt Schwitters during the winter of 1922–1923, for example, when Moholy-Nagy first turned to making photomontages. The Bauhaus's new constructivist was thus one who considered the spiritual and irrational alongside the practical and functional in his work and teaching, and for this reason, *light* became his most significant medium. For Moholy-Nagy, it was not merely a way of creating pictures, like oil and canvas had been and would often continue to be; light was also its own subject, both form and energy.[127] Spiritism, transferred thoughts, mediumistic drawing, or the teachings of Mazdaznan were taken by others to relate to abstraction, which they likewise saw as having the potential to convey universal ideas in newly discovered forms or to render profound if unspecific meaning. Over time, Moholy-Nagy saw some of the same potentialities bound up with the still emerging technology of electric lighting.

Moholy-Nagy's experiments with and teaching about light and photography made manifest the school's new alignment with technology as a source of transformation. Early on in his tenure, he enthusiastically embraced Hirschfeld-Mack's light machine, which Moholy-Nagy dubbed *Reflected Color Displays* (*Reflektorischen Farbenspiele*). "We see in the reflected light-displays the powerful physical and psychical effect of the direct colored beams combining with rhythmic accompanying music to evolve into a new artistic genre and also the proper means of building a bridge of understanding between the many who remain bewildered in the face of the painters' abstract pictures and the new aspirations in every other field, and the new views from which they have sprung," he wrote in his 1925 *Painting Photography Film*.[128]

Once the Bauhaus moved to Dessau in 1925, the photogram became one of Moholy-Nagy's primary means of artistic expression, so-called cameraless photography, which he made—almost certainly in collaboration with Lucia Moholy—by direct exposures on light-sensitive paper.[129] An untitled 1926 photogram shows direct traces of the shadow made by Moholy-Nagy's head and face (figure 1.16). His glasses are removed and placed directly on the light-sensitive paper. Adjacent to the shadow image of his eyes, the glasses evoke the artist's focused vision. Yet, removed from his face, they can no longer help the artist to see. The glasses become mere objects; their frames and lenses create novel formal effects as compositional elements in Moholy-Nagy's picture. So direct is this process that the photogram bears traces of secretions from Moholy-Nagy's face in its lower portion. He has also further defined this light apparition through multiple exposures—the same technique used in some of the spirit photographs—and by using circle stencils to mask some parts of the light-sensitive paper and reveal others, so that they become a

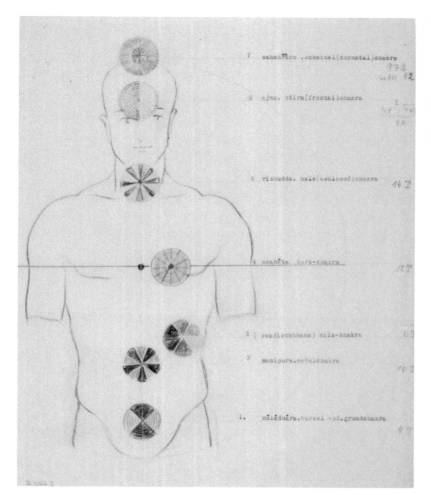

FIGURE 1.15. Joost Schmidt, *The Seven Chakras (Die sieben Chakras)*, from *Nature: The Work of Man (Natur: Menschenwerk)*, c. 1930, pencil, colored pencil, and typewriter ink on tracing paper. 10.6 x 8.7 in. (26.8 x 22. 1 cm). Stiftung Bauhaus Dessau © 2019 Artists Rights Society (ARS), New York / VG Bild-Kunst, Bonn.

structured realm of darkness out of which the face emerges. This photogram functions as a self-portrait that records Moholy-Nagy's physical and physiological traces and which gestures to the ideas and methodological processes operating within this head, technology harnessed to index spirit.

In 1930, after he had left the Bauhaus, Moholy-Nagy's ongoing work with light culminated with *Light Prop for an Electrical Stage (Lichtrequisit einer Elektrischen Bühne)*, a project that he had been developing since 1922.[130] Not merely a mechanical sculpture that reflected light, the *Light Prop* was made to create experiential environments in individual rooms or on the stage.[131] In a 1930 issue of the journal *Die Form*, Moholy-Nagy wrote of his new experiments:

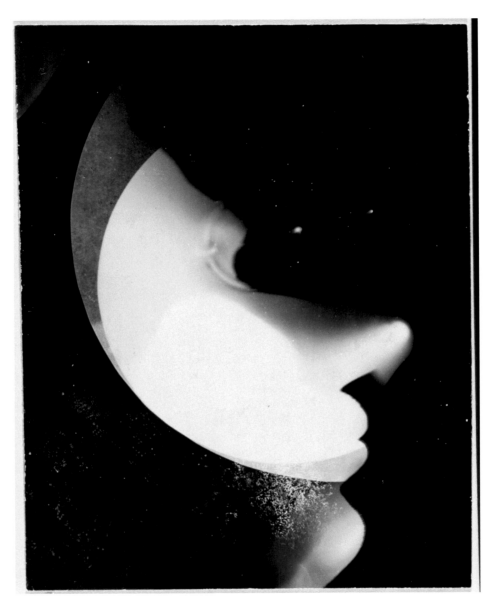

FIGURE 1.16. László
Moholy-Nagy, Untitled (*fgm
163*), 1926, photogram on
developing paper mounted on
cardboard. 9.1 x 6.9 in. (23.1
x 17.6 cm). Museum Folkwang,
Essen.

Today, adjustable artificial electric light allows us to effortlessly create rich lighting effects. With electric power, one can perform movements calculated in advance that can be ever repeated in unchanged form. Light and movement, as is appropriate for today, are again elements of design. The fountains of the Baroque era, the water fountains and water spectacles of the Baroque festivals, can be creatively reinvented by light fountains and mechanical electrical movement machines. These possibilities are likely to be used in the near future for advertisement or at folk festivals as entertainment, in the theater as an augmentation of the moment of tension. It is even foreseeable that these and similar plays of light will be transmitted by radio—partly as tele-projections, partly as a real play of light, in that the receivers themselves have lighting equipment with electrically adjustable color filters which are remotely controlled by a central radio station.[132]

With words that harken back to Gropius's call for festivals for the people and even further to Spiritist mediums' capacities to channel electricity like telegraphs, Moholy-Nagy imagines the *Light Prop* as a reproducible apparatus that will be able to transmit and recreate transformational collective experiences through new technology. But now, thanks to modern technologies, this and similar machines can be manufactured, so that experiences are no longer tethered to specific locations or contexts; they can serve in advertisements or festivals. Nor are they temporally bound, since the regular flow of electricity and radio transmissions mean that spectacles can be repeated. It is clear from Moholy-Nagy's description that among the parallels he has in mind are multi-sensory and immersive spectacles, that light projection can accompany and augment dramatic theater scenes and offer a modern renewal of the fantastic displays of the Baroque.[133]

The same year that Moholy-Nagy completed the *Light Prop*, he filmed the machine in motion to create *lightplay black white gray* (*lichtspiel schwarz weiß grau*), an abstract film which, as Anne Hoormann points out, was Moholy-Nagy's answer to the animated abstract films of Eggeling and Hans Richter, both of whom he criticized for creating pictures and animations on film stock—a kind of imitation of painting—instead of using the photographic, light-capturing capabilities of the medium of film.[134] Moholy-Nagy instead captures direct pictures of the machine and its projected light abstractions. Moholy-Nagy did not give up on painting, but, since light technologies were still too weak to serve as a proper medium, continued it as a means of exploring abstract color.[135] Yet he believed that the photogram, photography, and film were most powerful when used to map direct traces of visual phenomena that could be seen, and their power lay in the fact that they were new technologies that offered viewers fundamentally transformational experiences. Like Gropius's earlier ideas

about architecture offering a total structure for a creative utopian collective of artists, Moholy-Nagy's light projector had, in theory, the potential to engage with almost any setting into which it was placed and to remake it, even if in practice electric light was not yet strong enough to accomplish his aims. Looking back, he wrote of it specifically in relation to the metaphysical, "I felt like the sorcerer's apprentice. The mobile was so startling in its coordinated motions and space articulations of light and shadow sequences that I almost believed in magic."[136]

In "Production Reproduction," a text now credited to both Lucia Moholy and Moholy-Nagy, the authors use the example of the phonograph record to point out that new machines are most often employed simply to copy that which already exists rather than to make something truly new, such as a record which could be manipulated like an instrument—in this case, a practice that would become common several decades later. Moholy and Moholy-Nagy write of the creative potential of *production* instead of copycat *reproduction*: "this is one of the reasons why new creative experiments are an enduring necessity. *From this point of view the creations are valuable only when they produce new, previously unknown relationships.*"[137] These imagined "relationships"—in which creative acts might unlock fresh connections to spirituality, to life after death, or to other people—were at the heart of the Bauhaus project. Over the span of its years, the Bauhaus offered images, objects, and visual experiences as agents of wonder and encouraged the creation of pictures informed by multi-sensory experiences. Collectively, these "New Visions"—to borrow a word from Moholy-Nagy—were intended to yield original knowledge based in a collective connection.

I want to close this chapter on the enduring centrality of spiritual experiments at the Bauhaus with a final photograph made by Hungarian Bauhaus student Judith Kárász relatively late in the Bauhaus's existence, 1930, after her fellow Hungarian Moholy-Nagy and many discussed in this chapter had departed (figure 1.17).[138] It presents a portrait of the Bauhaus weaver Otti Berger in a double-exposure that combines her with the façade of the Dessau Bauhaus building's Prellerhaus wing, where students had their combined working and living studios. Berger—one of the most accomplished innovators of high-tech weaving design at the school—was much beloved by her fellow *Bauhäusler* and the subject of many photographs.[139] Here, she appears as a romantic, modern Mona Lisa, with a far-away gaze and swept back hair. Her face is blended with the overtly modern, networked architecture of the Bauhaus building itself, full of communicative balconies, but seemingly photographed on a foggy day, so that its hard edges are blanketed in mist. Kárász shows Berger as a new kind of beauty, the spirit of her new age, rather than a spook from the past or the return of the repressed. When the picture was made, neither woman could know that its haunting nature would project forward in time so tragically. Berger was murdered in Auschwitz, and this

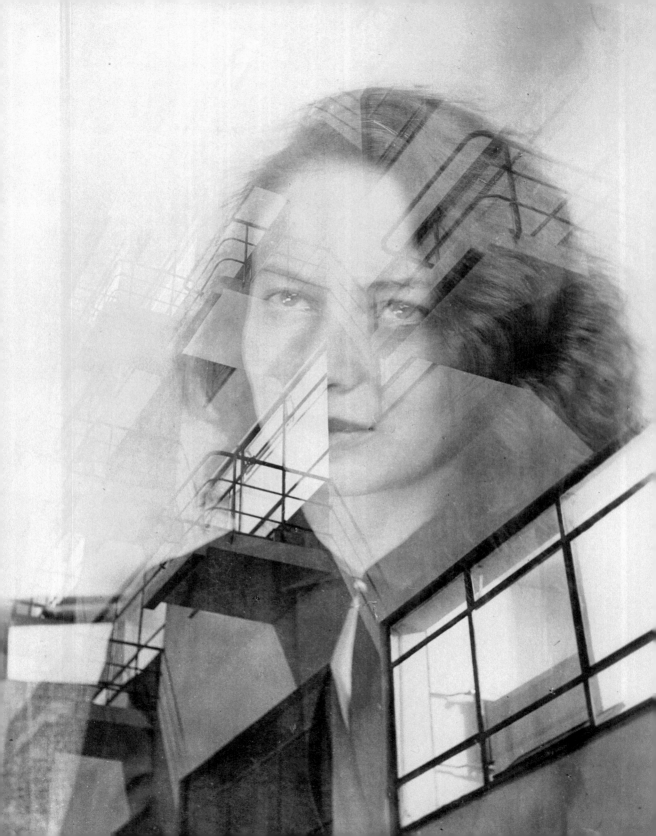

photograph in retrospect became the most fitting memorial to her perfect embodiment of the Bauhaus's futurity that was so diminished by Nazi Germany and the Holocaust.

These Bauhaus artworks of the age of technical reproducibility persist in various kinds of mediumistic representations, from thought-transfer drawings to spirit photography and inkblots, and they were the subject of active pursuit by teachers and students at the Bauhaus, a place so often touted as ground zero for the eradication of such elements from art.[140] In search of renewal of body and spirit, they partook of a highly eclectic range of religions, theories, and personal persuasions in order to tap into the promise of making visible the invisible and harnessing the irrational to promote and achieve good. And yet, the relationship between the various forms of modernist abstraction propagated in early twentieth-century Europe and the spiritual and the Spiritist have nevertheless remained, from art history's point of view, the dark side of modernism. Across the span of the place, school, method, idea, and *Weltanschauung* known as the Bauhaus, there was a constant push to probe how material objects and modern experiences could unite the sensory and the spiritual to perceive the world in all of its complexity.

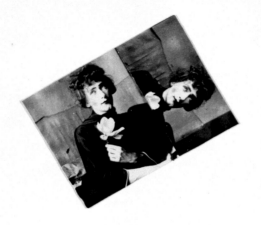

Mein lieber Walter, bewahre
unser süsses Geheimnis.
Deine Ewig Getreue.

18. V. 24.

FIGURE 2.1. Marcel Breuer, *Portrait of Marcel Breuer as Girl with a Magnolia: For the Birthday on May*

NEW VISIONS OF THE ARTIST: THE ARTIST–ENGINEER AND SHADOW MASCULINITY

DOUBLED MASCULINITIES OF THE BAUHAUS

On Walter Gropius's forty-first birthday, May 18, 1924, he received many gifts, for the day had become an unofficial, school-wide, annual holiday at the Bauhaus. One of these gifts would have stood out particularly: a large sheet of white paper with two prints of the same photograph cleverly joined in a montage (figure 2.1). An unknown New Woman is shown in the photographs. She is well dressed in modern clothing, with makeup and short hair, and she gazes wistfully off into the distance while holding a magnolia. The left photograph is the more complete of the two, a bust portrait that reveals the sitter's torso and her strong hands. On the right, the same photo is shown rotated a quarter turn to the right and cut off just below the woman's shoulders, but her body seems to extend into the other photograph in the line of the wall drapery, evoking her body and giving her an ethereal double presence. The shape of these paired photos and their interlocking and double-headed composition evokes that of a playing card laid out in the middle of a large white space, in which case the sitter is a queen. Her voice seems to reach even beyond this doubled portrait through the carefully hand-written lavender text at the lower left: "My Dear Walter, keep our sweet secret. Yours, eternally true."

For years, the sitter's identity was unknown, but recently "she" was revealed as the young furniture designer and eventual architect, Marcel Breuer.[1] This portrait is such a radical departure from other photographs of Breuer that it long went unrecognized. Having arrived at the Weimar Bauhaus in 1920 when only eighteen, Breuer had befriended Gropius by 1924, when he sat for this portrait, and was nearly finished with his time as a student. The following year he took up a position as a junior master to head the furniture workshop at the Dessau Bauhaus.[2] A more typical image of him is Erich Consemüller's "Marcel Breuer and his Harem" ("Marcel Breuer und sein Harem") from around 1927, which shows Breuer as a cool customer who assesses the comparatively petite and wild-haired young women to his left (figure 2.2). Clearly this is anything but a standard "harem" image; it is no orientalist fantasy of conventionally beautiful women who are obviously sexually available.[3] But it does not preclude these New Women's sexual availability to Breuer, and thus reinforces his status as a virile, heterosexual man of his day.[4]

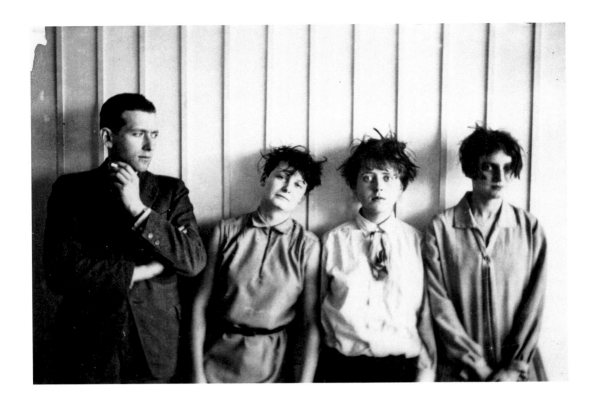

FIGURE 2.2. Erich Consem-
üller, Marcel Breuer and his
Harem (Marcel Breuer und
sein Harem), c. 1927. 2.2 x
3.3 in. (5.7 x 8.3 cm). Klassik
Stiftung Weimar, reproduced
with kind permission of
Stephan Consemüller. From
left to right the photograph
shows: Marcel Breuer, Martha
Erps, Katt Both, and Ruth
Hollós)

The love declaration picture's doubled photograph is a clue that, on several levels, this composition is duplicitous. Whereas a single photographic image is most often taken as a window into reality, one that effaces the conditions of its production, a photograph's repetition highlights its actual status as a composed and created representation. In the picture of the two Breuers, this is even more the case, since he is clearly in costume as someone he is not: a modern woman. Despite Breuer's heavily made up and romanticized appearance, the work's intended viewer, Gropius, would have immediately identified the sitter as Breuer merely playacting at being a smitten woman. In a sense, then, the picture emphasizes the artificiality of gender binaries, since knowing viewers at the Bauhaus could have recognized him as both woman and man at the same time. Like the picture, the montage's inscription also carries a double meaning. It appears as an earnest plea for secrecy in a love affair, and, for the in-the-know readers at Gropius's 1924 birthday party, it is also an elaborate, inside joke.[5]

The complex, negotiated, and even fraught nature of constructions of masculinity at the Bauhaus are this chapter's focus. In it, I argue that quite a number of *Bauhäusler*, like Breuer with his queer and uncannily doubled

self-portrait, used photographic images of their own or other bodies to construct coded representations that clustered around certain ranges of visual tropes. Some of these were speculative attempts to image male bodies as fit to build a better future; others appear as the preventative—perhaps even protective—investigations of the dark sides of masculinity or the doppelgänger who embodies the return of the repressed.

In the previous chapter, I argued that, after the war, artists from throughout Europe came to the Bauhaus with both a suspicion of machine logic and an understanding of the need to harness modern technology's potential for good, and I explored how spirituality enabled them to thread this needle. In this chapter, I further pursue this line of thought by examining how visualized constructions of masculinity were aimed at generating new, productive ideals, particularly through a masculine type that goes by several names, but which I will call the artist-engineer.[6] Parallel to Bauhaus members' work to design and build the new society, they constructed this new artist ideal that emerged in Bauhaus photography, photomontage, and texts, usually unnamed but persistently present. He is the one who could walk that line between emerging technologies that had already proved Janus faced, and the utopic potentials of this new world.[7] As I will show, many, and not only male, Bauhäusler were engaged in defining what the work of the artist-engineer should be; some female Bauhäusler also experimented with this type in photographic self-styling and photomontage images of others.

While the search for this new kind of artist was a clear preoccupation of Bauhaus artists, a competing type lurks in the margins of Bauhaus art, text, and design. This type likewise did not have a specific name in Bauhaus parlance, and yet he is there, shadowing the artist-engineer with an uncanny masculinity that took varied forms, but always involved the male body (and often its psyche) doubled, mocked, undercut, or impotent. These haunting doubles appeared not only in Bauhaus art but simultaneously across Weimar culture, particularly in the interwar period's burgeoning popular film industry.[8] Members of the Bauhaus were future oriented to such an extent that direct reflections on the First World War—a defining experience for nearly all Bauhäusler as either soldiers or civilians—are conspicuously absent from their work. But they were also wary of glorifying armored or overly tough masculinity, since such types were simultaneously being deployed by the political right wing. As I contend, these shadow figures were therefore prophylactic; they aim to check traditional male dominance, but they equally look to the past and function as a productive haunting. They conform to Sigmund Freud's concept of the "unlaid ghost," that something not understood will inevitably reappear, because "it cannot rest until the mystery has been solved and the spell broken."[9] The work undertaken by these shadow figures in confronting the past and revealing a permeable male body and psyche in the present was vital to building the future.

The school opened less than five months after the First World War's disastrous conclusion. The Bauhaus's temporal proximity to the war meant that most of its male teachers and students (as well as at least one female student) were veterans who arrived there "direct from active service, hoping for the chance to make a fresh start and give meaning to their lives," according to Magdalena Droste.[10] Indeed, all of the male *Bauhäusler* under discussion in this chapter served in the war, with the exception of Breuer, who, born in 1902, was too young but who, like subsequent generations of *Bauhäusler*, grew up in an atmosphere of war and was influenced by it.[11] Many of the former soldiers at the Bauhaus during these early years had few possessions and almost no clothing. They often dressed in simple, collarless button-down shirts that were in fact soldiers' uniforms dyed and altered by their female fellow students.[12] These and other aspects of the men's military experiences carried over to the Bauhaus. Yet at the same time they worked together and shared their lives with the school's women, a strong contrast to their experiences of war.

In his now classic study of proto-fascist, post-World War I masculinities, *Male Fantasies*, Klaus Theweleit argues that there is a particular imperative to examining representations of manliness in Germany of the interwar period. Theweleit finds that for the men who became members of right-wing paramilitary groups known as the *Freikorps*—and for all such men with weak ego structures, most importantly National Socialists—maintaining the body's wholeness and its boundaries was psychologically essential. In Theweleit's argument, "the soldier male's most intense fear is his fear of decomposition."[13] By preserving these boundaries, such men were able to hold on to the identities as soldiers and fighters that they had developed in the recently lost war, and they could stave off what Theweleit refers to as "the mass," a term that covers a broad range of concepts, including filth, animal nature, the enemy, and, above all, women, all of which the soldier male must avoid at any cost in order to maintain himself.[14] Theweleit asserts that certain concepts, including culture, race, nation, and wholeness, and such organizations as the military form the fascist male's defense against the mass and render him the perfect machine.

> The new man is a man whose physique has been machinized [sic], his psyche eliminated—or in part displaced into his body armor, his "predatory" suppleness. We are presented with a robot that can tell the time, find the North, stand his ground over a red-hot machine-gun, or cut wire without a sound. In the moment of action, he is as devoid of fear as of any other emotion. His knowledge of being able to do what he does is his only consciousness of self.
>
> This, I believe, is the ideal man of the conservative utopia: a man with machinelike periphery, whose interior has lost its meaning.[15]

In the realm of representation, Theweleit sees this ideology at work in sculptures by National Socialist artist Josef Thorak in which he represents heroic male nudes clad in nothing but their own impenetrable musculature.[16] In a French postcard from the First World War that Theweleit reproduces in *Male Fantasies*, even the soft, chubby bodies of newborn baby boys can take on this armor.[17]

At the start of the Weimar Republic, just this type of hyper masculinity circulated widely in such objects as a recruitment poster from approximately 1919 for the Volunteer National Guard (*Freiwillige Landesschützenkorps*), one of the many armed paramilitary *Freikorps* groups active in Germany after the war (figure 2.3). It shows a disembodied, helmeted soldier's head that projects out from the background of a red-and-white flag.[18] His eyes open wide in alarm, this soldier's chiseled features are skull-like as he shouts—screams almost—for prospective comrades to come forward and fight those who would disturb German labor, presumably Communists threatening a strike. The large opening of his mouth suggests both a vulnerability in this armored face and thus its need for help from volunteers, but it is also protected by the force of his cry. The victory wreaths that echo the yelling mouth's form in the upper corners of the poster promise triumph in the end. While this militarized imagery would have appealed to former soldiers, the last line of text also reached out to the next generation: "also those with no service record will be accepted." After the humiliating defeat of the First World War, such myth-making representations of an aggressive German male body that was invincible when situated in a military collective, appealed to many and would, according to Theweleit, help form the essential core of Nazi imagery and ideology.[19]

And yet, visual and popular cultures of the Weimar Republic offered many other models of manhood. While no single, iconic type akin to the *neue Frau* or New Woman epitomizes shifts in interwar ideas about masculinity or provided a fulcrum around which the conversation turned, the period was in many ways equally disruptive with respect to traditionally encoded aspects of masculine identity.[20] On the one hand, the republic's legal framework stressed sexual and gender conformity by including §175 in the Penal Code to explicitly criminalize what it termed "sodomy," as a general term for sexual relationships between men. On the other hand, many men who were expressly interested in forging new forms of masculine ideals routinely contested this drive to conformity in, for example, Berlin's bustling gay scene.[21] This interest arose for diverse reasons, including homosexual desire of course, but also a deep suspicion of traditional masculine ideals following the loss of the First World War, new technological possibilities that obviated the need for male physical strength in the workplace, and the dawning influence of science on questions of gender and sexuality. And these aspects of a culture of new gendered potentials was made manifest not only in institutions such as Magnus Hirschfeld's

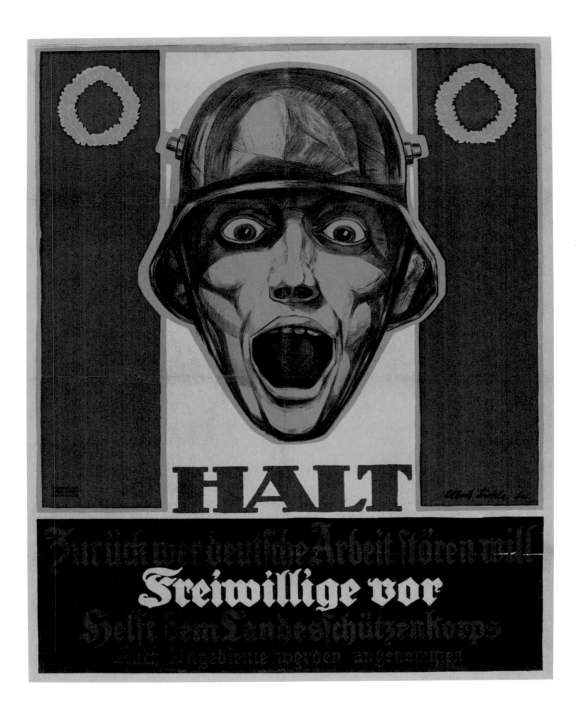

Institute of Sexual Science and the Berlin Psychoanalytic Institute, but also in the first gay-rights film, *Different from the Others* (*Anders als die Andern*, 1919), which was made in Germany.[22] Mass-market magazines of the day promoted nudity and displayed naked male and female bodies without prudery; other, smaller print-run journals fostered networks of gay and lesbian culture that extended throughout Europe.[23] Experimental ideas and anxiety about bodies thoroughly permeated the Weimar Republic, and they were fundamental to the Bauhaus's attempts to remake art and life. The past two decades have seen a turn in art historical scholarship to engage the subject of early twentieth-century masculinities in such modernist movements as Dada, Futurism, and surrealism.[24] But the Bauhaus's attempt to remake art and life has rarely been explored in relation to constructions of masculinity.

At the Bauhaus, it was in the medium of photomontage that these experiments with and critiques of masculinity most often took place.[25] In contrast to the rigid, hyper-masculine imagery evident in the recruitment poster, the messy, ad-hoc practice of photomontage offered space for speculative and humorous male types to be tested out. Born out of later nineteenth- and early twentieth-century advertising, composite portraiture, and other forms of juxtaposed imagery, photomontage became a new, nontraditional practice that was embraced by a number of avant-garde groups in the interwar period. Montage allowed artists to create representations out of found images and to reorder the interwar illustrated press's "blizzard of photographs" that cultural critic Siegfried Kracauer described as threatening to overwhelm his contemporaries.[26] Photomontage often drew source material from the dynamic views of modernist, New Vision photography; it was part of a broader attempt to see the world anew through the use of the latest imaging technologies that also included X-ray and film, technologies to which László Moholy-Nagy drew his readers' attention in his Bauhaus publications of the time.[27] The word "Montage" is, however, at least two centuries old, borrowed from French and the vocabulary of machines; only after World War I did members of Dada begin to use it to refer to a form of picture.[28] In calling this new type of image a montage, artists were asserting that these were not works of art but rather functioning machines with use value. Embedded in the process of creating a montage is also a claim by the maker to be a *"Monteur"*—machinist or laborer—rather than an artist. The terms *Monteur* and *Montage* were in use among members of Berlin Dada by 1920 at the latest, and at the Bauhaus by 1925.[29] In foregrounding the technical and mechanical as the basis for making pictures, photomontage was an answer to Gropius's call for an end to "salon art" and a quintessential form for the Bauhaus. It also played an integral part in the school's social life, since many *Bauhäusler* created montaged works as commemorative gifts, such as Breuer's for Gropius, and these helped foster the communal feeling at the school.[30]

FIGURE 2.3. Albert Birkle, *Stop: Back with those who would disrupt German work! Volunteers Forward!*, no date, color lithograph on wove paper. 35.7 x 26.3 in. (90.8 x 66.7 cm). Los Angeles County Museum of Art, Gift of the Robert Gore Rifkind Foundation, Beverly Hills, CA © 2019 Artists Rights Society (ARS), New York / VG Bild-Kunst, Bonn. Photo © Museum Associates/LACMA.

Photomontage was also a transformative practice that allowed for the contemplation and manipulation of the human figure in order to experiment with represented gender roles. Michel Foucault offers a relevant critique of the concept of sexual identity as unified and fixed in *The History of Sexuality*. He finds that the process of modernization involved a relegation of sexual identities and practices to the realm of medicine and a concurrent "exigency of normality." By the later nineteenth century, he asserts, "the notion of 'sex' made it possible to group together, in an artificial unity, anatomical elements, biological functions, conducts, sensations, and pleasures, and it enabled one to make use of this fictitious unity as a causal principle, an omnipresent meaning, a secret to be discovered everywhere: sex was thus able to function as a unique signifier and as a universal signified."[31] In place of this "austere monarchy of sex" Foucault suggests that, as an alternative, we think of an open structure of "bodies and pleasures."[32] Focusing on Bauhaus constructions of manhood allows us to discover how these alternated between a certain kind of rigidity in relation to the competent and controlled artist-engineer, and a freedom to explore the uncanny repressed behind this type.

CONSTRUCTING THE ARTIST–ENGINEER

In 1926, Lucia Moholy made a photograph of her husband Moholy-Nagy as a perfectly coiffed Bauhaus master, in a serious pose, and wearing coveralls, a white-collared shirt, and a tie (figure 2.4). Moholy-Nagy appears in what looks like a machinist's suit (*Monteuranzug*), which would certainly have been practical for painting, darkroom work, or teaching, but it was also a fashion statement that identified him specifically as a Monteur, a mechanic or technician. According to contemporary sources, this suit was actually orange, but in the photograph, it is a rich and neutral gray.[33] Moholy-Nagy is dressed in a manner distinctly different from traditional artists of the time, who usually wore collared, flowing, white smocks.[34] His darker, fitted suit covers all of his clothing including his trousers and marks him as a different kind of artist, one who works—*labors* even. Yet his white collar and tie peeking through at the suit's open neck show him as more designer than grease monkey. He stands outside of his and Lucia Moholy's new Bauhaus master's house in Dessau with a neutral white rectangle as a backdrop to create as objective and serious a portrait as possible. When cropped close to Moholy-Nagy's head, the photograph would serve as an ideal headshot to highlight his set facial expression and the power of his vision—emphasized through his wire-rimmed glasses—complete with a starkly neutral background. However, his seriousness is somewhat undercut in the full print of the portrait, which reveals its own makeshift nature. The shadows of tree branches fall across Moholy-Nagy's body, and his "objective" backdrop is clearly just a white, unhinged Bauhaus door that is propped up against the building. Shown in full, the door

FIGURE 2.4. Lucia Moholy, Portrait of László Moholy-Nagy, 1926, gelatin silver print. 9.1 x 6.3 in. (23 x 15.9 cm). Bauhaus-Archiv Berlin. © 2019 Artists Rights Society (ARS), New York / VG Bild-Kunst, Bonn

ultimately fails as a backdrop, since it does not quite extend down to his feet.

Still, the portrait stakes a bold claim: in contrast to romantic images of the passionate artist, Moholy-Nagy embodies the *Monteur* and the artist-engineer type. He appears tough and capable, as if his body were armored in his practical coveralls. He thus stands as the link between the Bauhaus and the broader sweep of members of the avant-garde attempting to rethink the role of the artist in a society responding to ongoing industrialization, emerging technologies, and the First World War. He is the key figure of the Bauhaus's late 1922 and early 1923 turn away from expressionism, the period when Moholy-Nagy joined the staff and "Art and Technology: A New Unity" became the school's slogan.

Confined not only to the Bauhaus, there were critical antecedents and parallels to Moholy-Nagy's artist-engineer in both De Stijl and Soviet constructivism.[35] And indeed the question of the creative artist's role in revolutionizing modern society for the better endured beyond the 1920s, as it preoccupied Walter Benjamin in his 1934 lecture on "The Author as Producer."[36] In the Soviet context, Aleksandr Rodchenko's 1922 production clothing of his own design was remarkable for its rugged practicality, with its numerous oversized pockets and sturdy fabric that supported the work of the constructor and obviated the need for daily clothing choices. Moholy-Nagy may or may not have known of Rodchenko's production clothing, but the two knew each other's work well and had direct contact through letters.[37] In either case, performing the part of the new artist-engineer sartorially clearly mattered to both of these men. Rodchenko could have made do with old clothes in the economy of incredible scarcity of 1922 Soviet Russia in which he was living; Moholy-Nagy, frankly, could have bought a smock even more easily, and it would have served him just as well. But neither did. In addition to their similarities, it is worth noting a difference in these suits: Moholy-Nagy did *not* design his own, one-of-a-kind artist-engineer outfit, but purchased extant, off-the-rack clothing that was already associated with work.

Clothing was just one way that artist-engineers could make themselves known. Because the artist-engineer figure was linked to the idea of the *Monteur*, the productive nature of what previously might have been artist's work—making paintings or sculptures, for example—to a certain extent became akin to that of the laborer, the engineer, or the scientist. This was even more the case with the new, collaborative activities of *Bauhäusler*; they were involved in utopian attempts to redesign everyday objects and thus to expand the experience of modernity into all aspects of daily life. The words "New Vision" (*neues Sehen*) in this chapter's title refer to Moholy-Nagy's term for technologically based seeing, the integration of which he proposed as the task of the artist of his own day. Joyce Tsai has traced the origins of this thinking to Moholy-Nagy's World War I deployment to Galicia in an artillery unit of the Austro-Hungarian army, where he served as a reconnaissance officer (*Aufkläreroffizier*). In this capacity, he was responsible for identifying enemy targets and securing safe passage for his comrades and their howitzers, the short-nosed, shell-firing cannons that were essential in this war fought over greater distances than ever before. Moholy-Nagy's work would have required the use of improved and new technologies including field glasses and the rotating telescopes for surveying known as theodolites.[38] During his service, Moholy-Nagy experienced the devastating Brusilov Offensive of 1916, in which a Russian side that was vastly inferiorly resourced in its munitions and supplies none the less attacked Moholy-Nagy's Austro-Hungarian side and managed to devastate them through their use of military intelligence, reconnaissance, and above all strategy, an experience that Tsai sees as formative for

Moholy-Nagy as an artist. "The mere possession of technology secures no tactical advantage," was the lesson he learned from his side's punishing retreat.[39] One had to be smart and creative about using it, and this became the job of the artist-engineer.

Moholy-Nagy had turned to photomontage only after having initially dismissed it. In a 1920 letter to a Hungarian colleague, he wrote of having seen an exhibition at *Der Sturm* and complained, "a man called Kurt Schwitters is exhibiting pictures made from newspaper articles, luggage labels, hair, and hoops. What's the point? Are these painterly problems?"[40] Yet it was while sharing a studio with Schwitters during the financial crisis of the winter of 1922–1923 that Moholy-Nagy produced his first known Dadaistic, fragmentary montage.[41] At the Bauhaus, he would fully develop his own montage techniques. When he arrived at the school in April 1923, he not only became the paradigmatic figure in the institution's shift from its expressionist roots to an aesthetic approach based in constructivism; he also was the Bauhaus's youngest master ever at age twenty-seven. Moholy-Nagy was thus in some ways a harbinger of the new who had already embraced emerging technologies.[42] Photomontage provided a method of creating figurative images from scavenged photographs that particularly appealed to him at a time when painting had become a medium for experimenting with abstraction. Moholy-Nagy's photomontages often reveal a surprising emotional engagement with, and probing of, a troubled masculinity, strong contrasts to the bold formal visual experiments for which he is better known. Radically different from the Dadaists' fragmentary and often somewhat messy montage work, Moholy-Nagy's photomontages tended to rely on a strong sense of linearity and a use of negative space that marks them as in keeping with constructivism, an approach that was extremely influential for a number of Bauhaus artists.[43] Using a technique later made famous by John Heartfield, Moholy-Nagy often considered his montages maquettes for what he called photo-sculptures (*Fotoplastiken*)—infinitely reproducible photographs of the original montages.

In analyzing photomontage representations of the artist-engineer, it is essential to consider that it was not only male *Bauhäusler* who created insightful and timely representations of male bodies; women at the Bauhaus also played a significant role in critiquing this armored masculinity and recrafting the image of the artist. In particular, Marianne Brandt—who is best known for her iconic metal designs, but who also painted, photographed, and indeed repurposed illustrated journals into dynamic montage compositions—often took direct aim at militarized masculinities and created images of future-oriented new male and female types in photomontage and photography. A comparative look at Moholy-Nagy and Brandt's photomontages from their time at the Bauhaus makes it clear that she learned much about compositional style from her mentor, and many of the works of both artists utilize the dynamism of modernist design to create images of stunning, perhaps even ironic, optimism about the possibilities for the

experience of modernity to alter the post-World War world.

Moholy-Nagy's 1923 "Advertising Poster" (*Reklameplakat*) *Pneumatik* utilizes compositional and typographic strategies to convey the driving speeds possible with modern tires (figure 2.5). It does this, however, without actually focusing on the tires themselves, even though they are ostensibly the advertisement's subject. Oversized text is upended across the picture plane to form a road that recedes dramatically into the distance upon which a speeding car zooms towards us; the letter "n" of "Pneumatik" doubles as both text and the car's shadow. The movement of our eyes across the letters sets this still image into motion, and the car appears to be propelled forward in the opposite direction to our reading. With its curving lines and strong design, *Pneumatik* is situated in blank, abstract space to evoke open roads and infinite possibilities. The car's driver appears only as a round head with glowing eyes. He is a tiny element of this composition, yet we know that he is the master of the scene of dynamism and speed that unfolds before us—a stand in for Moholy-Nagy himself, whose design skill and imagination created this dynamic image of abstracted modern experience. Moholy-Nagy was clearly enamored of this picture, for he republished it in 1925 as a page in *Painting Photography Film*, his first contribution to the Bauhaus Books, a series of manifestos and daring examples of emerging visual technologies.

Painting Photography Film was republished with a few updates in 1927, and that same year, Brandt created a work that responds to *Pneumatik* with her own dizzying vision: *Tempo-Tempo, Progress, Culture* (*Tempo-Tempo, Fortschritt, Kultur*), likewise a clean, futuristic vision of a technology in which text swirls around the figure of an artist-engineer who competently mans an incomprehensible mass of machinery (figure 2.6). Like Moholy's *Pneumatik*, this is a still image that is set into filmic motion by composition and text. The black, gray, white, and red lettering arcs and weaves through it as Brandt's simple lines and strong shapes materialize on an empty background to direct viewers' gazes within a space of open possibilities. In the composition's lower portion and just off center, the machine is circled by two lines that focus our attention through a kind of ring; wherever the ring overlaps text, Brandt has lightened it with gouache in order to indicate the ring's presence, as glass or plastic for example, between us and the text. Once this structure is established by the design, the sense of depth and illusion of space are increased by the engineer's position straddling this ring. He and his machine thus pop out from the page, propelled into our space by compositional elements of line and color.

Other, swirling pictorial elements surround the small central figure of *Tempo, Tempo, Progress, Culture*. Like the driver in *Pneumatic*, he is dwarfed by the composition, yet he mans his own complex machine competently and with smiling aplomb. Brandt has utilized a skillful montage to alter his stance and arm positions to give him an expansive pose that

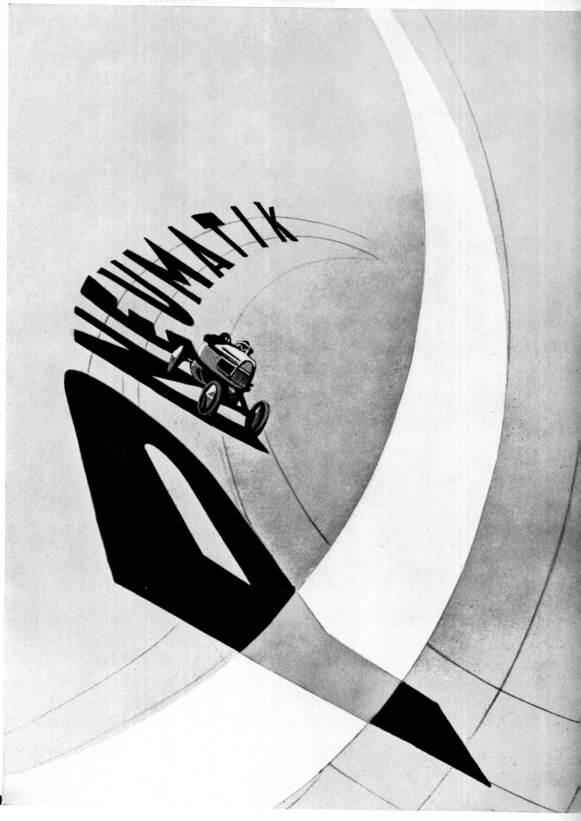

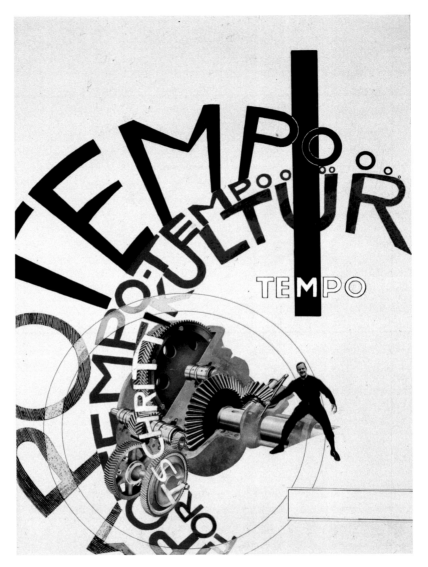

FIGURE 2.6. Marianne Brandt, *Tempo, Tempo, Progress, Culture* (*Tempo, Tempo, Fortschritt Kultur*), 1927, montage of newspaper clippings, black, red, and white ink. 20.5 x 15.7 in. (52 x 39.8 cm). Kupferstich-Kabinett, Staatliche Kunstsammlungen Dresden. © 2019 Artists Rights Society (ARS), New York / VG Bild-Kunst, Bonn. Photo: Herbert Boswank.

suggests his power and competence. Magician-like, this engineer controls the giant metallic gears through the mere shifting of the thin lever that he holds. To create the gears and levers of this oversized engine, Brandt has montaged a collection of seven technical drawings together to form a machine full of gears that appears highly realistic, but is no longer recognizable as a specific type of machine. Instead, it is a generalization of the idea of a machine that pumps out text through its optimistic drive.

Moholy designated *Pneumatik* as an advertising poster, and *Tempo-Tempo, Progress, Culture* also gestures towards its own potential usefulness in the modern economy. It appears to have been a draft magazine cover for *Tempo: Magazine for Progress and Culture* (*Tempo: Magazin für Fortschritt und Kultur*), a lifestyle illustrated magazine produced by the popular Ullstein press that went into production in 1927. Attached to Brandt's photomontage is a tracing paper overlay with markings for the journal, including the issue number and a price of one mark, that appear in the oblong box at the lower right. Brandt selected the most dynamic words of the journal's name—tempo, progress, and culture—and put them into play as Modernist design elements that have been produced by the lone figure of an engineer and his mammoth machine.

Similar to Moholy-Nagy, Brandt conceived of this figure of an engineer or a New Man seemingly in tandem with her thinking about her own role in artistic production and of her self-conception as an artist. In photographs, Brandt explored her own image as a modern, female designer and the potential for her own female body to fill the mold of the artist-engineer, a topic I explore in more depth in the following chapter on Bauhaus constructions of New Womanhood. But one particular photographic self-portrait, made in around 1930, after she had left the Bauhaus and was head of design for household goods at the Ruppelwerk factory in Gotha, achieves the hybrid, artist-engineer form completely (figure 2.7).[44] "Self-Portrait, Double Exposure" ("Selbstporträt, Doppelbeleuchtung") shows Brandt as an engineer figure in a white lab coat, her technical know-how made manifest by the drafting tools at hand. She is clearly in control of her own representation, for she holds the shutter release in her hand. Her long hair, pouting lips, and the beads at her neck soften and feminize the image. This double-exposed self-portrait evidences Brandt's technical skill as a photographer; it was shot from an unusually extreme high angle—the camera must have been mounted on a shelf or even to the ceiling—and yet the photograph is perfectly composed and clearly in focus. Likewise, the strange, surrealist-influenced presence of her ghostly second face in the background is expertly executed through her double exposure of the negative. Brandt, creator of sleek new designs for lamps, tea- and coffee-sets, and other household items in the Bauhaus metal workshop has here moved on from the school to revamp an entire line of household goods for mass production. Her reimagining of herself as an artist-engineer suits her new status, and it

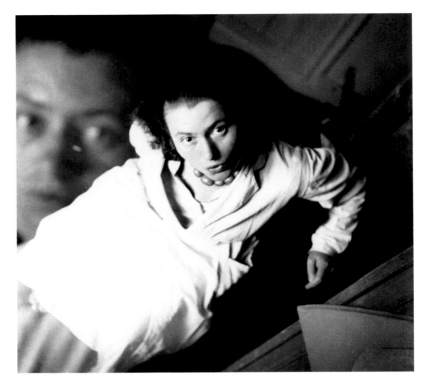

FIGURE 2.7. Marianne Brandt, Self-Portrait in the Studio in Gotha, Double Exposed (Selbstporträt im Atelier in Gotha, Doppelbelichtung), c. 1930/31, modern photograph from vintage negative. 9.4 x 12.1 in. (23.8 x 30.8 cm). Bauhaus-Archiv Berlin. © 2019 Artists Rights Society (ARS), New York / VG Bild-Kunst, Bonn.

was part of the broader attempt to remake the roles of artists and designers in a society experiencing a radical break with its past. While most imagined this type as male, Brandt claimed the role and made it her own.

Brandt was not the only Bauhaus woman to use her own body to evoke female artist-engineer types. The Dessau Bauhaus's women's gymnastics instructor Karla Grosch, a frequent performer in Oskar Schlemmer's dance pieces that were full of abstract, otherworldly, and uncanny bodies, also embodied a version of this type in Schlemmer's 1929 *Metal Dance* (figure 2.8). Luminous against the darkness, her image was captured by photographer and fellow *Bauhäusler* T. Lux Feininger.[45] Grosch's head is encased in a bell jar and her shoulders are ringed with a row of glass metallic ornaments; she raises an elongated glass laboratory vessel like a scepter as if conjuring the new future. Here is a figure of the female artist-engineer as a futuristic goddess. Aside from the transformative visual properties offered by the reflective metallic surfaces of the stage set for *Metal Dance*, by 1929, metal had come to hold a special place at the Bauhaus as one of its most significant departments.[46] It had vastly outpaced most of the others in its creation of successful designs that were in

mass production by manufacturers; therefore, in many ways, it epitomized the Bauhaus dream. In Schlemmer's dance, as Susanne Lahusen asserts, metal, arguably the Bauhaus's most powerful modern material, does not overwhelm the dancer. Grosch controls and dominates it, dynamically orchestrating her own futuristic vision.[47]

Representations of new humans—especially but not only New Men— who embodied and evoked a new kind of creative force, an artist-engineer of sorts, emerged in unexpected quarters of the Bauhaus's visual landscape. In photomontage, dance, and design work, *Bauhäusler* explored these new modes of post-war personhood. As I argue in the rest of this chapter, these future-oriented modes of being, particularly in their masculine forms, were haunted by the recent traumatic past—and by fears of what men could again become.

SHADOW MASCULINITIES

The events of the First World War and the transformations it imposed upon male bodies and psyches led to at least a partial unhinging of traditional constructions of masculinity. Among these events, I would name just a few: the mass conscription of men, the total mobilization of culture and society, the unprecedented number of wounded and dead, and—despite these unprecedented sacrifices—Germany's defeat in the end. Masculinity during the Weimar Republic was in an unprecedentedly fragile state.[48] But the period's visual cultures offered an outlet for fears about these damaged

FIGURE 2.8. T. Lux Feininger, Karla Grosch in a Glass Mask by Oskar Schlemmer (Karla Grosch in Glasmaske von Oskar Schlemmer), Bauhaus stage, Glass Dance. 1929, artist's reprint in 1980, gelatin silver print. 3.5 x 4.7 in. (9 x 12 cm). © Estate of T. Lux Feininger, Photo: Art-Archives. net.

masculinities and a place perhaps to remake them as whole again. Stories of men who were evilly duplicitous, who appeared to be one thing but were really something much more dangerous, became common themes in the burgeoning suspense and horror cinema of the Weimar Republic. Types such as the killer sleepwalker, the man afraid of his own murderous impulses, the soul-stealing double, and the *Hochstapler* or con-man abound in paintings and stories, but perhaps nowhere more powerfully than in the interwar period's flourishing cinema culture.[49] These haunted cinematic masculinities came to life consistently in the work of Conrad Veidt, who is perhaps best remembered as the sleepwalker in *The Cabinet of Dr. Caligari* of 1929, but went on to play his own doppelgänger and a pianist who believes he possesses and is possessed by the hands of a murderer.[50] Veidt was also considered one of the great sex symbols of his day, something that is perhaps difficult for modern viewers to appreciate, but is suggested in multiple sources from his time. Among these is Brandt's 1928 photomontage *Behind the Scenes* (*Hinter den Kulissen*), in which Veidt, at the upper right, appears as both a danger and a temptation to a New Woman who cannot see him, but is clearly enjoying the sensual touch of the disembodied hand on her back (figure 2.9). The striking and consistent duality of such a prominent actor as Veidt—who toggled back and forth between roles as dangerous haunter and passionate heartthrob and sometimes was both at the same time—is not merely in keeping with the Bauhaus masculinities I am tracing in this chapter; it epitomizes a broader parallel for male types of this period. In 1919, Freud published his essay, "Psychoanalysis and the War Neurosis," in which he asserted the prevalence of a conflict between an individual's war and peace egos, in which the former feels compelled to kill, and the latter feels an equally strong compulsion not to kill, a conflict that can cause mental paralysis and even psychic collapse.[51]

Drawing her visual material directly from the illustrated press—frequently from film journals, as she did in *Behind the Scenes*—Brandt also created a number of photomontages that specifically express anxiety about the armed or militarized male body.[52] Her images raise critical questions about the interwar enthusiasm for technology and for rearmament—the latter expressly forbidden by the terms of the Treaty of Versailles and yet a constant topic in the right-wing press. The consequences of war are played out in an untitled work from approximately 1930 that presents three male figures in a landscape (figure 2.10). Brandt specifies a military context for this picture even in its uncharacteristic use of monochrome, black-and-white images that here read as "field gray" (*Feldgrau*), the color of soldiers' uniforms. An aircraft looms overhead as two uniformed men accompany a central heroic figure through a bare, snow-covered field of grave markers, names partially visible upon them. The smaller soldiers to the left and right strike agitated poses of panic and defeat. The man at the upper right gesticulates wildly, as if he is attempting to signal for help

to the airplane above. The figure in the lower left has a bloody face as he crawls through the mud, dirtying and tearing his elaborate, old-fashioned uniform, which is ornamented by a skull and crossbones symbol on his sleeve, an evocation of those right-wing *Freikorps* paramilitary groups that I discussed earlier (figure 2.3). Both of these smaller figures are unseen or ignored by the modern man who is the picture's central protagonist; he also appears unaware of the devastation that surrounds him in the barren graveyard landscape, as he cavalierly engages in a casual game of lawn bowling. Yet, for viewers of this picture, the smaller men flanking him

FIGURE 2.9. Marianne Brandt, *Behind the Scenes* (*Hinter den Kulissen*), 1928, photomontage of newspaper and magazine cuttings on black cardstock, mounted on black cardstock. 11.9 x 8 in. (30.3 x 20.2 cm). Stiftung Bauhaus Dessau © 2019 Artists Rights Society (ARS), New York / VG Bild-Kunst, Bonn.

cannot be missed. Ghostly, they seem to haunt the modern figure like a return of the repressed.

Like Brandt, Moholy-Nagy also problematized potentially heroic masculinities; in his case, the image of manhood he held up for question was his own. While he worked together with Lucia Moholy to stage his own portrait as a steely constructor (figure 2.4), he also took this very image as the basis of no less than three photomontages that render him as foolish, awkward, and impotent.[53] One of these, *The Chump* (*Der Trottel*), uses a negative image of his door backdrop as a sort of silhouette portrait in reverse, repeated three times (figure 2.11). Moholy-Nagy gave this picture, one of his re-photographed "photo-sculptures" from a photomon-

FIGURE 2.10. Marianne Brandt, *Untitled* (*Airplane, Soldiers and Military Cemetery*), c. 1930, photomontage on cardboard. 25.6 x 19.7 in. (65 x 50 cm). Kupferstich-Kabinett, Staatliche Kunstsammlungen Dresden. © 2019 Artists Rights Society (ARS), New York / VG Bild-Kunst, Bonn. Photo: Herbert Boswank.

tage original, as a gift to the Hannover-based artist, photographer, and journalist Kate T. Steinitz. Like many of the drawings, photographs, montages, and other artists' gifts that Steinitz received, she pasted this image into her "guestbook," a kind of scrapbook she kept from 1921 to 1961 as a record of her friendships among the artists' milieus in which she lived.[54] Thus, Moholy-Nagy's image was on display for numerous other members of the international avant-garde who visited Steinitz and viewed her guestbook over the years.

In *The Chump*, Moholy-Nagy retools his portrait as a resolute constructor to reveal himself as an embodiment of absence and lack of substance. In each of the three reversed silhouettes, Moholy-Nagy has carefully cut away everything but the black rectangle against which he stands. While the three doors might normally offer the viewer a series of enticing choices, we can already see that behind each of them is nothing—or at least very little. In the left and center doors, Moholy-Nagy's empty form appears armless, hunched, and rather stumpy. These silhouettes teeter off to the left on unsteady bases of black pigeon-toed feet, which appear to have come from positive prints of the same portrait with the right and left feet switched. Both silhouettes seem to look intently to the right at their fellow, a third figure who attempts to break out of his mummifying frame. Behind this third, furthest right door, muscular limbs sprout awkwardly from the lean body of an athlete. Spread out across the largely empty field of the composition, these three self-portraits progress from a closed and self-protective posture to one that has opened up and, reading from left to right, almost appears to run forward. But the frame itself of the empty-headed chump remains unchanged; rather than allowing himself to become something new in the third iteration, his construcitivist frame makes his arms and legs appear gangly and out of place. Having based this montage on a photograph of himself as a modernist artist-engineer, Moholy-Nagy images both a transcendence of this trope and his own inability to fill the role he created for himself. Try as he might, he is still an ungainly *Trottel*, a chump who appears unable to fill or successfully break out of his frame. Clearly female artists such as Brandt were not the only ones challenging and nuancing the artist-engineer trope and its assumptions about masculinity.

In placing this vision of himself in Steinitz's guestbook in the mid-1920s, Moholy-Nagy makes a visual joke on the supposed rigidity of modernist design, one that would have been understood by the avant-garde viewership of the guestbook. It was becoming a truism among critics of the Bauhaus that the school was seeking to make humanity subservient to a tyranny of rectilinear design.[55] On a more personal level, this photo-sculpture is a gift in which Moholy-Nagy seems to contradict his own public persona as the serious and multi-talented Bauhaus professor he had become by the mid-1920s. This montage thus also undermines the possibility of Moholy-Nagy's portrait as an artist-engineer becoming a

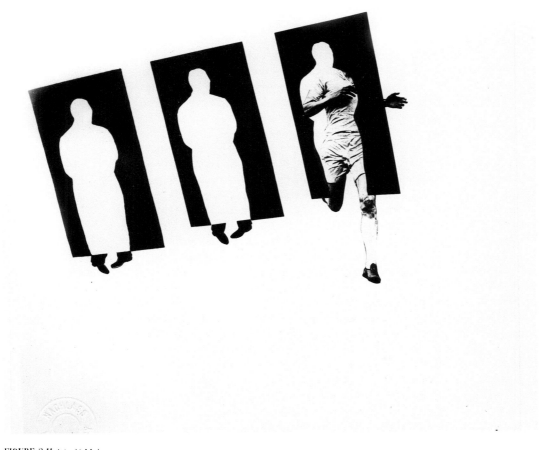

FIGURE 2.11. László Moholy-Nagy, *The Chump* (*Der Trottel*), c. 1926, photoplastik (re-photographed photomontage, gelatin silver print). 9 x 7 in. (22.9 x 17.8 cm). Collection of Hattula Moholy-Nagy, Ann Arbor, Michigan.

heroic or hard-bodied male along the lines of Theweleit's militarized men, and it is in this sense that I see this and the other two photomontages based on his portrait as fulfilling a potentially protective function. Bauhaus artists might seek to create themselves anew, but they should not be armored, impenetrable, or infallible.

The contradictory nature of the male Bauhaus body is also addressed by Moholy-Nagy and Breuer's fellow *Bauhäusler* Herbert Bayer, who also made a series of photomontages for Walter Gropius, and these images have strong, specific references to Bauhaus masculinities. Most powerfully, these images relate to Gropius as the Bauhaus patriarch, the school's founder and its director for nine years, for these were birthday gifts for him. As very young men, both Breuer and Bayer had presented their portfolios to Gropius for admission to the Weimar Bauhaus; he accepted both of them, and later, in 1925, made them masters of the furniture workshop and the printing and advertising workshop respectively. Breuer and Bayer, too, were good friends who influenced each other's work. The connections among these men fostered a deep knowledge of each other through mentorship, friendship, and rivalry. It was in this context of trust that new images of the masculine self and other could be most substantively developed and explored.[56]

In contrast to the fake love affair insinuated by Breuer's photomontage gift, an actual, well-documented, and somewhat public love affair is part of the context of an accordion-folded series of five square, double-sided, montaged panels by Bayer, a consummate graphic designer (figures 2.12 and 2.13). This gift to Gropius as he became a half-century-old is titled *50 Years of Walter Gropius and How I Would Like to See Him Still: For the Occasion of His Birthday, May 18, 1933* in typed text that appears on its front cover. It was made after both men had left the Bauhaus, but at a time when the institution still continued to be a defining influence in their work and lives. The affair that provides the backdrop to this work began in 1932 between Bayer and Ise Gropius, who had been Gropius's wife since 1923; it is a relationship that threatened the very foundations of the Gropius marriage.[57] The two men had had a strong mentor/student relationship since the twenty-one-year-old Bayer first arrived at the Weimar Bauhaus in traditional Austrian peasant clothing (*Tracht*) for his interview with Gropius in 1921, having hiked there from Darmstadt in central Germany, since he had no money to take the train.[58] Over time, he and Gropius had become good friends, and, as Bayer rose in the Bauhaus ranks, colleagues. Even with the strain that this affair placed on the relationship between Bayer and Gropius in the early 1930s, they maintained a strong friendship and continued to work together periodically on design projects.[59]

In this series of epic photomontages, tensions between Bayer and his mentor come clearly—if also playfully—to the surface in seven pictures of Gropius as philanderer, cuckolded lover, sensualist, and dirty old man.

Yet Bayer also shows Gropius as virile, full of life, and even heroic. The first and last portions of this work situate it in the context of the love affair.[60] The work's cover shows a photograph of a headless female with the number "50" strung merrily between bows on her two nipples, a seeming gesture to Ise Gropius's two suitors, who were the gift's giver and recipient. The final image in the series is a skillfully executed montage which includes picture frames, classical sculpture, and careful airbrushing—elements which often appeared in some of Bayer's best-known works in montage, such as his covers for the lifestyle magazine *Die neue Linie*.[61] Here a female nude appears again, this time seen from behind. Her body is cut off at the knees and the ribs in clean breaks that reveal her as made of stone. A small photograph of a laughing Bayer hangs from this montage by a trompe l'œil string with a handwritten message: "and, nevertheless, best wishes, Herbert Bayer," a joking, coded acknowledgement.[62] In its imagery and text, the entire montage series is framed in the context of Bayer's affair with Gropius's wife, and it calls repeated attention to her body as an object that, like this gift, passed between the two men.

In the fold-out book's only two-page spread, the montage that the viewer first encounters after the cover, mass-produced putti draw back a purple velvet curtain to reveal Gropius, shirtless, reclining, and seemingly asleep, his hands resting on his chest (figure 2.12). Luscious fruit and delectable photographic female nudes from the realm of soft-core pornography surround him. These women are sexually objectified, but they also serve as ironically-presented examples of a genre. Engaged in playful bondage, they are among many kitschy, baroque elements in a still life of

FIGURE 2.12. Herbert Bayer, *50 Years of Walter Gropius and How I Would Like to See Him Still: For His Birthday, May 18, 1933* (*50 Jahre Walter Gropius und wie ich Ihn noch erleben möchte: Zum Geburtstag am 18. Mai 1933*). 1933, second and third of ten panels (five double-sided), cardboard panels with photomontage, chromo-lithographic prints, gouache, watercolor, paper and type written text, bound with linen. 11.6 x 23.2 in. (29.5 x 59 cm). Bauhaus-Archiv Berlin. © 2019 Artists Rights Society (ARS), New York / VG Bild-Kunst, Bonn.

FIGURE 2.13. Herbert Bayer, *50 Years of Walter Gropius and How I Would Like to See Him Still: For His Birthday, May 18, 1933 (50 Jahre Walter Gropius und wie ich Ihn noch erleben möchte: Zum Geburtstag am 18. Mai 1933)*. 1933, fourth of ten panels (five double-sided), cardboard panels with photomontage, chromolithographic prints, gouache, watercolor, paper and type written text, bound with linen. 11.6 x 11.6 in. (29.5 x 29.5 cm). Bauhaus-Archiv Berlin. © 2019 Artists Rights Society (ARS), New York / VG Bild-Kunst, Bonn © 2019 Artists Rights Society (ARS), New York / VG Bild-Kunst, Bonn.

elaborate glass and brass tableware overflowing with fruity bounty that epitomizes everything that Bauhaus artists had rejected. Another typed text at the montage's top left praises Gropius as an object of lust and an unvanquished if sleeping paterfamilias: "fifty springtides the unconquered one dozes; potency gushes from pores [like an animal] in heat [*brünstig*]."

In one of the most dramatic portions of the gift montage, another stand-in for Gropius is seen from behind (figure 2.13). Here he is a muscular, nude bodybuilder, a Hercules who poses, with arms outstretched, on an approximation of a Nemean lion pelt and looks down on a scenic town that appears made of the Froebel blocks Gropius played with as a child. With nothing but paper, an architect's drawing triangle, and a pencil of epic proportions, this heroic architect is ready to conquer the built landscape that sprawls out before him. Like the portrait photograph of Moholy-Nagy as a constructor, this is a representation that evokes the artist-engineer. Rather than a blend of coverall-clad technician and modernist artist, Gropius here is made into a muscular, hard-bodied constructor who bears some resemblance to the armored nudes critiqued by Theweleit. Yet this image's crude humor in elements

such as the oversized and phallic pencil dangling near his rounded buttocks that suggests Gropius's body as penetrable, or the fact that the former Bauhaus director seems to be proudly flashing the little village in front of him, undermines any suggestion of the fascist male body—even though, in May of 1933, when this work was given, the National Socialists had already taken power.

According to the text at the bottom of the image, while it is significant that Gropius has conquered the landscape with his monumental (and distinctly un-Bauhaus) buildings, this architect wins the woman he loves through his physical attractiveness and his craft. The text reads, "the architect, formed athletically, opens his heart up to a woman geometrically." Given the ongoing affair that Bayer was having with Gropius's wife, this montage's text seems to be a message of reassurance to Gropius that Ise Gropius will remain with him despite her dalliance with Bayer. In the broader context of modernist masculinities, this image of Gropius presents a glorified superhuman artist-engineer while at the same time revealing his physical and emotional vulnerabilities.

In the years just prior to the creation of Bayers's elaborate gift of playful photomontages in *50 Years of Walter Gropius*, Bayer made a series of eleven photomontages that he called *Man and Dream* (*Mensch und Traum*). Some of these draw on the visual language of surrealism to probe his own masculinity. The early 1930s were a time of increasing unrest due to the ongoing Great Depression; it is also the period of 1931 and 1932, when Nazi politicians took over the local government of Dessau and evicted the Bauhaus from its purpose-built building. Bayer had already moved to Berlin by this time, but the increasingly politicized environment and the premature destruction of what was in many ways his home as a designer and artist was part of a broader climate of fear that Bayer experienced. The meticulously constructed illusion of *Humanly Impossible* (*Self-Portrait*) (*Menschen unmöglich* [*Selbst-Porträt*]) is, like many of Bayer's montages, extremely clever and beautifully executed (figure 2.14). It is also a disturbing image in which he uses his craft to render himself an amputee.[63] And yet a curious detail—missed in most interpretations—gives the image yet another interpretive layer. In the original photograph that he took as this work's basis, Bayer holds a round sponge in his hand; in the finished work, he replaces it in the mirror with the slice of marble sculpture he has removed from his arm. But in the non-mirrored image, the part closest to us, it is still a sponge, an element of cleansing or purifying left facing one of artistic self-mutilation.[64] Bayer's continuation of this eerie and coded self-destruction in *Lonely Metropolitan* (*Einsamer Großstädter*) again images a kind of polished self-mutilation (figure 2.15). Here the dreary, run-down, façade of the interior courtyard of a Berlin apartment house serves as the backdrop to Bayer's own raised but severed hands—curiously with a modern business man's dress shirt and suit-jacket sleeves

still attached. Sad, mismatched eyes stare out from the palms of these hands to evoke the pain of urban life generally, but also to lend a sense of personal identity—an almost-but-not-quite face—to his severed designer's hands, which, along with his mind and the eyes evoked here, were the tools of Bayer's own form of the artist-engineer.

Behind its reform of design and architecture, one of the tasks of the Bauhaus was to imagine the artist of the future and to connect technology to that future. At the same time, many *Bauhäusler* fulfilled the classic task of the avant-garde: to offer oblique social critique that activates viewers and challenges them to turn a critical gaze on their own

FIGURE 2.14. Herbert Bayer, *Humanly Impossible (Self-Portrait)* (*Menschen unmöglich [Selbst-Porträt]*), 1932, gelatin silver print (from a photomontage). 15.3 x 11.5 in. (38.9 x 29.3 cm). Museum of Modern Art, New York, Thomas Walther Collection. Digital Image: © The Museum of Modern Art, Licensed by Art Resource, NY © 2019 Artists Rights Society (ARS), New York / VG Bild-Kunst, Bonn.

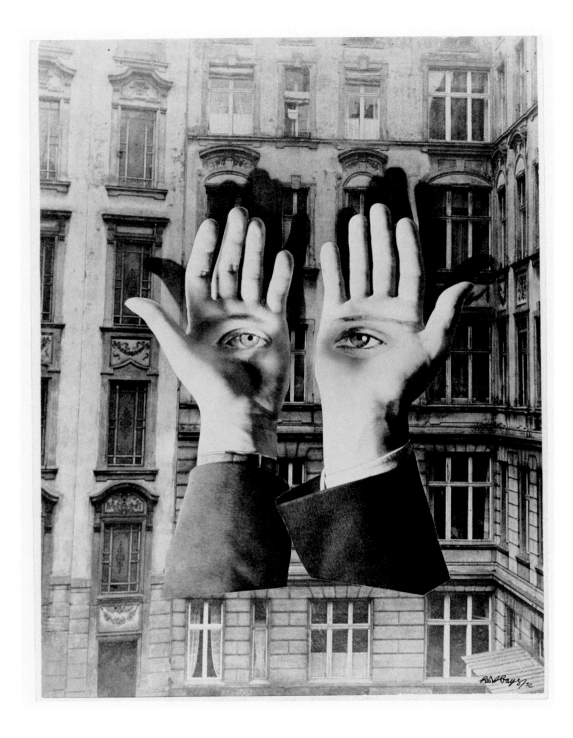

Chapter 2

contemporary world. Members of the school created heroic or fraught self-portraits, declarations of love, and representations of rivalry and respect that they gave as gifts to each other, and which circulated among members of the broader avant-garde context. The school offered a space in which to renegotiate the status of the male artist and manhood itself.

Some of these works—Brandt's spooky or militarized men, Moholy-Nagy's *The Chump,* or Bayer's gift to Walter Gropius—seem to trouble masculinity by imaging the self or other as haunted by the past or inadequate to the present, or by ironizing the aging male body. But in these and in Breuer's self-portrait, fragile masculinities were also connected to the more utopian and playful ideals of the Bauhaus. Indeed, at times these works seem to gesture towards Foucault's "bodies and pleasures" and away from constructions of normalcy and "that austere monarchy of sex" in which anatomies, experiences, and identities are falsely unified. Frederic J. Schwartz has pointed out that "the utopias of the Bauhaus were numerous and varied."[65] Play—in the classroom, in the studio, and after hours—was an essential part of these utopias and of the school's attempts to remake life and to recast manhood as something other than the unified, hard-bodied, military masculinity that was a strategy and a product of World War I, and would subsequently feed the rise of paramilitary masculinities and, eventually, of Nazism. In contrast to the armored and impenetrable fascist body, the Bauhaus photomontages discussed here all exhibit a spirit of experimentation that rejected the construction of manhood as armored and uniform, a construction of which these former soldiers and children of the war would have had personal knowledge. These works allow us to broaden our understanding of the Bauhaus's project and the nature of its societal critique. Above all, they help us to see how traditional gender norms haunt the work of Bauhaus artists, even as an exploration of changing experiences of gender—masculinity as much as femininity—was integrated into this most influential institution of modernism.

FIGURE 2.15. Herbert Bayer, *Lonely Metropolitan* (*Einsamer Großstädter*), 1932, gelatin silver print (from a photomontage). 10.6 x 13.4 in. (26.8 x 34 cm). Collection of the Victoria and Albert Museum, London. © Victoria and Albert Museum, London © 2019 Artists Rights Society (ARS), New York / VG Bild-Kunst, Bonn.

Ein Kleidverschluß mit vielen Knöpfen, ganz gleich ob vorn, hinten oder an der Seite, ist schlecht, weil er unbequem ist, Zeit wegnimmt und nervös macht.

Wir haben Reißverschlüsse.

Oder wenn es ein Knopfverschluß sein muß, warum dann so viele Knöpfe?

Es genügt einer —

oder zwei.

Man sieht sogar noch Knopfverzierungen, d. h. angesetzte Knöpfe, die gar nicht zum Knöpfen da sind, sondern zur „Verzierung".

Besonders die Konfektion liebt solche Dinge und verwendet minderwertige Stoffe, die schon nach wenigen Tagen jedes Aussehen verlieren, eine Wäsche aber schon gar nicht aushalten.

Was wir also von einem rationellen, eleganten, schönen Kleid verlangen müssen, ist:

daß es aus gutem Material gearbeitet ist:

daß der Schnitt in jeder Beziehung bequem ist:

daß das Kleid einfach genug ist, um Kombinationen mit einer Jacke, einem Schal, einem Gürtel, einer Blume usw. zu ermöglichen;

daß die Farbe zu der Trägerin paßt, ohne von den Vorschriften einer Modeindustrie abhängig zu sein;

daß außerdem die Farbe zu den übrigen Kleidungsstücken der Trägerin paßt.

Das Transformationskleid:

1. **Ein Kleid**
2. **Dasselbe Kleid mit einem zweifarbigen Pullover in passenden Farbtönen. Passender Ledergürtel**
3. **Dasselbe Kleid als Tailleur mit Jacke. Kragen und Krawatte mit passendem Schal, mit Handschuhen und Tasche**

La robe à transformations:
1. une robe
2. La même robe avec pullover en deux teintes aux tonalités assorties. Ceinture de cuir assortie
3. La même robe en toilette-tailleur avec jaquette, col. cravate et foulard assortis, gants, sac à main

The Transformation Costume: 1. One Dress. 2. The same dress with pullover in two harmonious shades. Leather belt to match 3. The same dress as tailormade, with coat, collar and tie, with scarf, gloves and bag to match

Dasselbe Kleid, über das ein Rock gezogen wird, der an der Seite mit Reißverschluß geschlossen wird. Passender breiter Gürtel. Kleines Cape mit Schmuck

La même robe, sur laquelle est tirée une jupe fermée sur le côté par fermeture-éclair. Ceinture large assortie. Petite pèlerine avec ornement

Dress as above, worn with a skirt closed at the side with patent hookless grip. Broad belt to match. Small trimmed cape

BAUHAUS FEMININITIES IN TRANSFORMATION

FIGURE 3.1. Renate Richter Green (later Ré Soupault) design and drawing, The Transformation Dress (Die Transformationskleid), published in *Die Form: Zeitschrift für Gestaltende Arbeit* 5.16 (1930): 417. 12 x 9.3 in. (30.5 x 23.5 cm). Private Collection. © 2019 Artists Rights Society (ARS), New York / VG Bild-Kunst, Bonn/ Manfred Metzner. The caption reads: "1. A Dress. 2. The same dress with pullover in two harmonious shades. Leather belt to match. 3. The same dress as a waistcoat, with jacket, collar, and tie, with scarf, gloves and handbag to match. 4. The same dress with a skirt over it that is zipped at the side. Broad belt to match. Small cape with jewelry."

TRANSFORMATION

"A dress is not there for its own sake, but to be worn," pronounced Paris-based fashion journalist and designer Renate Richter-Green, writing in the Werkbund journal *Die Form* in 1930. "Today, 90% of all women work, and these 90% need rational clothing…. Life is in perpetual motion. Preferences for line, color, and attitude change, and these penchants also differ for each person. It must be a matter of fulfilling the specific demands of a dress's utility. This is the central problem of today's fashion, fashion for the 90% of women."[1] Richter-Green's solution to these demands was the transformation dress, a simple, beautifully cut, sleeveless sheath that could be combined with a minimal number of elements to fit any occasion the modern woman might encounter (figure 3.1). For work, wear it alone, or add a belt and a sweater; to change up the look, switch those out with jacket, tie, gloves, and matching clutch. And no need to get a new gown for a refined evening event, when you can simply slip a long skirt over the sleeveless sheath and add a cape and jewelry. In total, this one dress could be transformed into ten different outfits. Looking back on how she designed this type of convertible clothing, Richter-Green recalled, "I always started with a concrete idea: a secretary or a saleswoman, etc., who wants to go out in the evening after work, but can't go home beforehand, transforms her dress…. The main requirements were first-class fabric that would stand up to all the stresses, and the cut."[2]

Renate Richter-Green—the *Bauhäusler* better known by her later name of Ré Soupault—was a designer, journalist, filmmaker, and photographer. We have already encountered Soupault in chapter one, where I discussed her engagement with Bauhaus spiritualities and her subsequent invention of a new kind of picture, the film photomontage, in which she deployed new visual technologies and the imagery of women's styles to convey the dynamism of the contemporary moment. With her transformation dress, Soupault reimagined female-coded clothing to match the unfolding life of New Women like herself whose dynamic, modern lives called for the need to adapt quickly and travel light. Affordability was key to her transformational designs, which she also created in a hybrid form of clothing of which she was one of the originators: culottes, also known as the split skirt, which allowed for greater movement. Additionally, Soupault

designed a version of the transformation dress with shorts underneath a sporty skirt that allowed its wearer to go directly from work to a weekend getaway without any luggage.[3]

As with her fashion designs, Soupault's life and work were seemingly in constant transformation. After two years at the Bauhaus, from 1921 to 1923, she moved to Berlin, although she also remained a member of the school, participating, for example, in the 1923 *Staatliches Bauhaus* exhibition; she was not officially removed from the student rosters until 1925.[4] In the capital city, she joined up with circles of fellow *Bauhäusler*, including her friend Werner Graeff, who introduced her to various avant-garde artists and filmmakers, among them Kurt Schwitters, from whom she received her life-long nickname of "Ré." She collaborated on films with two of the now best-known avant-garde filmmakers of the 1920s, above all Viking Eggeling, with whom she was romantically involved and who taught her the craft of filmmaking. In return, she helped him to complete his pioneering abstract *Symphonie Diagonale* (1924) prior to his death. She also shot portions of *Filmstudie* (1926) by Hans Richter, who she married that same year and with whom she befriended other avant-garde artists and filmmakers including Férnand Leger, Man Ray, and Sergei Eisenstein.[5] She soon began working as a fashion journalist and spent her time increasingly in Paris, where she opened her own company, Ré Sport. With her second husband, the French Surrealist poet and journalist Phillipe Soupault, whom she met in 1933, she traveled the world and photographed societies in the grip of ferocious change; she captured Parisian street life, architecture and rural villages in Norway, and Spain on the brink of civil war. Many of her images were published as illustrations for Phillipe's newspaper articles. Accompanied by a Tunisian police escort, she was granted unprecedented access to photograph in Tunis's "Quartier Réservé" or Reserved Quarter, a walled and locked neighborhood of female outcasts, where, in the space of just two days, she produced a series of images that are remarkable for both their empathy and their intimacy (figure 3.2).[6]

When Philippe and Ré Soupault fled advancing Italian and German fascist forces in 1942 by hitching a ride on one of the last buses out of Tunis to the Algerian border, she had to travel light: the Soupaults simply boarded with no possessions at all. This meant abandoning Ré's entire archive of negatives and leaving her camera behind. The loss of the latter may have been painful, but it was vitally important, since fascist forces would have shot her on the spot if they had caught her in possession of one.[7] Effectively stateless exiles for the next years, the Soupaults had no money to purchase her a new camera.

Yet, while the Soupaults were subsequently traveling through the Americas as Phillipe worked to create a network for a news agency for the French Committee of National Liberation, the provisional government under Charles De Gaulle, Ré used a found technology to make a daring

FIGURE 3.2. Ré Soupault, Untitled (double exposed photograph from the Reserved Quarter [*Quartier Réservé*] in Tunis), 1939, gelatin silver print. 10.2 x 10.2 in. (26 x 26 cm). Ré Soupault Archive, Heidelberg © 2019 Artists Rights Society (ARS), New York / VG Bild-Kunst, Bonn/ Manfred Metzner.

self-portrait, a photograph taken in an amusement park in Buenos Aires in 1944. Her expatriate friends, photographer Giséle Freund and screenwriter Jacques Rémy, appear in the background, distracted by someone or something outside of the picture plane (figure 3.3). Glamorous Ré Soupault, by contrast, is singularly focused in the foreground. Her attention appears locked upon the viewer, who, deciphering the image, will soon realize that she is armed and dangerous. Soupault's face is partially obscured, but it's not with a camera—as is the case with so many classic self-portraits of modernist New Women—but a gun that is trained on the viewer.[8] This powerful photograph evokes the violence and uncanny nature of the wartime context in which it was made. It also encapsulates the improvisational spirit fostered by Soupault's contingent situation, for, cameraless though she was, she made it herself. A camera took her self-portrait as a keepsake when the perfect bulls-eye she shot with an air gun triggered the instantaneous award of a "prize": this photograph. While a cursory reading might interpret this as an image of a woman driven to violence, in fact, the photograph captures her mastering yet another mechanized imaging technology so that she could still take a picture at

OBSEQUIO AL BUEN TIRADOR
PARQUE JAPONES
Temporada 1943-44

a time when she had nothing but the elegant and surely transformable clothes on her back. For the duration of the frozen moment captured in this image, she was a photographer again.[9]

I begin this chapter on Bauhaus artists' transformative femininities with Ré Soupault's work because it epitomizes the drive to explore new ways of living and being that was the spirit of Bauhaus New Womanhood. Further, she is of interest in my narrative as a representative case of a multifaceted and highly original Bauhaus artist and member of the international avant-garde who has been unjustly omitted from these movements' histories—but who nevertheless haunts their margins.[10] Soupault's own transformations are also reflective of the dramatic historical events through which she and other *Bauhäusler* lived and that created a range of monumentally shifting circumstances that forced them to react and adapt. In this chapter, I argue that, in their work and lives, many of the female artists and designers of the Bauhaus undertook the continuous if largely unarticulated collective project of actively defining what it was to be a modern woman. They also explored how emerging femininities could best be articulated and lived in the dramatically shifting years of the 1920s through the '40s, in a society recovering from the First World War, emerging as a democracy, and then sinking into National Socialism and another war. These female *Bauhäusler* experimented with art and design to meet what they saw—and often experienced—to be the needs of female consumers; their objects served as assets in New Women's living out of modernity.[11] And several of them turned to photography—a technological and thus modern means of creating visual representations—to explore and define new identities for themselves and each other.

In the previous chapter, I began an inquiry into gendered representation with the figure of the artist-engineer, particularly as it related to Bauhaus constructions of masculinity. In the current chapter, I engage themes of transformation—particularly in design and photography, both fields in which Soupault worked—that were at the heart of the Bauhaus and its projects. As the mainstream view of the Bauhaus is one dominated by male artists, designers, and architects, so too the tendency is to think of the ideal consumer of Bauhaus products as male, or at least not as specifically female. In this chapter, I argue that themes of transformation crop up again and again in a wide array of Bauhaus women's art. Of course, the modular, transformable, and adjustable were key to much of Bauhaus design, but my focus here on Bauhaus women's work reveals a very different agenda, in which these designers and photographers were imagining and meeting new needs for female consumers.[12] *Bauhäusler* of all stripes were well aware of interwar working women's increased purchasing power and their shifting status as they redefined female identity as members of a new democracy that, for the first time in history, recognized them as equals to their male fellow citizens.

The argument in this chapter is not merely that the Bauhaus fostered

FIGURE 3.3. Ré Soupault, Self-Portrait, Buenos Aires, January 31, 1944, gelatin silver print. 5.3 x 3.3 in. (13.5 x 8.5 cm). Ré Soupault Archive, Heidelberg © 2019 Artists Rights Society (ARS), New York / VG Bild-Kunst, Bonn/ Manfred Metzner.

the work of those designing for the significant sector of female consumers in the emerging interwar market, but that Bauhaus women offered a particular take on modernity. As I demonstrate in this chapter's first half, they often became experts in adaptable design that was oriented towards an imagined positive future and that could respond to the opportunities and uncertainties of modern life. The Bauhaus's effectively higher admission standards for female students meant that it drew a particularly strong crop of women who navigated life and work at a school that by turns fostered their creativity and held it in check. Likely in part because of their overall exceptional qualifications and perhaps also as a response to the challenges that they faced at the Bauhaus, female *Bauhäusler* constituted a generation of highly adaptable artists and designers who often shifted easily among an array of media that they simply saw as the means to a diverse range of ends. Like Ré Soupault, many Bauhaus women developed a penchant for transformable or modular design, creating signature modernist objects and spaces.

Bauhaus women also explored new constructions of self, as I demonstrate through the photographic and photomontage work of Marianne Brandt and Gertrud Arndt—to which I turn in the chapter's second half. In particular, both used photography to explore their own identities as multiple, shifting, and emerging, and they both drew on images of traditional femininity to define and probe their new identities as female *Bauhäusler*. But these two women's projects also diverged dramatically: one embraced the Bauhaus's constructive and future oriented ethos, and the other rejected it out of hand.

Despite the preponderant embrace of futurity by the female artists and designers whose work is explored in this chapter, their collective Bauhaus femininities are also haunted by futures foreclosed upon by both historical events and the structures of sexism that persisted even within this visionary institution and certainly outside of it. It is the complex topic of gender and sexism at the Bauhaus that I tackle in the next section of this chapter. Despite the odds stacked against them, as I argue, these transformative femininities were intrinsic components of a larger conversation in which design and representation were purposed as experiments in the possible.

WOMEN AT THE BAUHAUS

The enormous range of vibrant artistic contributions made by the over 450 female *Bauhäusler* throughout the fourteen-year existence of this 1,253-person movement is plain to see in archives. However, until recently, mainstream accounts of the school have most often failed to acknowledge the significance of Bauhaus women's work either on its own or in relation to its impact on the institution. This is even true where logic might dictate otherwise, as in the case of the record set for the highest price ever paid at auction for a Bauhaus object, Marianne Brandt's model number MT 49

FIGURE 3.4. Photographer unknown, Walter Gropius with Bauhaus Masters on the roof of the Dessau Bauhaus building on the occasion of its opening, December 4th or 5th, 1926, gelatin silver print. 7.1 x 9.4 in. (18 x 24 cm). Bauhaus-Archiv Berlin. From left to right the photograph shows: Josef Albers, Hinnerk Scheper, Georg Muche, László Moholy-Nagy, Herbert Bayer, Joost Schmidt, Walter Gropius, Marcel Breuer, Wassily Kandinsky, Paul Klee, Lyonel Feininger, Gunta Stölzl, and Oskar Schlemmer.

tea-extract pot, which sold in 2007 for $361,000.[13] It is not only the art market that has placed a high value on this object; Bauhaus-Archiv curator Klaus Weber called it "Bauhaus in a nutshell," for its perfect encapsulation of the principles of modern design.[14] And yet Brandt's name is still only occasionally included in mainstream accounts of the school. When it is, she most often stands as the single woman, included seemingly as a token gesture.[15]

The fact that women have been relegated to the margins of Bauhaus history is consistent with aspects of the institution in its own time, despite its auspiciously inclusive beginnings. In 1919, Gropius had founded the Bauhaus with the proclamation that it would make, "no distinction between the fair and the strong sex."[16] Accordingly, in the school's first semester, the balance exceeded parity, with women outnumbering men, eighty-four to seventy-nine, a configuration that would never again occur during the institution's existence.[17] Instead, the proportion of female students to male decreased starkly over time.[18] This is surprising given that, after the profound losses of the First World War, there were significantly fewer young men alive and well enough to attend art school; female

applicants were simply available in greater numbers.[19] The reason for the Bauhaus's shift from a female- to male-dominated student population is simple: afraid that charges of "dilettantism" might be levied against an art school with a significant proportion of women, early in the life of the institution, Gropius took clear steps to curtail the number of women admitted.[20] The minutes of a masters' council meeting held in February of 1920, less than a year after the Bauhaus's start, record the following statement: "In order to fill the first few places in the workshops with the most qualified, Gropius recommends proceeding as strictly as possible with the acceptances, and above all to ensure that the female element gradually takes up no more than one-third of the spots."[21] That Gropius and the other Bauhaus masters would have taken such a step backwards from the enlightened gender politics of the Weimar Republic seems hardly in keeping with the Bauhaus's reputation as progressive by almost any measure— particularly in its design and pedagogy, of course, but also in its ideas about reform and the role of art in society. And this step would have had to be keep secret, since, under the new republic's laws, women were guaranteed the same access as men not only to the vote, but also to education and all aspects of public life. Further, although the official 1921 statutes

FIGURE 3.5. Lux Feininger, Sport Classes at the Bauhaus, Women's Gymnastics on the Bauhaus Roof (Sportunterricht m Bauhaus, Gymnastik der Frauen auf dem Dach des Bauhauses), 1930, gelatin silver print. 3.4 x 4.5 in. (8.5 x 11.5 cm). Bauhaus-Archiv Berlin © Estate of T. Lux Feininger.

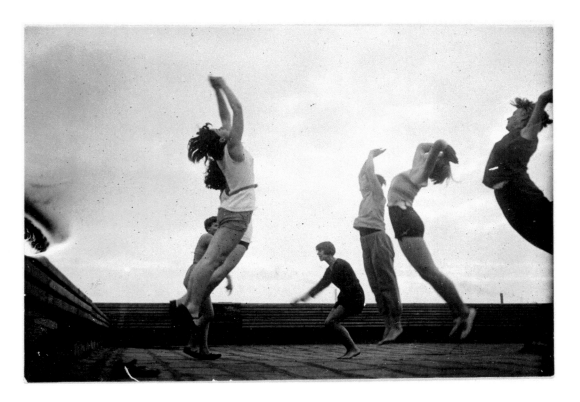

of the Bauhaus stated clearly that students could select the workshop of their choice for specialization, already starting with that February 1920 meeting, most female students were strongly encouraged to go into the weaving workshop, which was dubbed for a brief period "the women's class."[22]

An official photograph that offers a kind of graphic of women's status at the school was taken in December of 1926, just as the Dessau Bauhaus officially opened. In this group portrait of Bauhaus masters posed together on the building's roof, weaving-workshop head Gunta Stölzl (second from furthest right) stands as a bold example of Bauhaus women's modernity and progressiveness with her bobbed hair and fashionable clothing (figure 3.4). Stölzl also appears rather diminutive next to her neighbors Lyonel Feininger and Oskar Schlemmer, the masters of the printing and theater workshops respectively, and the latter a friend and supporter of hers. But not only is she off to the side, she is flatly outnumbered by her male colleagues, twelve to one. The Bauhaus might have publicly stated that women would be treated equally, but this official photograph of the school's faculty, with its single woman shunted aside, suggests otherwise. Historical documents seem to support this view; they show that Stölzl was given an inferior title for the same work and received less pay than her male counterparts—even once she too received the title of junior master.[23] This picture leaves little doubt that women's promised equality was not achieved at the Bauhaus.

In her book *Ghostly Matters*, an influential critique of her own home discipline of sociology, Avery Gordon writes precisely about those who have been lost or disappeared from a discipline in which representation and visibility are at the heart of scholarly inquiry.[24] Art history is, of course, similarly defined by the visible, not only as a history of pictures, but in that the range of its objects of study is often delimited to that which appears in the blockbuster exhibition, the long-term display in a famed museum, or the survey textbook. Writing against postmodernism's tendency to simplify, reduce, and totalize, Gordon's notion of haunting is not only a way of engaging those "who are meant to be invisible [yet] show up without any sign of leaving." More broadly, this haunting describes a paradigmatic way in which life, particularly modern life, "is more complicated than those of us who study it have usually granted," since "visibility is a complex system of permission and prohibition, presence and absence...."[25]

And the truth of the matter is that the Bauhaus simply *was* more complicated than the now iconic official photograph on the roof implies; one just has to look at different pictures and objects to see that. Three-and-a-half years later, the same location—the roof of the Dessau Bauhaus—played host to the women's gymnastics course, likely a regular event there (figure 3.5). On this occasion, Bauhaus photographer T. Lux Feininger was present to capture multiple pictures of these young women as they leapt and tumbled under the guidance of modern dancer Karla Grosch,

Mädchen wollen etwas lernen

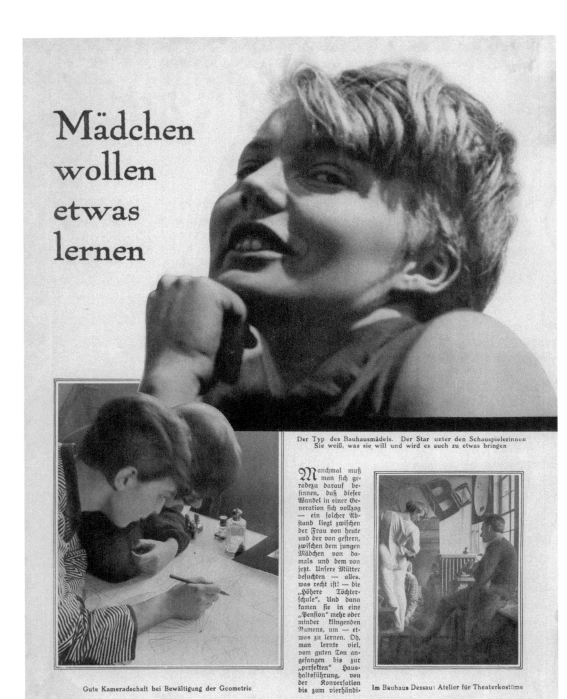

Der Typ des Bauhausmädels. Der Star unter den Schauspielerinnen
Sie weiß, was sie will und wird es auch zu etwas bringen

Gute Kameradschaft bei Bewältigung der Geometrie

Im Bauhaus Dessau: Atelier für Theaterkostüme

Manchmal muß man sich geradezu darauf besinnen, daß dieser Wandel in einer Generation sich vollzog — ein solcher Abstand liegt zwischen der Frau von heute und der von gestern, zwischen dem jungen Mädchen von damals und dem von jetzt. Unsere Mütter besuchten — alles, was recht ist! — die „Höhere Töchterschule". Und dann kamen sie in eine „Pension" mehr oder minder klingenden Namens, um — etwas zu lernen. Oh, man lernte viel, vom guten Ton angefangen bis zur „perfekten" Haushaltsführung, von der Konversation bis zum vierhändi-

the Bauhaus instructor for women's gymnastics, pictured arcing her body through the air at the image's far right. These women's uninhibited movements and their practical and relatively minimalistic clothing suggest just how comfortably they could own this space. Indeed, in a manner of speaking, they "jump over the Bauhaus," as Feininger titled his better-known picture of athletic male *Bauhäusler* that likely was taken on the same day.[26] Like the picture of the Bauhaus masters, this photograph of leaping female *Bauhäusler* can also be read as an illustration of a different set of facts; while many have assumed that most or all women were pushed into the weaving workshop, recent research has revealed that they were present throughout the Bauhaus in every workshop and program—albeit in limited numbers in some cases, and with evidence of at least some hazing by male colleagues.[27]

The young, smart, skilled, and independent *Bauhäuslerin*, or female Bauhaus member, also became a visual *type*, one that was at times useful to the institution and its members, not least in representations of them made by famed Bauhaus painter Paul Klee.[28] Images of *Bauhäuslerin* appeared frequently in press coverage of the school, as in a photo essay illustrated with further photographs by Feininger that was printed in the prestigious and high-circulation illustrated journal *Die Woche* (The Week) in 1930 (figure 3.6). Next to the headline "Girls Want to Learn Something," Karla Grosch appears, pixy like. Under her photo is a caption that makes clear she is to stand in for all Bauhaus women: "The Bauhaus-gal type. The star among the actresses. She knows what she wants and will get it."[29] Over time, the "female element" at the school really was reduced—to use Gropius's term from that February 1920 masters' council meeting, where they decided to cut back on admitting women. The evidence suggests that, as women at the school became fewer in number, they were also seen as less of a threat, which could account for their playful presence in pictures from the school.

In addition to the facts I have assembled here—that Bauhaus women permeated the institution and that their images helped define the school's modernity—there is something else to bear in mind about the presence of women at the Bauhaus: from a design and financial perspective, having them there paid off. This was surely in part because the women who managed to secure admission to the Bauhaus did so under more stringent admission standards than their male counterparts, so that, generally speaking, those admitted women were exceptional; certainly, the strength and innovation of their work reveals them to have been thus. Regardless, aspects of the Bauhaus in which women were particularly involved often proved financially viable and helped to support the school, far from a small matter for a new art school trying to establish itself in the context of the perennial financial instability of the Weimar Republic. Significant income came into the school through the weaving and metal workshops—the latter during the two years that Marianne Brandt handled that shop's business

FIGURE 3.6. "Mädchen wollen etwas lernen" ("Girls Want to Learn Something") *Die Woche*, 32.1 (January 4, 1930): 30; newspaper clipping, 7.2 x 8.7 in. (18.2 x 22 cm). Private collection. Photographs by T. Lux Feininger, Fotografie DEPHOT (Deutscher Photo-Dienst, Berlin) © Estate of T. Lux Feininger.

affairs first as its associate (*Mitarbeiterin*) and its acting head (*stellver-tretende Leiterin*). Bauhaus wallpaper designs, about one-third of which were created by Margaret Leiteritz, also produced a substantial revenue stream for the Bauhaus starting in 1929.[30] Certainly sales or income for the school are not the only or necessarily the best way to evaluate the worth of Bauhaus objects. But it is significant that, in the Bauhaus's day, female designers achieved one of the key goals of the school, measurable movement towards its financial self-sufficiency. Given this, as well as their participation in all parts of the school, for Bauhaus women's names to be almost totally omitted from its histories, while perhaps understandable in the context of earlier historiographical cultural and gendered biases, is now untenable.

BAUHAUS WOMEN'S TRANSFORMATIVE DESIGNS: MARIANNE BRANDT, ISE GROPIUS, AND FRIEDL DICKER

Despite experiencing some adversity at the Bauhaus, the school's women mastered new ideas and technologies in order to create functional designs and modern spaces, as the following look at the work of Marianne Brandt, Ise Gropius, and Friedl Dicker demonstrates. Multifunctionality was a sought-after quality in interwar modern design, and not only by Bauhaus female designers. It was necessitated by modern urban settings where space was at a premium, and the post-war housing shortage meant that building small offered the promise of meeting the necessity of housing more people at lower cost.[31] Pairing smaller apartments with smart, multi-functional design offered consumers the possibility that these small places would not merely suffice, but that they would serve multiple purposes and thus be in some ways superior to the grand homes that were beyond the reach of most. Multifunctionality could also serve as a sign of luxury, where a space could transform beautifully from one use to another. And in this ca-pacity, another essential quality comes to the fore: transformability served as a kind of short hand for modernity itself, for the well-designed object that epitomized the times. While multifunctional and transformable design was far from a specifically female domain, a responsiveness to specific changes in women's lives was a hallmark of Bauhaus women's designs, as evidenced in the case of Ré Soupault's transformation dress. These gambits offered a new take on women's everyday both within the school and outside of it. And these female designers' adaptable skill sets proved able to accommodate a range of needs, including shifting ideological ones, and inform responses to unforeseen political realities that would emerge particularly once the Bauhaus closed.

Lamps by Marianne Brandt—designed alone or in partnership with her colleagues from the metal workshop—hung throughout the new Bau-haus building in Dessau, completed late in 1926. Photographs of the airy spaces of the weaving workshop show it filled with rows of nickel-plated,

adjustable-height, overhead lights, designed by Brandt and her workshop colleague, Hans Przyrembel.[32] Created in response to the still relatively new availability of electricity, these lamps were functional, practical, and recognizably modern. Further, with a weighted pulley system that made their height easily adjustable, they served multiple purposes.[33] The lamps' flexibility was important to the Dessau weaving workshop which, while still stocked with hand looms for teaching the craft of weaving, had moved to designing for mass production, along with the rest of the Bauhaus. Lamps such as these could be raised to create general lighting throughout the workshop, or lowered for the more concentrated, specific light required by design work.

Outside of the metal workshop, other Bauhaus women were also instrumental in imagining Bauhaus spaces that modeled methods for living in a modern way to a broader audience. Even Ise Gropius, Walter Gropius's second wife, who is not remembered as a designer, made important contributions on this score. As Mercedes Valdivieso has shown, Ise Gropius arrived as a new bride at the Bauhaus and, quickly adapting to the role of the director's wife, became Walter Gropius's closest collaborator; she was central to the school's management and for establishing its reputation, since she served as its unofficial publicist and diarist. When the Bauhaus was forced out of Weimar, Ise Gropius even had a hand in securing its new home in Dessau as a part of the team that negotiated with Fritz Hesse, Dessau's mayor.[34] She was well versed in the contemporaneous literature on modernizing the home, and when it came time to design the interiors of the Gropius master's house in Dessau in 1926, it was she who took on the project.[35] She later recalled,

> Endless search for objects for the kitchen, which I designed myself with much effort, since modern kitchens in Germany did not yet exist. There was hardly anything on the normal market that could have satisfied our modern requirements, both technical as well as aesthetic. At this point, at the suggestion of my husband, I began to look through strictly technical and scientific production sites, which satisfied us more often than those goods that were produced specifically for the household.[36]

When the house was completed, it was Ise Gropius who particularly shaped its reception by giving tours of it to journalists and women's groups; she also worked in the house with the film crew shooting the documentary film *Wie wohnen wir gesund und wirtschaftlich?* (How Do We Live Healthily and Affordably? 1926–1928). The film profiles the new kitchen as a kind of technological machine with its female operator, in this case a bobbed-haired maid, as she uses industrial fittings brought home to improve daily life (figure 3.7). As the film seeks to show, this modern, highly functional space is worlds away from the dark,

abb. 115 wohnungen der bauhausmeister
spüle des einzelhauses gropius
heißwasser-soda-dusche; geschirrkorb; tellerabtropfregal

humboldt-film / berlin

disorganized kitchens with their wood- or coal-fired stoves in which most women worked. Walter Gropius clearly approved, for he selected stills from this film—montaged together to suggest that they came from a single strip of film—to show off the kitchen in his 1930 book on the Dessau Bauhaus buildings, thus evoking a new form of visual presentation to capture a key element of modern living envisioned and designed by his wife. Yet, for all its modernity, it must also be stated that this was a luxury kitchen that few could afford at the time. As Robin Schuldenfrei has pointed out, the film shows "a uniformed maid at work washing dishes or putting them away in the convenient pass-through cupboards…while Ise Gropius drinks tea with friends in the living room 'tea corner.'"[37]

In addition to designing modern objects, a number of Bauhaus women became architects, literally transforming the built landscapes around them. Friedl Dicker, also known as Dicker-Brandeis after her 1936 marriage, was a member of the early group of Bauhaus students who came to the school in 1919 with Johannes Itten. Dicker was seemingly able to design and make anything; she worked in weaving, book binding, painting and drawing, photography, stage-set and costume design, and interior and exterior architectural design. She is best remembered for her work in the Theresienstadt ghetto and concentration camp, where she taught over 500 children, in part using Bauhaus methods to connect hand and spirit that she had learned from Itten and Gertrud Grunow.[38] In Theresienstadt, Dicker-Brandeis's aim was not, however, to help the children to connect to their historical moment; rather, she sought to enable them to escape from it for a while. Ultimately, she was murdered at Auschwitz.[39]

Long before her tragic last years, however, Dicker was part of a Bauhaus design duo that created visionary architecture and interior design, together with Franz Singer, with whom she had studied first with Itten in Vienna, and then at the Bauhaus. For a time, they were romantic partners. Among other achievements, their 1922 collaboration on plans for a building with four apartments is the earliest documented flat-roofed design in which a female Bauhaus student is known to have participated.[40] Writing in his 1931 survey text on nineteenth- and twentieth-century art and design, art historian Hans Hildebrandt praised the pair's "…rationalization of interior architecture and furniture that unites the highest degree of practicality and economy with pure, noble, forms derived entirely from their function."[41] There is rich documentation of the duo's multifaceted work, which was completely of the moment, especially once they returned to Vienna and, in 1926, opened their business, Atelier Singer-Dicker, a firm for architecture, interior, and fashion design.

Multifunctionality was a hallmark of Atelier Singer-Dicker, with convertible furniture and multi-use spaces, and even toys, such as their ingenious Phantasus toy kit from 1925. This collection of colorful shapes could be used to create animals (rabbit, giraffe, seal, and cat) and other forms (locomotive, wheelbarrow, or box), according to a child's fantasies.[42] More

FIGURE 3.7. Humboldt Film, Berlin, *bauhaus masters houses (wohnungen der bauhausmeister)*, film stills reproduced in Walter Gropius, *Bauhausbauten Dessau* (Fulda: Parzeller, 1930) [125]. 9.8 x 6.9 in. (25 x 17.5 cm). The caption reads: "kitchen sink of the gropius detached house / warm water – soda – rinse; drainer; plate-drainer shelf."

elaborate than Alma Siedhoff-Buscher's 1923 Bauhaus toy set, Phantasus is a precursor to the interactive building sets like Lego that would only go into production after the Second World War.[43]

Dicker and Singer's design aesthetic was unique in Vienna, a distinction that also attracted international clients and gave them the scope to take on projects further afield: Berlin, Prague, Tsilna, and Budapest. Their colorful and dynamic rendering of a site plan for a tennis club—represented with courts, colorful, flat-roofed buildings, and even the nearby streetcars zipping by—gives a sense of new urban leisure space as relaxing and fun.[44] Their clients, members of the intellectual bourgeoisie,

FIGURE 3.8. Atelier Singer Dicker (Franz Singer and Friedl Dicker), Living Room in the Guesthouse of Countess Heriot, by day and by night, Vienna, 1932–34, two gelatin silver prints mounted on cardboard. 7.9 x 14.9 in. (20 x 14.9 cm); upper photograph 3.3 x 5.9 in. (8.4 x 13.6 cm), lower photograph 3.4 x 5.9 in. (8.7 x 13.6 cm). Georg Schrom, Vienna. Reproduced with permission of D Singer.

embraced the design duo's overt modernity.[45] A particular specialty of the firm was its convertible furniture and interior design, so that, to take a straightforward example, a built-in upholstered bench could be turned into a guest bed. But their designs incorporated much more complex transformations as well. Their stunning modernist guesthouse in Vienna for the Countess Heriot was outfitted with two main guest rooms, each of which could be transformed from a sunlit living room into a bedroom for a family (figure 3.8).[46] In the larger of these guest quarters, by day, an elevated platform breaks up the room into a grander reception space and a cozy corner for meals and a desk. By night, the stairs to the platform retract, and a double bed rolls out from under it, complete with built in nightstands. This luxurious and futuristic space epitomizes Dicker and Singer's creative and flexible modern design.

After seven highly productive years, in early 1931 Dicker and Singer closed their Viennese firm, in part because Dicker appears to have decided to dedicate herself to teaching and political work. With the global economic crisis that began with the New York Stock Market crash of 1929, Vienna, as with much of Europe, experienced a growing political polarization, and Dicker became a left-wing activist and a

FIGURE 3. 9. Friedl Dicker, *Abundance of Goods/ Sales Crisis: The Bourgeoisie are Becoming Fascist* (*Warenüberfluss/Absatzkrise: Das Bürgertum faschisiert sich*), undated, c. early 1930s, two photographs of a destroyed work in photomontage and collage. 10.7 x 7.1 in. (27.3 x 18 cm) each. © University of Applied Arts Vienna, Collection and Archive.

member of the Communist Party.[47] She again transformed herself as an artist and began making highly political photomontages, works that drew on the visual vocabularies of John Heartfield and László Moholy-Nagy. *Abundance of Goods/Sales Crisis* (*Warenüberfluss/Absatzkrise*) decries the injustices of class divisions in a dynamic and monumental photomontage that centers on the powerful but helpless form of a laborer and his starving child (figure 3.9). Around these tragic figures, photographic fragments highlight the senselessness of mass-producing weapons in a society that cannot feed all of its citizens. Stenciled letters spell out praise for the Soviet Union and criticize Dicker's Austrian contemporaries; "the bourgeoisie are becoming fascist," the montage observes bitterly. Dicker was committed to the cause, but in 1934 she was arrested, interrogated, and imprisoned, and it was Singer who helped secure her freedom. She fled to Prague but, before she left, she destroyed her photomontages, which, because of their unabashed leftist and pro-Soviet politics, had become a danger to anyone who might possess them. An artist with seemingly no end to her technical skills, Dicker had studied photography in Vienna before joining the Bauhaus. Her political pictures thus survive only because she was able to document them photographically prior to their destruction.[48]

From these female *Bauhäusler* who adapted their art and design to changing historical circumstances, I turn now to focus on two very distinct oeuvres of photographic self-portraiture that were both produced in Dessau, one by Marianne Brandt, the other by Gertrud Arndt. I contend that these Bauhaus women's solitary experiments in transforming their own faces and bodies were meaningful responses to an institution that both enabled and hindered their development as designers. These photographic self-portraits have a ghostly quality in their picturing of isolated women in Bauhaus spaces—women whose stories now haunt Bauhaus history itself. As I will ultimately argue in this chapter's conclusion, it is now time to finally bring these and other female *Bauhäusler* into the mainstream historiography of the school and, by doing so, to enhance our understanding of what "Bauhaus" looks like and means. The two sets of photographs that I turn to next might seem a surprising place to push forward a process of redefining "Bauhaus," for both oeuvres are magnificently weird. However, they both also have a particularly practical aspect: made at moments of intense change in these two women's lives, they were a means of exploring their own, individual identities that were still in the process of becoming.

EXPLORING THE SELF IN TRANSFORMATION: MARIANNE BRANDT AND GERTRUD ARNDT

Like their masculine counterparts, women at the Bauhaus lived identities that were just emerging and not always articulated in words. They had a

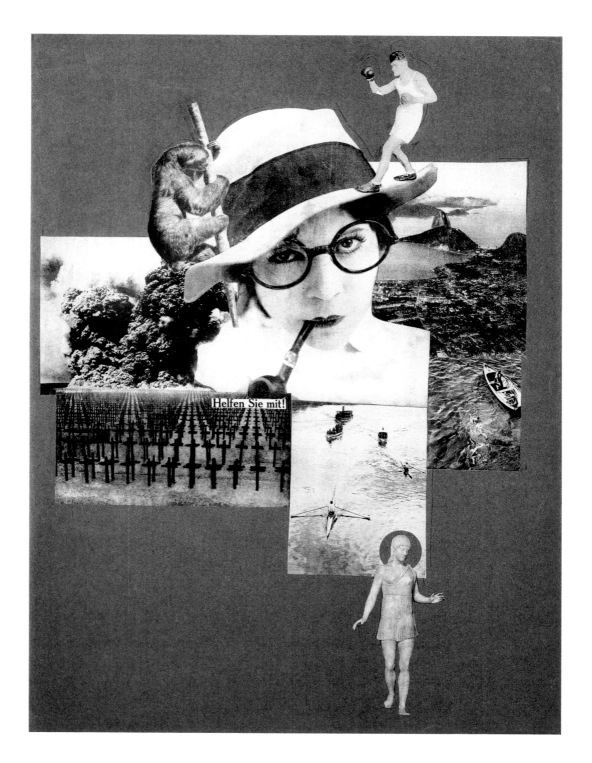

Text in image: Helfen Sie mit!

wide range of experiences and goals and explored the limits of what was possible in anti-conventional living in this post-First World War society. To be clear, there was no one, single, "Bauhaus femininity." In the collective project of exploring new ideas and possibilities, a number of Bauhaus women used cameras to explore just who they were becoming and to picture the process of change itself. Brandt and Arndt offer rich examples of Bauhaus women's exploration of identities that point in very different—almost contradictory—directions.

Over the course of her five and a half years at the Bauhaus, Brandt's identity as an artist shifted dramatically. She came to the school in 1924 as a trained painter, but she moved away from representation definitively by burning her earlier work in 1926.[49] Henceforth, it was through photomontage and photography that she continued to investigate the visible world—without recourse to paint and canvas. These media appealed particularly to Brandt and her contemporaries because they were overtly modern, machine-based, and devoid of the usual associations with fine art—such as the trace of the artist's hand or the unique nature of the individual object—that they deemed passé.[50] Brandt was prolific in the medium of photomontage. Having initially tried it in Moholy-Nagy's preliminary course, she turned to photomontage as her primary form in 1926 while on sabbatical from the Bauhaus in Paris; in total, there are over forty known works by her made during the Weimar Republic.[51] The magazine-snippets of her photomontages were culled from the rich visual archive of contemporaneous popular media culture. Advertisements, illustrated newspapers, and film journals proliferated in the interwar period, offering lively pictures not only in black and white, but sepia and other tints too.

Brandt's photomontages most often explore the dynamic imagery surrounding the New Woman, the imagery of which had developed hand in hand with the incipient media cultures and the quest for women's rights of the nineteenth century. By the interwar period, this type came to dominate global visual culture through the cinema, illustrated journals, and photography.[52] The New Woman was associated with speed—fast fashion and loose morals—and thus with progress, but she was also fundamentally identified with appearance as such. Films and novels frequently revealed her modernity as either a transitory phase or as an only superficially new embodiment of traditional negative female stereotypes including materialism and licentiousness. Like many of her contemporaneous female artists, photographers, and photomonteurs, including Hannah Höch, Germaine Krull, and Marianne Breslauer, all of whom had insider knowledge of the experience of being New Women, Brandt tended to represent this type in relation to her struggles, desires, and other, more complex aspects of interwar life.[53]

Brandt's *Help Out! The Liberated Woman* (*Helfen Sie mit! [Die Frauenbewegte]*) photomontage of 1926 is typical in that it centers on a clear, central protagonist, a New Woman who confronts the viewer's gaze

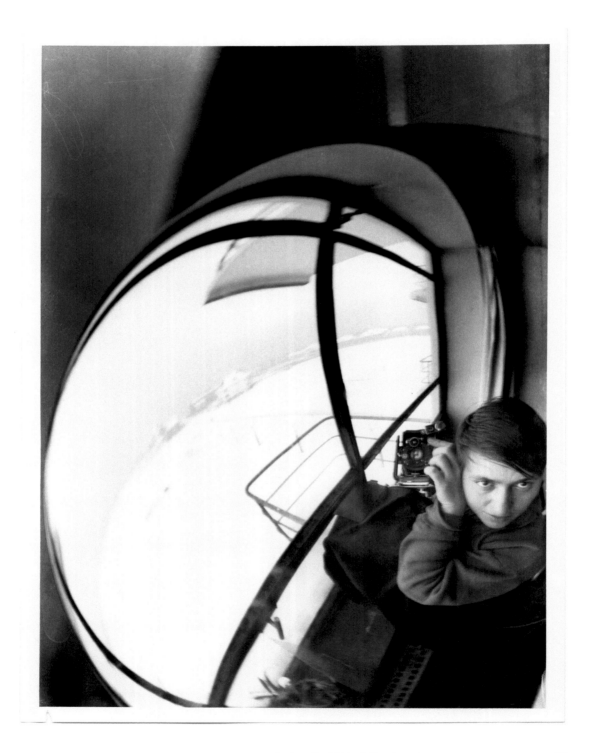

and provides a figure of identification (figure 3.10).[54] This figure is situated in an array of dynamic scenes culled from the period's illustrated journals that are ordered through a complex visual logic in which juxtaposed elements echo and rhyme visually but are jarringly disparate in their meaning and content, a strategy typical of Brandt's photomontage work. Square cutout pictures of land and seascapes flow almost seamlessly into one another and up to the same horizon—despite the fact that their scale and content clash jarringly. These oppositions and contrasts in content create unresolved visual dialectics related to the quandaries of the modern era. This New Woman's pipe exudes what sounds like a political call to arms—"Help Out!"—but, like the boxer on her hat who spars with a sloth, it is unclear what this individual could accomplish in the face of the dramatic landscapes that unfold across the page and, at the left, go up in the smoke of a massive explosion. In the end, the New Woman in *Help Out!* presents the dynamism and danger of her own time but appears unable to enact positive change. The work reveals Brandt's mastery of intuitive visual harmony that, through its contradictory and dialectically opposed content, creates a new kind of picture.

Brandt had learned photography prior to coming to the Bauhaus, but as a student of Moholy-Nagy she took a new, modernist approach to the medium. Brandt created a substantive body of photographic work; at least one hundred photographs can be securely attributed to her Bauhaus period.[55] This medium resonated with her work as a designer of metal objects whose flawless, reflective surfaces mirrored the modern world around them. Like polished metal, photographic film captured light and shadow, but photography fixed these fleeting traces so that they could be reproduced as positive prints in serial production. This quality too made photography akin to Brandt's metal designs, which were intended for mass production as part of Gropius's plan for the Bauhaus to become self-supporting.

In the previous chapter, I offered Brandt's double-exposed photographic self-portrait from 1930 or '31 as a complex and successful example of a representation of a female artist-constructor (figure 2.7). But this was not her first foray into exploring her identity as this new kind of technologically savvy designer. Two years earlier, in the winter of 1928 to '29, while she was acting director of the metal workshop and thus one of the highest-ranking women at the school, and during what would be her final year at the Bauhaus, Brandt created a very different series of photographic self-portraits.[56] This series was largely unknown until a cache of her negatives came to light in East Germany a half-century after their making. Among them are six photographs that she took in her studio in the Dessau Bauhaus's Prellerhaus wing. Each shows her reflected in a metallic-coated glass ball, so that her face and body are imaged through metal, the material of her revolutionary designs. This use of a reflective ball in modernist and Bauhaus portraiture was an established trope by

the time of Brandt's portrait series.[57] But in Brandt's use of the form, the photographs function like snow globes to reflect, capture, and encapsulate a distorted version of her Bauhaus world.

In one of these portraits, Brandt poses with her camera next to her face; she shows herself as technologically competent but also bright-eyed and childlike, an androgynous imp who peers in from the side of the picture plane (figure 3.11). The photograph centers on a play of contrast and form, as reflected elements of a snowy landscape and the Gropius-designed Bauhaus building curve across and are transformed and softened by the metallic ball's surface. This photograph's composition requires engaged viewing to interpret it. It can be read either as a direct, two-dimensional image of a woman and her camera surrounded by a series of curved and straight structures, or it can be viewed in all of its depth, as a distorted reflection cast on the surface of a metallic ball suspended from a thin, out-of-focus string at the top of the image. If perceived in this latter mode, the viewer realizes that she is looking not simply at a photograph, but into a mirror, a perception that evokes the uncanny sensation of standing in the place where the artist once stood. This is an effect common to photographic self-portraits made with a mirror, but Brandt's use of a round reflective surface disorients and thus destabilizes easy identification on the part of the viewer, or a too simple reliance on photography's "truth claim."[58] If we indulge this interpretation, the picture might give the viewer the eerie sense that Brandt, the clever constructor, is watching mischievously as interpretations of this image play through the viewer's mind. It thus evokes an otherworldly presence in a manner akin to the Bauhaus spirit photographs I discuss in chapter one. The photograph also serves as a kind of picture puzzle (*Bilderrätsel*), the device that Sigmund Freud evokes as akin to the structure of the dream; it can only be understood through associative exploration, and does not have a single solution.[59]

The creation of this and all of the photographs in this series required both skill and a willingness to leave some elements to chance in the interactions among the artist, her environment, and the camera. Brandt worked with a Rolleiflex, a camera with its viewfinder on the top that is usually held at chest height when in use. The photographer composes by looking down into the camera, where she can see her composition upside down and backwards. By contrast, in this photograph, Brandt has the camera next to her head, and the viewfinder was of no use to her. Most likely she deduced its proper aim by looking for her own reflection in the camera's lens, mediated through the metallic ball's surface. She meets the camera's gaze with her own and, as in the metal workshop, takes a machine and the metal surface as her collaborators.

A second image from this series positions Brandt's reflected face and head as one of several round objects in a row (figure 3.12). To take the photograph, she placed the camera behind her and took the

picture with a hand-held shutter release. The image is a curious mixture of objects photographed directly by the camera—striped and textured fabric, corrugated paper, and even, at the lower left, an out-of-focus smudge of Brandt's hair—and other elements that were first reflected in the ball's metallic surface before they were captured on film, including the environment of Brandt's atelier and, positioned on top of a Marcel Breuer stool, the camera itself. At the center of this swirling field of crisp textures and black, white, and grey tones, Brandt's face appears in direct proximity to the camera. This composition thus echoes the *Tempo, Tempo!* photomontage that I discussed in the previous chapter, in which spiraling elements center around the artist-constructor and his machine (figure 2.6). In the photographic self-portrait, the large metallic globe creates an altered reality, a view through the looking glass as in *Alice in Wonderland*. Small details close to the camera, like the weave of the cloth, appear large; other items that we know to be much larger—the artist's head or the camera stand—seem tiny in the distorted distance of the reflective surface. Diminutive though she may be, Brandt stares out at us, a creature of the metal surface upon which her face has been transferred. Throughout the series, Brandt's face is a constant, but her body is not, an indicator of the difficulty of integrating a female body into the visual tropes of Bauhaus modernity that Brandt is testing. Often these photographs either diminish her body through distortion, as in the previous photograph, or they hide it from view, as in this one.

A final example from this series takes on this issue of the represented female body directly—in relation to both traditional, modern, and even Bauhaus tropes of femininity (figure 3.13). The entire composition of this self-portrait plays out in the reflective sphere, which is otherwise framed by the stark architecture of Brandt's Bauhaus studio in the picture's background. This time, Brandt shows herself in full if also in miniature; dressed in white, she stands out against a dark background. She reclines on the studio's built-in couch-bed and looks up into the reflective globe to meet the viewer's gaze with a "come hither" look, a pose that recalls the long tradition of the reclining female nude. Her hair is sleek, her face made up, and she appears in a high-fashion, fancy dress with its skirt hiked up to show off her legs, clad in white stockings and high heels. The camera peeks around the corner above her head, but it blends in with items from the background, so that it is hidden in plain sight. Thus, the closed circuit of the other images—in which camera and metallic surface clearly reflect each other—potentially remains open here. Brandt appears all the more as a figure within the sphere who gazes out at the viewer.

This self-portrait also evokes and seemingly ironizes key stereotypes of the New Woman that reduce her modernity to superficial fashion and posit her as a creature of commercial and media culture—the latter evoked by the magazine displayed prominently next to her. So what does the modern, sexy, Bauhaus New Woman read in her leisure time? Why, it's the most recent issue of *Bauhaus*, the school's in-house journal, of course![60] The magazine appears as if in a playful product placement in keeping with the period's growing sophistication in advertising.

This, however, is not just any issue of *Bauhaus*; specifically, it is number one of 1929 and contains Brandt's only published essay of her Bauhaus period, "bauhaus style." In it, she defends the members of her workshop against an accusation made by constructivist sculptor Naum Gabo in the journal's previous issue, namely that they were merely interested in creating an aesthetic style. Gabo called for the workshop to embrace constructivist and scientific design principles rooted in efficiency, necessity, and truth to materials.[61] Brandt's response took the form of a letter to Ernst Kallai, the Hungarian art historian who had recently been hired by Hannes Meyer to edit the *Bauhaus* journal. She details the workshop members' scientific approach and explains that their objects' forms were in fact driven entirely by practicality and necessity. "While we may not have invented the electric light bulb," she writes, "we have never-the-less endeavored to find a proper application of its essence and, for example, to liberate it from forms like the candelabra and the gas lamp, adopted without consideration for utility."[62] Within the context of the Bauhaus community, displaying this copy of *Bauhaus* referred clearly to Brandt's ideas that style for its own sake should never dominate design, but must always be determined through utility and technical necessity, so as to be of its own time—ideas that could be applied to objects but also to her own

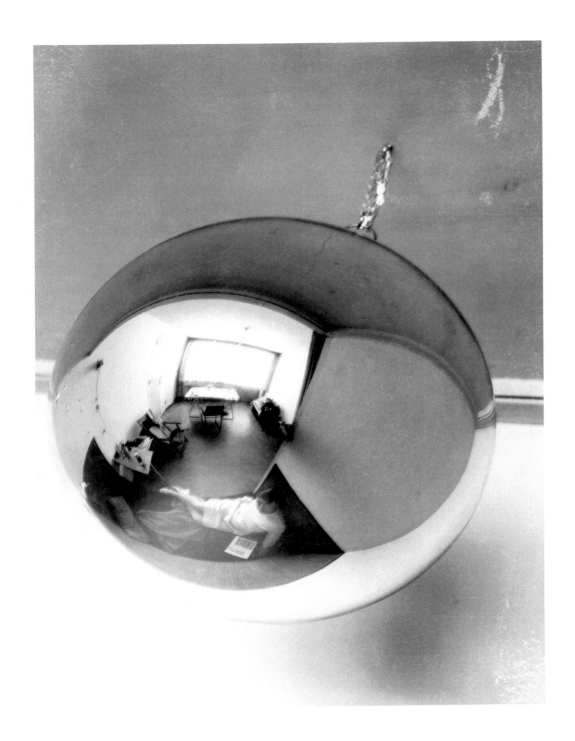

appearance. It seems no coincidence that this *Bauhaus* issue also reproduced an iconic contemporaneous representation of a female body transformed from flesh and blood to metal, the Maria robot from Fritz Lang's 1927 film, *Metropolis*. An image of the mask of this metal robot woman was paired with one from Oskar Schlemmer's *Triadic Ballet* to suggest the latter's influence on the film figure's design.[63] Thus the presence of this journal in Brandt's photographic self-portrait potentially evokes the specter of a cybernetic, metallic New Woman—which, in some ways was exactly what Brandt, director of the metal workshop and one of its top designers, was becoming.

Clearly this photographic self-portrait engages multiple devices to show tension between surface and depth. But why did Brandt package it all in a picture that trades on a relatively traditional representation of female beauty, in which she poses and pouts like a mirror image of Titian's *Venus of Urbino*? To answer this question, we can look to an essay written during the same period as when Brandt was taking these photographs, by another woman—without a direct known connection to the Bauhaus—who articulated new theories about women's self-presentation and their relationship to gendered power. In 1929, the British psychoanalyst Joan Riviere published her essay "Womanliness as Masquerade" on professional women who at times display an overabundance of femininity to their male colleagues. Riviere hypothesized that these women feared retribution for having sought and attained some measure of phallic power. She writes,

> womanliness therefore could be assumed and worn as a mask, both to hide the possession of masculinity and to avert the reprisals expected if she was found to possess it—much as a thief will turn out his pockets and ask to be searched to prove that he has not the stolen goods. The reader may now ask how I define womanliness or where I draw the line between genuine womanliness and the "masquerade." My suggestion is not, however, that there is any such difference; whether radical or superficial, they are the same thing.[64]

In a move very different from her contemporaneous colleagues in psychoanalytic theory—Freud most notably—Riviere posits femininity as *exclusively* a construction, one that in retrospect we might call a "performance" with no essence at its core.[65]

Riviere was particularly interested in professional women working in heavily male-dominated fields; her analysis of one such female patient led to her development of this theory. Of this woman's relationship to her own senior male colleagues, Riviere reports that, "she bitterly resented any assumption that she was not equal to them, and (in private) would reject the idea of being subject to their judgment or criticism." Riviere muses that

FIGURE 3.13. Marianne Brandt, Self-Portrait Reflected in a Ball (Selbstporträt in einer Kugel gespiegelt), Bauhaus Dessau, 1929, gelatin silver print from a vintage negative. 9.4 x 7.1 in. (23.9 x 18.1 cm). Bauhaus-Archiv Berlin. © 2019 Artists Rights Society (ARS), New York / VG Bild-Kunst, Bonn.

her patient belonged to a category of women who "wish for 'recognition' of their masculinity from men and claim to be the equals of men.…" Within psychoanalytic theory, the woman's public display of her intellectual prowess through her work is, symbolically, a claiming of phallic power and, thus, a castrating of the father figure. After making these public displays, the patient was subsequently "seized by horrible dread of the retribution the father would later enact" for her claiming of this phallic power.[66] The performance of femininity, then, is her attempt to placate such father figures, the powerful men with whom she worked.

Brandt, as the metal workshop's acting director as of 1928, was among only a handful of women to have achieve such prominence at the Bauhaus. She was the workshop's public face in meetings with businessmen, and often she was the only woman present. She led the group of designers to trade fairs—especially the famed Leipzig fair—and managed the workshop in collaboration with her assistant (*Mitarbeiter*), Hin Bredendieck. Her tenure was successful by many measures, particularly in terms of the number of contracts for industrial production that she secured for the workshop. But the work was difficult and not made easier by challenges mounted to her authority by male colleagues, to which her very limited notes and diary entries from the time attest. Even Bredendieck, who was not just her assistant but also a friend, confronted her one day in 1929 with the suggestion that she was not serious about her work; "how is it that the Bauhaus gets to provide for you?" he queried her.[67] She would cite these challenges in her April 1929 letter to Bauhaus Director Hannes Meyer in which she announced her plans to resign in the near future, which she followed through on three months later.[68]

Brandt's self-portrait in a white dress resonates with Riviere's contemporaneous ideas about high-powered women in male domains, which the Bauhaus metal workshop clearly was. Brandt was in the process of remaking herself after she had taken on male authority by stepping into the shoes of no less of a figure than her own mentor, the metal workshop's former director, Moholy-Nagy. On the one hand, this photograph is a quiet declaration of Brandt's identity as a woman who had become one with metal, the material of her craft, but as a designer and constructor rather than a mere superficial New Woman. On the other hand, in this and the other self-portraits of this series, Brandt trades on her femininity by making herself diminutive and cute, or vampy and modern. In the private space of her studio, she used photography to try out antidote identities to the work life she was developing at the Bauhaus, an institution that was ill-disposed to support a woman in such a dominant leadership role. Katie Sutton has pointed out that the so-called "masculinization of woman" was a Weimar cliché, the butt of jokes and source of fears.[69] Brandt's impinging onto terrain previously perceived as male—something that many Bauhaus women were attempting—is played out in some of these portraits, even as others represent a hyper-femininity as if

to obscure any such impinging. These photographs offer the chance to explore the nature and meaning of her appearance and her power in what was in some ways still very much a man's world.

A final body of work rounds out my exploration; the extraordinary photographic self-portraits by Gertrud Arndt offer a very different take on Bauhaus femininity in transformation. As was the case with Brandt's photographs—as well as in the photo-based works by Marcel Breuer, Herbert Bayer, and Moholy-Nagy that I examined in chapter two—self-portraiture enables the creation of a charged pictorial field in which to tease out emerging identities. Like Brandt's photographs, completed in her studio in the Prellerhaus wing of the Bauhaus's main building, Arndt's self-portraits were also made in a solitary space on the Dessau Bauhaus campus, the master's house that she shared with her husband, her former classmate Alfred Arndt, who became a junior master at the Bauhaus in 1929. Like Brandt's photographic self-portraits, Arndt's can be interpreted in relation to Riviere's concept of femininity as a masquerade. However, as I argue in the coming pages, in fact, they are much better understood as Arndt's own aestheticized declaration of refusal.

Gertrud Arndt—last-named Hantschk at the time—arrived at the Bauhaus in 1923, the year prior to Brandt, with the express plan of becoming an architect. She had good prospects, since she already had two years of training in the Erfurt office of the progressive architect and Werkbund member Karl Meinhardt under her belt. She had also been a member of the progressive *Wandervogel* youth group, studied drawing and art history, and taught herself the basics of photography for her work with Meinhardt.[70] After completing the Bauhaus's preliminary course in one semester, she was admitted to the architectural drawing course (*Werkzeichenkurs*), a first step in formal architectural studies at the Bauhaus, and joined the weaving workshop at the same time. While she later recounted that it was clear to her that the way forward for a woman at the Bauhaus lay nearly exclusively in that workshop, weaving was also work at which she excelled, in part surely because of her grasp of complex structures through her architectural training.[71] She quickly became the workshop's expert for rug design, and these works soon came to represent the school through publications like Gropius's *Neue Arbeiten der Bauhauswerkstätten* (New Work from the Bauhaus Workshops) of 1925; one of her rugs was even placed in Gropius's director's office.[72]

She completed her Bauhaus studies in 1927 and, on March sixth of that year, she passed her journeyman's examination as a weaver. That same day, she promised herself never again to sit at a loom; weaving was simply not for her.[73] Committed to her refusal of the profession to which she had dedicated her four years at the Bauhaus, she married Alfred, and the pair moved away for him to pursue his career as an architect. When they returned to the Bauhaus in 1929, Gertrud did not reconnect to the school through her identity as a skilled weaver, but as a master's wife

1930

living in isolation from the school building that she knew and loved, residing instead in the master's house recently vacated by Oskar Schlemmer and family. This could have been a luxury, but for Arndt, she felt that she had become a "do nothing" (*Nichtstuerin*). Out of what she later recalled as "pure boredom," Arndt began to take photographs.[74] One of her two main subjects was her close friend and fellow weaver, Otti Berger. Berger owned a trunk full of fabric and costumes and dressed up in these to be photographed as specific, recognizable characters, a clown or a Spanish lady, for example.[75] Arndt's other main photographic subject was herself, and she too drew from the trunk as well as from her own clothing to create a series of approximately forty-three self-portraits that are much less easy to pin down. She called her efforts "Mask Photos."[76] Despite the title, Arndt wears no masks in these self-portraits; instead she transforms herself with makeup, veils, hats, and her own lively facial expressions. In a later interview, she said she turned to self-portraiture because photographing others didn't allow her to express as precisely what she wanted to capture in the pictures.[77]

She later recounted her method: "I sat opposite the camera, about two meters from the window, in a chair. A broomstick leaned behind the chair, to which a fine-printed piece of paper was attached. I focused [the camera] on this."[78] To take the picture, she rigged threads to the camera's shutter release, ran them under a heavy object to keep the camera from tipping, and pulled. The dress-up performances she enacted seated in front of the camera's lens are captured on film as if they are windows into intriguing, private worlds of unknown women. Although the "Mask Photos" are numbered, the order of most of them is without logic, as if to emphasize that the endless transformations she performs are not to be understood as having a particular trajectory.[79] Whereas so much of the work by female *Bauhäusler* I have discussed in this chapter is oriented towards imagining a modern present and a better future, Arndt's portraits reject that futurity, instead embracing their own nonsensical "now."

A quintessential example is Arndt's "Mask Photo 39 A," where she wears a look of surprise at the polka dots floating on the veil directly in front of her face, seemingly astonished at her own encapsulation in fabric (figure 3.14). Her face is ringed by a broad-brimmed hat that highlights her beauty and intriguing expression. Her upper torso and breasts are visible through layers of transparent tulle, a daring presentation of her semi-nude body. And yet she almost blends in with the busy background behind her in a picture layered with patterned fabric. As a former weaver, fabric had been her medium; here, it has become her useless ornament, and an overwhelming environment from which she cannot escape.

Other examples of the "Mask Photos" series reveal Arndt transforming herself into equally unspecific roles. Number 34 shows her as a Victorian lady done up with a complex coiffeur topped by ribbons, lace, and ostrich feathers on her bonnet (figure 3.15). An import from another era,

FIGURE 3.15. Gertrud Arndt, Mask Photo No. 34 (Masken-foto Nr. 34), 1931, gelatin silver print. 8.8 x 6.1 in. (22.2 x 15.6 cm). Bauhaus-Archiv Berlin. © 2019 Artists Rights Society (ARS), New York / VG Bild-Kunst, Bonn.

Arndt captures herself in profile, turned away from the camera so that she offers us her face but denies us her gaze. In another, Number 3, dramatic makeup and a clenched rose in her teeth might fall in line with a kitschy image of a Spanish dancer–a subject that Berger chose to embody–but Arndt merely stares back at us, composed and again wrapped in layers of patterned fabrics.[80] Upon seeing this work, her friend, *Bauhäusler* Joost Schmidt–one of only three contemporaneous viewers of the work along with her husband and Otti Berger–exclaimed, "you look like a whore!"[81] By contrast, in Number 28, she appears almost saint-like, with her wide face, bow lips, arced brows, and downcast eyes.[82] She is almost immobilized by the layered, elaborate veil that falls from her head to her waist and covers her entirely, removing her capable designer's arms from sight. Number 22 has a clarity and simplicity that is refreshing after the layered barrages of the other portraits (figure intro. 1). Posed in a kind of contrapposto, Arndt turns to look at the camera over her shoulder with an almost smile that suggests connection to and even complicity with the viewer. The "mask" of makeup and a hat and veil are here in place, as in the other photographs of this series, but she also appears mysterious, sexy, and modern.

The excess of Arndt's self-portraits comes to a head in Number 16, where the layered surfaces are double-exposed, rendering her face translucent and multiple at the same time (figure 3.16). As if caught up in a metaphor for the restraints she experienced on her creativity at the Bauhaus, Arndt appears caged by her beautiful layers. Yet the two exposures show her as moving, negotiating, and recreating herself. In the midst of this play of texture, pattern, and posing, one clear eye peers out from the overabundance of material in a moment of direct confrontation. Here is a picture from a surrealist Bauhaus, a skilled designer and technician who renounces her own craft and instead pictures herself as an uncanny beauty.

A single self-portrait by Arndt from this period has quite a different effect than the works in the "Mask Photos" series. Apparently shot in the bathroom of her Bauhaus master's house, it shows Arndt dressed simply in a white blouse and reflected in an endless play of her image (figure 3.17).[83] The swaths of fabric are gone, and she strikes an expansive pose, reaching out in a gesture of embrace or flight and inhabiting the grid, dominating this high modernist space of glass and mirrors. But this structure too appears to reign her in; rather than luxurious fabrics, she is caged by the hard edges of architecture itself.

As a body of work, Arndt's "Mask Photos" and the mirrored self-portrait are experiments in the process of renouncing a Bauhaus identity to explore what it might be like to cease striving and to instead become utterly useless, pure ornament. The "Mask Photos" gesture towards nostalgia for a past, yet without any serious interest in it. The untitled self-portrait surrounded by architecture reaches out to the future, but in a likewise blasé manner. And both the "Mask Photos" and the architectural self-portrait

explore the imagery of confinement, not liberation. While so many of Arndt's male and female colleagues were engaged in discovering new identities for themselves as artists and designers and considering how best to serve emerging markets—a path that Arndt herself had taken in her exceptionally fine work in the weaving workshop—in these photographs, she instead embraces a creative *un* becoming. What if, in an institution aimed at producing the right designs for the modern moment, she simply refused to strive, perform, or progress? As a member of a movement that prized quality, simplicity, and the eradication of all unnecessary ornamentation, what if she herself became *nothing but* surface and needless adornment? What if she let the trappings of multiple femininities simply overtake her?

The result of these thought experiments are photos that capture Arndt as if in a kind of carnivalesque excess—although they are largely devoid of the joy of carnival's abandonment of convention.[84] In their refusal of the Bauhaus's optimistic embrace of the future, the "Mask Photos" can be connected to the topic of my next chapter, queerness, through the ideas of scholars including Jack Halberstam and Lee Edelman, who theorize that failure and a lack of future orientation have long been perceived as queer.[85] "What kinds of reward can failure offer us?" asks Halberstam. He continues, "failure allows us to escape the punishing norms that discipline behavior and manage human development with the goal of delivering us from unruly childhoods to orderly and predictable adulthoods. Failure preserves some of the wondrous anarchy of childhood and disturbs the supposedly clean boundaries between adults and children, winners and losers."[86]

More than other works from the Bauhaus, Arndt's self-portraits draw on the language of surrealism, particularly the contemporaneous dress-up photographs that Claude Cahun made with her partner Marcel Moore. These too usually focus on a single, starkly posed figure through whom feminine tropes are explored and blurred.[87] And while, like Brandt, Arndt's masquerades engage in constructions of hyper femininity, they do not do so in order to deflect masculine reprisals for her success. For Arndt, failure—to secure a job designing for industry, running a private weaving workshop, or teaching others to weave—was an option, and she chose it. This choice plays out in her photographs that explore the confines of fabric and architecture and celebrate an ever-extending (but never progressing) mash up of femininity. Through these pictures, Arndt transitions from the forceful, emancipated *Bauhäusler* that she was from an early age—a woman who came to the Bauhaus to study architecture and had the skills and talent to do it—to a master's wife and, by the time she concluded the series in 1931, mother.[88] Different from Brandt, Arndt made her self-portraits in a context in which she did not need to fear masculine reprisals for her success. She had set her work as a designer aside for what appeared, at least on the surface, a relatively conventional life.[89]

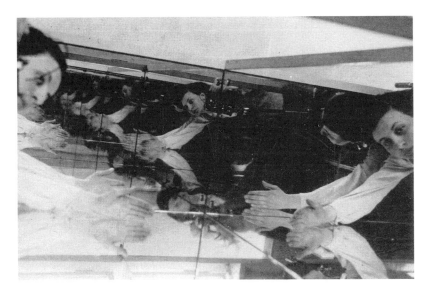

FIGURE 3.17. Gertrud Arndt, Self-Portrait, 1930, gelatin silver print. Location unknown; reproduced in Galerie Octant, *Bauhaus Photographie*, Paris, 1983, cat. No. 33. © 2019 Artists Rights Society (ARS), New York / VG Bild-Kunst, Bonn.

TRANSFORMING BAUHAUS HISTORIES

> Because ultimately haunting is about how to transform a shadow of a life into an undiminished life whose shadows touch softly in the spirit of a peaceful reconciliation. In this necessarily collective undertaking, the end, which is not an ending at all, belongs to everyone.
>
> – Avery Gordon, *Ghostly Matters*[90]

What do we get by making *Bauhäusler* who have been relegated to the margins—if they have appeared at all—the center of the story? As I have argued in this chapter, one of the many payoffs is a richer understanding of what the Bauhaus was, what it means, and why it matters. An artistic node that drew high-powered, young, creative women from throughout Europe and beyond, the Bauhaus produced artists and designers who were highly adaptable in their work. Most often they were, as in Ré Soupault's description of the ideal fabric for her transformation dress, able to "stand up to all the stresses." Their flexibility in their work and their penchant for multifunctional designs illuminated and defined Bauhaus spaces, as with Brandt's lights for the Dessau Bauhaus and Ise Gropius's kitchen design for her master's house; their work also brought Bauhaus adaptability and flexibility into new spaces outside of the Bauhaus, as with the toy design, architecture, and luxury interior design by Dicker and Singer. Female *Bauhäusler* like Dicker and a number of others—including Lena Meyer-Bergner, whose work in the Soviet Union I address in chapter five—transformed their art and

designs into instruments of their political commitment. Dicker ultimately retooled her skill set one last time when she was sent to the Theresienstadt ghetto and concentration camp, by developing pedagogy as a kind of proto art therapy for children imprisoned there—accomplishments surely at an extreme of what Bauhaus training could accomplish.

Reintegrating these women into the Bauhaus's history also enables us to understand the limits and failures of the institution's experiments. Brandt's inability to find a satisfactory identity as a female leader within the Bauhaus was surely not due to her own shortcomings. Instead, she is a case study that reveals the school as an institution that—as the 1926 photograph of the thirteen masters on the Dessau Bauhaus rooftop suggests—might as well have had a glass ceiling, as far as its women were concerned, given how few of them were able to rise to the upper echelons of its leadership and stay there. Arndt's return to the Bauhaus and ascension to life in a master's house did not occur by virtue of recognition of her own work, but that of her husband, hired as a junior master. She had renounced her work as a weaver—the skill most identified with Bauhaus women—and instead turned to photography to create gorgeous and eerie self-portraits that proclaim her own uselessness. Brandt and Arndt's self-portraits respond to their different but related circumstances—Brandt searches as yet uncharted territory in Bauhaus and constructivist New Womanhood; Arndt seems to have thrown in the towel with gusto.

Avery Gordon probes the very question of re-centering history on what was previously thought marginal by relating our own present to history. What stories still remain hidden to us? And what are the impacts that continues to reverberate from a refusal to see? She writes:

> Today scholars know more than they ever have about the subtleties of domination, about the intersections of the modern systems that organize the production, reproduction, and distribution of social life, about the edifice of constructions upon which culture sings and weeps, about the memories and the overflowing accounts of the disremembered and the unaccounted for. Yet our country's major institutions—the corporation, the law, the state, the media, the public—recognize narrower and narrower evidence for the harms and indignities that citizens and residents experience…. It has renewed a commitment to blindness: to be blind to the words *race*, *class*, and *gender* and all the worldliness these words carry in their wakes.[91]

Considering how the markers of difference have been uncritically permitted to stake out a boundary between who matters and who doesn't for a movement's history, who defines that movement and who doesn't even register in its definition, who is authorized as an innovator and who isn't, allows us potentially to pry that history free from its well-worn track. But to do this,

we must acknowledge not only the operations that have been at work to give us a faulty understanding of the past, we must also recognize that, in repeating those old histories, we participate in a foreclosing of potentially more fruitful futures. More than simply correcting history, reconsidering it through those who were formerly relegated to its margins allows us to fully grasp Gordon's deceptively banal theoretical statement that, "life is complicated."[92] History is too.

Bauhaus women created bodies of work that were insistently flexible, seemingly constantly in transition, and, for the most part, staunchly oriented towards an optimistic future. Theirs was a collective push for positive change, to design adaptable objects for a modern society in which women's status as equal members would not even be a question. By contrast, Arndt's mysterious, poised, and strangely beautiful figures stop time and interrupt the forward reaching flow of the Bauhaus.[93] She images another Bauhaus woman, unknown but also unknowable, unenthusiastic, and productive only of gestures at identity that can never be pinned down. These photographs refuse the efficacy of the institution's striving by revealing another, uncanny Bauhaus—one evoked more publicly in Oskar Schlemmer's theater of human dolls, as well as in works I have discussed in this book's first two chapters.[94] In the following chapter, I turn to another hidden history of the institution, what we might consider its haunted closet, in order to begin to write a queer history of the Bauhaus.

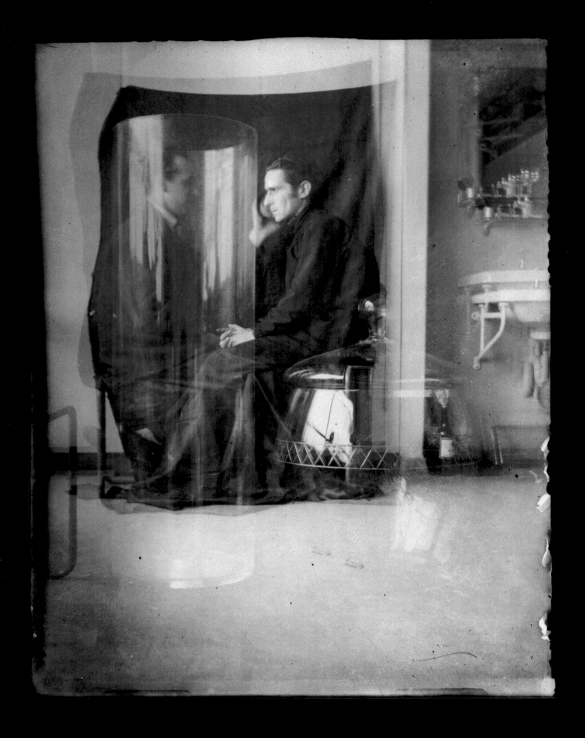

QUEER BAUHAUS

FIGURE 4.1. Heinz Loew, Double Portrait of Loew and Trinkaus in the Studio, Bauhaus Dessau, Double Exposure (Doppelporträt Heinz Loew und Hermann Trinkaus im Atelier, Bauhaus Dessau, Doppelbelichtung), 1927, modern silver gelatin print (1988) from an original glass negative. 9.4 x 7.1 in. (24 x 18 cm). Bauhaus-Archiv Museum für Gestaltung.

A CODED COUPLE

In a vintage print of a 1927 photograph by Heinz Loew, taken within an atelier in the Dessau Bauhaus building, a man sits in profile with his hands in his lap (figure 4.1).[1] He faces the translucent, ghostly apparition of another man who returns his gaze. Both figures are draped in black, so that it is difficult to discern where the body of one man ends and the other begins. Behind them, hung from the doors of a closet, a black cloth creates a defined area around the two figures and puts their faces and hands into high relief. The figure on the left appears to be confined to the glass cylinder that dominates and contains him, yet he manages to reach out beyond his glass cage to stroke the other man's face. In the disorienting scene presented by this double-exposed photograph, objects repeat and appear only partially. Only one element is a constant: the man in the middle of the picture. Compared to the unsteady visions around him, he is solid and impassive, and he seems transfixed by the affectionate apparition who appears before him. Hermann Trinkaus, on the left, was photographed in only one of the photograph's two exposures, so that he is both present and absent, as if he were a figment of Loew's imagination, a projection of his desires, or the memory of a lost love.

Through its two exposures, this is a doubled double portrait. It thus invites allegorical interpretation, the simultaneous enfolding of multiple meanings.[2] Certainly "Double Portrait of Loew and Trinkaus" can be interpreted in relation to the proliferation of photographic experimentation that was a defining part of the Bauhaus.[3] Photography freed *Bauhäusler* to represent their world by using modern technology rather than paint. With its translucent glass vase and metallic reflective glass cylinder superimposed upon the scene, this photograph could be understood as an inside joke; the man Trinkaus—whose name means "drink up"—appears in a glass! The image is also visibly akin to other Bauhaus visual experiments, such as Marianne Brandt's self-portraits reflected on the surface of a metallic ball, discussed in chapter three. And the photograph's double exposure also links it to the genre of spirit photography of the past and the Bauhaus itself; as I show in chapter one, a number of Bauhaus photographers used this technique to playfully capture modernist spirits, to evoke, as well, the *Zeitgeist* of their school, and to create dream visions of the

future. In Loew's spirit photograph, the visitation is from an attractive and tender young man who, perhaps evoking the visual tactility of Alois Riegl's haptic, offers his caress with a feather-light touch.[4] Drink up, indeed.

Even more than this ghostly figure, however, this picture is haunted by the love that dare not speak its name.[5] It is an image of tenderness between men that is relatively rare in the history of art and the known corpus of Bauhaus images. We know little of Loew and Trinkaus's personal lives or of their relationship to each other.[6] But this is a queer picture for sure, in multiple senses of the word: uncanny, eccentric, and gay. Yet while the photograph captures loving men together, it does so in a manner that is qualified; the figures are constrained through compositional elements, and one of them is ghostly—present and absent at the same time. It is, in short, *coded* in order to afford plausible deniability of its aspirations to represent male same-sex desire, as it could easily be interpreted as nothing more than a formal photographic experiment. Understood thus, Loew and Trinkaus, and by extension the photograph's viewers, are innocent. The picture may be formally original and complex, but, as it is not sexually explicit or otherwise overt in its approach to same-sex desire in its content, it plays things safe—which is entirely in keeping with its creation in a society in which sexual acts between men were criminalized, as they were under §175 of the Weimar constitution.[7] Given what Christian Rogowski has called "the extremely narrow discursive confines within which homosexuality could be addressed publicly during the Weimar Republic," artists and viewers of the time were particularly adept at reading into pictures.[8]

Pictorial representation has long been recognized for its ability to convey meaning through suggestion, symbols, and allegory; this has allowed artists and others to discretely communicate ideas to some viewers in ways that others would likely not perceive. Jonathan Katz refers to this tradition as "the art of the code," an approach mastered by many queer artists living in diverse contexts under regimes that criminalized their desires.[9] In his instructively titled essay, "Hide/Seek," Katz points to how, "the social universe of sexual desire, in painting, as in life, is so often of necessity communicated through the subtlest gestures, glances, and codes. When the desire in question is literally illegal, it is all the more fugitive, such that images of queer historical import…have passed under our contemporary perception utterly undetected."[10] Further, this dynamic is familiar to members of subcultures "long used to employing protective camouflage, while at the same time searching for tiny signs, clues, or signals that might reveal the presence of other queer people."[11] Paradoxically, queer art of the past, and portraiture in particular, has, Katz asserts, "drawn power from oppression and from the inventiveness, ingenuity, and originality it encouraged as a strategy of survival. Absent constraints, after all, queer portraiture would not need to look or operate any differently than any other portraiture."[12]

A photograph incorporating a vocabulary of modernist experimentation and set within a strict, Bauhaus interior, "Double Portrait of Loew and Trinkaus" relies on the art of the code to at once represent and hide its imaging of queer desire. In addition to announcing itself as a duplicitous view, specific compositional elements within the picture evoke coded content. The presence of the twinned vessels, the vase and jar, superimposed on its surface suggest an attempt at containment of the picture's male subjects. A more overtly sexual reading is possible in the case of the vase, an object whose shape is phallic but whose purpose is to serve as a receptacle. Perhaps the most heavily coded element of the photograph appears in the interaction between the men, their mutual gazing and the gesture of Trinkaus stroking Loew's face. This latter is a common expression of love and intimacy, but in the context of the picture's making, it was particularly charged. In Germany's interwar silent cinema, which was subject to heavy censorship by the government's Film Review Office, it was through hands—reaching and stroking—that sexual intimacy of any kind was overtly implied to a public schooled to understand such codes.[13] The power of this gesture is particularly evident in *Different From the Others* (*Anders als die Andern*) of 1919, which was screened throughout Germany and is widely recognized as the first gay-rights film.[14] At key points, the film's narrative relies upon the gesture of one man reaching for and touching the face or body of another to communicate both sexual desire and—essential for the film's role in advocating for gay male rights—true love.[15]

QUEERING THE BAUHAUS

This chapter's pairing of the ideas of "queer" and "Bauhaus" might be unexpected, and indeed, to my knowledge, no other scholarship explicitly addresses cultural production at the Bauhaus in relation to gay, lesbian, or transgender sexuality and identity. Yet investigating a queer Bauhaus makes sense; as I have argued in this book's previous chapters, openness to new ways of living was at the heart of the Bauhaus project, and this included ideas about sex and, to some extent, sexuality.[16] Despite the Weimar Republic's restrictive laws around homosexuality, abortion, and birth control, a broad culture of sexual experimentation flourished between the World Wars, both within and outside of Germany. Journals with overtly gay and lesbian visual and written content circulated widely and fostered networks of queer culture linked to clubs in cities, but they also reached readers in smaller towns.[17] The period also saw a blossoming in the study of both biological and cultural aspects of sexuality, above all in the work of groundbreaking sex researcher Magnus Hirschfeld, who founded the world's first institution dedicated to sex research, the Institute of Sexual Science in Berlin, the lifespan of which coincided precisely with the years of both the Bauhaus and the Weimar Republic. It was founded on the

principle that science, rather than religious morality, should be the basis for public policy and social norms.[18] "Soon the day will come when science will win victory over error, justice a victory over injustice, and human love a victory over human hatred and ignorance," proclaimed Hirschfeld optimistically in his speech at the opening of *Different From the Others*.[19] For many, the 1920s were a time not so far from this ideal, a period of broad optimism about the public's potential to become more accepting of sexual difference. Given this defining aspect of culture during the Weimar Republic, progressive ideas about sexuality contributed to life and design at the Bauhaus, which, as I establish in chapter one, can itself be considered a reform movement.

This chapter sets out to queer the Bauhaus movement in the broad sense in which the term "queer" has come to signify in recent decades. Now often used as a synonym for individuals who desire and love members of the same sex as well as for those who in appearance or practice do not conform to normative ideas of sexuality and gender, the historic layers of meaning associated with the term have been cogently summed up by Tirza True Latimer: "The word *queer* retains connotations from the modernist period, when it circulated as a synonym for 'eccentric, strange, odd, peculiar; suspicious, dubious; abnormal.'"[20] Jack Halberstam writes of a queer "way of life" that encompasses "subcultural practices, alternative methods of alliance, forms of transgender embodiment, and those forms of representation dedicated to capturing these willfully eccentric modes of being."[21] The idea of "a queer Bauhaus" is necessarily provisional and exploratory, since this new research area ventures into identities and practices that were criminalized and subject to discrimination during the Weimar Republic. Some of the works that I explore under the rubric of a queer Bauhaus were made by the few identifiable gay and lesbian *Bauhäusler*; with other artists, as with Heinz Loew, we may never have certain knowledge of their sexual identities and preferences. Yet works can evoke the present-yet-hidden specter of queer desire independent of their makers' sexualities, and these works are essential to the story I trace in this chapter. In this sense, my approach to a queer Bauhaus follows on Alexander Doty's relatively early use of queerness as an interpretive lens to be applied both to cultural production made by identifiable gays, lesbians, and bisexuals, as well as to works that simply lend themselves to queer interpretations.[22] Like the other chapters of this book, this one is a disruption of the narrative of a normative Bauhaus in order to tell the much richer history that only emerges when we look at a new range of Bauhaus works and artists, and reconsider the questions that we ask of them.

Avery Gordon's idea that often the figures who insistently haunt the margins of what we take as fixed and finalized history are those "who are meant to be invisible" is again relevant in this chapter.[23] In queer studies, that same enforced invisibility is discussed as "the closet," which Eve Kosofsky Sedgwick describes as "the defining structure for gay oppres-

sion" in the twentieth century.[24] Certainly this architectural metaphor applies well to the Bauhaus. More recently, the critical concept of "queer hauntology" offers a reparative approach to the past. Drawing on Jacques Derrida's interpretation of Karl Marx's work, it aims at theorizing, as Elizabeth Freeman puts it, "an ethics of responsibility toward the other across time—toward the dead or toward that which was impossible in a given historical moment"; this ethics of responsibility, she finds, calls us to create a different future. Queer hauntology is therefore, according to Freeman, "the idea that time can produce new social relations and even new forms of justice."[25]

The archives hold images and designs for which extant histories of the Bauhaus cannot account. Some burn with same-sex desire; others appear to gesture to broader queer networks. These pictures are puzzles, given the absence of discussion of this topic elsewhere. In the rest of this chapter, I investigate the Bauhaus through the work of four *Bauhäusler* who, in differing ways, were queer figures. Max Peiffer Watenphul and Florence Henri both made remarkable photographs of gender play and performance that speak to same-sex desire. Margaret Camilla Leiteritz evoked a classical lesbian past in some of her works and asserted the right to singleness in others. Richard Grune's photomontages focused on positive political collectivity that does not convey overtly queer content; yet as a gay man, he would suffer untold inhumanities at the hands of the Nazis, which he would later struggle to represent in his artwork. As a community dedicated to rebuilding and reforming life through art and design, the Bauhaus attracted people who were interested in a place that could, among other things, foster a questioning of traditional models of desire and identity. It is time we looked for them and integrated them into the institution's history.

SEX AND GENDER AT THE BAUHAUS

As much as ideas about masculinity and femininity, sex was certainly on the minds of those at the Bauhaus, from the students through the directors; it even interested the school's critics. At the Bauhaus, relatively new ideas about the role of sexuality and sexual identity were topics of discussion. In a 1928 article published in the in-house *Bauhaus* journal, the school's second director, the Swiss, leftist architect Hannes Meyer, provocatively listed "sex life" (*geschlechtsleben*) at the top of his list of the dozen factors that should determine a house's construction.[26] While Meyer—who had relationships with several female *Bauhäusler*—was almost certainly thinking of heterosexual sex when he created his list, his text stands as an example of the fact that the Bauhaus was in many ways extremely modern in its approach to the body and sex. As Juliet Koss argues, the imagined bodies that emerged from the Bauhaus theater workshop and onto the stage under Oskar Schlemmer's direction suggest an enthusiasm for troubling

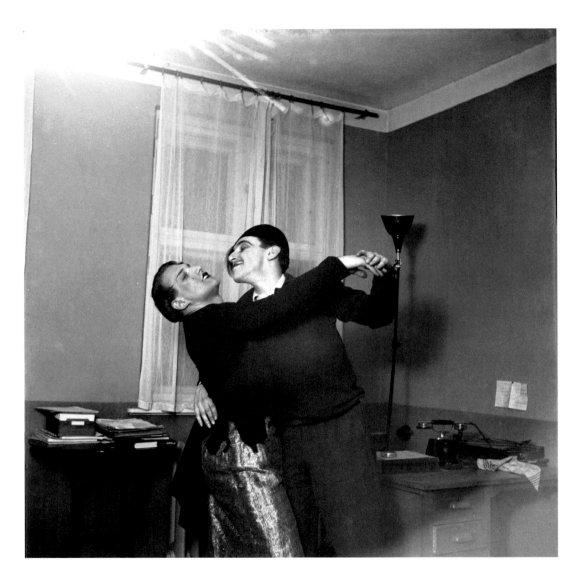

FIGURE 4.2. Ivana Tom-
ljenović, Preparing for a
Party (David Feist and Tibor
Weiner), 1930, modern print
from a vintage negative. 2.4 x
2.4 in. (6 x 6 cm). Museum of
Contemporary Art, Zagreb.

gender binaries and norms.[27] Posed photographs of male *Bauhäusler* in drag, sometimes feigning romantic interactions with other men, were part of the Bauhaus's legendary party culture (figure 4.2).[28] To some extent, such performative male drag is just the kind of "fictitious transsexuality" that Klaus Theweleit identified as among the "playful, apparently transgressive, but ultimately strictly regulated…flirtations with the homosexual" that even took place within military contexts.[29] Still, even fleeting performances of gender fluidity and same-sex desire can convey the potential for new identities and desires to emerge as a part of what José Esteban Muñoz refers to as "future possibilities."[30] The Bauhaus, an institution dedicated to imagining the future, allowed for at least some speculative ideas and behaviors about gender and sexuality as a part of its culture.

Critiques of the Bauhaus were sometimes made in sexualized terms. The Bauhaus's perceived permissiveness around sexual relationships between male and female students provided fodder for the school's right-wing critics, as in a 1924 *Weimarische Zeitung* article. The author complains of the Bauhaus's approach to "the most private matters," that both male and female *Bauhäusler* frolic naked outdoors, and that the freedom enjoyed by "the two sexes together" sometimes leads to pregnancies:

> …I cannot help but castigate it as the product of an utterly depraved sensibility and, furthermore, as the outcome of the destructive methods as regards teaching and upbringing at the Bauhaus, when such motherhood is also publicly celebrated with all manner of ballyhoo, when, for example, a cradle is made in the Bauhaus workshops by the young men involved and then taken in a kind of triumphal procession to where the victim lives, as has been known to occur. Anyone who is capable of forming a clear mental picture of the psychological effects of such events, must urgently warn everybody not to allow a son, let alone a daughter, to enter this institute….[31]

It is noteworthy that a breaking point for the author is the Bauhaus women's lack of shame at pregnancy out of wedlock, and that Bauhaus designs were deployed to reinforce this new, debased way of life. Perhaps it is no wonder that Gropius too was attacked by a disgruntled former master, Carl Schlemmer, on trumped-up charges of philandering with female students.[32]

Yet while its opponents sought to represent it as a bastion of licentiousness, in many respects, the Bauhaus appears to have been relatively traditional in its approach to sex and sexuality. In part, this was surely a deliberate attempt to deny local critics more fodder for criticism. But queer figures seem to have posed a particular challenge for an art school in conservative Weimar, even before the advent of the Bauhaus. Sascha Schneider, a famed Symbolist painter and professor at the Bauhaus's pre-

decessor institution, the Weimar Saxon Grand Ducal Art School, had to quit his job and flee to Italy in 1908 when a former male partner blackmailed him under the terms of §175; it was precisely this kind of blackmail that *Different from the Others* would later critique.[33]

At the Bauhaus itself, while clues to the sexuality and gender identity of the students are sparse, the archives contain the case of a 1920 applicant who, because he had studied sculpture for several years at Weimar's School of Arts and Crafts, likely would have had the background for admission to the Bauhaus's preliminary course. The records may not be complete in this case, but it is certain that he was not accepted into the school, and there is not even an indication that the masters asked to see a portfolio, which would have been the standard next step. What might explain the apparent lack of engagement with this student is a sentence at the end of his narrative of his qualifications: "Since the end of September of this year, I have permission from the authorities to wear men's clothes, a permission which I am now using." The letter was signed "Hans Voelker, also known as Johanna Voelcker."[34] Nothing more about this application is recorded, but this single document tells us that at least one student whom we would anachronistically call "transgender"—he would have been known as a "transvestite" (*Transvestit*) at the time, a term coined by Hirschfeld in 1910—was not given a place in the Bauhaus.[35] Known lesbians may also have been discouraged from being a part of the school. Annemarie Hennings, the daughter of cabaret artist and Dadaist Emmy Hennings, had an affair with the Swiss student and weaver Maria Geroe-Tobler, and, when this became known to the Bauhaus leadership, Hennings left the school.[36] While she was a junior master, Gunta Stölzl was attacked by conservative students for her leftist politics, but the barely-veiled accusation that circulated first in rumor and then in a leftist *bauhaus* student journal, the story that was intended to compromise her reputation, was that of her lesbian seduction of one of her innocent, young, female students.[37]

The period's anti-homosexual laws and the Bauhaus leadership's unwelcoming stance to both male and female homosexuality meant that traces of a queer Bauhaus were often coded—as with Loew's double portrait—if they were visible at all. Additionally, the subsequent Nazi regime's campaign against homosexuals means that whole oeuvres—as well as lives—have been lost in the interim. However, there are a handful of discernable queer *Bauhäusler* whose sexuality is imprinted in their work in significant ways that we can still examine today. Several Bauhaus members made their most overtly queer works only once they had left the school, but often still within the context of Bauhaus circles of friendship, and these pictures and circles also constitute part of my inquiry.[38] Through their work and networks we can indeed begin to discern the outlines of a queer Bauhaus.

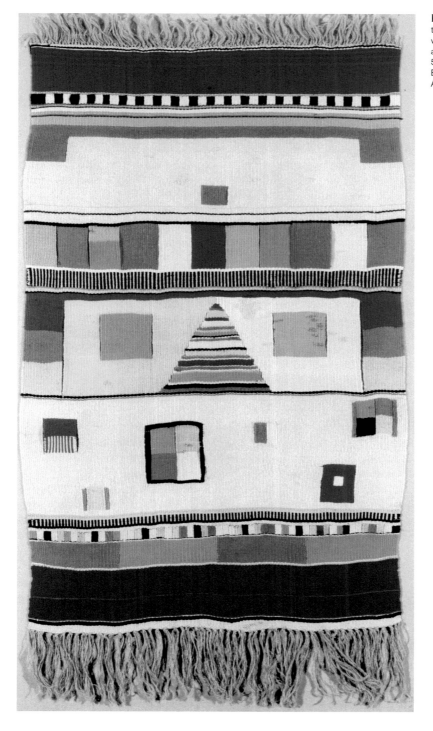

FIGURE 4.3. Max Peiffer Watenphul, slit tapestry, c. 1921, white, grey, yellow, blue, black, and red toned hemp and wool. 53.9 x 29.9 in. (137 x 76 cm). Bauhaus-Archiv Berlin © Archiv Peiffer Watenpul.

QUEER WORKS AND QUEER NETWORKS: MAX PEIFFER WATENPHUL AND FLORENCE HENRI

At least one student who we know in retrospect was queer joined the school the year that it opened, Max Peiffer Watenphul. Remembered mostly for his modernist city and landscape paintings, Peiffer Watenphul had already completed a law degree and a doctorate when he encountered an exhibition of Paul Klee's painting and decided to come to the Bauhaus in 1919 to become an artist.[39] Peiffer Watenphul was immediately singled out as highly talented; Gropius gave him a studio of his own and permitted him to move freely among the workshops so as to have full autonomy in his experimentation without having to prove himself through the preliminary course. He remained at the school for four semesters and stayed on in Weimar until 1923.[40] Part of his diverse production from his two Bauhaus years is a colorful slit tapestry, made sometime around 1921 (figure 4.3). At the Bauhaus, weaving was generally viewed as women's work. The vast majority of the workshop's members were women, and, for a period of time starting in 1920, the workshop was also called simply "the women's class."[41] Its clear female dominance caused Oskar Schlemmer to joke, "where there's wool you'll women find, weaving just to pass the time."[42] Because of this extremely strong gendered link, one could view this object as coded in terms of what we might call "medium drag," in which the artist is to some extent feminized by engaging a gendered mode of production. As in performative drag, this kind of crossing is playful and is usually perceived to be temporary. And indeed, the critical reception with respect to this tapestry is often at pains to emphasize that this was Peiffer Watenphul's one, brilliant weaving. The resulting work, with its bold color and abstraction through elementary forms, was perceived as quintessentially Bauhaus. In this case at least, the Bauhaus was quite tolerant of a man crossing into feminized territory; the tapestry was selected for reproduction in the 1923 *Staatliches Bauhaus* exhibition catalogue.[43]

Peiffer Watenphul quickly found success as a painter; by 1920, he was being represented by the prominent gallerist Alfred Flechtheim, which gave him a steady income. Peiffer Watenphul became a member of the Düsseldorf-based Junges Rheinland artists' group, and befriended members of the avant-garde including Otto Dix and Max Ernst.[44] When he left Weimar in 1923, he continued to frequent Bauhaus circles and maintained strong friendships with Maria Cyrenius and Grete Willers, both weavers, and subsequently became close friends with Florence Henri and her partner Margarete Schall, also both *Bauhäusler*.[45]

Although his reputation now rests on his modernist-fauvist paintings and his singular weaving, Peiffer Watenphul also picked up photography at the Bauhaus and deepened his skills in the medium in the late 1920s at the Folkwang School in Essen. His friendship with Henri, beginning in the later 1920s, clearly influenced his work as well. Her sensibility for bold texture and clarity of form begins to unfold in his photographic work too,

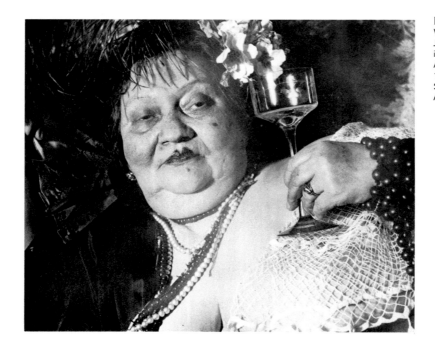

FIGURE 4.4. Max Peiffer Watenphul, Portrait of Johanna Ey, 1931, published in *Photographie 1931* (Paris: Arts et métiers graphiques, 1931), 81. 7.5 x 9.1 in. (19.2 x 23.1 cm). Private collection © Archiv Peiffer Watenphul.

particularly in his portraits and his images of ancient Roman architecture from the early 1930s.[46] Most notable is an extraordinary series of portraits that he produced during the late 1920s and early 1930s, some of which he gleefully titled "Grotesques." Among them are photographs of women, including his glamorous young sister Grace, and Willers, one of his favorite subjects in photography and painting.[47] The women are portrayed in individual, performatively posed portraits; each is encrusted with jewels and beads, draped in layers of fabric and netting or flanked by a gaudy painting, and caked in garish makeup. The most dramatic of these is his photograph of the Düsseldorf-based art dealer Johanna Ey that was one of several by Peiffer Watenphul that appeared in a 1931 volume of cutting edge photography published by the French graphic arts magazine *Arts et métiers graphiques* (figured 4.4). Ey's now famed portrait by Otto Dix, in which she wears a tiara, a purple dress, and a prim half smile, appears quite tame in comparison. Peiffer Watenphul shows Ey in a state of utter excess, as a kind of drunken bacchante or perhaps as Bacchus himself. Ey is enveloped in textured layers; with fans and fabrics surrounding her, she reclines off-kilter with her generous décolleté exposed, bedecked with jewelry, ostrich feathers, lace, fake flowers, and garish makeup. Ey's empty wineglass, half-closed eyes, and state of partial undress give the picture a seedy intimacy and an aura of merry debauchery.

With the "Grotesque" portraits, Peiffer Watenphul abandoned any

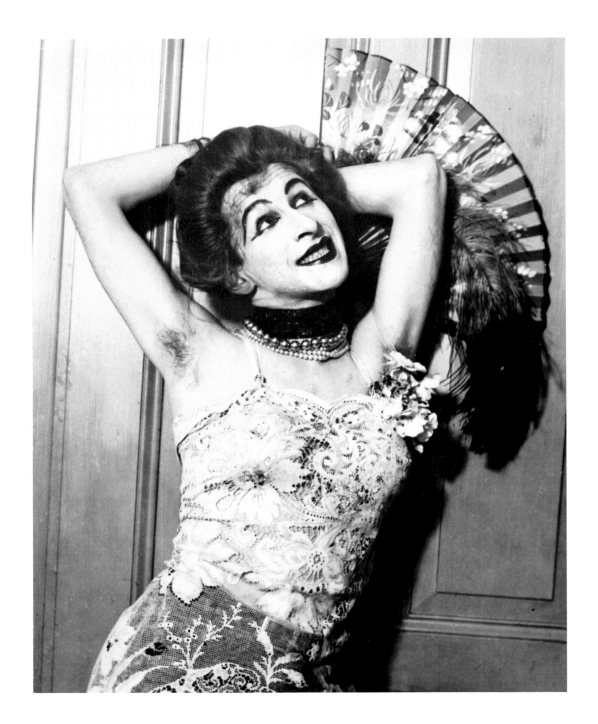

lingering adherence to photographic New Objectivity and the Bauhaus's pared-down aesthetic to embrace a vision of decadent collaboration with his sitters. In a 1932 letter to Cyrenius, he sent an update on the series: "Made brilliant new photos. But people say they're *very perverted*!!!?"[48] With Peiffer Watenphul's portraits in this style, we are deep into the territory of camp, a term that Susan Sontag summed up in her seminal "Notes on Camp," as a "love of the unnatural: of artifice, exaggeration, and double entendre. And Camp is esoteric—something of a private code, a badge of identity even, among small urban cliques."[49] It is, Sontag writes, "good because it's awful," a sensibility and a manner of looking at things that turns on artifice and irony; "camp sees everything in quotation marks. It's not a lamp, but a 'lamp'; not a woman, but a 'woman.'"[50] Camp also embraces gender play and gender ambiguity, as "the triumph of the epicene style. (The convertibility of 'man' and 'woman,' 'person' and 'thing.') But all style, that is, artifice, is, ultimately, epicene."[51] And to be camp, art must embrace a passionate "attempt to do something extraordinary."[52] Camp also draws from subcultural communities and has come to be seen as an inherently queer aesthetic. In the case of Peiffer Watenphul, his subcultures included his Bauhaus connections and, as best as can be reconstructed, his friends in the gay underground scene.

"Woman with a Fan," one of the pictures that Peiffer Watenphul specifically subtitled "Grotesque," has some of the same elements and props as previous pictures, including the necklaces, fan, feather, and cloth flowers (figure 4.5). To the busy, revealing clothes and exaggerated makeup, he has added a wig for this sitter. This is useful in this case because, in contrast to the campy woman shown in the portrait of Ey, the subject of this hyper feminized portrait appears to be a "woman" played by a man in drag. She smiles broadly and flirtatiously lifts her arms overhead in a contrapposto pose that evokes abandonment, as if a moment captured from a dance. A second, close-up photo shows this same subject enveloped from behind by a flower-bedecked cloth; she gazes slyly and pensively off to the side.[53] These two drag "Grotesques," as well as some of the other campy portraits, had a curious afterlife: they ended up in the collection of Nazi industrialist and collector Kurt Kirchbach, and only resurfaced at the end of the 1990s.[54]

In addition to picturing some of the members of Peiffer Watenphul's Bauhaus circles, the "Grotesques" also circulated among them; Josef Albers, remembered as one of the Bauhaus's most austere modernists, owned two photographs from the series.[55] This community of his Bauhaus friends was clearly very important to Peiffer Watenphul; on the back of one of his portraits, of Willers, he pasted a fragment of a text: "this 'occurrence on a summer night' shows us a circle of contemporary people who embody an age-old tradition. They are not adventurers, but rather free people, close to heaven, the earth, and all the beasts."[56] These networks provided Peiffer Watenphul with an ongoing community in which to

FIGURE 4.5. Max Peiffer Watenphul, Woman with Fan (Grotesque) (Frau mit Fächer [Groteske]), c. 1928, gelatin silver print. 11.9 x 9.5 in. (30.2 x 24.1 cm). Gallery Berinson, Berlin © Archiv Peiffer Watenphul.

FIGURE 4.6. Max Peiffer Watenphul, Untitled (Young Italian Man), c. 1931/32, silver gelatin, modern print from vintage negative. 9.4 x 7 in. (23.9 x 17.7 cm). Bauhaus-Archiv Berlin © Archiv Peiffer Watenphul.

experiment with life and queer sensibilities. His photographs from this time playfully recreate theatrical femininities that would have had particular resonance for Peiffer Watenphul, since they likely related to his life as a gay man where cross-dressing was a part of the lively underground gay culture.[57]

Peiffer Watenphul's travels took him to Italy first in 1921; in 1931, he won Germany's Rome prize and spent a year at the German Academy in the Villa Massimo. It was likely during this year that he took another short series of photos, this one showing a young man in a state of near total undress, in sexually suggestive poses (figure 4.6). In these photographs, all trace of campy performativity has vanished. These photographs radiate frank, sexual desire between the model and his photographer. In their direct capturing of a desired Italian youth, they echo the works of German photographer Wilhelm von Gloeden of earlier decades.[58] In all of the photographs in this series, the photographer's subject stares into the camera with a seductive smile. In one, he stands by a bed, a strong suggestion that these photographs are a prelude to a sexual encounter. In contrast to Peiffer Watenphul's paintings, which are faux-naive landscapes and portraits, photography seems to have emboldened him to explore gendered play with his friends and to photograph a young man he desired.

Like Peiffer Watenphul, it was through the Bauhaus that Florence Henri found her path as an artist as well as a circle of like-minded friends. Henri was orphaned at a young age, grew up amidst the European avant-garde, and was trained as a classical concert pianist, but it was a brief visit to the Bauhaus in April of 1927 that would lead her to discover photography as her medium. Two women with whom she was already friends, Margarete Schall and Grete Willers, were studying there; once Henri arrived, she opted to stay on as a nonmatriculated student. As an heiress, Henri had the financial means to make this spontaneous choice. She attended László Moholy-Nagy and Josef Albers's preliminary course and the classes of Wassily Kandinsky and Klee. Lucia Moholy took photographs of Henri there as a distinctively modern woman; it is also relatively certain that Moholy also taught Henri photography, making use of the darkroom in her and Moholy-Nagy's master's house, where Henri likely also stayed. At the Bauhaus, Henri made life-long friends including Walter and Ise Gropius, Hinnerk and Lou Scheper, Herbert and Irene Bayer, and Marcel Breuer, whose chrome-plated Bauhaus furniture was among Henri's purchases—along with a glass teapot by Wilhelm Wagenfeld—when she left the Bauhaus in August. It went to her Parisian apartment, as did her friend Margarete Schall, who by that time at the latest had become her romantic partner.[59] The Bauhaus enabled Henri to learn the technique of photography and to define her artistic practice as well as her social milieu. She in turn would also define the Bauhaus; in 1938, she was the only female photographer included in the catalogue for the first Bauhaus

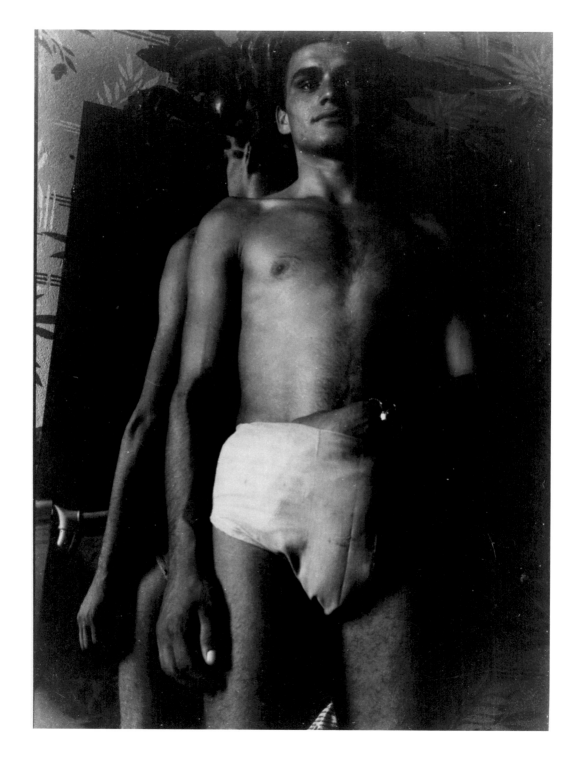

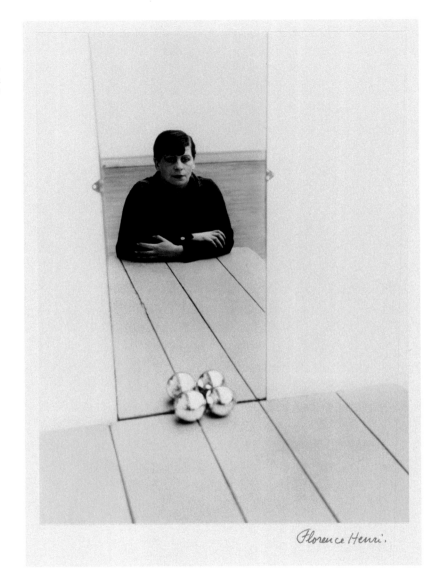

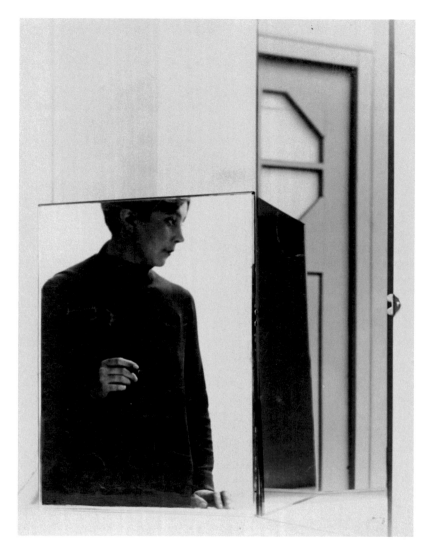

FIGURE 4.8. Florence Henri (1893–1982), Portrait Composition (Margarete Schall), 1928, gelatin silver print. 10.6 x 7.7 in. (27 x 19.6 cm). Museum Folkwang, Essen, Photography Collection. © Galleria Martini & Ronchetti, courtesy Archives Florence Henri. Photograph © Museum Folkwang Essen–ARTOTHEK.

exhibition in the U.S., held in New York, the city of her birth, at the Museum of Modern Art.[60]

In his 1928 essay on her photographs for the Dutch international art journal *i10*, Moholy-Nagy wrote that, with Florence Henri's photos, "photographic practice enters a new state to a greater extent than previously could have been predicted."[61] Above all, she created groundbreaking images of daringly independent womanhood, such as her 1928 "Self-Portrait," now an icon of interwar photographic history (figure 4.7).[62] Henri appears stoically reflected in a mirror; she shows herself in a setting that is stripped down to a bare minimum of architectural elements that are staged so that they appear both perfectly aligned and off-center at the same time. With its architectural strictness and its strangely absent subject—she appears in the mirror but not in the primary space of the picture—Bauhaus intersects with surrealism. Henri has placed metallic reflective spheres at the base of the mirror, the same photographic elements Marianne Brandt used, also in 1928. In Henri's photo, she has paired and positioned them in such a way that she has endowed herself with "balls," a visual pun that clashes with the seriousness of her pose and setting. Yet this is also a moment of an abstracted queer pairing. Two perfect objects are paired to emphasize their sameness; they are two of a kind. And, unlike the work's ostensible subject, the metallic spheres do appear on both sides of the mirror to highlight their symmetry and the perfection of their forms.

In addition to her self-portraits and modernist still lifes, Henri also trained her lens on other women, as well as on a few men, Peiffer Watenphul among them. She made several photographs of her partner, Schall, that, like her self-portraits, intermingle off-kilter mirrored reflections with architecture, creating competing centers of visual attention and making it difficult to specifically place their illusive subject. In a photograph from 1927 or 1928, Schall, smoking, appears boyish, modern, and seemingly lost in thought (figure 4.8). This is a remarkably self-possessed woman, a lesbian subject whom we can see but can't quite place, for she is just out of reach.

Henri also took a series of intimate and sensual photographs of the *Bauhäusler* Ré Soupault, who had likewise moved to Paris and whose transformational dress and photographs are featured in chapter two (figure 4.9). Reclining on a soft white ground and, with her eyes almost closed, seemingly half asleep, Soupault is nude but for draped netting that eroticizes her. The netting brings to mind lingerie and even fetish gear, an association furthered by a prominently revealed erect nipple. Yet this is also a modern nude of a beautiful, reclining woman, and this was one of Henri's specialties as a photographer.

At the end of the 1920s, Henri's photographs were suddenly everywhere; in 1929, a reviewer of the *Contemporary Photography* exhibition in Essen wrote, "France contributed with many dated imitations but only one modern photographer: Florence Henri."[63] That same year, she had

over twenty photographs in the 1929 *FiFo* (*Film und Foto*) exhibition in Stuttgart. Her "Composition" with mirrors and bobbins was among the few pictures illustrated in the exhibition's catalogue. Josef Albers, a tough critic, could not resist marking "the best" next to Henri's photo in his own copy of the catalogue—something he wrote to her to say he had simply been compelled to do.[64]

Just as she was achieving success as a creative photographer, the Great Depression set in, beginning in 1929 and 1930. Henri's inheritance no longer provided her with sufficient income during the ensuing years. She opened a portrait studio, took on a range of commercial work, and trained students, some of whom, like Gisèle Freund and Lisette Model, would each go on to develop strikingly original approaches to human subjects and portraiture. Through her commercial work at this time, Henri also popularized New Vision photography in unlikely places, including the soft-core pornographic *Paris Magazine*, which billed itself as being "très AUDACIEUX" and containing "100 very lively photographs"; in addition to Henri's work, the magazine published more conventional pin-ups and film stills as well as surrealist nudes by Germaine Krull and Man Ray.[65] Still, Henri's nudes are unusual for this context (figure 4.10). As with her photograph of Soupault, almost without exception, their subjects do not meet the viewer's gaze. They carry an erotic charge but, to a certain extent, they also retain a degree of self-possession; at the same time, their lack of any confrontational gaze also means that their bodies are available to the viewer. In a *Paris Magazine* image from 1934, a nude woman with short cropped hair is shown from the waist up, reclining on perhaps the same soft white cloth as in Soupault's picture. But this woman appears upside down, so that her body is both eroticized and made strange. While it may have appeared in a mainstream, soft-core publication, this is not a typical nude with a coy, come-hither look. Instead, it is more a photograph of an unclothed, beautiful individual.

Other photographs of Henri's draw more overtly on the iconography of bondage even as they create new female types of a sexually self-possessed modern woman. A portfolio of nude photos from 1934 includes an image of a slim woman shot close in so that her figure entirely fills the picture plane (figure 4.11). These photographs do not seem to have been made for her commercial work that went to mass-market print, but as singular pictures, art for pleasure. In this particular photograph, the subject is wearing nothing but a belt, a slim strip of black leather with a shiny buckle that divides her lithe body in two and echoes the architectural black stripe on the wall behind her. The belt makes this woman's nudity overtly sexual, as if she were dressed for an erotic game, and yet the photo's young subject with her bobbed hair appears pensive and independent, like a Diana for the modern age. Here again, the model averts her gaze from the camera, a gesture that evokes her own sensual experience and mental life. And yet, this erotically charged picture could clearly appeal to any viewer,

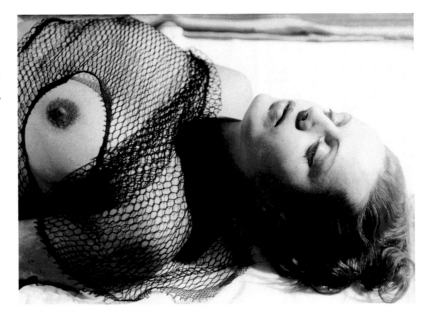

FIGURE 4.9. Florence Henri, Portrait of Ré Richter (later Ré Soupault), Paris, 1930, modern print (2007) from original glass-plate negative. 10.2 x 15 in. (26 x 38 cm). Ré Soupault Archive, Heidelberg. © Galleria Martini & Ronchetti, courtesy Archives Florence Henri.

FIGURE 4.10. Florence Henri, Untitled photograph published in *Paris Magazine*, 1934. Page: 7 x 10.6 in. (17.8 x 27 cm), photographic reproduction: 5.3 x 6.9 in. (13.5 x 17.5 cm). Private collection. © Galleria Martini & Ronchetti, courtesy Archives Florence Henri.

female or male. Since Henri apparently did not sell these photographs for publication, she maintained control of visual access to these images that seem to have remained more as private objects, shared among friends and within the space of the studio.[66]

Considering both Max Peiffer Watenphul and Florence Henri as queer Bauhaus figures illuminates new aspects of their work, and reveals previously unseen circles of attachment, another side to the Bauhaus itself. These networks of Bauhaus photographers fostered the creation of new forms of imagery, campy portraiture, "Grotesques," nudes that burn with queer longing, and others whose nudity speaks to their self-possession and their own desires as much as the viewer's. Already a part of the Bauhaus diaspora, both Peiffer Watenphul and Henri published their queer photographs in Paris. Not only was France more receptive to such work in its mainstream publications than was Germany, but by 1934, when Henri published her *Paris Magazine* nudes, the Nazi assumption of power and the *Gleischaltung* (state coordination) of its media would have made the mainstream publication of these photographs in Germany—by a foreign woman, no less—extremely unlikely. Still, the presence of queer *Bauhäusler* persisted in Germany even during the Nazi period, as in the case of the next *Bauhäusler* to whom we will turn, Margaret Camilla Leiteritz. Like Henri, she created works that seem to vacillate between queer pairings and radical independence, but many of them draw deeply on coded languages of abstraction.

Elle loua une maison, sur les remparts Camino, non loin de celle où Pierre Loti vint mourir, lassé de tant de voyages.

Elle ne sortait jamais. Une vieille servante basque, à moitié sourde, sévère comme une porte de prison, faisait le ménage et les commissions. Quand on l'interrogeait sur sa maîtresse, elle faisait celle qui n'avait pas entendu.

Pendant un mois, les cancanières du bourg s'inquiétèrent de cette recluse ; puis personne n'en parla plus.

●

J'ai dit qu'elle ne sortait pas de sa maison ; ce n'est pas tout à fait exact. Si on ne la voyait jamais en ville, on pouvait apercevoir Mercédès, à la belle saison, prendre son bain.

A marée haute, le flot remontant l'estuaire venait battre le pied de la terrasse feuillue qui servait de jardin à l'espagnole. C'est à ce moment que Mercédès descendait d'un pied craintif l'escalier, usé par les vagues et par le temps, rejetait son peignoir blanc et se précipitait dans l'eau.

Des jeunes gens tentèrent d'approcher la baigneuse.

Ils ne réussirent qu'à la faire s'enfuir après avoir eu, l'espace d'une seconde, la vision de sa brune beauté. Alors, comme les commères, ils se lassèrent bientôt de s'intéresser à la solitaire.

Toutes les semaines, au début de son séjour à Hendaye, le facteur lui apportait du courrier venant d'Espagne : une lettre chargée. Puis les envois se firent rares, cessèrent. C'est à ce moment que Mercédès avisa une agence de location qu'elle était disposée à sous-louer une partie de sa villa. Condition expresse, le locataire serait une femme.

●

A la même époque, Mme Thérèse J..., qui habitait le splendide hôtel d'Hendaye-Plage, venait d'être abandonnée par son amant.

L'amant était jeune, riche, amoureux et généreux. Thérèse perdait tout en le perdant.

oto Florerce Henri

A QUEER SINGLETON: MARGARET CAMILLA LEITERITZ

"She must have been an unusual woman."[67] Such is the conclusion reached by Klaus E.R. Lindemann in writing about the life and work of the *Bauhäusler* Margaret Leiteritz. In particular, Lindemann is looking at a series of forty paintings that Leitertitz made from 1961 to 1974 titled *Painted Diagrams* (*Gemalte Diagramme*). One of these, *Point Interceptor* (*Punktfang*), shows an eerie night scene of glowing, colorful orbs in space, arrayed out on barren branches like pussy willow blossoms (figure 4.12). The atmosphere around these abstracted, seemingly natural objects is modulated, like clouds in the night sky. Formally, paintings in this series evoke those of Georgia O'Keeffe and, closer to home, Moholy-Nagy—who left the Bauhaus in 1928, just as Leiteritz arrived, but whose work she would have known. And they draw on the teachings of Josef Albers, with whom Leiteritz studied and whose methods she drew on specifically for making these paintings, thirty years and more after she left the Bauhaus. Albers encouraged students to maintain a collection of colored papers in order to aid in color selection for compositions; Leiteritz possessed such a collection and, for each picture, created a full list of the precise the colors she used.[68]

Where *Point Interceptor* really shows itself to be "unusual," to borrow Lindemann's word, is in the graph that Leiteritz preserved to show its inspiration, something she did for each of the works in the series. Titled, *Measuring Points on Six Straight Lines*, the simple line graph has the same composition as the painting; further accompanying documentation tells us that the graph shows "composition vs. temperature of six viscosity index improvers" from a scientific paper on "Viscosity-Temperature Characteristics of Hydrocarbons" published in the journal *Industrial and Engineering Chemistry* in 1949.[69] Thus the seeming pure abstraction of *Point Interceptor* is in fact a figural representation, and doubly so. First, it precisely recreates the composition of an extant graph that charts these lines and points; second, the graph itself is a representation of specific scientific information with which the artist would have been familiar. In fact, all of Leiteritz's *Painted Diagrams* were based on scientific diagrams to create sublime abstractions. These are strange paintings, but this does not fully explain why the woman behind them would herself be characterized as "unusual."

At the Bauhaus, Leiteritz studied in the free or fine-art painting workshop for two semesters and for a semester in the weaving workshop; she is, however, best remembered for her central role in the wall-painting workshop during the late 1920s, a time when the workshop was undergoing a major conceptual and practical shift.[70] At the start of 1929, the energies of the workshop were focused on developing modern wallpaper for mass production and installation in homes, in order to replace the time-con-

FIGURE 4.12. Margaret Camilla Leiteritz, *Point Interceptor* (*Punktfang*), 1962, oil on masonite. 12.6 x 14.2 in. (32 x 36 cm). Collection of the Heinrich Neuy Bauhaus Museum, Steinfurt.

suming practice of painting walls. Workshop members collaborated with *Bauhäusler* Maria Rasch, whose family owned the Gebrüder Rasch wallpaper company, in order to produce Bauhaus designs. Trying to imagine what Bauhaus wallpaper should look like, the workshop's students competed to create the best designs, and one-third of those that were selected for production were by Leiteritz. Then, at the Rasch factory, Leiteritz supervised the manufacture of all of the Bauhaus wallpaper designs, a project that generated so much income for the school that it financed its last years.[71] Summing up his accomplishments as the Bauhaus's director when he was forced out in 1930, Hannes Meyer stated that, "Within one year, 4,000 homes had been lined with Bauhaus wallpaper."[72]

Leiteritz received her Bauhaus diploma in May of 1931, a difficult time to find a position as a designer or artist, and so, in 1933, she fell back

on her first profession, librarianship, working first in Dresden's Decorative Arts Library during the entirety of the Nazi period (1933–1946) and eventually at the Institute for Gas Technology, Fuel Technology, and Water Chemistry at Karlsruhe's Technical College. Through her multifaceted education and career, Leiteritz developed tremendous knowledge of both art and science, as well as of systems and the transfer of information, and these diverse interests coalesced in her art practice, maintained on the side of her professional life, particularly in the work of her *Painted Diagrams*. In addition to their scientific content and their abstract beauty, these open-ended works can also be interpreted as gesturing toward her own unusual life.

Lindemann's characterization of Leiteritz also applies to her personal life. He quotes her own 1952 application for the position in Karlsruhe; "I am single and independent of attachment to a particular place of residence."[73] Leiteritz never married, and astonishingly little information—more or less nothing, in fact—has survived regarding her personal life or any romantic partnerships. We know from other sources that, with her friends, she used the modern and ambiguously gendered nickname "Mark," which shortens her first name, and masculinizes it.[74] Unmarried, unpartnered, and at times ambiguous in her gender performance, Leiteritz reads historically as a version of queer. It could be that she was a lesbian who very carefully covered her tracks, something at which a librarian and archivist would have been particularly adept. But she may also be another kind of woman who breaks out of the mold: the singleton.

The emerging field of singleness studies enables us to avoid, in the words of Andreá Williams, "recentering coupling" as the key for understanding every life. It also helps us to move beyond assumptions that an unwed or unpartnered individual's desires and sex life must be "hidden" if we do not know about them.[75] Indeed, Leiteritz's singleness—her refusal to couple—seems to have been central to her identity. We may also read it in her abstractions. Some of these, like *Curve in Daylit Room* of 1970, with its beautiful, shaded white line arcing through clear but gently modulated blue space, edit out other lines from her original source material in order to trace exquisite, solitary trajectories that arc through a graph of time and space, as if they were an abstracted representation of a beautiful solo life.[76] While Leiteritz gave some of these works titles that merely describe their curves, she gave others names like *Solitary Line* of 1966 or *Pilgrimage* of 1963.[77] We can consider these as abstract works that gesture to personal truths.[78] But Leiteritz's paintings also stand as a kind of queer art of negation, a defining refusal not only to conform in both her life and art, but to explain herself.

In addition to her gloriously strange abstract paintings, Leiteritz did make figurative drawings and paintings during her 1928 to 1931 Bauhaus period and throughout the 1930s, including a significant number of costume designs.[79] Several of these represent female pairs and individuals in

FIGURE 4.13. Margaret Camilla Leiteritz, *Psyche*, illustration for the artist's book *Amor and Psyche*, 1929, reproduced from Claudia Hohmann, *Margaret Camilla Leiteritz: Bauhauskünstlerin und Bibliothekarin* (Frankfurt: Museum für Angewandte Kunst, 2004), 49. Reproduction: 6 x 4.5 in. (15.2 x 11.4 cm).

FIGURE 4.14. Margaret Camilla Leiteritz, *Ceres and Juno*, illustration for artist's book *Amor and Psyche*, 1929, reproduced from Heinrich P. Mühlmann, *Margaret Camilla Leiteritz: Studium am Bauhaus* (Dessau: Meisterhäuser Klee/Kandinsky, 2006), 35. Reproduction: 3.25 x 2.7 in. (8.3 x 6.9 cm).

intriguing ways. In 1929, Leiteritz completed a series of stark illustrations in the almost cartoon-like style she used in much of her graphic work, for the classical tale of *Amor und Psyche*, long depicted by artists as centered on a beautiful young man and woman who long for each other but are kept apart by the wrath of the gods and cruel fate. Leiteritz's simple ink drawings instead focus almost exclusively on female figures. One of these shows Psyche in an elegant gown and flanked by a flower-covered drapery; her hands are raised and her hair flows out behind her as she dives off alone into the unknown (figure 4.13). Another features the Roman goddesses Ceres and Juno, easily identifiable through their attributes, Ceres with wheat from a bountiful harvest, and Juno with her peacock (figure 4.14). With a minimum of detail, Leiteritz shows the two women's bodies situated in an unspecified space; they are pressed together in a contemplative pose as they gaze off into the distance, smiling.

In 1937, she completed another series of images that center on female pairs, three gouache and pencil drawings that she called *Illustrations for "The Story of the Six Women,"* which, she indicated, was one of the tales in *Thousand and One Nights*. The setting of each scene here too is largely undefined, abstract white space. This is in keeping with a Bauhaus approach, but it also allows the story to exist in the open space of fantasy. The six women all appear in pairs of two, always with at least one figure in a provocative state of undress. In the first, the women look out and engage the viewer; in the other two, they turn their attention to each other.[80] In the second illustration, the woman on the right has her back to us as she proudly drops her beautifully patterned garment and displays her corpulent body to the other woman (figure 4.15). The skinny figure on the left wears nothing but heels and reclines on a bench or low wall, a slim horizontal line that is the only detail of a setting in these pictures. This second figure strikes a complicated pose; her upper body is turned coyly away, but she looks to the other woman with seeming interest and exposes her crotch—cartoonishly marked by a dark stripe of pubic hair. The third picture shows a disrobing blond, white woman paired with a fully clothed black woman. They too engage each other with looks that could be wary or anticipatory.

That "The Story of the Six Women" comes from the *Thousand and One Nights* means that Leiteritz was illustrating content from a classical tale. Except she wasn't. There is no such tale in the complete translations of the *Thousand and One Nights* in either English or German. There is, however, "The Man from Yemen and his Six Slave Girls," and the women's physical descriptions in the story conform precisely to the pairs of women in Leiteritz's three pictures. This is a story within a story told to Khalif El Mamoun of a wealthy man from Yemen who comes to Baghdad with his family and stays. With him are his wonderous "six slave-girls, the first fair, the second dark, the third fat, the fourth thin, the fifth yellow and the sixth black, all fair of face and perfectly accomplished and skilled in the arts

FIGURE 4.15. Margaret Camilla Leiteritz, *Illustration (two of three) for "The Story of the Six Women"* ("Die Geschichte der sechs Frauen," as adapted from *The Thousand and One Nights)*, 1937, gouache and pencil. 17.9 x 17.9 in. (45.5 x 45.5 cm). Reproduced from Peter Hahn, ed., *Junge Maler am Bauhaus* (Munich: Galleria del Levante, 1979), n.p.

of singing and playing upon instruments of music."[81] The story focuses on the utter enchantment with these "girls" by both Khalif El Mamoun and the man from Yemen. But in her recasting of the tale as "The Story of the Six Women," Leiteritz has edited out any indications of them performing or singing, and, most important of all, she has removed the men from the story, who are the sole audience for their delights in the original. Rather than merely illustrating one of the *Thousand and One Nights*, in fact, Leiteritz is the storyteller here, and all distractions—male characters or any indication of surrounding interiors—are put aside to focus exclusively on same-sex pairings between women who display their bodies and interact mostly with one another. These "illustrations" are clearly isolated moments extracted from tales, but these are tales that have not yet been written. None of the paired six women touches another, and we are left to wonder how their stories will continue to unfold beyond the frames of these illustrations.

Essential to note is that these pictures were made in 1937, when a representation of overt female same-sex desire in Nazi Germany

FIGURE 4.16. Richard Grune (with Niels Brodersen), cover of *The Children's Red Republic: A Book by Workers' Children for Workers' Children* (*Die Rote Kinderrepublik: ein Buch von Arbeiterkindern für Arbeiterkinder*) (Berlin: Arbeiterjungendverlag, 1928). 11.3 x 9 in. (28.7 x 22.9 cm). Private collection.

would have been risky at best, and could have resulted in arrest and incarceration in a concentration camp. While gay men were much more often the victims of Nazi homophobia—after all, §175, which was still in place, applied men to only—there was intense pressure for women to conform to gender norms.[82] As Claudia Schoppmann has pointed out, lesbians were aware of the danger and tended to retreat into small circles of friends.[83] In this context, Leiteritz's representations of scenes of nude and partially nude women having sexually charged interactions in abstracted, private spaces could have related to Leiteritz's actual experiences or fantasies during these perilous times. Regardless, creating such images under a fascist regime that strictly regulated both the content of art production and its citizens' sexual behavior could only occur if the pictures were presented as something other than expressions of the artist's desire. As mere illustrations for a classical "exotic" text like the *Thousand and One Nights*, written long ago and far away, these pictures could be held harmless. Leiteritz's abstractions, even when she is working in a representational mode, parallel the blank spaces that she left behind in her biography—even if they do not explain them.

QUEER POLITICS: RICHARD GRUNE

Nazi Germany's vehement homophobia was indeed a greater threat to men; this prejudice became increasingly focused as official policy during the second half of 1934.[84] In the final portion of this chapter, I will briefly consider the work of Richard Grune, a *Bauhäusler* who, like Leiteritz, stayed in Germany during the Nazi period. This was not the case for Loew and Henri; Peiffer Watenphul remained in Italy until his financial situation obliged him to take a teaching post in Krefeld, Germany—one that had been obtained for him by his former Bauhaus teacher Georg Muche. Grune was in Germany for the entire Nazi period, and his experience and the remains of his work are particularly instructive for understanding why traces of a queer Bauhaus have so long remained hidden. If it was dangerous to be a gay man living under §175 during the Weimar Republic, it was deadly under Nazism. In considering the experience of state-sponsored terror, Avery Gordon points out that we cannot comprehend these events in their full dimension. Rather, she turns to Raymond Williams's "structure of feeling" to explore what we might be able to recognize; this is an open-ended concept denoting the space between official discourse and the popular response to that discourse, particularly as it may be represented in cultural artifacts.[85] Gordon states, then, that we can understand the experience of state-sponsored terror through the ghost that "makes itself known to us through haunting and pulls us affectively into the structure of feeling of reality we come to experience as a recognition."[86] As I will show, engaging the fragments of Grune's surviving oeuvre pulls us both to his queer utopias and his anguished mourning.

Chapter 4

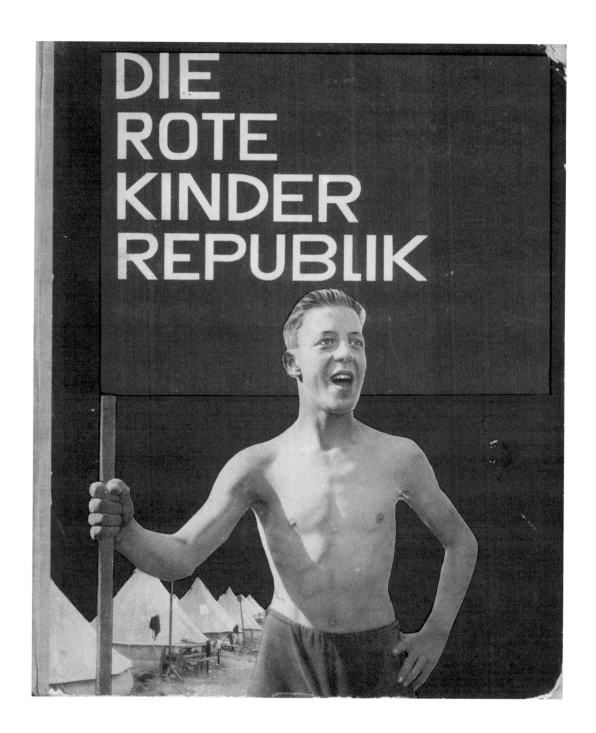

"Mr. Grune still requires some time to gain greater peace in the new world that arises in Weimar and the Bauhaus for him. His powers, however, seem certainly able to become remarkable."[87] This was Gertrud Grunow's assessment of the young Grune when, in July of 1922, he had just finished his first semester. Although he was only eighteen at the time, he already had five semesters of graphic design studies in his native Kiel behind him, completed before coming to the Bauhaus.[88] He was instructed to repeat the preliminary course, as were eight other students, including one who would become among the most famous *Bauhäusler*, the future Anni Albers.[89] But after another semester, Grune, along with one other student, was still deemed unready for acceptance into a workshop—"indecisive" seemed to be the main criticism of Grune—and so he left.[90] This was not an infrequent fate among *Bauhäusler*, many of whom were at the school for as little as one semester. Still, that Grunow diagnosed Grune as in need of "greater peace" to adjust to the new world he was encountering at the Bauhaus also evokes the possibility that Grune was coming to grips with his own sexuality as a gay man in a homophobic society, which, by all later accounts, he was, unambiguously.

Although Grune left after a year, his Bauhaus training and experiences were clearly imprinted on his subsequent overtly modern and constructivist graphic design and his work as a leftist activist in the Social Democratic Party. He drew illustrations and took photographs for party newspapers. In 1927, he became the artistic director of the Social Democratic National Working community's first summer camp. Dubbed "the children's red republic," the Seekamp camping ground near Kiel hosted 2,300 children from working-class families; principles of collaboration, self-governance, and pacifism were preached. Working together with the children, Grune and another artist, Niels Brodersen, produced a book the following year to commemorate *The Children's Red Republic* through photomontages of scenes of the children's independent lives there.[91] The book's cover shows a strong and happy youth who holds up a stylized red flag of the imagined republic, an optimistic harbinger of the new day in a reimagined society that the children and the artist clearly believed was dawning (figure 4.16). While the picture does not convey queer content per se, an image of a healthy boy on the cusp of manhood who was part of a free, utopian community certainly offers an inviting alternative to those seeking to live outside of traditional norms. Using his photography and design skills to commemorate utopian children's communities became a bit of a specialty of Grune's; three years later, in 1931, he would produce another such book, this one to commemorate the sixth official meeting of German Workers' Children in Frankfurt and a camp that they hosted on the Rhine island of Namedy.[92]

With the Nazi assumption of power in 1933, Grune continued his socialist activism and, along with friends from Kiel, helped to create two single-edition anti-fascist newspapers, one in 1933 and another in 1934.

He was arrested in 1934, but not for his anti-fascist activities or propaganda production; Grune had been denounced as a homosexual who, according to the source, had held two extravagant gay parties in his Berlin artist's studio.[93] Convicted as a homosexual, Grune would spend the next eleven years almost entirely in various prisons and concentration camps. In 1937, he was sent to Sachsenhausen and from there, in 1940, on to Flossenbürg, a forced labor camp with a stone quarry where known gay inmates were routinely given the most brutal and deadliest work. Grune left the camp as part of a death march in 1945 but managed to survive.

§175 remained law in Germany until 1994. After the war, those who, like Grune, had been arrested by the Nazis for homosexuality were never compensated for their losses by the successor governments in East or West Germany, and in fact their persecution by the state often continued. Grune's pre-war work, other than that which was published, seems to have been entirely destroyed, and he was never interviewed about his Bauhaus work or his life. However, in 1945, the same year that he managed to come out of Flossenbürg alive, Grune produced a series of lithographs, titled *Passion of Twentieth Century*, that represented some of

FIGURE 4.17. Richard Grune, *"Rack": Flogging in the Concentration Camp* (*"Bock": Prügelstrafe im KZ*), 1945, published in 1947, lithograph. 16.7 x 12.2 in. (42.5 x 30.9 cm). KZ-Gedenkstätte Neuengamme.

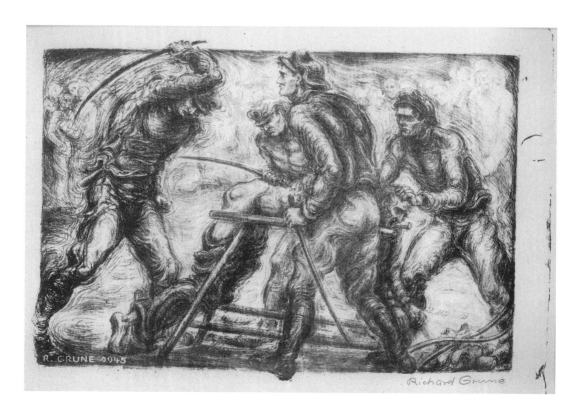

the horrors of his experiences in the concentration camps. *Rack*, a scene of torture, centers on a victim bent over a saw horse and being whipped (figure 4.17). He appears emaciated, half dead, indeed a mere ghost of a man. The expressive gestures through which Grune seeks to communicate the unimaginable horrors of the concentration camps, among the most dehumanizing experiences possible, still draw on his Bauhaus training through the gestural drawing practiced during his year of study with Johannes Itten. More significant than any particular lineage to Grune's formal approach, as Thomas Röske has pointed out, what is most striking and most disturbing about this picture is its eroticism. The artist's lines linger with great attention to detail on the bodies of the muscular, broad shouldered, and clearly brutal guards. And while this is an autobiographical picture of Grune's memory of being savagely beaten, it also looks as if this is a scene of gang rape.[94] It was through his art—with its capacity both to represent and to suggest without specifying—that Grune could memorialize his own suffering. In *Rack*, he draws particularly on queer codes to image his grief and perhaps to exorcize his memories. Yet while the *Passion of the Twentieth Century* series explores the artist's own martyrdom, it does not offer any satisfying resolution to the senseless persecution and violence that Grune only barely survived.

QUEER HAUNTINGS

Given that Nazism sought to eradicate all traces of interwar Germany's vibrant queer culture, it is important now to restore to the Bauhaus's story what we can of the queer Bauhaus histories that haunt its margins. The school's administration is not known to have overtly offered a hospitable space to transgender, gay, or lesbian artists, and, indeed, there is some evidence that they may actively have been kept out of the school. Yet the Bauhaus did foster experimentation more broadly, and the precise nature of those experiments was something determined as much by incoming students as the administration. Taken purely on their artistic merits, several of the artists I have identified in this chapter as queer belong to the most talented of the school—they were successful painters, photographers, and designers. It may be that queer Bauhaus artists often fulfilled the school's mission so fully in part because, to return to Katz's point, they needed to be particularly inventive in order to communicate in code, and to constitute their emerging audience of other viewers attuned to queer ideas.

In their time after leaving the school, *Bauhäusler* had a range of connections to the institution and to each other. Networks that started at the school—in friendships and perhaps shared aesthetic and cultural sensibilities—extended across time and space, as we see with the circles of Peiffer Watenphul and Henri. These artists stretched the Bauhaus's approach in creative ways to accommodate and even celebrate queer

visions and the play of groups of queer Bauhaus friends. Leiteritz's singular abstractions and queer pairings exemplify how the generation of independent New Women that the school fostered—the focus of the previous chapter—included some who dared to live new kinds of radically independent lives, which may or may not have included intimate relationships with other women. In Leiteritz's case, we will never know. She was a very good archivist who curated her legacy for posterity through a selection of works and documents; the rest she consigned to the trash heap. Grune's fragmented life story and largely missing artistic oeuvre demonstrate the intense danger and violence experienced by some *Bauhäusler*, especially those who, through their politics and their sexuality, dared to push society's limits. The work of identifying and engaging with what remains of a queer Bauhaus does permit us to think—along with Elizabeth Freeman's writings on queer hauntology—about a history in which new social relations and new works tell the story. Perhaps, as she indicates, this can also produce new forms of social justice.[95]

In Grune's and other *Bauhäusler*'s art and histories, questions of politics also haunt the margins. In the book's final chapter, "Red Bauhaus, Brown Bauhaus," I will turn more specifically to the issue of politics and the specter of Communism that is so frequently repressed from Bauhaus history. Even more disturbing is another topic that this chapter takes on: Bauhaus connections to Nazism.

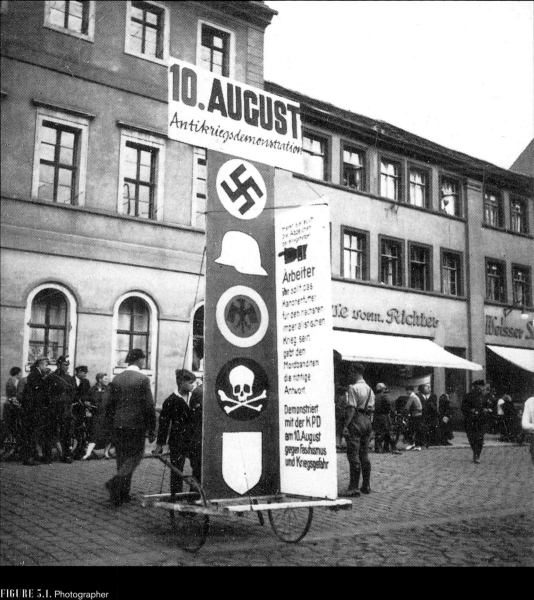

FIGURE 5.1. Photographer unknown, Bauhaus Students' Agitation Cart for the Anti-War Demonstration in Dessau (Agitationswagen der Bauhausstudenten zur Antikriegsdemonstration in Dessau), 1930. 3.9 x 3.6 in. (9.9 x 9.1 cm). Location unknown; reproduced from *Bauhaus Photography* 309. Designs

RED BAUHAUS, BROWN BAUHAUS

DESIGN POLITICS

A photograph of Dessau's city center from the summer of 1930 shows modern design on a mission: a propaganda cart made by Bauhaus students to alert and invite fellow citizens to the anti-war demonstration of the German Communist Party, known as the *Kommunistische Partei Deutschlands* or KPD (figure 5.1). This cart is a Bauhaus object that did not survive the intervening fascist years. It wasn't intended to, since it was made as a quick, clear communication device for the moment, not for posterity. In the photograph, the cart is flanked by two youths, a well-behaved local boy minding the cart to the left, and a poised young man to the right, his back to the camera. He wears the uniform of the Red Front Fighters' League (*Roter Frontkämpferbund*), the party's paramilitary arm, and is presumably there to talk politics with any curious passersby, since recruiting friends and neighbors for the growing Communist movement was an important activity of party members. A policeman observes the orderly scene from a distance—he is at the photograph's left edge—but seems unconcerned.

This cart is an excellent example of Bauhaus advertising design, with its clear modernist symbology that conveys a direct trajectory from fascism and nationalism to war and death. In order to protect individual *Bauhäusler* within the collective, no artist's name would have been attached to such pieces, but the cart's style is very much that of Bauhaus typographer Theo Ballmer, one of a handful of students who were expelled for their political activity just a few months later, in the fall of 1930.[1] Next to the attention-grabbing symbols is a more specifically worded message: "Workers, you are supposed to be the cannon fodder for the next imperialist war. Give the murderous scoundrels the right answer. Demonstrate with the KPD on August 10th against fascism and the danger of war."

The days in 1930 leading up to this demonstration constituted a volatile moment in the life of the Bauhaus. On August 1st, after two years in the role of the school's second director, Swiss architect Hannes Meyer was unceremoniously fired, or, as he would put it in an open letter to Dessau's Lord Mayor published in the Berlin journal *Tagebuch* (Diary) two weeks later, "expelled."[2] On August 5th, likely around the date of this photograph, Ludwig Mies van der Rohe signed his contract to become the school's

new, and, as no one could have predicted, final director.

Still, looking back, this photograph of a propaganda cart in 1930 appears to capture a hopeful moment. That many in the school turned to Communist activism reminds us that the terrible future of the school—and of Germany and Europe—was not a foregone conclusion. In some ways Bauhaus Communism seems the logical outcome of the utopian seeking that had motivated it from its very start. But, as this chapter will reveal, Bauhaus methods and aesthetic approaches had no inherent politic direction. As Germany became increasingly politicized in the late 1920s and early 1930s, so too did the Bauhaus. The Bauhaus and *Bauhäusler* could be "red" (Communist), "brown" (fascist), or many other political colors and stripes, as the movement's global dissemination during the 1930s demonstrates. This chapter will look at how diverse political ideologies became the driving force behind the work of many *Bauhäusler* both while the school existed and after its final closure, after fascism became the law of the land.

The Bauhaus's history after 1933 often centers on those members who emigrated, but in fact, the majority of *Bauhäusler* either could not leave Europe for safer shores or chose not to. They stayed in Nazi Germany or in the countries that it began annexing by treaty or occupying by force between 1938 and 1942. Rather than looking at the New Bauhaus in Chicago or the *Bauhäusler* who worked at North Carolina's Black Mountain College, staying focused on the Continent allows us to examine not only those Bauhaus members who survived Nazism, but those who embraced it or became its victims. This approach also allows us to look at the Communist afterlife of *Bauhäusler* in the Soviet Union. As we will see in this chapter as well, female *Bauhäusler* played an essential role in these aspect of the movement, and gendered ideals and ideology were important in the Bauhaus's interface with both Communism and Nazism.

BAUHAUS COMMUNISM

In the spring of 1928, nine years after he opened the Bauhaus, Walter Gropius stepped down from directing a well-functioning school that had become a beacon for creative youth from throughout Europe and beyond.[3] He transferred the directorship to Meyer, a political leftist who oriented the school toward designing affordable housing and practical prototypes for mass production in order to serve the broad public. Under Meyer, "the needs of the people instead of the need for luxury," became the Bauhaus's watchwords.[4]

Like their new director, Bauhaus students were increasingly politicized; a small minority of them embraced the ideology of the nationalist right, but most vocal were the members of the larger group, the Communist and Socialist left. Architecture student Belá Scheffler had established a Com-

munist cell within the Bauhaus already in the summer of 1927, prior to Gropius's departure.[5] It became known as the "Kostufra," short for *Kommunistische Studenten Fraktion* (Communist Students' Faction), and was the strongest political party at the Bauhaus; when it organized meetings, demonstrations, and other events, as many as sixty percent of the school participated.[6] Soon, the cell had at least thirty-six official members, over twenty percent of the student body, a significant number given that party membership carried automatic dues that many students could ill afford.[7] According to Michael Siebenbrodt, one of the first to research Bauhaus Communism, at least another fifteen were highly active without becoming official members, which means that as much as a quarter of the Bauhaus student body was directly involved in Communist activities during the period from 1928 to 1930.

In considering the turn of so many at the Bauhaus to Communism, Avery Gordon's assessment of what Marxist Communism makes visible is instructive,

> Marxism…provides a paradigm for understanding the impact of unseen forces. Marxism calls the ensemble of these unseen forces a mode of production, which never can be located as such, but that produces real, often quite phantasmatic, effects: objects that come alive only when you can't see the labor that made them; markets that are ruled by invisible hands; value that is a surplus of what has been appropriated from you; groups of people, classes, that are bound to each other in a wrenching division.[8]

Particularly under Meyer's direction, the Bauhaus, a school of design focused increasingly on the production of goods, sought not only to make visible all classes of consumers but to begin to align itself with those goods' laboring producers. This is, in many ways, the next step for the artist-engineer type that I discuss in chapter 2. Donning the coveralls of the laborer was, for many in this politicized environment, no longer enough; one had to begin to identify with the proletariat.

Bauhäusler Irena Blühová later recalled her and other Kostufra students' activism through the "close and friendly contact" that they had with workers at the local Junkers factory. On one occasion in 1931 or 1932, she and a number of Kostufra members conspired with these workers to smuggle a truckload of their children to Berlin for a Soviet children's festival, despite the fact that the local right-wing government had forbidden them to go.[9] During this period of intense politicization, the Communist students even began to use the iconic Dessau Bauhaus building as a device with which to communicate their ideals. On an evening before a national election day, the inhabitants of the Prellerhaus wing organized and turned their studios' lights either on or off, so that the building's

façade formed a giant lighted four, the number to vote for the KPD's list. In another episode on the working-class day of action (a so-called "Kampftag der Arbeiterklasse"), the Bauhaus administration forbid the students to hang flags from their balconies. So instead they simultaneously aired their down comforters—which just happened to all have red covers.[10]

On May 1st—May Day or International Workers' Day—1930, the Kostufra published the first edition of its own *bauhaus* journal, the same name as the school's official journal that ran from 1926 through the end of 1932. The Kostufra's *bauhaus* was always written in lower case and bore additional subtitles: "mouthpiece of the students/organ of the kostufra" (*sprachrohr der studierenden/organ der kostufra*). It was also easy to distinguish from the official *Bauhaus* journal because it was a very simple, low-tech, mostly text-based affair that was reproduced by hectograph, a nineteenth-century duplicating technology that the students could access in the local KPD office (figure 5.2). The students' journal was so low tech that its pages were simply stapled together in the upper left corner. However, because the KPD recognized the Kostufra as an official party operational cell (*Betriebszelle*), *bauhaus* was likewise considered official, a Communist journal that the party helped to distribute by hand, mail, and through subscriptions.[11] *bauhaus*'s stated mission was to "address all issues concerning the bauhaus politically," and it proposed to "provide a Marxist analysis of all phenomena and draw conclusions from it…. Our duty has to be to convince everyone that, with our studies, we will be true pioneers of culture only if we follow the example of our soviet brothers, together with the revolutionary workers' class."[12] In practice, the journal critiqued the school, its policies, and the Bauhaus's leadership in relation to Communist ideals and the political events that unfolded during its two-and-a-half-year run. While records are spotty, between fifteen and sixteen issues were produced, the final one in November of 1932, after the Bauhaus had moved to Berlin.

Creating message-driven images increasingly became a feature of leftist Bauhaus students' work, and these took a number of forms. Ivana Tomljenović was among those who used photography to document student participation in Communist marches and demonstrations.[13] Photographers including Edith Tudor Hart worked to document the lives of the struggling members of the working classes and unemployed; others, including Irene Blühová, focused on visualizing the dignity of labor.[14] Some Bauhaus Communist students used the camera to explore new forms of equalitable interaction within the school, capturing their fellow politicized *Bauhäusler* in moments of modern, collaborative living, as in Etel Mittag-Fodor's gorgeous take of her friends "Albert Mentzel and Lotte Rothschild," both Communist activists (figure 5.3). Mentzel was, secretly, the editor of the Kostufra *bauhaus*, and this photograph was likely made during the pair's last year at the school, before they left in 1930 for Frankfurt where Rothschild would work full-time as a journalist for a

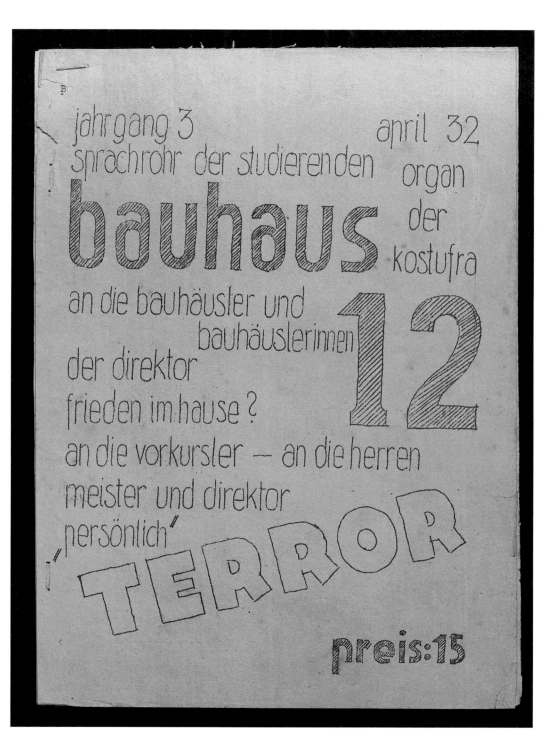

jahrgang 3 april 32
sprachrohr der studierenden organ
bauhaus der
kostufra
an die bauhäusler und
bauhäuslerinnen **12**
der direktor
frieden im hause?
an die vorkursler — an die herren
meister und direktor
„persönlich"
„TERROR"
preis:15

FIGURE 5.5. Etel Mittag-Fodor,
Albert Mentzel and Lotte
Rothschild, c. 1930, gelatin
silver print. 8.7 x 7 in. (22 x 17.7
cm). Bauhaus-Archiv Berlin ©
Bauhaus-Archiv Berlin.

Communist newspaper.[15] As Karen Koehler has observed, this double portrait unfolds through the echo of the two subjects' curved, intertwined bodies and parallel arms and hands.[16] It is a picture rich, as she points out, in the abstract play of form and structure—surely informed by Josef Albers's preliminary course assignments involving cutting and folding that were intended to help students grapple precisely with issues of form and structure. But Mittag-Foder's photograph is also a new kind of picture of a pair of male and female subjects who are in harmony and dialogue with each other; through them, the photographer captures a vision of free people of the present—and possibly of the future.

Bauhaus students also pursued Communist- and leftist-inflected design outside of the school and thus brought their aesthetic to a wide, politically active audience. Herman Trinkaus, a student at the Bauhaus from 1927 through 1930 and the subject of a photograph I discussed in chapter 4 (figure 4.1), made cover art and other graphic design for the Leipzig-based journal, *Kulturwille*, or *The Will to Culture*. Sabine Hake has characterized this official publication of the Workers' Education Institute as an ideal platform for the project of education and self-cultivation that had long been central to Social Democratic ideas about class and community.[17] Trinkaus's work was regularly featured in *Kulturwille* as slim page runners that were printed across the top of one sheet in each issue throughout a particular year. One of these, *Art and The People* (*Kunst und Volk*), which ran in every issue of 1928, features a battle for the right to broad artistic experimentation that is specifically located at the Bauhaus (figure 5.4). While the runner was always the same, the particular print that I reproduce here appeared in a 1928 special issue on "Socialism and Unions," which features a number of pro-Bauhaus items and articles, including plans for Hannes Meyer's ADGB Trade Union School in Bernau and an essay praising Meyer's work as Bauhaus director that referred to the Bauhaus as the "armorer of the fighting proletarians" (*Waffenschmiede des kämpfenden Proletariats*).[18] In this context, the year's page runner takes on added resonance. At its left, futuristic figures from the Bauhaus stage frolic directly in front of a poster advertising a film melodrama with

FIGURE 5.4. Hermann Trinkaus, *Art and the People* (*Kunst und Volk*), page runner for *Kulturwille: Monatsblätter für Kultur der Arbeiterschaft* 5.9 (Sept. 1928): 173. 1.9 x 7.5 in. (4.8 x 19 cm). Private collection.

working class protagonists. The *Bauhäusler* dance under and around the mismatched, collaged letters of the phrase, "kunst und volk" (art and the people), which carries over to the Prellerhaus wing of the Dessau Bauhaus building. The clean lines of the building's sweeping form dominate the picture's right side. Trinkaus associates it with an unlikely comparison, the Taj Mahal, which he positions as an exotic but enduring example of monumental architecture, directly behind the school building. At the right, an evil force attacks the Bauhaus, embodied in the figure of an angry-looking, giant bureaucrat who dwarfs the huge building and claws at it as he raises his fist in rage toward the romping Bauhaus figures at the left. Almost cinematically, a dragon's head flows out of the top of the Prellerhaus to beat back this giant and defend the school, while a concerned Charlie Chaplin, that clown hero of the day's films, looks on. Trinkaus's vision centers on a happy panorama of old and new art at the Bauhaus that villainizes those who would threaten it.

Other *Bauhäusler* sought to put their skills even more directly behind the cause by making political propaganda; the anti-war demonstration cart parked one day in Dessau's city center was not a one off. Max Gebhard serves as a good example of the path from *Bauhäusler* to Communist propagandist. He joined the Bauhaus in 1927 and became a KPD member almost immediately. Gebhard specialized in advertising under the guidance of Herbert Bayer, with whom he subsequently worked at the Studio Dorland advertising firm in Berlin.[19] For a 1930 Communist election advertisement, he photographed fellow Bauhaus member Bella Ullmann-Broner posed as a valiant female worker to make a poster so successful that it was reproduced in slightly altered form on the black, white, and red cover of the get-out-the-vote edition of the national Communist women's newspaper, *Die Kämpferin* (The [Female] Fighter; figure 5.5). The following year, the original poster would be reused again as the cover for the *Bauhaus Dessau 1928–1930* exhibition in Moscow.[20] Clad in a work smock and silhouetted against the smoke of factory production, Ullmann-Bronner has been photographed from below to emphasize her heroism as a female worker; she raises her fist in the Communist party salute, a gesture that connects her to the factory smokestacks soaring behind her. With rudimentary technologies, Gebhard creates a powerful image of the female worker as essential both to the work force and the electorate.

Many of the Communist students were emboldened to experimentation in both their work and their lives, and they sought to find new art forms that might bring these two more closely together. Tomljenović, a Yugoslavian *Bauhäusler*, epitomized interwar daring and glamor; ever fashionably dressed, she was an athlete—a European champion in the sport of Czech handball, in fact—a rich girl turned revolutionary, and a Communist spy.[21] While studying art in Vienna, she heard the charismatic Meyer give a lecture and was inspired to immediately quit her studies and head for the

Jahrgang 1930 Nr. 13/14 10 Pf.

DIE KÄMPFERIN

ORGAN DER GESAMTINTERESSEN DER ARBEITENDEN FRAUEN

werktätige Frauen

Kämpft mit uns um Lohn u. Brot!

WÄHLT KOMMUNISTEN LISTE 4

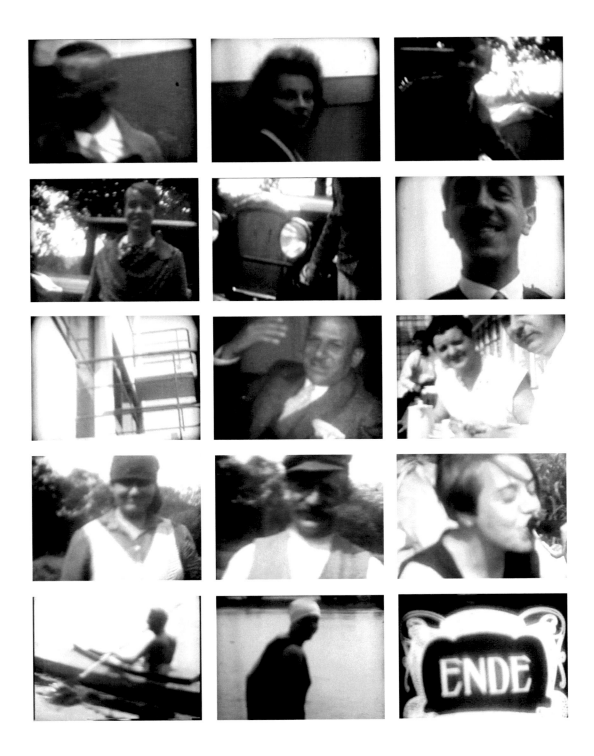

Bauhaus. Tomljenović attended the school from 1929 to 1930 and was active in its political life including joining the KPD. She studied in the preliminary course with Josef Albers, who photographed her, and, in the spring, 1930 semester, became a student in Walter Peterhans's photography class.[22] Perhaps most significant of all, Tomljenović created one of only two films of the Dessau Bauhaus building known to exist.[23] Despite much theorizing about Bauhaus films—prominently by László Moholy-Nagy in his *Painting Photography Film*, published in 1924 and widely read at the school and elsewhere—Tomljenović is the only person to ever create an experimental Bauhaus film shot on site at the school.

Tomljenović made this untitled film of fifty seconds with a Pathé Baby camera, an inexpensive format created in the early 1920s for amateur filmmakers and home viewing that used 9.5-millimeter film. While not an experienced filmmaker, she was well versed in avant-garde film and had conversed with avant-garde filmmakers who visited and showed their films at the Bauhaus, including Hans Richter. She and the other students criticized his and others' films that he screened as useless abstractions and accused him of being bourgeois; they even insisted that he show them his Communist party membership card, which he did.[24] For Tomljenović's Bauhaus film, she created the film's sequences not through editing but rather by simple, sequential shooting, with the film stock left in the camera between takes. The film shows various scenes of the Bauhaus building, recognizable Bauhaus members, *Bauhäusler* having coffee outside of the school's canteen, and a panning shot of the Bauhaus's Prellerhaus-wing façade from top to bottom (figure 5.6).[25] A few scenes were probably shot when she returned to her native Zagreb in the summer of 1930, but then she returns to a Bauhaus subject for the last scenes—her friend, the weaver Kitty Fischer van de Mijll Dekker relaxing and cavorting by and in a wide river, likely the Elbe in Dessau. The film has no narrative per se, and yet Tomljenović coyly includes the word "Ende" (End) as the last shot, a surrealist twist on the more standard cinema of the day.

Tomljenović's untitled film may be rough, but it relies on a relatively new visual technology to capture the Bauhaus, with a particular focus on picturing the interwar freedoms experienced by her fellow female *Bauhäusler*. It is also the vision of a camerawoman on the move across Europe, motion that she translates into the film. In one shot, a middle-aged man mirrors her own movements as she hand-cranks the camera—the Pathé Baby required two cranks per second to capture sixteen frames of film—as if to signal his amused impatience with her newfangled technology. The film is Bauhaus imagery that is fleeting and cannot be co-opted as "practical design." It is a new kind of experimental work. It does not contain overt political content; rather it takes an egalitarian, "slice of life" approach that is akin to aspects of Worker Photography of the period and evokes Dziga Vertov's *Man with a Movie Camera*, which had been released in 1929, the previous year.[26]

FIGURE 5.6. Ivana Tomljenović, stills from a film of the Dessau Bauhaus, 1930. Original film: 9.5 mm., c. 57 seconds, 1930. Museum of Contemporary Art, Zagreb.

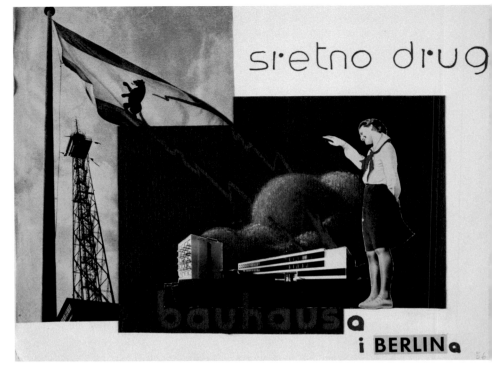

Tomljenović's most important work at the Bauhaus was photography, not filmmaking. Her photographs and photomontages sometimes also included humor—in part out of frustration at the backlash against the Communist students. In what was likely one of her last works made at the Bauhaus, Tomljenović cheerfully blows up the school (figure 5.7). *Good Luck, Bauhaus and Berlin Comrades, and See You After the Revolution* is a photomontage that combines photographic elements from the Bauhaus period—including the one at the far right, which was her taken by her teacher, Albers—together with montage elements that Tomljenović then remontaged sometime well after the Bauhaus. At the left, she appears as a Communist Young Pioneer, wishing her "Bauhaus Comrades" (just to her right) good luck as she waves to an exploding Bauhaus. Tomljenović departed the school in the fall of 1930 after Meyer was removed and Mies van der Rohe, as the new director, expelled any openly Communist Bauhaus students; this last photomontage seems to be her revenge. Tomljenović was not among those students whom Mies expelled for their known Communist activities and party membership. She left in solidarity.

Others stayed, and the anonymity of the Kostufra *bauhaus* journal gave

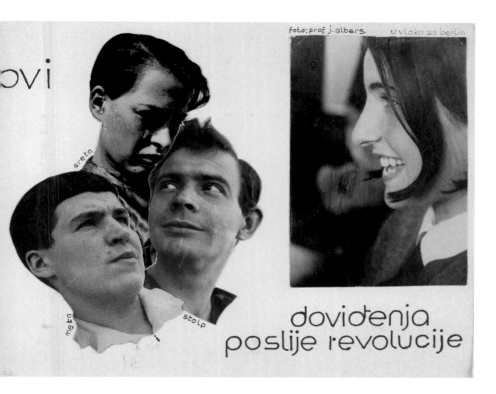

foto: prof. j. albers.　u vlaku za berlin

dovidenja
poslije revolucije

them freedom to continue their criticisms of Mies and the city of Dessau, which was using increasingly heavy-handed methods against them. The April 1932 issue has the word "TERROR" written boldly across its front (figure 5.2). Its first article—addressed to "Bauhäusler und Bauhäuslerin-nen!"—makes clear that "TERROR" references the students' perception of the director as openly anti-Communist.

> None of you will have witnessed the most recent events at the Bauhaus without them having left the deepest impression on you: the brutal measures of the directorate, the unabashed trampling of your basic rights, the deployment of the police's force against students who, during their lunch break, discuss their most burning questions—anyone who still has a spark of the sense of liberty in their belly must clearly see the true situation, and be shaken to the core and incited.[27]

The anonymous author goes on to call the Bauhaus's current directorship "fascist."

FIGURE 5.8. Lena Meyer-Bergner. Design for "Metro" Textile, 1932. Gouache, graphite, and crayon on paper. 8.25 x 11.25 in. (21 x 28.6 cm). The Metropolitan Museum of Art. © Heirs of Lena Bergner. Photograph: © The Metropolitan Museum of Art, image source: Art Resource, NY.

Meanwhile, outside of the school, *Bauhäusler* were fanning out from the institution to participate in essential leftist experiments, often far from the Bauhaus premises. To return to that summer of 1930, with which I begin this chapter, it was after a series of public quarrels and one fateful meeting at the school—in which Meyer lost his patience and quipped to Dessau's Lord Mayer, Fritz Hesse, and another official, Dr. Ludwig Grote, "but Mr. Grote, you know perfectly well that I am a scientific Marxist"—that Meyer was dismissed after serving for only two years.[28] He soon departed for the Soviet Union with a group of former students who became known as the "Red Bauhaus Brigade."[29] Among those who accompanied him was Belá Scheffler, the founder of the Bauhaus's Communist cell who spoke Russian and translated for the group, and quite a number of female students and associates.[30] Etel Mittag-Fodor later wrote about her trip to visit Meyer and "the Bauhaus Group" in Moscow, where they lived in the city center; Mittag-Foder took photographs while there that were published in the *AIZ* (*Arbeiter Illustrierte Zeitung*, Worker's Illustrated Newspaper).[31] Along with other modernists such as the *Gruppe May* (May Group), which was named for the New Frankfurt architect Ernst May and included *Bauhäusler* Fred Forbat, in the early 1930s they contributed designs for a number of building projects, including for the ambitious building of the industrial town of Magnitogorsk.[32]

One of the *Bauhäusler* who moved to the Soviet Union to join the group in 1931 was weaver Lena Meyer-Bergner. At the time, she was a Bauhaus graduate working in Germany as a clear success story. She had completed her degree the previous year after four years of study; a master weaver, she had also trained in graphic design at the Bauhaus and was known as a brilliant colorist who created resolutely modern designs. In 1931, Bergner had an excellent job as head of the East Prussian Hand-Weaving Mill, a charitable organization that helped poor tenant farmers supplement their incomes with small-scale hand weaving.[33] It was much more than chance that she was in a job in which she could work for the betterment of others and of society; as a teen, Bergner had been a member of the leftist scouting troop *Wandervogel* (Hiking Birds), the movement through which so many *Bauhäusler* first became engaged with *Lebensreform* and leftist activism. At the Bauhaus, she had become involved with Communism, although the degree of her involvement is not entirely clear.

Despite seeming to have achieved her dreams in 1931, she quit her job and headed to Moscow to join the pro-Soviet Red Bauhaus Brigade, where she and Hannes Meyer would eventually become a couple.[34] After initial struggles with Russian, she became the lead—and only—fabric designer for a furniture-fabric factory with 600 employees. Meyer-Bergner later recalled how, during this period of the first Soviet Five-Year Plan, all media, even fabric design, were deployed to communicate the tasks at hand. She created one propagandistic fabric design for the fifteenth anniversary of the Red Army with a cascading pattern of impressive tanks

emblazoned with large red soviet stars zipping back and forth across the material. She later found out that, "in the opinion of the red army soldiers, the tanks were a bit dated. but as a lay person, naturally i couldn't have known that."[35] In her 1932 design for that "Metro" textile, Meyer-Bergner's fabric design becomes architecture and city planning, with a hyper-modern vision of interlocking streets, buildings, and streetcars unfolding dynamically on a diagonal across the material (figure 5.8). Meyer-Bergner used Bauhaus design to model a futuristic vision of the seamlessly functioning Soviet city.[36]

Meanwhile, in Dessau, as Mies took over the Bauhaus directorship in August 1930, the institution was in political crisis. He responded with a heavy hand by temporarily closing the school for six weeks and with his dismissal of the most politically active students.[37] When the Bauhaus reopened, all student political activity was banned, and Mies personally interviewed the remaining students to assess their work and politics. Yet political activism persisted among the students, if in a somewhat more clandestine manner, and it was not solely of the leftist kind. An anonymous account from a student identified only by the initial "M" and the fact that he was a Swiss national was published at the time and details the intensely politicized atmosphere at the Bauhaus early in 1932. He describes a meeting in the canteen to elect student representatives where the room was divided physically, with leftists and Communists on one side and rightists, including Nazis, on the other. Mies again intervened and banned students from the meeting.[38]

Another ideological divide among the students began to interfere with the workings of the school; between those who were political and those who were not. In the 1932 manuscript for an article that was never published, likely because of political tensions on a national level, *Bauhäusler* Katja and Hajo Rose wrote of these conflicts and their unforeseen impact on the Bauhaus's unique approach to art education,

> Whereas, in the past, [*Bauhäusler*] had been first and foremost *Bauhäusler*…young *Bauhäusler* were now frequently roped into the party by Communist cells right from the start. The Communist group at the Bauhaus thus grew to a considerable size, and argued that you could only be a true *Bauhäusler* if you were a Marxist, because Marxism alone stood for freedom and progress…. This radical behavior caused a split among the students. A counter-movement arose. At first only weak, it increased with the banding together of a new type of student…. [since] with its growing reputation, [the Bauhaus] now started to attract people who were only interested in studying their subject…. They opposed the Communist group on every occasion and rejected any proposals they put forward. Much to the detriment of the

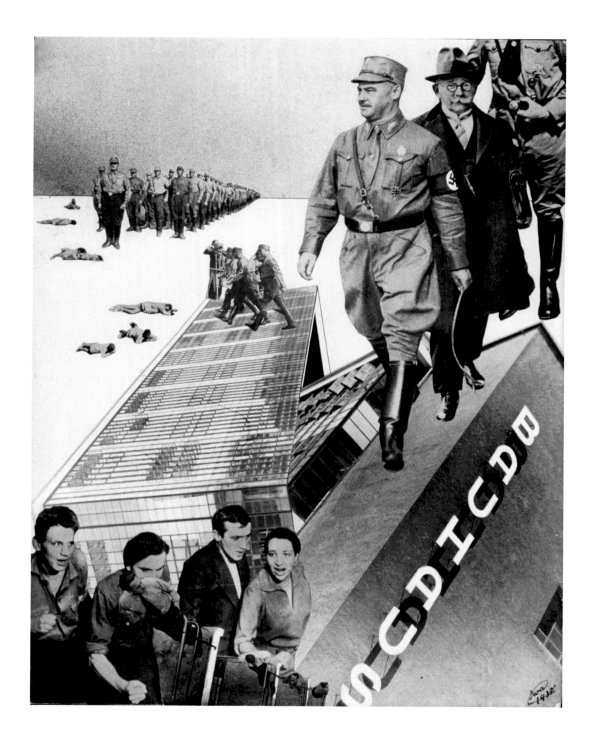

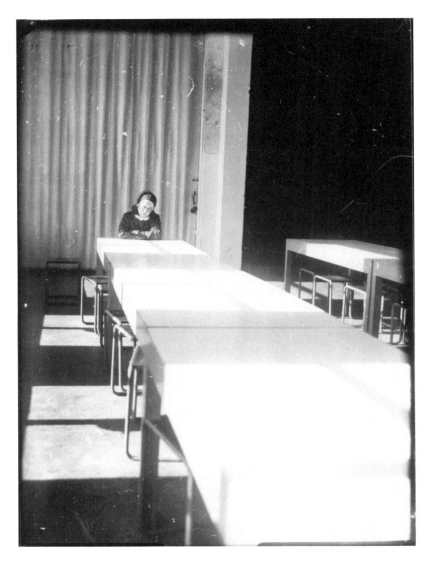

FIGURE 5.10. Gertrud Arndt, Last Day in the Canteen, Otti Berger (Letzter Tag in der Kantine, Otti Berger), 1932, gelatin silver print. 3.7 x 2.8 in. (9.5 x 7 cm). Bauhaus-Archiv Berlin. © 2019 Artists Rights Society (ARS), New York / VG Bild-Kunst, Bonn.

Bauhaus. For the Communists also wanted to organize the Bauhaus as liberally as possible, and thus their demands were for the most part justified. The few students caught between the two groups usually supported the Marxists when it came to Bauhaus matters.[39]

Bauhaus polarizations between left, right, and center continued to heighten as tensions grew within the school.

Nationalism among the students began to reveal itself clearly as of 1930, with a small but vociferous group of right-wing students. The sworn enemies of the Kostufra group, they were early adopters of the swastika, which they painted on junior master Gunta Stölzl's Bauhaus studio door because of her Communist activism and marriage to fellow *Bauhäusler* Arieh Sharon, who was Jewish.[40] This was part of these students' larger efforts against Stölzl, which eventually caused her to resign in 1931.[41] Communists insisted that the three students responsible for these actions be expelled, and they were, but only to be reinstituted by Dessau's Lord Mayor.[42] Despite Mies's constant attempts to depoliticize the Bauhaus, the city of Dessau itself had moved definitively to the National Socialist right in the 1931 elections and, by 1932, no longer tolerated the progressive institution in their town. The masters' contracts were illegally terminated as of October 1, before the completion of the calendar year, which enabled them to subsequently win the award of additional compensation and the rights to the income from the production of Bauhaus wallpaper; this provided a funding basis for the school to continue.[43] Be that as it may, the Bauhaus was evicted from its own, purpose-built building in the fall of 1932, and the Dessau Bauhaus closed.

A *Bauhäusler* who stayed until the bitter end in Dessau was Iwao Yamawaki; in his photomontage *Attack on the Bauhaus*, he lays out his own photographs so that the rectilinear Bauhaus building is sprawled across the page, as if the monumental structure was folding in upon itself (figure 5.9). He collages these with cuttings from the Communist *Arbeiter Illustrierte Zeitung* to show a column of oversized brown-shirted Nazis led by the notorious Ernst Röhm, head of the SA (*Sturmabteilung* or Storm Detachment), followed by the Nazi businessman and head of the DNVP (German National People's Party) Alfred Hugenberg, and a faceless Nazi soldier. A group of Bauhaus students recoil in horror from the Nazis at the lower left. Yamawaki expresses fears for the future that we now know were justified; scattered around troops of marching Nazis at the upper left are the bodies of anonymous victims.[44]

Gertrud Arndt and Otti Berger also collaborated to mourn the Dessau Bauhaus by staging photographs that evoke the haunting absence of life and normalcy within the building that had been the space for their creative, collaboration-filled lives for the proceeding years. A sense of utter loss permeates Arndt's photograph titled "Otti Berger in the Canteen

FIGURE 5.11. "Die Landes-
frauenarbeitsschule im
Bauhaus" (The State School
for Women's Work/Home
Economics), *Anhalter Anzei-
ger*, 35 (Sept. 2, 1933): n.p.
("Heimat" section). 15 x 22.8
in. (40 x 58 cm).

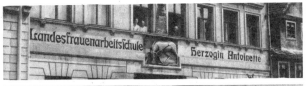

DieLandesfrauen-Arbeitsschule im Bauhaus

Die Schule, die sich früher in der Stein-
straße befand, ist jetzt nach dem Bauhaus
übergesiedelt. Schon seit längerer Zeit
ist der Gedanke erwogen worden, der
Schule ein moderneres Gebäude zu geben,
das den Anforderungen der Zeit ent-
spricht. Diese Verwendung des Bauhauses
ist wohl die zweckmäßigste.

Die Leiterin der Schule, Frau Direktorin Jahn.

Ein Hitlerbild im unteren Flur zeigt, daß
auch in den Räumen des Bauhauses ein
neuer Geist eingezogen ist, so schmücken
auch die Farben des neuen Deutschland
den lichtdurchfluteten Festsaal.
Was hier gelehrt wird, brauchen wir
nicht zu sagen. Die Bilder sprechen da-
von, daß hier tüchtige Hausfrauen heran-
wachsen, die in der Familie später an
der richtigen Stelle anzupacken wissen.
In jeder Beziehung wird hier die Fraulich-
keit gefördert und das praktische Können
unter tatkräftiger Leitung erweitert. Die
seminaristische Ausbildung der Landes-
frauen-Arbeitsschule findet hier ebenfalls
ihren Fortgang.

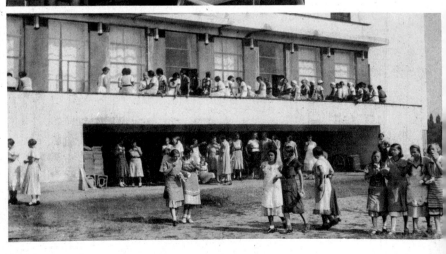

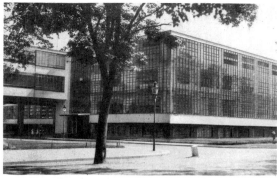

Das neue Heim der Landesfrauenarbeitsschule: Das Bauhaus.

Im Plättkeller herrscht Hochbetrieb.

Zu den Mutterpflichten gehört auch die richtige Behandlung des Kleinkindes.

Hier wird fleißig gehäkelt.

Von der Ausbildung der Turnerinnen.

Emsig drehen sich die Räder der Nähmaschinen.

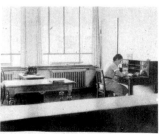

Nach getaner Arbeit im Wohnraum.

on the Last Day of the Bauhaus," from 1932 (figure 5.10). The photograph's deep depth of field reveals Berger achingly far away, a tiny figure at the end of a long table full of empty Breuer stools that evoke the fellow *Bauhäusler* who are no longer present.[45] With the shuttering of the Bauhaus in Dessau in 1932, much of the experimental culture that has been the focus of this book had to find new homes or cease to exist, at least publicly.

But the Bauhaus did not quite end then and there, on that "last day." Mies stewarded the school to its third and final location, an abandoned telephone factory in Berlin's Steglitz district, where it became a small, private architecture institute that opened only a few weeks later, on October 15, 1932.[46] The Nazis assumed power on a national level on January 30, 1933, and, after the Bauhaus managed to host one more crazy party for Carnival in February, on April 11, the local Berlin police and Nazi Storm Troopers entered and searched the Berlin Bauhaus. They arrested Bauhaus students and claimed, falsely, to have found several boxes of illegal printed material.[47] In reality, what Nazi officials wanted was simple: a *gleichgeschaltetes* Bauhaus, one whose approach was coordinated with Nazi ideology and which could reopen only after certain conditions had been met. These conditions included the dismissal of foreigners on staff, like Wassily Kandinsky—who had in fact taken German citizenship and, ironically, himself belonged to the school's conservative wing. On July 20, 1933, facing terrible economic strain and the loss of not only financial but moral support, rather than comply with these demands, the remaining faculty under Mies's leadership voted unanimously to dissolve the Bauhaus.[48]

THE NAZI AFTERLIFE OF THE BAUHAUS

Because of the Bauhaus's international reputation as a progressive art school, many in the Nazi party and the regime maligned it. It was particularly hated by right wingers in the city of Dessau. This is a badge of honor in retrospect, since the institution thus appears to have been on the right side of history. While many in Dessau hoped to tear it down, the building continued to stand, and, still referred to as "the Bauhaus" by locals, it had quite an afterlife, since, as an extremely large, modern building, it proved infinitely useful to the regime as a workspace and ideological tool.[49] The local Nazi authorities lost no time in housing in it a school for home economics, the *Landesfrauenarbeitsschule im Bauhaus* (figure 5.11). Surely filling the school with women training in skills gendered as traditionally feminine was a source of pleasure to and a form of revenge for those who for years had fought to shut down an institution they saw as devoted to degenerate culture; they allowed the body of the Bauhaus building to live on as a teaching institute, but only in a feminized form and without the same soul. Because it was so capacious, the Bauhaus building would come to

additionally house numerous other groups, most of whom were part of the regime's illegal militarization and rearmament. These included a Nazi *Gauschule* (district school) and offices for Albert Speer, Hitler's chief architect and Minister of Armaments and War Production as well as offices for the Junkers airplane factory, responsible for building and maintaining the Luftwaffe. The local Nazi government also gave the building something they saw as essential for practical, but above all ideological reasons: a pitched roof.[50]

Modern art and artists were publicly defamed under the Nazi regime, and many *Bauhäusler*, including Herbert Bayer, Ilse Fehling, Wassily Kandinsky, Paul Klee, Max Peiffer Watenphul, and Oskar Schlemmer were stigmatized as Degenerate Artists; artworks by several of them were included in the 1937 *Degenerate Art* exhibition in Munich.[51] The regime persecuted numerous Bauhaus members, who were forced to abandon their work and, sometimes, their homes. Of those who stayed in Germany, even if they survived, many, like Richard Grune, suffered irreparable trauma during their time in Nazi concentration camps. Eleven *Bauhäusler* are known for certain to have perished in the Holocaust, including Friedl Dicker, whose work with the children of Theresienstadt Ghetto and Concentration Camp I discussed in chapter three, and Otti Berger and Lotte Rothschild-Mentzel, who appear in photographs in this chapter.[52]

It is well known that Nazi ideology drew on romanticized, racist notions of a collective German past. Yet the Nazi state also wanted to appear modern and even progressive in its own particular way.[53] And in fact, the work of some *Bauhäusler* and indeed some of the artists who were listed as Degenerate Artists helped the regime to do just this. As Michael

FIGURE 5.12. Herbert Bayer, double-page spread from the *Germany Exhibition* (*Deutschland Ausstellung*) catalogue, 1936, halftone print of photomontage in brown, black and blue, 16 pages, n.p. 8.3 x 16.4 in. (21 x 41.6 cm). Bauhaus-Archiv Berlin. © 2019 Artists Rights Society (ARS), New York / VG Bild-Kunst, Bonn.

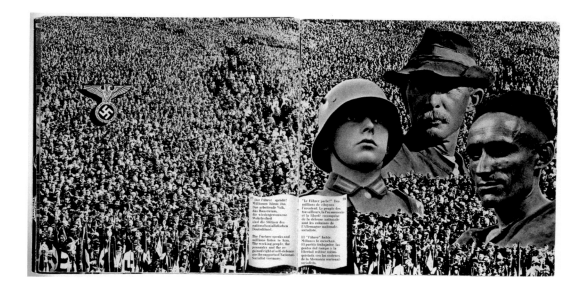

Tymkiw has cogently demonstrated, state-sponsored exhibitions under Nazism served not only as platforms for attacking modern art, but also as forums for artists, designers, and architects to continue modernist experimentation in a manner shifted to serve the regime. Bauhaus members including Lilly Reich, Ludwig Mies van der Rohe, Walter Gropius, and Joost Schmidt designed exhibits for the prominent 1934 exhibition *German People—German Work* (*Deutsches Volk—Deutsche Arbeit*), all four of them concentrated in the Hall of Energy and Technology. The exhibition's primary purpose was to demonstrate German industry's power and augment its new collective identity that was coordinated under the nationalist regime.[54] So, while the Bauhaus itself was maligned, its designers were clearly welcome to put their skills in the service of showing off the technology and design skills of the new regime. Scholars often search for signs of subtle, formal "resistance" in the work of modernist artists who served the Nazi regime; Tymkiw argues convincingly that, in this case, there is no evidence to support such interpretations.[55] It is dubious history to attribute to these artists and designers a foresight about the regime's evils that, at least in 1934, few had.

There are also cases in which Bauhaus members supported the regime and its ideology even more actively, as an examination of the designs of Herbert Bayer and Franz Ehrlich makes evident. In chapter two, I examined Bayer's gift to Gropius, *50 Years of Walter Gropius and How I Would Like to See Him Still*, which was given at a significant moment, the spring of 1933, shortly after the National Socialists assumed power. In retrospect, it was clearly the end of an era personally for these Bauhaus members. The following year Gropius left Germany for England, but Bayer remained until 1938, for five more years of Nazi rule and work as a graphic designer. This led most particularly to Bayer's creation of Nazi propaganda, an aspect of his oeuvre and life for which some have been apologists and others critical.[56] More recently, scholars have examined the complexity of Bayer's situation—as a non-German citizen married to a Jewish woman and father to a daughter who the regime would have classified as a "half Jew"—and his staunchly apolitical stance at the time, not to excuse his work for the regime, but to understand this history.[57]

In perhaps his most notorious photomontage, the prospectus for the *Germany Exhibition* (*Deutschland Ausstellung*), which was held during the Berlin Olympics of 1936, Bayer again turned to the format he used in Gropius's fiftieth-birthday gift (figures 2.12 and 2.13), a square book in which his photomontages were laid out on single- and double-page spreads (figure 5.12). With its use of photography and montage and its sleek modernist design that fills the pages right up to the edges, there is no denying that the *Germany Exhibition* prospectus has Bauhaus connections; in fact, the image reproduced here is taken from Gropius's personal copy of the *Germany Exhibition* catalogue that was signed by Bayer and given to him as a gift, a likely indication of Bayer's pride in

ILSE FEHLING:

Wunder des
FUNDUS

Die bekannte Filmausstatterin Ilse Feh-
ling, eine der besten Praktikerinnen auf
diesem Gebiet, berichtet hier in Wort und
Bild über die Lösung eines Problems, das
heutzutage jede Frau persönlich bewegt,
aber auch in künstlerischer Beziehung bei
jedem Film aufs neue gelöst werden muß.

Die Devise „Aus Alt mach Neu" haben wir eigentlich
schon wieder ganz vergessen, wahrscheinlich aus dem
Grunde, weil jede Frau mit Phantasie (und welche Frau
hätte keine?) schon immer gewohnt war, aus Vorhandenem
Neues zu zaubern und dieses Spiel der Erfindung nicht nur
als praktische Gabe betrachtete, sondern auch die Lust
einer Zauberin dabei empfand.

Aus zwei Girl-Kostümen in dem Film „Napoleon ist an allem
schuld" (oben) und „Casanova heiratet" (Mitte) entstanden
neu: ein Pierrot mit Halskrause (unten) und ein schwarz-
weißes Revue-Kostüm, das durch einen schwarzen Hutrand
und ein weißes Haarnetz noch eine besondere Note erhält
(Lula von Sachnowska)

12

this work. But while the 1936 work has multiple formal links to Bayer's Bauhaus design past, with its kitschy and mythologized vision of Germany and unambiguous heroization of traditional masculinity, its content is entirely Nazi. This is most obvious in the oversized heads of three German male types that appear superimposed over a seemingly endless crowd punctuated by Nazi flags: the worker, the farmer, and the soldier. Unlike the teasing couplets which framed Gropius's birthday gift, the text for the *Germany Exhibition*, printed in four languages, is unambiguous—"The Fuehrer speaks and millions listen to him. The working people, the peasantry, and the regained right of self-defense are the supports of National-Socialist Germany," it reads. Bayer's turn away from the open-ended and multiple possibilities of Weimar masculinity is here complete. In contrast to the playful spirit and ambiguous admiration that characterized his gift montage to Gropius, the *Germany Exhibition* spread shows manhood as a set of fixed types differentiated only in the manner in which they serve their Fuehrer, the man they all unquestioningly obey.[58] Through his ongoing work designing brochures for various exhibitions put up by the regime, Bayer applied Bauhaus aesthetics to designs for propaganda-laden exhibitions including *The Wonder of Life*, a show on the human body with particularly virulent rhetoric on the purity and superiority of the German race and blood. Of this work, Sabine Weissler has asked, "how clueless or how disengaged could a person like Herbert Bayer be in aestheticizing such slogans?"[59]

FIGURE 5.14. Franz Ehrlich, Gates to Buchenwald Concentration Camp with the motto, "To Each His Own" (*Jedem das Seinem*) 1938. Digital photograph by Martin Kraft, 2015, licensed via Creative Commons.

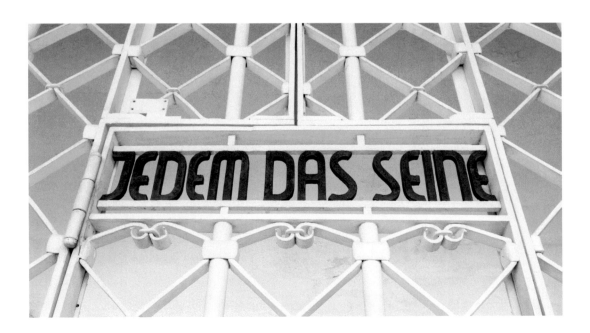

Other *Bauhäusler* worked for the regime's entertainment industry, as Ilse Fehling did, designing lush costumes and sets in Nazi-period escapist films (figure 5.13). By 1936, she had become head of costume design for Tobis Film.[60] The costumes were often conformist confections that paled in comparison to the radically abstract sculptures of Fehling's Bauhaus period, work for which the Nazi government listed her a Degenerate Artist. Still, it meant that Fehling, as a single mother, had work and a space for limited creativity. When war broke out, a fashion journal published an article on Fehling's work in the film studio's "stock" (*Fundus*), the technical term for a theater's collection of costumes. Introduced by the journal's editors as "the well-known Film designer Ilse Fehling, one of the best practitioners in this area," she wrote an upbeat, short piece on reusing film costumes to create one fantastic outfit after another, a relevant topic for fashion-minded readers in the midst of World War II. The caption at the lower left of the page explains how the two costumes at the top and middle left, from *Napoleon ist an allem Schuld* (*Napoleon is to Blame for Everything*, 1938), could be repurposed. "…Any woman with a bit of fantasy (and what woman has none?) has always known how to conjure something new from what's available," stated Fehling. The costumes at the page's lower left and right are the result of Fehling's costume thrift. Fehling's relatively apolitical work folded easily into Nazi propaganda: women should conserve and yet still be fashionable. But the outré film models next to Fehling's words also irritate with uncanny association: with a range of elements including the frilly underskirt and ruff, the wire-structured miniskirt, performative capes and hats, and two-color asymmetry, these costumes seem like much tamer versions of the figures of Bauhaus theater on which Fehling collaborated under the direction of her mentor, Oskar Schlemmer.

A number of Bauhaus-trained architects, including Gustav Hassenpflug and Pius Pahl, continued to design buildings of various scales in Germany during the Nazi period, from private homes with luxury interiors to factories.[61] There are also at least two *Bauhäusler* whose architectural work in Nazi concentration camps is documented. Fritz Ertl was a Bauhaus architect and SS member who became the head of planning of Auschwitz's new construction in 1940, which, beginning in 1942, included barracks, gas chambers, and crematoria.[62] Seven of his fellow *Bauhäusler* are known to have been murdered in precisely this camp which Ertl willingly helped to construct.[63] When considered together, these buildings' simplicity—while not initiated by Ertl as the basis of concentration camp architecture—garishly echoes Bauhaus design principles, and their modern efficiency modeled Bauhaus planning and production twisted to serve genocide.

There were also *Bauhäusler* who had ties to both Communist and Nazi histories. Franz Ehrlich studied at the Bauhaus from 1927 to 1930, and during his last year became a member of the KPD and a Commu-

nist activist. In collaboration with others, he produced an anti-Nazi journal through 1934, for which he was denounced, arrested, and convicted of "Preparations for High Treason" (*Vorbereitung zum Hochverrat*).[64] After three years in a workhouse in Zwickau, Ehrlich was transferred to the Buchenwald Concentration Camp, located on the outskirts of the city of Weimar, the Bauhaus's first location. Initially he was given hard labor, but he discovered the camp had an architecture office, and asked to be transferred to it. There Ehrlich worked on numerous projects including the design for the camp's expansions and even on one of its most ideologically charged designs, its front gates, which bear the words *Jedem das Seine*—"To Each His Own" (figure 5.14). This bitter slogan, which suggests that all inmates were merely getting what they deserved, was forged in a Bauhaus, sanserif font.[65] After he was freed, Ehrlich continued working at the Buchenwald planning office on private commissions, some of which included contract work at Buchenwald and on concentration-camp architecture itself. While, during its last years, the Bauhaus became increasingly politically polarized between the right and the left, during the Nazi period, even Communists could be convinced to do morally abhorrent design work on behalf of the National Socialist state.

ANOTHER BAUHAUS

In this chapter, as in this book in its entirety, I have sought to tell Bauhaus history otherwise. How did earlier life experiments in spirituality, gender, and sexuality enter the realm of extremist politics at the Bauhaus? As we have seen here, the Bauhaus became politicized, as did much of Germany, toward both Communism and nationalism, while a group of largely apolitical members were stranded somewhere in the middle. In particular, it was Communism that animated *Bauhäusler* of the school's later years, and their experiments crossed new formal boundaries, as in the creation of the only experimental film ever made directly at the Bauhaus; Tomljenović's untitled short gleefully captures moments of a still carefree life within the structure of the modernist building. Communist and Communist-influenced *Bauhäusler* sought to invent formal languages to valorize the dignity of work and image the new forms of parity and equality they were experiencing in their lives, as we see in photographs by Etel Mittag-Fodor and even in the overtly propagandistic poster made by Max Gebhard. As with his poster and magazine cover, Bauhaus Communist creativity also took directly activist forms, as in the designs for a propaganda cart in Dessau, and for buildings and useful items made by members of the Red Bauhaus Brigade who left for the Soviet Union.

Concluding this book with an exploration of the political activities of *Bauhäusler*, including some members' collusion with or victimization by Nazis, could leave the mistaken impression that that is the end point of the

Bauhaus movement. Nothing could be further than the truth. Well known are the experiments brought to the U.S. by *Bauhäusler*, where their innovative methods found fertile soil at The New Bauhaus, Black Mountain College, thriving Northeastern universities like Harvard and Yale, as well as at lesser-known but important centers such as the Pond Farm artists' colony in California.[66] Further, the Bauhaus found its way to Argentina, Australia, Canada, India, Israel, Japan, Turkey, and many other countries.[67]

Rather than an end point, Bauhaus political work is the crucial final piece of my exploration of what has too often been pushed to the margins in Bauhaus history. As with its openness to questions of spirituality or gender and sexuality, the Bauhaus intersected with politics and supported a wide range of ideologies, some of which were directly opposed to one another on the political spectrum. I have argued in this book that many Bauhaus works are best understood as artifacts of life experiments aimed at profound change, and I have sought to take an expansive look at the richness and diversity of this experimentation, with a particular eye to reintegrating the school's women into my haunted history of the Bauhaus's unqualified search for utopia. But *Haunted Bauhaus* has also demonstrated the need for a nuanced understanding of a movement that could be transported to many new contexts—geographical and political. It went around the world and was purposed to serve democracy, Communism, and fascism. Apolitical itself, its haunted histories reveal nonetheless that *Bauhäusler* invested their work at the institution and afterwards in myriad ways. The Bauhaus was a deep and wide-ranging experiment in spirit, body, identity, and politics that would become powerful shorthand for the modern.

ENDNOTES
BIBLIOGRAPHY
INDEX

ENDNOTES

INTRODUCTION

Unless otherwise noted, translations throughout the book are mine, and the German original texts can be consulted in the footnoted source. Where it appears in the originals, I reproduce Bauhaus members' use of exclusively lower-case writing (*Kleinschreibung*), which was adopted as official policy late in 1925; the one exception is the school's official *Bauhaus* journal, which I capitalize in order to distinguish it from the *bauhaus* journal created by the school's communist students.

1. Amelia Jones, *Irrational Modernism: A Neurasthenic History of New York Dada* (Cambridge, Mass.: MIT Press, 2004), 25–26.

2. The notion of Bauhaus as a mere style was debated in the school's own day and refuted, for example, in Marianne Brandt, "Bauhausstil," *Bauhaus*, 1929: 1, 21. In the immediate post-war period, Lucia Moholy likewise asserted: "Bauhaus is not 'style,' not a set formula, but expression derived from an understanding of material, function, form, color, etc., that timely and over time, steadfastly continues evolving." Lucia Moholy, "Der Bauhausgedanke," *Blick in die Welt* (Hamburg), 1948: 8, 30–31; reprinted in Rolf Sachsse, *Lucia Moholy: Bauhaus Fotografin* (Berlin: Bauhaus-Archiv, 1995), 95.

3. An example of the oft-presumed link between the Bauhaus and theories of Scientific Management is Mauro Guillén's *The Taylorized Beauty of the Mechanical: Scientific Management and the Rise of Modernist Architecture* (Princeton: Princeton University Press, 2006), esp. 45–59. Taylorism was much discussed in the interwar period in Germany and elsewhere, but its reception was highly equivocal, particularly among artists. See Anson Rabinbach, *The Human Motor: Energy, Fatigue, and the Origins of Modernity* (Berkeley: University of California Press, 1990, 1992), esp. 253–258.

4. While the narratives that I point to dominate discourses on the Bauhaus, nonetheless, over the decades, there have been key scholarly inquiries into the utopian and irrational at the Bauhaus including Joseph Rykwert, "The Darker Side of the Bauhaus," *The Necessity of Artifice* (New York: Rizzoli, 1982), 44–49, first published in Italian in 1970; Sixten Ringbom, "Transcending the Visible: The Generation of Abstract Pioneers," and Rose-Carol Washton Long, "Expressionism, Abstraction, and the Search for Utopia in Germany," both in *The Spiritual in Art: Abstract Painting, 1890–1985*, ed. Maurice Tuchmann (New York: Abeville Press, 1986), 131–153, 201–217; Rolf Bothe, Peter Hahn, and Hans Christoph von Travel, ed., *Das frühe Bauhaus und Johannes Itten* (Ostfildern-Ruit bei Stuttgart: Dr Cantz'sche Druckerei, 1994); Oliver Botar, "Biocentrism and the Bauhaus," Structurist 43/44 (2003–2004), 54–61; and Allison Morehead and Elizabeth Otto, "Representation in the Age of Medium-

istic Reproduction, *From Symbolism to the Bauhaus,"* in *The Symbolist Roots of Modern Art*, ed. Michelle Facos and Thor J. Mednick (Farnham: Ashgate, 2015), 155–168.

5. For more on Bauhaus numbers, see the website of "Die bewegten Netze des Bauhauses": https://forschungsstelle.bauhaus.community and Patrick Rössler and Anke Blümm, "Soft Skills and Hard Facts: A Systematic Assessment of the Inclusion of Women at the Bauhaus," in *Bauhaus Bodies: Gender, Sexuality, and Body Culture in Modernism's Legendary Art School*, ed. Elizabeth Otto and Patrick Rössler (New York: Bloomsbury Visual Arts, 2019), 7, 9.

6. A significant recent intervention that challenges both the idea of the Bauhaus as primarily a project of modernist progress and conventional distinctions between the so-called romantic and functionalist phases of the Bauhaus is: T'ai Smith, "The Bauhaus Has Never Been Modern," in *Craft Becomes Modern: The Bauhaus in the Making*, ed. Regina Bittner and Renée Padt, Bauhaus Edition 51 (Bielefeld: Kerber Verlag, 2017), 142–152.

7. Avery Gordon, *Ghostly Matters: Haunting and the Sociological Imagination*, revised edition (Minneapolis: University of Minnesota Press, 1997/2008), xvi.

8. Several recent books and films draw out key links between the historical Bauhaus and contemporary design strategies. See Laura Colini and Frank Eckardt, ed., *Bauhaus and the City: A Contested Heritage for a Challenging Future*, Bauhaus Urban Studies (Würzburg: Königshausen and Neumann, 2011); Edith Tóth, *Design and Visual Culture from the Bauhaus to Contemporary Art: Optical Deconstructions* (London: Routledge, 2018); and Niels Bolbrinker and Thomas Tielsch, dir., *Vom Bauen der Zukunft: 100 Jahre Bauhaus* (English title: *Bauhaus Spirit*; Hamburg: Filmtank/Neue Visionen Filmverleih, 2018).

9. Rössler and Blümm, "Soft Skills and Hard Facts," 10.

10. See, for example, "Mädchen wollen etwas lernen," *Die Woche*, April 4, 1930, 30, the first page of which I reproduce as figure 3.6 in ch. 3. The diverse deployment of Bauhaus women's images is the subject of Patrick Rössler, *Bauhausmädels* (Cologne: Taschen, 2019); and Kai-Uwe Schierz, Patrick Rössler, Miriam Krautwurst, and Elizabeth Otto, ed., *4 "Bauhausmädels": Gertrud Arndt, Marianne Brandt, Margarete Heymann, Margaretha Reichardt* (Dresden: Sandstein Verlag, 2019).

11. Gordon, *Ghostly Matters*, xvi.

12. There are a few important exceptions to this, including Anja Baumhoff's pioneering work on the specific nature of women's discrimination at the Bauhaus, *The Gendered World of the Bauhaus: The Politics of Power at the Weimar Republic's Premier Art Institute, 1919–1932* (Frankfurt am Main: Peter Lang, 2001); and "What's in the Shadow of a Bauhaus Block? Gender Issues in Classical Modernity," in *Practicing Modernity: Female Creativity in the Weimar Republic*, ed. Christiane Schönfeld (Würzburg: Königshausen & Neumann, 2006), 53–57. More recently, T'ai Smith has engaged gender in relation to art, craft, and theory through the work and writings of Bauhaus weavers: T'ai Smith, *Bauhaus Weaving Theory: From Feminine Craft to Mode of Design* (Minneapolis: University of Minnesota Press, 2014). Several of the essays in Otto and Rössler, *Bauhaus Bodies* also focus on Bauhaus women in relation to specific themes, including dance, fashion, and photography.

13. See Hans M. Wingler's now classic summary of the school's history through

primary documents: Hans M. Wingler, ed., *The Bauhaus: Weimar Dessau Berlin Chicago*, trans. Wolfgang Jabs and Basil Gilbert (Cambridge, Mass.: MIT Press, 1962). More recent Bauhaus histories have added considerable nuance, including Magdalena Droste, *Bauhaus* [2nd edition] (Cologne: Taschen, 2019); *Bauhaus 1919–1933: Workshops for Modernity*, ed. Barry Bergdoll and Leah Dickerman, ed. (New York: Museum of Modern Art, 2009); and Jeannine Fiedler, ed., *Bauhaus,* trans. Translate-A-Book (Cologne: Könemann, 2006).

14. The categories of "masters and students" are nonetheless attached to important scholarship of the past, such as Frank Whitford, ed., *The Bauhaus: Masters and Students by Themselves* (New York: Overlook Press, 1993).

15. Herbert Bayer later dated his drawing *The Model Bauhäusler* (*Der Muster Bauhäusler*) to 1923 (https://www.harvardartmuseums.org/art/225752). 1923 also yields three hits for "Bauhäusler" in Google Books' Ngram Viewer, which traces word use in print over time but does not reveal the sources. A more widely circulating example is Bayer's letter-press card for the first party in Dessau and the Bauhaus's topping-out ceremony, "DAS WEISSE FEST, frühjahrsfest der Bauhäusler" (THE WHITE PARTY, spring party of the *Bauhäusler*), March 20, 1926. Bauhaus-Archiv Berlin, Inv. Nr. 1995/26.18.

16. Walter Gropius, "Program of the Staatliche Bauhaus in Weimar" (April 1919), rpt. in Wingler, *Bauhaus*, 32.

17. An invitation to the Bauhaus masters for this event and the speech's text are held in the Bauhaus Thüringen Hauptstaatsarchiv Weimar (131: 40–43), and reprinted in *Das Staatliche Bauhaus in Weimar: Dokumente zur Geschichte des Instituts 1919–1926*, ed. Volker Wahl (Cologne: Böhlau, 2009), 238–240, quotation on 238.

18. Friedl Dicker was likely the first student selected to teach other students, starting in 1920. See Elena Makarova, *Friedl Dicker-Brandeis: Vienna 1898–Auschwitz 1944* (Los Angeles: Tallfellow Press, 2001), 9–11. It became increasingly common practice for students to teach each other informally, in the weaving workshop perhaps most of all. In 1925, former Bauhaus students Josef Albers, Herbert Bayer, Marcel Breuer, and Joost Schmidt all became junior masters (*Jungmeister*). That same year, Gunta Stölzl, likewise a former student, was instead made master of craft (*Werkmeisterin*) in the weaving workshop, and became its leader (*Leiterin*) the following year; she was granted the status of junior master in 1927, but at a lower salary than her male colleagues. She threatened to quit and was finally given a raise in 1928. See Monika Stadler and Yael Aloni, ed., *Gunta Stölzl: Bauhaus Master*, trans. Allison Plath-Moseley (New York: Museum of Modern Art; Ostfildern: Hatje Cantz, 2009), esp. 78, 91–92, 94, 116.

19. In using the term "subculture" to describe one aspect of *Bauhäusler* identity, I am thinking of Dick Hebdige's classic *Subculture: The Meaning of Style* (London: Routledge, 1979), esp. ch. 7, 100–127. On Hannes Meyer, Etel Fodor, who enrolled in September of 1928, described the surprisingly free discussion and socializing at the Bauhaus under his directorship; see Etel Mittag-Foder, *Not an Unusual Life, for the Time and Place*, Documents from the Bauhaus-Archive Berlin, *Bauhäusler 3*, ed. Kerstin Stutterheim (Berlin: Bauhaus-Archiv/Studio Ferdinand Ulrich, 2014), 100. For more on students participation in the institution, see Folke Dietzsch, "Die Studierenden am Bauhaus: eine analytische Betrachtung zur Struktur der Studentenschaft, zur Ausbildung und zum Leben der Studierenden am Bauhaus sowie zu ihrem

späteren Wirken," v. 1 (PhD diss. Hochschule für Architektur und Bauwesen Weimar, 1990), esp. the section: "Mitsprache der Studierenden," 95–98.

20. Irena Blühová, "Mein Weg zum Bauhaus," in *Bauhaus* 6, ed. Hans-Peter Schulz and Staatlicher Kunsthandel der DDR (Leipzig: Galerie am Sachsenplatz, 1983), 8, 9.

21. See Klaus-Jürgen Winkler, *Baulehre und Entwerfen am Bauhaus 1919–1933* (Weimar: Bauhaus-Universität Weimar, Universitätsverlag, 2003), esp. the chart detailing instruction of all architecture students who obtained diplomas, which shows almost no activity during the early years (28–29), and another which specifies the work of all architecture (*Baulehre*) instructors from 1927 on (31).

22. On this first collective Bauhaus building project (1920–1922), see the section, "The Sommerfeld House: First Experimental Worksite of the Bauhaus," in Barry Bergdoll, "Bauhaus Multiplied: Paradoxes of Architecture and Design in and After the Bauhaus," in Bergdoll and Dickerman, *Bauhaus*, 43–45; for documents related to the interior's completion during 1922, see "The Sommerfeld House," in Whitford, *The Bauhaus*, 106–111. More on the context of this project is available in Celina Kress, "Neue Akteure beim Bau von Groß-Berlin: Adolf Sommerfeld und sein Netzwerk," in *Neues Bauen im Berliner Südwesten: Groß-Berlin und die Folgen für Steglitz und Zehlendorf*, ed. Brigitte Hausmann (Berlin: Gebr. Mann Verlag, 2018), 29–46.

23. Rössler and Blümm, "Soft Skills and Hard Facts," 10.

24. Winkler, *Baulehre und Entwerfen am Bauhaus*, 5, 162–166.

25. Particularly influential in German Idealism is Georg Wilhelm Friedrich Hegel's 1807 *Phänomenologie des Geistes* (*Phenomenology of Spirit*) for his elaboration on existing notions of a secular *Weltgeist* and in relation to secular subjectivity and perception. For more on Hegel and Idealism, see Andrew Bowie, ch. 3: "German Idealism," *German Philosophy: A Very Short Introduction* (Oxford: Oxford University Press, 2010), 32–50, esp. 45–50; much more detail is available in Frederick Beiser's superb *German Idealism: The Struggle Against Subjectivism, 1781–1801* (Cambridge: Harvard University Press, 2002).

26. Erik N. Jensen, *Body by Weimar: Athletes, Gender, and German Modernity* (Oxford: Oxford University Press, 2010), 6.

27. Paul Lerner, *Hysterical Men: War, Psychiatry, and the Politics of Trauma in Germany, 1890–1930* (Ithaca: Cornell University Press, 2003), 193–248.

28. Helen Boak, ch. 2: "Women and Politics," *Women in the Weimar Republic* (Manchester: Manchester University Press, 2013), 63–133.

29. Ralf Dose, *Magnus Hirschfeld: The Origins of the Gay Liberation Movement* (New York: Monthly Review Press, 2014), 51–67.

30. Gropius, "Program of the Staatliches Bauhaus in Weimar," 31.

31. Maria Tatar, *Lustmord: Sexual Murder in Weimar Germany* (Princeton: Princeton University Press, 1997). Anton Kaes argues that the Weimar Republic's cinema is likewise silently–literally, in the films through 1928–haunted by World War I. See Anton Kaes, *Shell Shock Cinema: Weimar Culture and the Wounds of War* (Princeton: Princeton University Press, 2009), esp. the introduction, 1–6.

32. Sigmund Freud, "Analysis of a Phobia in a Five-Year-Old Boy," *The Standard Edition of the Complete Psychological Words of Sigmund Freud*, v. X (1909),

ed. James Strachey, trans. Alix and James Strachey (New York: Vintage, 2001), 122. The subject of this case, referred to as "Little Hans," is suffering various phobias and experiencing vivid fantasies; in relation to two of the latter, Freud comments that they will inevitably reappear if not correctly understood through analysis.

33. See Baumhoff, ch. 3: "What's the Difference? Sexual Politics of the Bauhaus," in *The Gendered World of the Bauhaus*, 53–75, esp. 64–71. The term "women's class" (*Frauenklasse*) only appears in the records for a short period of time, almost exclusively during 1920.

34. Joan Riviere, "Womanliness as Masquerade" (1929), *The Inner World and Joan Riviere, Collected Papers: 1920–1958*, ed. Athol Hughes (London: Karnac Books/Melanie Klein Trust, 1991), 94.

35. Gordon, *Ghostly Matters*, xvi.

36. Carla Freccero, *Queer/Early/Modern* (Durham, NC: Duke University Press, 2006), 9.

37. Because of the secrecy surrounding the production of the Kostufra's *bauhaus* journal, records of it are spotty, but there were at least fifteen issues from 1930–1932; a page from a likely sixteenth issue is reproduced in Peter Hahn, ed., *Bauhaus Berlin: Auflösung Dessau 1932, Schließung Berlin 1933, Bauhäusler und Drittes Reich*, (Berlin: Bauhaus-Archiv and Kunstverlag Weingarten, 1985), 112.

38. "M., A Swiss Architecture Student Writes to a Swiss Architect about the Bauhaus Dessau," *Information* (Zurich), No. 3 (Aug.–Sept. 1932), reprinted in Wingler, *Bauhaus*, 175–176.

CHAPTER 1

1. The masters arrived at this slogan in the fall of 1922 as part of the lead up to the 1923 *Staatliches Bauhaus* exhibition. Gropius subsequently used the phrase often in speeches and publications. See Georg Muche, *Blickpunkt: Sturm, Dada Bauhaus, Gegenwart*, second edition (Tübingen: Wasmuth, 1965), 30.

2. Robert McCarter emphasizes the *ti 1a*'s originality but also its indebtedness to De Stijl designer Gerrit Rietveld; Robert McCarter, *Breuer* (London: Phaidon Press, 2016), 25. Breuer's subsequent, metal chairs quickly became ubiquitous, causing cultural critic Siegfried Kracauer, a trained architect, to write, "wherever one looks, steel chairs stand everywhere at the ready, and the impression deepens that the wood age is over for good. I long for it, given the worn-out steel framework. It is as if not people themselves but their x-ray images are using [the steel chairs] for sitting." Siegfried Kracauer, "Kleine Patrouille durch die [Deutsche] Bauausstellung," in *Frankfurter Zeitung*, June 7, 1931; quoted in Magdalena Droste, "Stahlrohrstühle als Objekte medialer Bildstrategien und ihr doppeltes Leben," in *Modern Wohnen: Möbeldesign und Wohnkultur der Moderne*, ed. Rudolf Fischer and Wolf Tegethoff (Berlin: Gebr. Mann Verlag, 2016), 209.

3. See Ann Braude, *Radical Spirits: Spiritualism and Women's Rights in Nineteenth-Century America* (Bloomington: Indiana University Press, 1991, 2001);

and Molly McGarry, *Ghosts of Futures Past: Spiritualism and the Cultural Politics of Nineteenth-Century America* (Berkeley: University of California Press, 2008). For Spiritism's introduction in Germany, see Corinna Treitel, *A Science for the Soul: Occultism and the Genesis of the German Modern* (Baltimore: Johns Hopkins, 2004), 7–8.

4. This definition was offered by philosopher and Spiritist Baron Carl du Prel in "Du Prel über den Spiritismus," *Sphinx* 1:3 (1886): 215.

5. Jeffrey Sconce, *Haunted Media: Electronic Presence from Telegraphy to Television* (Durham: Duke University Press, 2000), 12–14, 21–58.

6. Crista Cloutier, "Mumler's Ghosts," in *The Perfect Medium: Photography and the Occult*, ed. Clément Chéroux and Andreas Fischer (New Haven: Yale University Press, 2005), 20–23; and Louis Kaplan, "Where the Paranoid Meets the Paranormal: Speculations on Spirit Photography," *Art Journal* 62, no. 3 (2003): 18–27. Key early practitioners of spirit photography in Europe were Frederick Hudson in London and Édouard Isidor Buguet in Paris, see Pierre Apraxine and Sophie Schmit, "Photography and the Occult," in Chéroux and Fischer, *The Perfect Medium*, 15.

7. Tom Gunning, "Haunting Images: Ghosts, Photography, and the Modern Body," in *The Disembodied Spirit*, ed. Alison Ferris, (Brunswick: Bowdoin College Museum of Art, 2003), 10–11; and Tom Gunning, "Phantom Images and Modern Manifestations: Spirit Photography, Magic Theater, Trick Films, and Photography's Uncanny," in *Fugitive Images: From Photography to Video*, ed. Patrice Petro (Bloomington: Indiana University Press, 1995), 42–43.

8. Françoise Parot, "Psychology Experiments: Spiritism at the Sorbonne," *Journal of the History of the Behavioral Sciences* 29 (Jan. 1993): 22–28. In Germany, the movement continued unabated throughout the Weimar Republic, "with hundreds of occult clubs, businesses, institutes, and presses and thousands of devoted providers and consumers of occult goods and services" according to Trietel. See Treitel, *Science for the Soul*, 7 and ch. 9, "The Spectrum of Nazi Responses," 210–242. For a significant interpretation of the ghostly across German culture, see Stefan Andriopoulos, *Ghostly Apparitions: German Idealism, the Gothic Novel, and Optical Media* (New York: Zone Books, 2013).

9. Chéroux and Fischer, *The Perfect Medium*, 68–69.

10. Siegfried Kracauer, *The Salaried Masses: Duty and Distraction in Weimar Germany*, 1929. Trans. Quintin Hoare (New York: Verso, 1998).

11. Jacques Derrida, *Specters of Marx: The State of the Debt, the Work of Mourning and the New International*, trans. Peggy Kamuf (New York: Routledge Classics, 1994), 192n21.

12. For key conceptual and historical explorations of hauntological media, see Tom Gunning, "To Scan a Ghost: The Ontology of Mediated Vision," *Grey Room* 26 (2007), 94–127; and Sconce, *Haunted Media*.

13. Corinna Treitel argues that Germans' fear of rapid change—which she attributes to their country's late industrialization and self-constitution as a nation—was mediated by engagement with the occult; Treitel, *Science for the Soul*, 24. See also Anne Harrington, *Reenchanted Science: Holism in German Culture from Wilhelm II to Hitler* (Princeton: Princeton University Press, 1996), especially xvi–xix.

14. On Köhler illumination, see Guy Cox, *Optical Imaging Techniques in Cell Bi-

ology (Boca Raton: Taylor and Francis, 2007), 17–18. On x-rays, see Wilhelm Röntgen, "Über eine neue Art von Strahlen (Vorläufige Mitteilung)," *Aus den Sitzungsberichten der Würzburger Physik.-medic Gesellschaft Würzburg* (1895): 132–141; and, on popular understandings of early x-rays, Simone Natale, "A Cosmology of Invisible Fluids: Wireless, X-Rays, and Psychical Research around 1900," *Canadian Journal of Communication* 36 (2011): 265.

15. Linda Henderson underlines the broad interest in fourth dimensionality among members of nearly every major early twentieth-century art movement; see Linda Dalrymple Henderson, *The Fourth Dimension and Non-Euclidean Geometry in Modern Art* (1983) revised ed. (Cambridge, Mass.: MIT Press, 2013); and Henderson "Claude Bragdon, the Fourth Dimension, and Modern Art in Cultural Context," *Claude Bragdon and the Beautiful Necessity*, ed. Euginia Victoria Ellis and Andrea Reithmayer (Rochester: RIT Graphic Arts Press, 2010), 73–86. On stereography, see Melody Davis, *Women's Views: The Narrative Sterograph in Nineteenth-Century America* (Durham: University of New Hampshire Press, 2015).

16. Deborah Cohen, *The War Come Home: Disabled Veterans in Britain and Germany, 1914–1939* (Berkeley: University of California Press, 2001), 1.

17. John Alexander Williams, *Turning to Nature in Germany: Hiking, Nudism, and Conservation, 1900–1940* (Stanford: Stanford University Press, 2007), 11 n25. Williams traces the movement's origins to Anglo-Saxon elites in the late eighteenth century, including Benjamin Franklin, a convinced nudist. See also Wolfgang Krabbe, *Gesellschaftsveränderung durch Lebensreform: Strukturmerkmale einer Sozialreformerischen Bewegung im Deutschland der Industrialisierungsperiode* (Göttingen: Vandenhoeck und Ruprecht, 1974); Bernd Wedemeyer-Kolwe, *Aufbruch: Die Lebensreform in Deutschland* (Darmstadt: Philipp von Zabern, 2017), which delves into specific aspects of *Lebensreform*, including diet, alternative medicine, body culture, and the settlement movement; and Michael Hau, *The Cult of Health and Beauty in Germany* (Chicago: University of Chicago Press, 2003).

18. Adolf Koch, "Die Wahrheit über die Berliner Gruppen für freie Körperkultur," *Junge Menschen* (August 1924), 2, cited in Williams, *Turning to Nature*, 1.

19. Members included Gertrud Arndt and Lena Meyer-Bergner, both profiled in Elizabeth Otto and Patrick Rössler, *Bauhaus Women: A Global Perspective* (London: Bloomsbury UK/Herbert Press, 2019), 58–61 and 90–91. For more on the *Wandervogel*, see Williams, *Turning to Nature*, 123–145.

20. Gropius calls for "individual lectures on subjects of general interest in all areas of art and scholarship" in the "Program of the Staatliche Bauhaus," 32–33 (translation slightly amended). The letters of the local technical college's director Paul Klopfer attest to the positive impact the Bauhaus's lecture series had even on skeptics. See Peter Bernhard, ed., *Bauhausvorträge: Gastredner am Weimarer Bauhaus, 1919–1925* (Berlin: Gebr. Mann Verlag; Bauhaus-Archiv, 2017), 13.

21. See Isabel Schulz, "'Märchen unsere Zeit': Kurt Schwitters als Vortragskunstler am Bauhaus," in Bernard, *Bauhausvorträge*, 299–306; and Kurt Schwitters, *Lucky Hans and Other Merz Fairy Tales*, trans. and Intro. (Princeton: Princeton University Press, 2009)

22. For more on the significant influence that Trenkel and Classical Gymnastics had on the early Bauhaus, see Ute Ackermann, "'Bodies Drilled in Freedom': Nudity, Body Culture, and Classical Gymnastics at the Early Bauhaus," in *Bauhaus Bodies: Gender, Sexuality, and Body Culture in Modernism's Leg-*

endary Art School, ed. Patrick Rössler and Elizabeth Otto (New York: Blooms-
bury Visual Arts, 2019), 25–47.

23. Ulrich Linse, "Ludwig Christian Haeusser und das Bauhaus," in Bernhard, *Bauhausvorträge*, 157–178, esp. 165–168. On the "Inflationsheiliger" as a phenomenon of the early 1920s, see Ulrich Linse, *Barfüßige Propheten: Erlöser der zwanziger Jahre* (Berlin: Siedler Verlag, 1983).

24. For an excellent reconstruction of the events program of the Weimar Bauhaus, see "Chronologisches Verzeichnis der Gastveranstaltungen am Weimarer Bauhaus," in Bernhard, *Bauhausvorträge*, 363–366. Bernhard has been able to locate full texts from a few of the talks, including Kahn's, available online: https://www.bauhaus.de/en/bauhaus-archiv/2120_publikationen/2132_bauhaus_vortraege/.

25. Thomas Röske, "'sie wissen nicht, was sie tun': Hans Prinzhorn spricht am Bauhaus über 'Irrenkunst,'" Bernhard, *Bauhausvorträge*, 237–242.

26. Walter Gropius, "Program of the Staatliche Bauhaus in Weimar" (April 1919), rpt. in *The Bauhaus: Weimar Dessau Berlin Chicago*, ed. Hans M. Wingler, trans. Wolfgang Jabs and Basil Gilbert (Cambridge, Mass.: MIT Press, 1962), 31.

27. Annemarie Jaeggi, "Ein geheimnisvolles Mysterium: Bauhütten-Romantik und Freimaurerei am frühen Bauhaus," in Christoph Wagner, *Das Bauhaus und die Esoterik: Johannes Itten, Wassily Kandinsky, Paul Klee* (Bielefeld: Kerber, 2005), 38–41.

28. Jaeggi, "Ein geheimnisvolles Mysterium," 38; as she points out, Gropius was also reading intensely on the history of Freemasonry; see 41n29 and n30.

29. Gropius, "Program," in Wingler, *Bauhaus* (German version), 40.

30. Walter Gropius, letter to Ernst Hardt, April 14, 1919, cited in Jaeggi, "Ein geheimnisvolles Mysterium," 40. In addition, as Jaeggi shows, Gropius continued his exploration in Masonic symbologies, and these informed early designs for symbols to represent the Bauhaus (40–41).

31. Ackermann, "Bodies Drilled in Freedom," 32.

32. Marco de Michelis, "Walter Determann: Bauhaus Settlement Weimar, 1920," *Bauhaus: Workshops for Modernity*, ed. Barry Bergdoll and Leah Dickerman, (New York: Museum of Modern Art, 2009), 86.

33. Jaeggi, "Ein geheimnisvolles Mysterium," 41.

34. Ackermann, "Bodies Drilled in Freedom," 33.

35. Gropius, letter to Adolf Behne, June 2, 1920. Mappe 8, Arbeitsrat für Kunst, Gropius Archive, Bauhaus-Archiv Berlin, reprinted in Michelis, "Walter Determann," 89.

36. Jaeggi, "Ein geheimnisvolles Mysterium," 42.

37. Gropius, "Idee und Aufbau des Staatliches Bauhauses," *Staatliches Bauhaus in Weimar, 1919–1923* (Weimar: Bauhaus Press, 1923), 17. That Gropius would later seek to downplay some of the Bauhaus's more utopian aspects is evident in the fact that, when this essay was translated for the 1938 Museum of Modern Art exhibition catalogue, the entire section on the Bauhaus settlement was omitted, but for a final sentence on educational experiments. Gropius, "The Theory and Organization of the Bauhaus" (1923), trans. and rpr. in *Bauhaus 1919–1928*, ed. Herbert Bayer, Walter Gropius, and Ise Gropius

(New York: Harry N. Abrams, Inc., 1938), 29.

38. Michael Siebenbrodt, "Architektur am Bauhaus in Weimar: Ideen und Pläne für eine Bauhaussiedlung," in *Das Bauhaus kommt aus Weimar*, ed. Ute Ackermann and Ulrike Bestgen (Weimar: Klassik Stiftung Weimar, 2009), 240. For a critical discussion of this "utopia" that was deeply bound up with luxury, see Robin Schuldenfrei, ch. 3, "Capital: The Haus am Horn and the Early Bauhaus," in *Luxury and Modernism: Architecture and the Object in Germany, 1900–1933* (Princeton: Princeton University Press, 2018), 116–137, 286–289.

39. Oskar Schlemmer, letter to Otto Meyer-Amden, early June 1923, cited in Christoph Wagner, "Zwischen Lebensreform und Esoterik: Johannes Ittens Weg ans Bauhaus in Weimar," in Wagner, *Das Bauhaus und die Esoterik*, 65.

40. Helmut von Erffa, "The Bauhaus before 1922," *College Art Journal* 3, no. 1 (1943): 17.

41. Johannes Itten, Diary no. 10, March 2, 1918, quoted in Rainer Wick, *Teaching at the Bauhaus* (Ostfildern-Ruit: Hatje Cantz, 2000), 103.

42. Hanish claimed to have been raised by Zoroastrian monks in the Persian mountains. On his conflicting origin stories, see Bernadett Bigalke, "Gesundheit und Heil: Eine ideengeschichtliche Spurensuche zur Einordnung der Mazdaznan-Bewegung in ihren Entstehungskontext," *Gesnerus: Swiss Journal of the History of Medicine and Sciences* 69, no. 2 (2012): 276–279.

43. Paul Citroen, "Mazdaznan at the Bauhaus," *Bauhaus and Bauhaus People*, ed. Eckhart Neumann, trans. Richter E. Lorman (New York: A. Van Nostrand Reinhold, 1970), 44–50, 47.

44. Otoman ZA Hanish, "Reading Hieroglyphics," *Mazdaznan* 17, no. 1 (1918): 7–14.

45. Wick, *Teaching at the Bauhaus*, 120. See also: Linn Burchert, "The Spiritual Enhancement of the Body: Johannes Itten, Gertrud Grunow, and Mazdaznan at the Early Bauhaus," in Otto and Rössler, *Bauhaus Bodies*, 49–72.

46. David Ammann, *Mazdaznan Diätetik und Kochbuch*, 4th edition (Leipzig: Mazdaznan-Verlag, 1908, 1909). The book's overview includes sections on "The Art of Chewing" (13–15) and "Thou Shall Not Kill!" (19–22); in many respects, the cookbook's recipes for soups and items like "Gemüsebratling" (veggie burger) seem quite progressive in retrospect. See also: Dr. O. Z. Hanish, *Masdasnan Atemlehre*, ed. David Ammann (Herrliberg: Masdasnan-Verlag, c. 1920); the exercises are detailed in an insert. For more on the origin and development of Mazdaznan, in the U.S. and on Ammann's transmission of it, see Bigalke, "Gesundheit und Heil," 272–296.

47. Upton Sinclair, *The Profits of Religion: An Essay in Economic Interpretation* (Pasadena: self published, 1918), 250–252.

48. Itten lists them in his book, *Design and Form: The Basic Course at the Bauhaus and Later*, revised edition (New York: John Wiley and Sons, 1963, 1975), 7.

49. Citroen, "Mazdaznan at the Bauhaus," 50.

50. Collection of the Bauhaus-Archiv, Berlin. For a reproduction, see *The Spirit of the Bauhaus*, ed. Olivier Gabet and Anne Monier, trans. Ruth Sharman (New York: Thames and Hudson, 2018), 33.

51. Citroen, "Mazdaznan at the Bauhaus," 47.

52. Citroen, "Mazdaznan at the Bauhaus," 46.

53. Wagner, "Zwischen Lebensreform und Esoterik," 80–81.

54. Itten, *Design and Form*, quoted in Wick, *Teaching at the Bauhaus*, 104.

55. Wick, *Teaching at the Bauhaus*, 105.

56. Albert Schrenck-Notzing, *Phenomena of Materialization: A Contribution to the Investigation of Mediumistic Teleplastics* (1914), trans. E. E. Fournier d'Albe (London: Kegen Paul, Trench, Trubner & Co., 1920). See for example Figure 86, a photograph of Schrenck-Notzing observing the medium Eva C. with a materialization on her head and a light apparition between her hands; also in Chéroux and Fischer, *The Perfect Medium*, 194.

57. Martyn Jolly, "Ectoplasm," in *Faces of the Living Dead: The Belief in Spirit Photography* (New York: Mark Batty Publisher, 2006), 64–85, 154–155. See also Chéroux and Fischer, *The Perfect Medium*, 184–185, 192–215, and 220–229.

58. For examples of photographs of "extras," see Clément Chéroux, "Ghost Dialectics: Spirit Photography in Entertainment and Belief," Chéroux and Fischer, *The Perfect Medium*, 44–71.

59. Dr. Hübbe-Schleiden, "Kerners Kleksographien," *Sphinx* 11:61 (Jan. 1891): 48–50. Swiss psychologist Hermann Rorschach's inkblots also come from this tradition but were not invented until 1921.

60. See for example, Annie Bourneuf, *Paul Klee: The Visible and the Legible* (Chicago: University of Chicago Press, 2015); and Vivian Endicott Barnett and Christian Derouet, *Kandinsky* (New York: Guggenheim Museum, 2009) as defining studies on these artists.

61. Ute Ackermann and Volker Wahl, ed., *Meisterratsprotokolle des Staatlichen Bauhauses Weimar 1919–1925* (Weimar: Verlag Hermann Böhlaus Nachfolger, 2001). In 1922, the masters' council began to list Grunow publicly as one of the Bauhaus's instructors (160, 201); in their meeting of May 16, 1922 there was discussion on changing the council's name to "Bauhaus Council" and a statement that, in that case, "Fräulein Grunow" must be made a member (201). The council's name did not change, but in the meeting of October 22, 1923, she is simply present and her name recorded among the masters as "[Meister] Grunow" (brackets original, 316). In the *Staatliches Bauhaus in Weimar* catalogue of 1923, Grunow is listed among the twelve masters of form, 6.

62. During this same period, Helene Börner was the master for practical workshop instruction of the weaving workshop.

63. Ackermann and Wahl, *Meisterratsprotokolle des Staatlichen Bauhauses*; Grunow's reports on students are included in the minutes of each semester; see for example: 167–169, 160, 226–227, and 303.

64. See Gertrud Grunow, *Der Gleichgewichtskreis: eine Bauhausdokument*, ed. Achim Preiß (Weimar: Verlag und Datenbank für Geisteswissenschaften, 2001). Linn Burchert chronicles how, in 1944, Grunow sent the text to her friend and former Bauhaus student Gerhard Schunke to publish. Instead, he began to revise it by combining it with his own alternative medical approach. See Linn Burchert, "Spiritual Enhancement of the Body," 54.

65. Burchert, "Spiritual Enhancement of the Body," 54. Grunow's articles are compiled in *Die Grunow-Lehre: Die bewegende Kraft von Klang und Farbe,*

ed. Réne Radrizzani (Wilhelmshaven: Florian Noetzel, 2004).

66. Gropius, "The Theory and Organization of the Bauhaus," 24. Originally published as "Idee und Aufbau des Staatliches Bauhauses," 10.

67. Burchert, "Spiritual Enhancement of the Body," 54–56. See also: Cornelius Steckner, "Die Musikpädagogin Gertrud Grunow als Meisterin der Formlehre am Weimarer Bauhaus: Designtheory und productkive Wahrnemungsgestalt," in Bothe, Hahn, and von Travel, *Das frühe Bauhaus und Johannes Itten*, 200.

68. The specific information on the poses' corresponding notes and colors comes from Grunow's assistant, Hildegard Nebal-Heitmeyer via the Bauhaus-Archiv. See also Marisa Vadillo Rodriíguez, "La Música en la Bauhaus (1919–1933): Gertrud Grunow como Profesora de Armonía, La Fusión del Arte, el Color, y Sonido," *Anuario Musical* 71 (2016): 231; and the chart of "Equivalencias Establecidas por Grunow para el primer Orden (Circuito Sensible)," for further equivalencies in Grunow's theories (229).

69. For examples of these circles, see Otto and Rössler, *Bauhaus Bodies*, color plates 1 and 2.

70. Gertrud Grunow, "The Creation of Living Form through Color, Form, and Sound," *Staatliches Bauhaus in Weimar*, 20–23, trans. and rpt. in Wingler, *Bauhaus*, 69–71. It is worth noting that Grunow's essay was given a very prominent position in the catalogue; it was the first to appear after Gropius's own, even before those of Klee and Kandinsky. She also is the only woman among the catalogue's seven authors.

71. Grunow, "The Creation of Living Form," 70.

72. Grunow, "The Creation of Living Form," 70.

73. Lothar Schreyer, 1956, cited in Ulrike Müller, *Bauhaus Women* (Paris: Flammarion, 2009), 19.

74. Grunow was not present at the October 18, 1923 meeting where her fate was decided; the vote tally does not indicate how particular masters voted. Wahl, *Meisterratsprotokolle*, 314.

75. Christine Hopfengart, "The Magician as Artist of Quotas: Paul Klee and His Rise as a Modernist Classic," in *The Klee Universe*, ed. Dieter Scholz and Christina Thomson (Berlin: Hatje Cantz, 2008), 70.

76. Wahl, *Meisterratsprotokolle*, 302–303.

77. Paul Klee to Lily Klee, October 23, 1921, rpt. in *Paul Klee: Briefe an die Familie, 1893–1940*, v. 2: 1907–1940, ed. Felix Klee (Cologne: Dumont Buchverlag, 1979), 81.

78. Klee's 1928 drawing *what does it have to do with me (was gehts mich an?)* seems to show jumbled modernist furniture possessed in a table turning. See Osamu Okuda, "Kunst als "'Projection aus dem überdimensionalen Urgrund': Über den Okkultismus bei Paul Klee," in Wagner, *Esoterik am Bauhaus*, 100–102. On Klee's seeming allergy to dogma, see Osamu Okuda, "Klee und das Irrationale," *L'Europe des esprits: Die Magie des Unfassbaren von der Romantik bis zur Moderne*, ed. Serge Fauchereau (Bern: Zentrum Paul Klee, 2012), 97–98.

79. Wilhelm Worringer, *Abstraction and Empathy* (1908), trans. Michael Bullock (Chicago: Elephant Paperbacks, 1997), 46–48; Peter-Klaus Schuster, "The World as Fragment: Building Blocks of the Klee Universe," in Scholz and Thomson, *The Klee Universe*, 16.

80. Ann Temkin, "Klee and the Avant-Garde, 1912–1940," *Paul Klee*, ed. Carolyn Lanchner (New York: Museum of Modern Art, 1987), 14–20.

81. Temkin, "Klee and the Avant-Garde," 20–29. Herbert Bayer and Ré Soupault, both of whom are treated elsewhere in this book, are important examples of *Bauhäusler*'s visual and personal links to surrealism.

82. Okuda, "Klee und das Irrationale," 92.

83. See Gershom Scholem, "Walter Benjamin and His Angel," in *On Jews and Judaism in Crisis: Selected Essays*, ed. Werner J. Dannhauser (New York: Schocken Books, 1976), 198–236.

84. Walter Benjamin, "On the Concept of History," *Walter Benjamin: Selected Writings*, v. 4, 1938–1940 (Cambridge, Mass.: Belknap/Harvard, 2003), 392.

85. Scholem writes, "Benjamin always considered the picture his most important possession," and he details the significance of the picture in Benjamin's life and its travels along with Benjamin to Berlin, to his Parisian exile, and finally to the two suitcases of his most significant papers that, when he fled Paris in June of 1940, George Bataille hid in the Bibliothèque National. See Scholem, "Benjamin and his Angel," 209–210.

86. Examples include Klee's 1921 *Knowledge, Silence, Passing By*; *Adam and Little Eve*; and *The Saint of Inner Light*, reproduced in Scholz and Thomson, *The Klee Universe*, 115, 291, and 292. Scholem notes that Klee made approximately fifty pictures of angels; Scholem, "Benjamin and his Angel," 208.

87. Annie Bourneuf, "Too Many Times: On Klee's Angelus Novus," (lecture presented at the Second Triennial Lovis Corinth Colloquium on German Modernism "Elective Affinities/Elective Antipathies: German Art on Its Histories," Emory University, March 17, 2017). See also Annie Bourneuf, "The Margins of the *Angelus Novus*" and R.H. Quaytman, "Engrave," in *R.H. Quaytman, Chapter 29: Haqaq*, ed. Mark Godfrey (Tel Aviv: Tel Aviv Museum of Art, 2015), 34–41, 50–61.

88. Okuda, "Klee und das Irrationale," 92, 95–99. Okuda points out that certain of Klee's works, such as his 1923 *Materialized Ghosts (Materialisierte Gespenster)*, are visually similar to photographs of mediums published by Schrenck-Notzing in his 1914 *Phenomena of Materialization*. Given that both were in Munich and the circle of Franz von Stuck, they may also have known each other.

89. Bourneuf, *Paul Klee*, 10–11.

90. Marianne Ahlfeld-Heymann, "Erinnerungen an Paul Klee," in *Und trotzdem überlebt* (Konstanz: Hartung-Gorre Verlag, 1994), 78.

91. Original lost; reproduced in Scholz and Thomson, *The Klee Universe*, 284.

92. Gropius and Will Grohmann cited in Hans Suter, *Paul Klee and His Illness: Bowed but not Broken by Suffering and Adversity*, trans. Gill and Neil McKay (Basel: Karger, 2010), 120.

93. Vladimir Lerner and Eliezer Witztum, "Images in Psychiatry: Victor Kandinsky, M.D., 1849–1889," *American Journal of Psychiatry* 163, no. 2 (Feb. 2006): 209.

94. Sixten Ringbom, *The Sounding Cosmos: A Study in the Spiritualism of Kandinsky and the Genesis of Abstract Painting*, published as an issue of *Acta Academiae Aboensis* 38, no. 2 (1970): 132. See also: Rose-Carol Washton

Long, "Expressionism, Abstraction, and the Search for Utopia in Germany," in *The Spiritual in Art: Abstraction Painting 1890–1985*, ed. Maurice Tuchman (Los Angeles: Los Angeles County Museum of Art, 1986), 202; and, for a broader contextualization of the link between spirituality and abstraction and particularly the influential role of Adolf Hoelzel's work, see Hilke Peckmann, "Abstraktion als Suche nach neuer Geistigkeit," Buchholz, Latocha, Peckmann, and Wolbert, *Die Lebensreform*, v. 2, 65.

95. Heather Wolffram, *The Stepchildren of Science: Psychical Research and Parapsychology in Germany, c. 1870–1939* (Amsterdam: Rodopi/The Wellcome Series in the History of Medicine) 2009, 115.

96. Treitel, *Science for the Soul* 108; Ringbom, *The Sounding Cosmos*, 49–55. Wassily Kandinsky, *On the Spiritual in Art* (1911), *Complete Writings on Art*, ed. Kenneth Lindsay and Peter Vergo (New York: Da Capo Press, New York, 1994), 114–219.

97. In 1916 Kandinsky's work was shown in the first exhibition at Zurich's Galerie Dada. Later that year, his Klänge poems were read by Hugo Ball at the Cabaret Voltaire, and another poem was published in the group's journal. See Clark V. Poling et al., "Chronology," *Kandinsky: Russian and Bauhaus Years* (New York: Guggenheim, 1983), 350.

98. Kandinsky, "Reminiscences" (1913), *Complete Writings on Art*, 370.

99. Kandinsky, "Reminiscences," 370. See also Ringbom, *The Sounding Cosmos*, 131–153.

100. Kandinsky, *Point and Line to Plane* (1926), *Complete Writings on Art*, 570, 664.

101. Reinhard Zimmermann, "Der Bauhaus-Künstler Kandinsky: ein Esoteriker?" in Wagner, *Das Bauhaus und Die Esoterik*, 50–51.

102. Wassilly Kandinsky, "Die 'Bauhausfrage,'" *Leipziger Volkszeitung*, Oct. 23, 1924; facsimile of the full original (including omissions from the printed version) in *Wassilly Kandinsky: Unnterricht am Bauhaus, 1923–1933*, vol. 1, ed. Angelika Weißbach (Berlin: Gebr. Mann Verlag, 2015), 33.

103. Kandinsky, "Die 'Bauhausfrage,'" 41.

104. For more on Ré Soupault, see Otto and Rössler, *Bauhaus Women: A Global Perspective*, 52–55.

105. Ré Soupault, *Das Bauhaus: Die heroischen Jahre von Weimar*, ed. Manfred Metzner (Heidelberg: Verlag das Wunderhorn, 2009), 35. See also Inge Herold, "Meta Erna Niemeyer: Studentin am Bauhaus Weimar 1921–1925," in *Ré Soupault: Künstlerin im Zentrum der Avantgarde*, ed. Inge Herold, Ulrike Lorenz, and Manfried Metzner (Heidelberg: Verlag das Wunderhorn/Kunsthalle Manheim, 2011), 38.

106. Soupault, *Das Bauhaus*, 33.

107. For more on Johannes Itten's interest in ancient Indian art and culture and its impact on his teaching as early as 1917, see Christoph Wagner, "Johannes Itten and India," in *The Bauhaus in Calcutta: An Encounter of Cosmopolitan Avant-Gardes*, ed. Regina Bittner and Kathrin Rhomberg (Berlin: Hatje Cantz, 2013; Bauhaus Edition 36), 140–149.

108. Soupault, *Das Bauhaus*, 35. Although the film is attributed only to Eggeling, the essential collaboration of Soupault (then Niemeyer) is widely acknowledged. See for example: Louise O'Konor, *Viking Eggeling 1880–1925: Artist*

and Filmmaker, Life and Work, trans. Catherine G. Sundström and Anne Bibby (Stockholm: Tryckeri AB Björkmans Efterträdare, 1971), 14, 45 (as recalled by Raoul Hausmann), and 51.

109. In the listing of artists, Hildebrandt categorizes her as "Green, Renate. Berlin. Textiles, fashion design, fashion film, studies: Bauhaus." Hans Hildebrandt, *Die Frau als Künstlerin: Mit 337 Abbildungen nach Frauenarbeiten, Bildender Kunst von den Fruuhesten Zeiten bis zer Gegenwart* (Berlin: Rudolf Mosse Buchverlag, 1928), 184. Illustration on 174.

110. Theo Sprengler, "Horoscope from Mr. and Mrs. Moholy-Nagy," Sept. 1, 1926, 17. Estate of László Moholy-Nagy, Ann Arbor.

111. In addition to the 1926 horoscope, the archive of the Estate of László Moholy-Nagy holds others from 1931 and 1946, the latter of which arrived within days of the artist's death. Additionally, the archive holds a collection of Bauhaus members' palm prints, likely related to palmistry.

112. Sprengler, "Horoscope," 18.

113. Bauhaus-member Hubert Hoffmann later recalled Hannes Meyer's interests in both leftist movements and new spirituality, and that he drew on anthroposophy in his lectures; see Hubert Hoffmann, "Kontraste: Anthroposophie und Marxismus," n.d. (c. 1980s), Akademie der Künste, Archiv, Berlin. For more on the endurance of spirituality at the Bauhaus, see Georg Muche, *Blickpunkt: Sturm, Dada, Bauhaus, Gegenwart*, second edition (Tübingen: Wasmuth, 1965), 30.

114. Henderson, "The Fourth Dimension and Modern Art," 81.

115. Paul Klee, in Hannes Meyer, ed. *Junge Menschen kommt ans Bauhaus!* 1929 advertising brochure; cited in Lutz Schöbe, "Joost Schmidt: Die sieben Chakras," in Wagner, *Das Bauhaus und die Esoterik*, 107,

116. Ludwig Hirschfeld-Mack, The Bauhaus: *An Introductory Survey* (Victoria: Longmans, 1963), 5.

117. Hirschfeld-Mack, *The Bauhaus*, 6.

118. *Bremer Nachrichten*, 24 August 1923, "Bauhauswoche," reprinted in Ludwig Hirschfeld-Mack, "Farben Licht-Spiele: Wesen Ziele Kritiken," in *Der absolute Film: Dokumente der Medienavantgarde (1912–1936)*, ed. Christian Kiening and Heinrich Adolf (Zurich: Chronos, 2012), 132.

119. Hirschfeld-Mack's *Three-Part Color Sonatina (Dreiteilige Farbensonatine)* was performed as part of the now legendary "Absolute Film" matinee in May 1925, in Berlin, organized by the Novembergruppe. See, Rudolf Arnheim, "The Absolute Film" (1925), trans. Nicholas Baer, in *The Promise of Cinema: German Film Theory, 1907–1933*, ed. Anton Kaes, Nicholas Baer, and Michael Cowan (Berkeley: University of California Press, 2016), 459–461. Composer Walter Gronostay praised Hirschfeld-Mack's work as a singular experiment in which, "as in ballet, the visual movement would grow out of the rhythms and tensions of the music." Walter Gronostay, "Possibilities for the Use of Music in Sound Film" (1929), trans. Alex H. Bush, in Kaes, Baer, and Cowan, *The Promise of Cinema*, 567. For more on the development and ideas behind this project, see: Peter Stasny, "Die Farbenlichtspiele," in *Ludwig Hirschfeld-Mack: Bauhäusler und Visionär*, ed. Andreas Hapkemeyer and Peter Stasny (Ostfildern: Hatje Cantz, 2000), 94–109. Further, the Bauhaus-Archiv, Darmstadt recreated the apparatus and filmed one of these pieces, *Cross Play (Kreuzspiel)*, during 1964 and 1965, viewable from the Harvard Film Archive:

https://vimeo.com/262123821

120. Ludwig Hirschfeld-Mack, "farbenlichtspiele," *Farbe-Ton-Forschungen, Bericht über den 2. Kongreß für Farbe-Ton-Forschung (Hamburg, 1–5 Oktober 1930)*, v. 3, ed. Georg Anschütz (Hamburg: Psychologische-ästhetische Forschungsgesellschaft, 1931), 109–114; critical reception: 114–118.

121. A vintage print of the photograph is in the collection of the Metropolitan Museum of Art and is available at their website: https://www.metmuseum.org/art/collection/search/283292. For more on Steiner's Eurythmy, see Rudolf Steiner, *The Early History of Eurythmy*, trans. and ed. Frederick Amrine (Great Barrington, Mass.: Steiner Books, 2015). For more on Karla Grosch, see Otto and Rössler, *Bauhaus Women: A Global Perspective*, 121–125.

122. Schöbe, "Joost Schmidt," 107.

123. For a thorough interpretation of this and related works by Schmidt from this folder of teaching notes, see Schöbe, "Joost Schmidt," 107–112.

124. From the first mention of Moholy-Nagy's name in the masters' council, he is identified primarily as a "constructivist." See meeting of March 14, 1923, *Meisterratsprotokolle*, 299. Zeynep Çelik Alexander contextualizes Moholy-Nagy's work and Bauhaus teaching in a much broader context of what she calls "kinaesthetic knowing," the acquisition of knowledge through the body's physical interactions with the world. See ch. 5, "Designing: Discipline and Introspection at the Bauhaus," in Zeynep Çelik Alexander, *Kinaesthetic Knowing: Aesthetics, Epistemology, Modern Design* (Chicago: University of Chicago Press, 2017).

125. Sandra Neugärtner, "Utopias of a New Society: Lucia Moholy, László Moholy-Nagy, and the Loheland and Schwarzerden Women's Communes," in Otto and Rössler, *Bauhaus Bodies*, 73–100; and Oliver Botar, *Sensing the Future: Moholy-Nagy, Media, and the Arts* (Zurich: Lars Muller, 2014).

126. Moholy-Nagy, "Light: A Medium of Plastic Expression," *Broom* 4 (March 1923): 284; quoted in Herbert Molderings, "Light Years of a Life: The Photogram in the Aesthetic of László Moholy-Nagy," in *Moholy-Nagy: The Photograms, Catalogue Raisonné*, ed. Renate Heyne and Floris Neusüss (Ostfildern: Hatje Cantz, 2009), 19.

127. Molderings, "Light Years of a Life," 20–21.

128. László Moholy-Nagy, *Painting Photography Film* (1925, 1927), trans. Lund Humphries Publishers (Cambridge, Mass.: MIT Press, 1969), 81.

129. On the centrality of photograms in Moholy's work in Dessau, see Molderings, "Light Years of a Life," 19. Moholy-Nagy refers to one of his photograms as "cameraless photography" in *Painting Photography Film*, 71. Lucia Moholy's involvement in the making of figure photograms like 1.16 is attested to by one of the index cards she began to keep to catalogue and correct mistakes in publications about Moholy-Nagy after his death. It notes, "on page 8 it says, '…for this Moholy-Nagy then lay his head on the photo paper and created this picture without a camera' / should say '…lay…and Lucia Moholy created this picture without a camera." The quoted text is: Walter Boje, "Wo beginnt das Illegitime? Gedanken zur Spanweite der Photographie," pamphlet of a speech published by the Deutsche Gesellschaft für Photographie, 1965. This index card is reproduced in Ulrike Müller, "Lucia Moholy," in Otto and Rössler, *Bauhaus Women: A Global Perspective*, 65. It is worth noting that the catalogue raisoneé of the photograms contains a statement dismissing the idea of Lucia Moholy's involvement in their making, but without evidence that stands up to Lucia Moholy's reputation for integrity, and contemporaries' recollections of

her collaboration with Moholy-Nagy in all aspects of his work. See "Lucia, Sibyl, and the Photograms," in Heyne and Neusüss, *Moholy-Nagy: The Photograms*, 306.

130. Pictures of this object are widely reproduced. For more on it, Lucia Moholy, Moholy-Nagy *Marginal Notes: Documentary Absurdities...* (Krefeld: Richard Scherpe, 1972), 80–82; and Alex Potts, "László Moholy-Nagy: Light Prop for an Electric Stage, 1930," Bergdoll and Dickerman, *Bauhaus*, 274–277.

131. Hannah Weitemeier, *Licht-Visionen: ein Experiment von Moholy-Nagy* (Berlin: Bauhaus-Archiv, 1972).

132. László Moholy-Nagy, "Lichtrequisit einer Elektrischen Bühne," *Die Form: Zeitschrift für gestaltende Arbeit*, 5 (1930): 297. For a slightly different translation of this passage and to read the entire text in English, see "Light-Space Modulator for an Electric Stage," trans. Mátyás Esterhásy, in Krisztina Passuth, ed., *Moholy-Nagy* (New York: Thames and Hudson, 1985), 310–311.

133. Walter Benjamin's *Origins of German Tragic Drama* is an important contemporaneous parallel project here.

134. Anne Hoormann, *Lichtspiel: Zur Medienreflexion der Avantgarde in der Weimarer Republik* (Munich: Wilhelm Fink Verlag, 2003), 193.

135. Moholy-Nagy to Frantisek Kalivoda, June 1934, in *László Moholy-Nagy*, ed. Sibyl Moholy-Nagy (New York: Solomon R. Guggenheim Museum, 1969), 15. As Joyce Tsai explains in her excellent chapter on *Light Prop for an Electic Stage*, "Sorcerer's Apprentice," Moholy-Nagy did cease painting for a period of about two years, but began again to "investigate effects he once tried to achieve by other technologically mediated means." Joyce Tsai, *László Moholy-Nagy: Painting after Photography* (Berkeley: University of California Press, 2018), 105. She also charts his own growing ambivalence about light as a transformative technology in the mid 1930s when Albert Speer deployed it in the 1936 *Light Cathedral* as the culmination of the Nuremburg Rally (106–108).

136. László Moholy-Nagy, *The New Vision*, 80; quoted in Tsai, *László Moholy-Nagy*, 111.

137. László Moholy-Nagy [with Lucia Moholy], "Production Reproduction," *Painting Photography Film* 30, and Rolf Sachsse, *Lucia Moholy: Bauhaus Fotografin* (Berlin: Museumspadagogischer Dienst/Bauhaus-Archiv, 1995), 72.

138. This photograph was previously attributed to Lotte Beese, but has now been correctly reattributed to Kárász. See Péter Baki and Éva Bajkay, "Unbekannte ungarische Fotografinnen: Etel Fodor, Irén Blüh, Judt Kárász," in *"Von Kunst zu Leben": Die Ungarn am Bauhaus*, ed. Éva Bajkay (Pécs: Janus Pannonius Múzeum/Berlin: Bauhaus-Archiv: 2010), 328–329.

139. On Berger's innovative work, see T'ai Smith, ch. 4, "Weaving as Invention: Patenting Authorship," in *Bauhaus Weaving Theory: From Feminine Craft to Mode of Design* (Minneapolis: University of Minnesota Press, 2014), 111–139. Berger was also photographed by Gertrud Arndt, and an example of this work appears in ch. 5 of this book.

140. I am, of course, referring obliquely to Walter Benjamin, "The Artwork in the Age of Its Technical Reproducibility," in *The Work of Art in the Age of Its Technological Reproducibility, and Other Writings on Media*, ed. Michael Jennings, Brigid Doherty, and Thomas Levin (Cambridge, Mass.: Harvard University Press, 2008), 19–55.

1. The attribution was made by Klaus Weber. See Klaus Weber, ed., *Happy Birthday: Bauhaus-Geschenke* (Berlin: Ott + Stein, 2004), 82. Breuer expert Isabelle Hyman stated that the handwriting does not look like Breuer's, so it may be that this joke was a group effort. (Author email correspondence, April 24, 2009.)

2. Andrea Gleiniger, "Marcel Breuer," in *Bauhaus*, ed. Jeannine Fiedler (Cologne: Könemann, 2006), 320–321.

3. For a nuanced analysis of visualizations of harems as contested spaces of cross-cultural dialogue, see Mary Roberts, *Intimate Outsiders: The Harem in Ottoman and Orientalist Art and Travel Literature* (Durham: Duke University Press, 2007).

4. From left to right, the women are: Martha Erps, who would marry Breuer, the architect and designer Katt Both, and weaver Ruth Hollós, who would eventually marry this picture's photographer, Erich Consemüller. For analysis of this image in the context of gender dynamics in photography at the Bauhaus, see Burcu Dogramaci, "Disorder or Subordination? On Gender Relations in Bauhaus Photographs," in Elizabeth Otto and Patrick Rössler, *Bauhaus Bodies: Gender, Sexuality, and Body Culture in Modernism's Legendary Art School* (New York: Bloomsbury Visual Arts, 2019), 243–263. Both and Hollós are profiled in Otto and Rössler, *Bauhaus Women: A Global Perspective* (London: Bloomsbury UK/Herbert Press, 2019), 88–89 and 86–87.

5. In 1920, Man Ray's photograph of Marcel Duchamp's alter ego, Rrose Sélavy, was printed in the avant-garde journal *New York Dada*. It is therefore possible that it was known at the Bauhaus. See Amelia Jones, *Irrational Modernism: A Neurasthenic History of New York Dada* (Cambridge, Mass: MIT Press, 2004), 296n37.

6. Victor Margolin explores the related type of the artist-constructor; see Victor Margolin, *The Struggle for Utopia: Rodchenko, Lissitzky, Moholy-Nagy, 1917–1946* (Chicago: University of Chicago Press, 1997), esp. ch. 3, "Inventing the Artist-Constructor: Rodchenko 1922–1927," 80–121. Matthew Biro theorizes the New Man in relation to interwar avant-garde art in Germany; see Matthew Biro, *The Dada Cyborg: Visions of the New Human in Weimar Berlin* (Minneapolis: University of Minnesota Press, 2009). For another study of Bauhaus masculinities, not yet published as this book goes to press, see Anja Baumhoff, *Der Neue Mann und Das Bauhaus: Männlichkeitskonzepte in der klassischen Moderne* (Berlin: Reimer Verlag, 2019).

7. Anson Rabinbach, *The Human Motor: Energy, Fatigue, and the Origins of Modernity* (Berkeley: University of California Press, 1990), esp. ch. 10, "The Science of Work Between the Wars," 271–288.

8. Helen Barr argues that, in the widely circulating illustrated newspapers of the 1920s, images of men were fundamentally marked by uncertainty, fears of failure, and attempts at reorienting masculinity; see, Helen Barr, "*Cherchez l'homme!* Männerbilder in illustrierten Zeitschriften der 1920er-Jahre," in *Der Mann in der Krise? Visualisierungen von Männlichkeit im 20. Und 21. Jahrhundert*, ed. Änne Söll and Gerald Schröder (Cologne: Böhlau, 2015), 37–51. For the filmic context, see Anton Kaes, *Shell Shock Cinema: Weimar Culture and the Wounds of War* (Princeton: Princeton University Press, 2009); and Anjeana Hans, *Gender and the Uncanny in Films of the Weimar Republic* (Detroit: Wayne State University Press, 2014). See also Stefan An-

driopoulos, *Possessed: Hypnotic Crimes, Corporate Fiction, and the Invention of Cinema* (Chicago: University of Chicago Press, 2008).

9. Sigmund Freud, "Analysis of a Phobia in a Five-Year-Old Boy" (Analyse der Phobie eines fünfjährigen Knaben), *The Standard Edition of the Complete Psychological Words of Sigmund Freud*, v. X (1909), trans. Alix and James Strachey (New York: Vintage, 2001), 122.

10. Magdalena Droste, *Bauhaus: 1919–1933* (Cologne: Taschen, 1993), 22. Gunta Stölzl is the only female *Bauhäusler* known to have served in the First World War; she was a nurse.

11. Walter Gropius was an officer in the German army; Lászlo Moholy-Nagy served in the Austro-Hungarian army, and Herbert Bayer with the Imperial Austrian Army. See Reginald Isaacs, *Walter Gropius: An Illustrated Biography of The Creator of The Bauhaus* (Boston: Bullfinch, 1991), 55–56; Joyce Tsai, "Lászlό Moholy-Nagy: Reconfiguring the Eye," in *Nothing but the Clouds Unchanged: Artists in World War I*, ed. Gordon Hughes and Philipp Blom (Los Angeles: Getty Research Institute, 2014), 156–163; and Arthur A. Cohen, *Herbert Bayer: The Complete Work* (Cambridge, Mass.: MIT Press, 1984), 370. Marianne Brandt was a young art student in Weimar during the war and Karla Grosch, born only in 1904, was a child during the war.

12. Mercedes Valdivieso, "Art and Life: a New Unity," in Mercedes Valdivieso, ed., *La Bauhaus de Festa* (Barcelona: Obra Social Fundació "la Caixa," 2004), 169.

13. Klaus Theweleit, *Male Fantasies,* v. 2 *Male Bodies: Psychoanalyzing the White Terror*, trans. Erica Carter and Chris Turner (Minneapolis: University of Minnesota Press, 1989), 40.

14. Theweleit, *Male Fantasies*, v. 2, 3–7, 43. For Theweleit, a man who "heaves himself out of the mass" (he is quoting one Captain Berthold) becomes the phallus, or the phallic German (50–52).

15. Theweleit, *Male Fantasies*, v. 2, 162.

16. In Josef Thorak's *Camaraderie* (*Kameradschaft*) of 1937, for example, two such male nudes hold hands fiercely and demonstrate the way in which even an overtly homophobic culture can idealize the homosocial and even allude to homoeroticism; see Theweleit, *Male Fantasies*, v. 2, 63.

17. This French postcard shows the allegorical figure of Marianne flying through the air to distribute babies—readymade for the next war, wearing nothing but soldiers' helmets—to households in which their soldier fathers kiss their mothers goodbye and leave for the current battle; see Theweleit, *Male Fantasies*, v. 2, 100.

18. Theweleit reproduces this poster but does not discuss it; Theweleit, *Male Fantasies*, v. 2, 22.

19. Theweleit, *Male Fantasies*, v. 2, 347–349.

20. For more on the New Woman as the first global female icon, see The Modern Girl around the World Research Group, ed., *The Modern Girl Around the World: Consumption, Modernity, and Globalization* (Durham: Duke University Press, 2008); and Elizabeth Otto and Vanessa Rocco, ed., *The New Woman International: Representations in Photography and Film from the 1870s through the 1960s* (Ann Arbor: University of Michigan Press, 2011).

21. On this topic, see Laurie Marhoefer, *Sex and the Weimar Republic: German*

Homosexual Emancipation and the Rise of the Nazis (Toronto: University of Toronto Press, 2015); and Robert Beachy, *Gay Berlin: Birthplace of a Modern Identity* (New York: Knopf, 2014).

22. *Different from the Others (Anders als die Andern)*, Dir. Richard Oswald (1919). For more on this film, see James Steakley, "Cinema and Censorship in the Weimar Republic: The Case of A*nders als die Andern*," *Film History* (New York) 11, no. 2 (1999): 181–203, and Richard Dyer, "Less and More than Women and Men: Lesbian and Gay Cinema in Weimar Germany," *New German Critique* 51 (1990): 5–60.

23. On nudism, see for example the socialist and nudist Adolf Koch's *Wir sind nackt und nennen uns Du! Bunte Bilder aus der Freikörperkulturbewegung* (Leipzig: Ernst Oldenburg Verlag, 1932); the book's title translates roughly as, "we are naked and call each other by the informal you!" See also Bernd Wedemeyer-Kolwe, *Aufbruch: Die Lebensreform in Deutschland* (Darmstadt: Philipp von Zabern Verlag/Wissenschaftliche Buchgesselschaft, 2017), 108–109. For more on the fight for homosexual emancipation broadly, see Marhoefer, *Sex and the Weimar Republic*. For a vast and colorful sampling of Weimar Germany's underground sex cultures, see Mel Gordon, *Voluptuous Panic: The Erotic World of Weimar Berlin* (Port Townsend: Ferrell House, expanded edition, 2008).

24. See Brigid Doherty, "'See: *We Are All Neurasthenics!*' or, The Trauma of Dada Montage," *Critical Inquiry* 24, no. 1 (1997): 82–127; Hal Foster, "Fatal Attraction," in *Compulsive Beauty* (Cambridge, Mass.: MIT Press, 1995), 101–122; Amy Lyford, *Surrealist Masculinities: Gender Anxiety and the Aesthetics of Post-World War I Reconstruction in France* (Berkeley: University of California Press, 2007); Christine Poggi, *Inventing Futurism: The Art and Politics of Artificial Optimism* (Princeton: Princeton University Press, 2008); and David Hopkins, *Dada's Boys: Masculinity after Duchamp* (New Haven: Yale University Press, 2008).

25. Some of the works that I call "photomontages" would now often be classified as "photo-collages," since they are comprised of cut up elements and have not been re-photographed to yield a smooth surface, as, for example, the *AIZ* covers of John Heartfield. Because of its original contextual meaning, I use "photomontage" to cover both types of pictures, as the *Bauhäusler* would have. See also Elizabeth Otto, "Fragments of the World Seen Like This: Photocollage at the Bauhaus," in *The Photocollages of Josef Albers*, ed. Sarah Meister (New York: The Museum of Modern Art, 2016), 111–112.

26. Siegfried Kracauer, "Photography" (1927), in *The Mass Ornament*, ed. and trans. Thomas Levin (Cambridge, Mass.: Harvard University Press, 1995), 58.

27. László Moholy-Nagy, *Von Material zu Architektur* (Munich: A. Langen, 1929; Berlin: Florian Kupferberg, 1968); translated and published with some alterations as Moholy-Nagy, *The New Vision: Fundamentals of Bauhaus Design, Painting, Sculpture, and Architecture* (New York: W. W. Norton, 1938; Mineola, NY: Dover Publications, 2005); and Moholy-Nagy, *Painting Photography Film* (1925, 1927), trans. Janet Seligman (London: Lund Humphries, 1969). See also Christopher Phillips, "Resurrecting Vision: The New Photography in Europe between the Wars," in *The New Vision: Photography between the World Wars*, ed. Maria Morris Hambourg and Christopher Phillips (New York: Harry Abrams and the Metropolitan Museum of Art, 1989), 65–108.

28. Hanno Möbius traces the word "Montage" to mid-eighteenth-century French, in which context it meant to assemble a complex mechanism, device, or object

and to make it function. See Hanno Möbius, *Montage und Collage: Literatur, bildende Künste, Film, Fotografie, Musik, Theater bis 1933* (Munich: Wilhelm Fink Verlag, 2000), 16.

29. For example, John Heartfield's nickname among the Dadaists during the immediate postwar years was "Monteur-Dada." See Richard Hülsenbeck's text in *Montage: John Heartfield, Vom Club Dada zur Arbeiter-Illustrierten Zeitung*, ed. Eckhard Siepmann (Berlin: Elefanten Press, 1977, 1992), 24. Moholy-Nagy wrote about "photomontages" by Hannah Höch and Paul Citroen in his 1925 *Painting, Photography Film*, 106–107.

30. For a selection of these, see Weber, *Happy Birthday*. Contemporaneously, the French sociologist Marcel Mauss described how, in societies across time, gift-giving practices create social bonds and build community. See Marcel Mauss, *The Gift* (1925), annotated and translated by Jane I. Guyer (Chicago: Hau Books, 2016). Gropius's call to end "Salon Art" appeared already in his founding manifesto of the school: Walter Gropius, "Program of the Staatliches Bauhaus in Weimar" (April 1919), rpt. in *The Bauhaus: Weimar Dessau Berlin Chicago*, ed. Hans M. Wingler, trans. Wolfgang Jabs and Basil Gilbert (Cambridge, Mass.: MIT Press, 1962), 31.

31. Michel Foucault, *The History of Sexuality,* v. I: *An Introduction*, trans. Robert Hurley (New York: Vintage, 1990), 117, 154.

32. Foucault, *History of Sexuality*, v. 1, 157, 159.

33. *Bauhäusler* Max Gebhard reported visiting Moholy-Nagy in Berlin in the fall of 1928: "I wanted to ask Moholy-Nagy's advice, and went to Spichernstr. 2. That's where he had an apartment with an atelier and a darkroom. He received me in a friendly manner, clothed in an orange machinist's suit [*Monteuranzug*]"; Max Gebhard, "Erinnerungen des Bauhäuslers Max Gebhard an Moholy-Nagy," quoted in Irene-Charlotte Lusk, *Montagen ins Blaue: Laszlo Moholy-Nagy, Fotomontagen und -collagen 1922–1943* (Gießen: Anabas-Verlag, 1980), 181. Robin Schuldenfrei, who kindly directed me to Gebhard's quotation, notes another source as well: "while it does not affect the image Moholy-Nagy wanted to project, according to Lucia Moholy the garment was in actuality not a machinist's suit but a dark orange fishermen's coverall from Northern France, as noted by Rolf Sachsse, 'Telephon, Reproduktion und Erzeugerabfüllung: Zum Begriff des Originals bei László Moholy-Nagy,' presented at the Internationales László Moholy-Nagy Symposium, Bielefeld, Germany, 1995"; Robin Schuldenfrei, "Images in Exile: Lucia Moholy's Bauhaus Negatives and the Construction of the Bauhaus Legacy," *History of Photography* 37:2: 190n41.

34. See for example Hugo Erfurth's 1929 photograph of Otto Dix's painting class at the Dresden Academy: https://theartstack.com/artist/hugo-erfurth/otto-dix-his-painting-c.

35. See footnote 6 of this chapter. On De Stijl fashions, see Gabriele Mahn, "Kunst in der Kleidung: Beiträge von Sophie Teuber, Johannes Itten, under verwandten Avangarde," in *Künstler ziehen an: Avantgarde-Mode in Europa, 1910 bis 1939*, ed. Gisela Framke (Berlin: Edition Braus, 1996), 72. El Lissitzky's self-portrait as *The Constructor* from 1924 is a key example from Russian constructivism (see https://www.moma.org/collection/works/83836).

36. For Benjamin, the best model is Bertolt Brecht and his Epic Theater. Walter Benjamin, "The Author as Producer," Address at the Institute for the Study of Fascism, Paris, April 27, 1934, in *Walter Benjamin: Selected Writings*, v. 2 1927–1934, ed. Michael Jennings (Cambridge, Mass.: The Belknap Press of

Harvard University Press, 1999), 768–782, esp. 777–779.

37. Aleksandr Rodchenko's 1922 sketch for "production clothing" (*prozodezh-da*) is reproduced in *Aleksandr Rodchenko*, ed. Magdalena Dabrowski, Leah Dickerman, and Peter Galassi (New York: Museum of Modern Art, 1998), 183. Moholy-Nagy knew Soviet constructivism and specifically Rodchenko's work prior to coming to the Bauhaus; shortly after his fall 1923 arrival, he wrote to Rodchenko to get his opinion on the meaning of the term "constructivism"; see László Moholy-Nagy, Dec. 18, 1923 letter to Aleksandr Rodchenko, quoted in Bernd Finkeldey, "Im Zeichen des Quadrates: Konstruktivisten in Berlin," in *Berlin–Moskow 1900-1950*, ed. Irina Antonowa and Jörn Merkert (Munich: Prestel/Berlinische Galerie, 1995), 161. Rodchenko followed up by reproducing two of Moholy-Nagy's photos in a publication and called him "an extraordinary master"; see Margarita Tupitsyn, "Colorless Field: Notes on the Paths of Modern Photography," *Object:Photo, Modern Photographs: The Thomas Walther Collection, 1909–1949*, ed. Mitra Abbaspour, Lee Ann Daffner, and Maria Morris Hambourg (New York: Museum of Modern Art, 2015), 1–15, esp. 5, 11.

38. Tsai, "László Moholy-Nagy: Reconfiguring the Eye," 156–158.

39. Tsai, "László Moholy-Nagy: Reconfiguring the Eye," 160; see also 159.

40. Moholy-Nagy, letter to writer Iván Hevesy, Berlin, April 1920, collection of the Documentation Center of the Art History Research Group of the Hungarian Academy of Sciences, Budapest, reproduced in Krisztina Passuth, *Moholy-Nagy*, trans. Éva Grusz et al (New York: Thames and Hudson, 1985), 388.

41. For more on Moholy-Nagy's earliest Dada-influenced montage, *25 Pleitegeier* of 1922/1923, see Lusk, *Montagen ins Blaue*, 68–69, and Elizabeth Otto, "A 'Schooling of the Senses': Post-Dada Visual Experiments in the Bauhaus Photomontages of László Moholy-Nagy and Marianne Brandt," *New German Critique* 107 (Summer 2009): 91–95.

42. Moholy-Nagy was offered the post by Gropius after the latter had seen his work in a 1922 *Sturm* exhibition. See Passuth, *Moholy-Nagy*, 39–42. As I recount in ch. 1, he was brought in particularly as a "constructivist." For more on International Constructivism, see Kai-Uwe Hemken and Rainer Stommer, ed., *Konstruktivistische Internationale, 1922–1927: Utopien für eine europäische Kultur* (Stuttgart: Verlag Gerd Hatje; Düsseldorf: Kunstsammlung Nordrhein-Westfalen, 1992).

43. On Moholy-Nagy's deployment of alternative perspective systems in order to mobilize vision through his photomontages, see Devin Fore's Chapter 1: "The Myth Reversed: Perspectives of László Moholy-Nagy," in *Realism after Modernism: The Rehumanization of Art and Literature* (Cambridge, Mass.: MIT Press, 2015), 21–74.

44. For more on this period of Brandt's life and work, see Elizabeth Otto, "Marianne Brandt: 1893–1983," in *4 "Bauhausmädels": Gertrud Arndt, Marianne Brandt, Margarete Heymann, Margaretha Reichardt*, ed. Kai Uwe Schierz, Patrick Rössler, Miriam Krautwurst, and Elizabeth Otto (Dresden: Sandstein Verlag, 2019), 86–119. A significant parallel to Brandt's exploration of a gendered constructivist self is evident in Liubov' Popova and Varvara Stepanova's Soviet, productivist fabric and clothing designs; see ch. 3, "The Constructivist Flapper Dress," in Christina Kiaer, *Imagine No Possessions: The Socialist Objects of Russian Constructivism* (Cambridge, Mass.: MIT Press, 2005), 89–142.

45. Because she embodied many of the ideals of the Bauhaus with her dynamic presence, Grosch was frequently imaged by Feininger and others. See Susan Funkenstein, "Paul Klee and the New Woman Dancer: Gret Palucca, Karla Grosch, and the Gendering of Constructivism," Otto and Rössler, *Bauhaus Bodies*, 145–167; and Otto and Rössler, "Karla Grosch," *Bauhaus Women: A Global Perspective*, 121–126.

46. Susanne Lahusen, "Oskar Schlemmer: Mechanical Ballets?" *Dance Research: The Journal of the Society for Dance Research* 4, no. 2 (1986): 73–74. Lahusen attributes the metal workshop's success to Moholy-Nagy's leadership, but we should recall that Brandt, as the shop's assistant from 1927 and its acting director in 1929, also had a significant hand in its successes. For more in-depth information on the metal workshop, see Klaus Weber, ed., *Die Metalwerkstatt am Bauhaus* (Berlin: Bauhaus-Archiv, 1992).

47. Lahusen, "Oskar Schlemmer," 74.

48. On fragile male post-World War I psyches, see Paul Lerner, *Hysterical Men: War, Psychiatry, and the Politics of Trauma in Germany, 1890–1930* (Ithaca: Cambridge University Press, 2009).

49. *The Hochstapler* is the subject of Walter Serner's *Letzte Lockerung: Ein Handbrevier für Hochstapler und solche die es werden wollen* (expanded edition, 1927); reprinted by Munich: DTV Verlag, 1984. Of course, such types were also present in literature of the Weimar Republic; see Stefan Andriopoulos, *Ghostly Apparitions: German Idealism, the Gothic Novel, and Optical Media* (New York: Zone Books, 2013).

50. See *The Student of Prague* (*Der Student von Prag*, dir.: Henrik Galeen, 1926) and *The Hands of Orlac* (*Orlacs Hände*, dir.: Robert Wiene, 1924). I have written on Veidt and Weimar cinematic masculinities in "Schaulust: Sexuality and Trauma in Conrad Veidt's Masculine Masquerades," in *The Many Faces of Weimar Cinema: Rediscovering Germany's Filmic Legacy*, ed. Christian Rogowski (Suffolk, U.K.: Camden House, 2010), 135–152.

51. Sigmund Freud, "Psychoanalysis and the War Neurosis" (1919), cited in Kaes, *Shell Shock Cinema*, 209.

52. Additional examples are reproduced and discussed in my catalogue raisoneé of Brandt's photomontages, *Tempo, Tempo! The Bauhaus Photomontages of Marianne Brandt* (Berlin: Bauhaus-Archiv/Jovis Verlag, 2005). See, for example, *It's a Matter of Taste*, 1926 (46–49), *The Man Who Brings Death* of 1928 (94–95), and *On the March*, also of 1928 (96–99).

53. In addition to *The Chump*, the other two photomontages are both called *Jealousy* (*Eifersucht*). See Lusk, *Montagen ins Blaue*, 100–101.

54. *The Guestbook of Kate T. Steinitz*, reproduction (Cologne: Galerie Gmurzynska, 1977), n.p. See also William Emboden, "Kate T. Steinitz: Art into Life into Art," in *Kate T. Steinitz: Art into Life into Art*, ed. William Emboden, (Irvine, CA: Severin Wunderman Museum Publications, 1994), 25–43.

55. These and many other criticisms were heaped on the Bauhaus. See K.N. [K. Nonn], "The State Garbage Supplies: the Staatliche Bauhaus in Weimar," *Deutsche Zeitung* (Berlin), no. 178, April 24, 1924, reprinted in Wingler, 76–77.

56. These connections did not end with the Bauhaus period. All three of these men—and Moholy-Nagy as well—left the Bauhaus in 1928, and they continued to maintain relationships thereafter, even working together as a quartet

in 1930 to design the German section of the exhibition of the Société des Artistes Décorateurs in Paris. See Manfred Ludewig and Magdalena Droste, "Marcel Breuer," in *New Worlds: German and Austrian Art, 1890–1940*, ed. Renée Price, trans. Elizabeth Clegg (New Haven: Yale University Press: 2001), 554. All four of them also later immigrated to the United States.

57. Patrick Rössler and Gwen Chanzit, *Der einsame Großstädter: Herbert Bayer, Eine Kurzbiografie* (Berlin: Vergangenheitsverlag, 2014), 89–125. Weber, *Happy Birthday*, 216. See also Reginald Isaacs, who describes the affair and cites letters between Walter and Ise Gropius on the topic, but omits Bayer's name; Reginald Isaacs, *Walter Gropius: An Illustrated Biography of The Creator of The Bauhaus* (Boston: Bullfinch, 1991), 166–173.

58. Cohen, *Herbert Bayer*, 7. In a seeming reversal of this encounter, one of the panels of this montage shows Gropius as a lusty Austrian lad in traditional dress; see Weber, *Happy Birthday*, 217.

59. In the midst of the affair, Walter writes to Ise of an evening spent with Bayer drinking and talking openly until the next morning. Isaacs, *Gropius*, 170.

60. Both reproduced in Weber, *Happy Birthday*, 216–217.

61. Patrick Rössler, *Die neue Linie, 1929–1943: Das Bauhaus am Kiosk* (Berlin: Bauhaus-Archiv and Kerber, 2007), 44.

62. This photograph of Bayer is cut from one in which he originally appeared with Gropius and fellow *Bauhäusler* Xanti Schawinsky, all of them laughing. See Cohen, *Herbert Bayer*, 377.

63. On Bayer's virtuoso technique in this work, see MoMA conservator Lee Ann Daffner and curator Roxana Marcoci's essay: https://www.moma.org/interactives/objectphoto/objects/83703.html.

64. The original photograph is reproduced in Patrick Rössler, *Herbert Bayer: Die Berliner Jahre, Werbegrafik 1928–1933* (Berlin: Bauhaus-Archiv/Vergangenheits Verlag, 2013), 52. My analysis of this work benefited from productive conversations with Patrick Rössler.

65. Frederic J. Schwartz, "Utopia for Sale: The Bauhaus and Weimar Germany's Consumer Culture," in Kathleen James-Chakraborty, ed., *Bauhaus Culture: From Weimar to the Cold War* (Minneapolis: University of Minnesota Press, 2006), 115.

CHAPTER 3

1. Renate Richter-Green (Ré Soupault), "Probleme der Mode" (Problems of Fashion), *Die Form* 5:16 (1930): 414–415.

2. Ré Soupault, *Nur das Geistige zählt: Vom Bauhaus in die Welt, Erinnerungen*, ed. Manfred Metzner (Heidelberg: Wunderhorn, 2018), 50.

3. Soupault, *Nur das Geistige zählt*, 50. She designed the split skirt when she was working for Parisian designer Paul Poiret. On Soupault's career in fashion, see Inge Herold, "Ré Richter alias Renate Green und die Mode," in: *Ré Soupault: Künstlerin im Zentrum der Avantgarde*, ed. Inge Herold, Ulrike Lorenz, and Manfred Metzner (Heidelberg: Wunderhorn, 2011), 65–107.

4. Soupault, *Nur das Geistige zählt*, 29, 31.

5. On her film work, see Peter Bär, "Meta Erna Niemeyer und der abstrakte Film," in: *Soupault: Künstlerin im Zentrum*, 53–63; Louise O'Konor, *Viking Eggeling 1880–1925: Artist and Filmmaker, Life and Work* (Stockholm: Almquist and Wiksell, 1971); and R. Bruce Elder, *Harmony and Dissent: Film and the Avant-Garde Art Movements in the Early Twentieth Century* (Waterloo: Wilfrid Laurier University Press, 2010), 164n260. For Ré Soupault's own account of her work with Viking Eggeling and Hans Richter, see Soupault, *Nur das Geistige zählt*, 27–42, 228.

6. Photographs of the women and a description of Soupault's experience with them are in Ré Soupault, *Frauenportraits aus dem "Quartier réservé" in Tunis* (Heidelberg: Wunderhorn, 2001), esp. "Vorwort zur Neuausgabe," (3).

7. Ré Soupault recounts this hair-raising trip in her memoir, *Nur das Geistige Zählt*, 91. Happily, as she learned in 1988, a friend in Tunis rescued 1,400 of her negatives (230).

8. One of the most iconic of these is Germaine Krull's 1927 "Self-Portrait with Ikarett," reproduced on the cover of Elizabeth Otto and Vanessa Rocco, eds., *The New Woman International: Representations in Photography and Film, From the 1870s through the 1960s* (Ann Arbor: University of Michigan Press, 2011).

9. For more on Ré Soupault's life and work, see Manfred Metzner, *Ré Soupault: Das Auge der Avantgarde* (Heidelberg: Wunderhorn Verlag, 2011); Ursula März, *Du lebst wie im Hotel: Die Welt der Re Soupault* (Heidelberg: Wunderhorn Verlag, 1999); and Otto and Rössler, *Bauhaus Women: A Global Perspective* (London: Bloomsbury UK/Herbert Press, 2019), 52–55.

10. Bruce Elder's history of early twentieth-century avant-garde film has section headers for both Eggeling and Richter, but Ré Soupault appears only in a footnote and under the name Erna Niemeyer, which makes her difficult to recognize; see Elder, *Harmony and Dissent*, 194–195n208, 198n230, and 201n260. O'Konor's *Viking Eggeling* is clearer in that, Eggeling's biography, lists his meeting of "Erna Niemeyer (Ré Niemeyer-Soupault)" as the major event of 1923 (14), but she also appears elsewhere as "Mme Renate Green," with no connection made (45). Stephen Foster's edited volume, *Hans Richter: Activism, Modernism, and the Avant-Garde* (Cambridge, Mass.: MIT Press, 1998), makes no mention of her.

11. As Kathleen James-Chakraborty asserts, while Bauhaus women are often discussed as identical with the New Woman of the big city, in fact, they had their own unique fashion codes that aligned them with newness and the Bauhaus skill set and gestured towards a certain transcendence of gender. See Kathleen James-Chakraborty, "Clothing Bauhaus Bodies," in Elizabeth Otto and Patrick Rössler, ed., *Bauhaus Bodies: Gender, Sexuality, and Body Culture in Modernism's Legendary Art School* (New York: Bloomsbury Visual Arts, 2019), 125–144.

12. For more background on all of the female artists I discuss throughout this chapter, see Otto and Rössler *Bauhaus Women: A Global Perspective*, which profiles forty-five women of the Bauhaus. See also Ulrike Müller, *Bauhaus Frauen*, second edition (Munich: Elisabeth Sandeman Verlag, 2019); the first edition is available in English as *Bauhaus Women: Art, Handicraft, Design* (Paris: Flammarion, 2009).

13. Alice Rawsthom, "The Tale of a Teapot and its Creator," *The New York Times*, Dec. 16, 2007; https://www.nytimes.com/2007/12/16/style/16iht-design17.1.8763227.html.

14. Klaus Weber quoted in Rawsthom, "Tale of a Teapot." As Robin Schuldenfrei points out, this tea-extract pot design appears to evince "all of the concepts that modernism proclaimed—*Sachlichkeit*, functionality, hygiene, and the use of modern materials and construction methods," but in fact, it was laboriously hand fabricated to render it a pure luxury object. See Robin Schuldenfrei, *Luxury and Modernism: Architecture and the Object in Germany 1900–1933* (Princeton: Princeton University Press, 2018), 139–141.

15. For example, Amy Dempsey's new *Modern Art* for Thames and Hudson's "Art Essentials" series highlights seven *Bauhäusler*, none of them female; Amy Dempsey, Modern Art (New York: Thames and Hudson, 2018), 66–67. *Art Since 1900* does include one of Brandt's works among its seven illustrations, a 1928 bedside lamp that was mass-produced by Körting and Mathesien. See Hal Foster, Rosalind Krauss, Yve-Alain Bois, Benjamin H.D. Buchloh, and David Joselitt, *Art Since 1900*, v. 1: *1900 to 1944: Modernism, Antimodernism, Postmodernism*, 3rd edition (New York: Thames and Hudson, 2016), 209–213.

16. Walter Gropius, notes for a speech to the Bauhaus students, July 1919 (collection Bauhaus-Archiv, Museum für Gestaltung, Berlin), quoted in Anja Baumhoff, "What's in the Shadow of a Bauhaus Block? Gender Issues in Classical Modernity," in *Practicing Modernity: Female Creativity in the Weimar Republic*, ed. Christiane Schönfield (Würzburg: Königshausen & Neumann, 2006), 53–57 53–57.

17. In addition to the 163 male and female students known to have registered that first semester, there are two students only identified by their initials. For a list of the student body's numbers separated by gender ratio for each semester, see Adrian Sudhalter, "14 Years Bauhaus: A Chronicle," in: Barry Bergdoll and Leah Dickerman, eds. *Bauhaus 1919–1933: Workshops for Modernity* (New York: Museum of Modern Art, 2009), 323–327. A breakdown of numbers of Bauhaus students by gender, year, and area of specialization is available in Patrick Rössler and Anke Blümm, "Soft Skills and Hard Facts: A Systematic Overview of Bauhaus Women's Presence and Roles," in Otto and Rössler *Bauhaus Bodies*, 10. For further information see the website of the German Research Foundation (Deutsche Forschungsgemeinschaft) funded project, "Die bewegten Netze des Bauhauses" (https://forschungsstelle.bauhaus.community/), created by a team of researchers including Blümm and Rössler.

18. According to Folke Dietzsch, during the Bauhaus's Weimar period (1919–1925), 287 of the 638 total students were female; in Dessau (1925–1932), only 177 of 612 were. This is a shift from forty-five percent to just twenty-nine. See Folke Dietzsch, "Die Studierenden am Bauhaus: Eine analytische Betrachtung zur Struktur der Studentenschaft, zur Ausbildung und zum Leben der Studierenden am Bauhaus sowie zu ihrem späteren Wirken," v. 2 (PhD diss. Hochschule für Architektur und Bauwesen Weimar, 1990), 293; and Rössler and Blümm, "Soft Skills and Hard Facts," 3–24. On the symbolic marginalization of female bodies at the Bauhaus, see Paul Monty Paret, "Invisible Bodies and Empty Spaces: Notes on Gender at the 1923 Bauhaus Exhibition," in Otto and Rössler, *Bauhaus Bodies*, 101–122.

19. As I detail in ch. 2, of a pre-war population of over sixteen million active-duty-aged men in Germany, two million were killed and 1.5 million were permanently disabled. See Robert Whalen, *Bitter Wounds: German Victims of The Great War, 1914–1939* (Ithaca: Cornell University Press, 1984), 40–41; and Deborah Cohen, *The War Come Home: Disabled Veterans in Britain and Germany, 1914–1939* (Berkeley: University of California Press, 2001), 4, 193.

20. As he sought to establish the Bauhaus's reputation, Gropius was concerned that, especially because it incorporated craft, the institution would be associated with dilettantism. Anja Baumhoff has shown that, for Gropius, both craft and dilettantism were linked to female students at the Bauhaus. See Baumhoff, ch. 3, "What's the Difference? Sexual Politics of the Bauhaus," in: *The Gendered World of the Bauhaus: The Politics of Power at the Weimar Republic's Premier Art Institute, 1919–1932* (Frankfurt am Main: Peter Lang, 2001), 53–75, esp. 71–75.

21. Notes from the February 2, 1920 meeting of the masters' council, in: Ute Ackermann and Volker Wahl, eds., *Meisterratsprotokolle des Staatlichen Bauhauses Weimar 1919–1925* (Weimar: Verlag Hermann Böhlaus Nachfolger, 2001), 71.

22. Baumhoff, "What's in the Shadow of a Bauhaus Block?" 53–57. For more on the innovations and theoretical writings of key figures in the weaving workshop, see T'ai Smith, *Bauhaus Weaving Theory: From Feminine Craft to Mode of Design* (Minneapolis: University of Minnesota Press, 2014). The terms "Women's Class" (Frauenklasse) and "Women's Department" (Frauenabteilung) seem to have been used for a relatively short period of time and not past 1921. For an example of Gropius's use of the latter term, see: Elizabeth Otto, "Margarete Heymann: 1889–1990," in *4 "Bauhausmädels": Gertrud Arndt, Marianne Brandt, Margarete Heymann, Margaretha Reichardt*, ed. Kai-Uwe Schierz, Patrick Rössler, Miriam Krautwurst, and Elizabeth Otto (Erfurt: Angermuseum/Dresden: Sandstein Verlag, 2019), 124.

23. As I indicate in a footnote in the introduction, former students Josef Albers, Herbert Bayer, Marcel Breuer, Joost Schmidt, and Gunta Stölzl were all promoted to leadership positions in 1925. While the men became junior masters (*Jungmeister*), Stölzl was given the inferior title of master of craft (*Werkmeisterin*). In 1926, the year of this photo, she became the workshop's leader (*Leiterin*). Both of these posts were more poorly remunerated than the junior masters were. In 1927, she received the title of junior master, but still at a lower salary than her male colleagues. She was only granted a raise in 1928, when she threatened to quit. See Monika Stadler and Yael Aloni, ed., *Gunta Stölzl: Bauhaus Master*, trans. Allison Plath-Moseley (New York: Museum of Modern Art; Ostfildern: Hatje Cantz, 2009), esp. 78, 91–92, 94, 116.

24. Avery Gordon, *Ghostly Matters: Haunting and the Sociological Imagination* (Minneapolis: University of Minnesota Press, 1997, 2008), 3–28, esp. 3–5. See also Janice Radway's thoughtful contextualization of the book's impact since its publication; Radway, "Forward," in: Gordon, *Ghostly Matters*, vii–xiv.

25. Gordon, *Ghostly Matters*, xvi, 7, and 15.

26. T. Lux Feininger's "Jump Over the Bauhaus" photograph shows Xanti Schawinski and Erich Consemüller colliding in the air while playing soccer in a field next to the Dessau Bauhaus building, dwarfed in the distance behind them. See Rosalind Krauss, "Jump over the Bauhaus: Avant-Garde Photography in Germany 1919–1939," *October* 15 (Winter 1980), 102–110. For more on T. Lux Feininger's extraordinary photographs, see Jeannine Fiedler, "T. Lux Feininger: 'I am a Painter and Not a Photographer!'" in: *Photography at the Bauhaus*, ed. Jeannine Fiedler (London: Dirk Nishen Publishing, 1990), 44–53.

27. See Table 1.3 in Rössler and Blümm, "Soft Skills and Hard Facts," 10, which shows that, while the weaving workshop was by far the most likely destination for female Bauhaus students (128 women and thirteen men), they were indeed

present in every area of study. They made up half of the students in photography and there were even forty women who studied architecture (compared with 221 men). An example of what in retrospect could be called hazing occurred to Marianne Brandt, who was given exclusively mundane and repetitive jobs when she joined the metal workshop; only later did she find out that her male colleagues had hoped she would quit. See Marianne Brandt, "Letter to the Younger Generation," in: Eckhard Neuman, ed. *Bauhaus and Bauhaus People*, trans. Eva Richter and Alba Lormann, 1970 (New York: Van Nostrand Reinhold, 1992), 106; and Elizabeth Otto, *Tempo, Tempo! The Bauhaus Photomontages of Marianne Brandt* (Berlin: Jovis/Bauhaus-Archiv, 2005), 136–137.

28. Susan Funkenstein, "Paul Klee and the New Woman Dancer: Gret Palucca, Karla Grosch, and the Gendering of Constructivism," in Otto and Rössler, *Bauhaus Bodies*, 145–167.

29. "Mädchen wollen etwas lernen," *Die Woche* (April 4, 1930): 30. This type and the work of four Bauhaus women are the focus of Schierz, Rössler, Krautwurst, and Otto, *Bauhausmädels*; page reproduced on 11.

30. Already in the "Program of the Staatliche Bauhaus," Gropius wrote of the importance of all members of the school securing commissions. See Walter Gropius, "Program of the Staatliche Bauhaus in Weimar" (April 1919), rpt. in *The Bauhaus: Weimar Dessau Berlin Chicago*, ed. Hans M. Wingler, trans. Wolfgang Jabs and Basil Gilbert (Cambridge, Mass.: MIT Press, 1962), 32. The best source on the business aspects of the Bauhaus is Daniela Dietsche, "Studien zum Bauhaus als Wirtschaftsunternehmen," (MA Thesis, Technische Üniversität Berlin, 1993), esp. 57–75. For more on Leiteritz's work with Bauhaus wallpaper, see Morgan Ridler, "Dörte Helm, Margaret Leiteritz, and Lou-Scheper-Berkenkamp: Rare Women of the Bauhaus Wall-Painting Workshop," in: Otto and Rössler, *Bauhaus Bodies*, 195–216, esp. 204–206.

31. Dan P. Silverman, "A Pledge Unredeemed: The Housing Crisis in Weimar Germany," *Central European History* 3, no. 1/2 (1970): 112–139.

32. One such photograph is reproduced in Otto and Rössler, *Bauhaus Women: A Global Perspective*, 82. For more on Brandt's contributions to the Dessau Bauhaus's lighting, see Klaus Weber, ed., *Die Metallwerkstatt am Bauhaus* (Berlin: Bauhaus-Archiv, 1992), 161–162, 164.

33. For more on the interwar context of these light designs, see Thomas Heyden, "Mehr Licht! Lampendesign der 'Neuen Sachlichkeit' in Deutschland," in: Weber, *Die Metallwerkstatt am Bauhaus*, 98–103. On Bauhaus designs' mass production, see Olaf Thormann and Katrin Heise, "Bauhaus–Kandem," in *Bauhausleuchten? Kandemlicht! Die Zusammenarbeit des Bauhauses mit der Leipziger Firma Kandem*, ed. Justus Binroth (Leipzig: Grassi Museum, Museum für Kunsthandwerk Leipzig; Stuttgart: Arnoldsche Art Publishers, 2002), 156–203.

34. Fritz Hesse, *Vor der Residenz zur Bauhausstadt: Erinnerungen an Dessau* (1963), 212, a self-published book held in the Bauhaus-Archiv; cited in Mercedes Valdevieso, "Ise Gropius: 'Everyone Here Calls me Frau Bauhaus,'" trans. Jordan Troeller, in: Otto and Rössler, *Bauhaus Bodies*, 169–193.

35. Valdevieso documents Ise Gropius's reading of Bruno Taut's *Die neue Wohnung: Die Frau als Schöpferin* (The New Home: The Woman as Creator), in 1925, the year after it was published. Margarete ("Grete") Schütte-Lihotzky's Frankfurt Kitchen, a major landmark in kitchen reform of the time, also dates to 1926, but Valdevieso conjectures that Ise Gropius likely did

not see it until 1927, when it was shown at the Stuttgart Werkbund exhibition *Die Wohnung* (*The Home*). Valdevieso, "Ise Gropius," 178. For more on Schütte-Lihotsky in the context of housing reform and Das Neue Frankfurt, see Thomas Elsaesser, "The Camera in the Kitchen: Grete Schütte-Lihotsky and Domestic Modernity," in: Schönfeld, *Practicing Modernity*, 27–49.

36. Ise Gropius, Diary, supplemental commentary, 98; collection of the Bauhaus-Archiv. Cited in Valdevieso, "Ise Gropius," 176.

37. Schuldenfrei, *Luxury and Modernism*, 149.

38. For more on the teaching and influence of Gertrud Grunow on students of the early Bauhaus, see Linn Burchert, "The Spiritual Enhancement of the Body: Johannes Itten, Gertrud Grunow, and Mazdaznan at the Early Bauhaus," in: Otto and Rössler, *Bauhaus Bodies*, 49–72.

39. For more on her extraordinary work and life, see Elena Makarova, *Friedl Dicker-Brandeis: Vienna 1898–Auschwitz 1944* (Los Angeles: Tallfellow/Every Picture Press, 2001). In "Passages with Friedl Dicker Brandeis: From the Bauhaus through Theresienstadt," I suggest that Dicker's legacy survived in part through students like Edith Kramer, one of the originators of the art therapy movement in the U.S.; see *Passages of Exile*. ed. Burcu Dogramaci and Elizabeth Otto (Munich: Edition Text + Kritik, 2017), 230–251. See also Katharina Hövelmann, "Bauhaus in Wien? Möbeldesign, Innenraumgestaltung und Architektur der Wiener Ateliergemeinschaft von Friedl Dicker und Franz Singer," (PhD diss. Universität Wien, 2018).

40. Hövelmann, "Bauhaus in Wien?" 70–72. See also Corinna Bauer, *Architekturstudentinnen in der Weimarer Republik: Bauhaus und Tessenow Schülerinnen* (PhD diss. Universität Kassel, 2003), 67–68.

41. Hans Hildebrandt, *Die Kunst des 19 und 20. Jahrhunderts* (Potsdam: Akademische Verlagsgesellschaft Athenaion, 1924, 1931), 291.

42. Makarova, *Friedl Dicker-Brandeis*, 102–103. For more on the set: Paul-Reza Klein, "Der 'Phantasus' Tierbaukasten von Friedl Dicker und Franz Singer, Baukästen zwischen technischem Spiel und künstlerischem Ausdruck," (M.A. Thesis, Universität für angewandte Kunst Wien, 2015), 291 pages; available online: https://fedora.phaidra.bibliothek.uni-ak.ac.at/fedora/get/o:6717/bdef: Content/get.

43. For more on this set, see Amanda Boyaki, "Alma Buscher Siedhoff: An Examination of Children's Design and Gender at the Bauhaus during the Weimar Period" (PhD dissertation, Texas Tech University, 2010).

44. Reproduced in Makarova, *Friedl Dicker*, 84–85.

45. Georg Schrom and Stefanie Trauttmansdorf, *Bauhaus in Wien: Franz Singer, Friedl Dicker*, ed., (Vienna: Hochschule für Angewandte Kunst in Wien, 1989), 10. For more on the broader context in which they were working—and from which their Bauhaus-influenced designs were somewhat distinct—see Eva Blau, *The Architecture of Red Vienna, 1919–1934* (Cambridge, Mass.: MIT Press, 1999).

46. For an overview of the project, including its glass elevator, see Schrom and Trauttmansdorf, *Bauhaus in Wien*, 84–96.

47. Makarova, *Friedl Dicker*, 21. On Vienna's complex and relatively unique political culture in this period, see Helmut Gruber, *Red Vienna: Experiment in Working-Class Culture, 1919–1934* (Oxford: Oxford University Press, 1991).

48. Connections among Bauhaus women also merit further research. For example, I have been able to identify photographs of another female *Bauhäusler*, Edith Tudor-Hart, in at least one of Dicker's photomontages. See Otto and Rössler, *Bauhaus Women: A Global Perspective*, 15, 130–133. Like Dicker, Tudor-Hart was an Austrian Bauhaus member—if of a younger generation—and a highly committed Communist. These photographs were originals, making it nearly certain that the two women knew each other personally, a view confirmed in conversation with Duncan Forbes. See also: Duncan Forbes, ed., *Edith Tudor-Hart: In the Shadow of Tyranny*, exh. cat. National Galleries Scotland and Wien Museum (Ostfildern: Hatje-Cantz, 2013).

49. Karsten Kruppa, "Marianne Brandt, 'Annäherung an ein Leben,'" Weber, *Die Metallwerkstatt am Bauhaus*, 50.

50. As I assert in the previous chapter, photography was one logical response to Gropius's call for an end to "salon art," or painting that served no function, in his original "Program of the Staatliche Bauhaus." See Gropius, "Program of the Staatliche Bauhaus in Weimar," 31. To be sure, with Paul Klee and Wassily Kandinsky as masters at the school, painting was certainly alive and well. However, both of them taught within the institution's workshop structure in addition to teaching aspects of painting and drawing.

51. For reproductions of all known photomontages by Brandt, see Otto, *Tempo, Tempo!*

52. The Modern Girl Around the World Research Group, ed., *The Modern Girl Around the World* (Durham: Duke University Press, 2008); and Otto and Rocco, *The New Woman International*.

53. In terms of technique and content, it is logical to compare Brandt to Hannah Höch, who likewise created dynamic explorations of New Womanhood in photomontage. The two almost certainly knew each other through Moholy-Nagy. On Höch's complex and contradictory photomontages in relation to women's experiences of the new Weimar Republic's freedoms, see Patrizia McBride, "*Cut with the Kitchen Knife:* Visualizing Politics in Berlin Dada," in: Deborah Ascher Barnstone and Elizabeth Otto, ed., *Art and Resistance in Germany* (New York: Bloomsbury Academic, 2018), 23–38.

54. According to Peter-Ashley Jackson of York University, this photograph shows American Actress Olive Borden (private email correspondence). Elizabeth of OliveBorden.org identified this as Borden mocking director John Ford during the filming of *Three Bad Men* (1926).

55. Elisabeth Wynhoff, ed., *Marianne Brandt: Fotografieren am Bauhaus* (Ostfildern-Ruit: Hatje-Cantz, 2003), 21.

56. Brandt's diploma lists "engagement with photography" as an official part of her work during this period. Bauhaus-Diploma Marianne Brandt (signed Hannes Meyer), October 10, 1929, collection of the Bauhaus-Archiv, Berlin.

57. For example, László Moholy-Nagy reproduced one such photograph by George Muche, captioned "photographed reflections in a convex mirror," in *Painting Photography Film*, 1925, trans. Janet Seligman (Cambridge, Mass.: MIT Press, 1969, 1987), 103. For a history of this technique in relation to the Bauhaus and Brandt's self-portraits, see Anja Guttenberger, "Fotografische Selbstportraits der Bauhäusler zwischen 1919 und 1933" (PhD diss., Freie Universität Berlin, 2011), 107–111.

58. The phrase is from Tom Gunning's sensitive investigation of both analogue and digital photography's claim to accuracy. Gunning, "What's the Point of an

Index? Or, Faking Photographs," in: Karen Beckman and Jean Ma, ed., *Still Moving: Between Cinema and Photography* (Durham: Duke University Press, 2008), 23–40.

59. Freud's concept of the picture puzzle, which he also calls a rebus, is based in his idea that interpretation of both strange pictures and dreams must be done associatively and in an open-ended manner. See Sigmund Freud, *The Interpretation of Dreams*, trans. James Strachey (New York: Avon Books, 1965), 312; and Georges Didi-Huberman, *Confronting Images: Questioning the Ends of a Certain History of Art* (University Park: Penn State University Press, 2009), 143–145.

60. The school's official *Bauhaus* journal was published between 1926 and 1931 and should not be confused with the journal of the same name published by the Kostufra or Communist Student Faction beginning in 1930. I discuss this other journal in ch. 5.

61. Naum Gabo, "gestaltung?" *Bauhaus* 2, no. 4 (1928): 3. Gabo gave a lecture at the Bauhaus in 1928.

62. Marianne Brandt, "bauhausstil," *Bauhaus* 3, no. 1 (1929): 21.

63. *Bauhaus* 3, no. 1 (1929): 25.

64. Joan Riviere, "Womanliness as Masquerade" (1929), reprinted in *The Inner World and Joan Riviere, Collected Papers: 1920–1958*, Athol Hughes, ed. (New York: Karnac Books, 1991), 94.

65. Riviere's ideas were influential for Judith Butler's theory of gender as performance; see Judith Butler, *Gender Trouble: Feminism and the Subversion of Identity* (New York: Routledge, 1990), 64–64, 68–73.

66. Riviere, "Womanliness as Masquerade," 93.

67. Marianne Brandt, notebook held in the collection of the Bauhaus Dessau Foundation. Brandt merely noted Bredendieck's sentence, "wie kommt das Bauhaus dazu Dich zu unterhalten?" The verb is ambiguous, so that the sentence could also be translated as "how is it that the Bauhaus gets to amuse/entertain you?" In any of these interpretations, it is clear that Bredendieck was critiquing Brandt's leadership. See also Otto, "Good Day, Lady/That's the Way the World is," in: Otto, *Tempo, Tempo!* 110.

68. Brandt, Letter to Hannes Meyer, April 25, 1929, collection of the Bauhaus Dessau Foundation. She resigned effective July of that year.

69. Katie Sutton, *The Masculine Woman in Weimar Germany* (London: Berghahn Books, 2013).

70. Christian Wolsdorff, *Eigentlich wollte ich ja Architektin werden: Gertrud Arndt als Weberin und Photographin am Bauhaus 1923–31* (Berlin: Bauhaus-Archiv, 2013), 6–7. See also Patrick Rössler's essay on Gertrud Arndt in *Schierz, Rössler, \ Krautwurst, and \ Otto, 4 "Bauhausmädels,"* 56–85.

71. Wolsdorff, *Eigentlich wollte ich ja Architektin werden*, 18.

72. Wolsdorff, *Eigentlich wollte ich ja Architektin werden*, 20. See Walter Gropius, ed., *Neue Arbeiten der Bauhauswerkstätten* (Munich: Albert Langen Verlag, 1925), color plate I, between pages 16 and 17.

73. Wolsdorff, *Eigentlich wollte ich ja Architektin werden*, 60. According to Wolsdorff, Arndt stuck to the decision and never wove again in her life.

74. Arndt, n.d., quoted in Wolsdorff, *Eigentlich wollte ich ja Architektin werden*, 74.

75. Arndt's photographs of Berger are reproduced in Wolsdorff, *Eigentlich wollte ich ja Architektin werden*, 70–73, 77.

76. Sabine Leßmann gives the total number as forty-three in: Sabine Leßmann, "'Die Maske der Weiblichkeit nimmt kuriose Formen an…': Rollenspiele und Verkleidungen in den Fotografien Gertrud Arndts und Marta Astfalck-Vietz," in: *Fotografien hieß teilnehmen: Fotografinnen der Weimarer Republik, ed. Ute Eskildsen* (Düsseldorf: Richter Verlag/Museum Folkwang, Essen, 1994), 273. Wolsdorff updates the number as at least forty (*Eigentlich wollte ich ja Architektin werden*, 75).

77. 1990s interview with Gertrud Arndt, in Wolsdorff, *Eigentlich wollte ich ja Architektin werden*, 75.

78. Gertrud Arndt, unpublished manuscript, July 1979, cited in, Leßmann, "Die Maske der Weiblichkeit …" in, 273.

79. Wolsdorff points out that Numbers 1 and 2 were made earlier, while she still lived in Probstzella; after that, the numbers appear to be entirely random; Wolsdorff, *Eigentlich wollte ich ja Architektin werden*, 75.

80. Reproduced in Wolsdorff, *Eigentlich wollte ich ja Architektin werden*, 100 (Cat. No. 164).

81. Gertrud Arndt, quoted in: Marion Beckers, ed., *Photographien der Bauhaus-Künstlerin Gertrud Arndt*, exhib. cat. (Berlin: Das verborgene Museum, 1994), 42.

82. Reproduced in Wolsdorff, *Eigentlich wollte ich ja Architektin werden*, 89 (Cat. No. 153).

83. The current location of this photograph is unknown. It was reproduced in the small print-run catalogue of a Parisian exhibition in the 1980s: Alain Paviot, *Bauhaus Photographie*, (Paris: Galerie Octant, 1983), Cat. No. 33. A slightly cropped version was also reproduced in Roswitha Fricke, ed., *Bauhaus Photography*, 1982, trans. Harvey L. Mendelsohn (Cambridge, Mass.: MIT Press, 1985), 43.

84. In his classic study, Mikhail Bakhtin postulates carnival in the Middle Ages as having provided a necessary space of release through humor and even the grotesque in an otherwise repressive society. See Mikhail Bakhtin, *Rabelais and His World*, trans. Hélèn Iswolsky (Cambridge, Mass.: MIT Press, 1968).

85. See Jack Halberstam, *The Queer Art of Failure* (Durham: Duke University Press, 2011); and Edelman, *No Future: Queer Theory and the Death Drive* (Durham: Duke University Press, 2004), esp. "The Future is Kid Stuff," 1–31.

86. Halberstam, *Queer Art of Failure*, 3.

87. It is possible but not likely that Arndt learned of the work of Paris-based Claude Cahun and Marcel Moore in the midst of making her "Mask Portraits"; a single, distorted portrait of Cahun with her shoulders bared and with her head shaved appeared in the Surrealist journal *Bifur* in April of 1930. Arndt had already taken two of the *Mask Photos* in Probstella the previous year. More likely these artists were working in parallel in two different contexts, but with the same technology and related ideas. See Louise Downie, ed., *Don't Kiss Me: The Art of Claude Cahun and Marcel Moore* (New York: Aperture, 2006); and Jennifer Shaw, *Exist Otherwise: The Life and Works of Claude Cahun* (London: Reaktion Books, 2017).

88. Christian Wolsdorff recounts that, as a teenager already, she joined the *Wandervogel* movement, bobbed her hair, and officially renounced Catholicism; her daughter was born in Dessau in the middle of 1931. See Wolsdorff, *Eigentlich wollte ich ja Architektin werden*, 6, 76.

89. While Gertrud Arndt's marriage might have appeared conventional, there is evidence that it was not. Prior to marrying, she created a playful, collaged "Marriage Contract" that emphasizes equality in the relationship by jokingly binding both partners to complete mutual love and even "the perfect marriage" (*Die vollkommene Ehe*, the name of a contemporaneous love and sex manual), but also proposes annual trips, together or separately, as they wish. Reproduced in Wollsdorff, *Eigentlich wollte ich ja Architektin werden*, 62–63. Additionally, it is quite likely that Gertrud Arndt, already well trained as an architect's assistant before she came to the Bauhaus, worked in the private architectural firm that Alfred Arndt ran after they left Dessau in 1932.

90. Gordon, *Ghostly Matters*, 207–208.

91. Gordon, *Ghostly Matters*, 206–207.

92. Gordon, *Ghostly Matters*, 3. She asserts that taking the complicated nature of life and history seriously, "…asks us to move analytically between that sad and sunken couch that sags in just that place where an unrememberable past and an unimaginable future force us to sit day after day and the conceptual abstractions because everything of significance happens there among the inert furniture and the monumental social architecture" (4).

93. In her classic "Visual Pleasure and Narrative Cinema," Laura Mulvey asserts that, in some film structures—classic mid-century Hollywood film is her example—female characters *appear* and stop the narrative, whereas male characters *act* and move the story forward. See Laura Mulvey, "Visual Pleasure and Narrative Cinema, "Screen" 16:3: 11–13.

94. The phrase "Bauhaus Theater of Human Dolls" is Juliet Koss's; see ch. 7 of *Modernism After Wagner* (Minneapolis: University of Minnesota Press, 2010), 207–243.

CHAPTER 4

1. Comparison photos collected by the Bauhaus-Archiv prove without a doubt that this photograph was taken in one of the ateliers in the Dessau Bauhaus's Prellerhaus, presumably Heinz Loew's.

2. Contemporaneously to the Bauhaus, Walter Benjamin praised allegorical representation as "the art of interruption," fragmented or obviously constructed pictures that allow the viewer to understand complex "constellations" of meaning. Walter Benjamin, *The Origin of German Tragic Drama* [1925], trans. J. Osborne (London: Verso, 1977), 29, 32, 34, and 179.

3. Karen Koehler offers a rich interpretation of this image and its two figures as mirror doubles that evoke death and loss. See Karen Koehler, "Bauhaus Double Portraits," in *Bauhaus Bodies: Sexuality, Gender, and Body Culture in Modernism's Legendary Art School*, ed. Elizabeth Otto and Patrick Rössler (New York: Bloomsbury Visual Arts, 2019), 281–282.

4. See Antonia Lant, "Haptical Cinema," *October* 74 (1995): 50; and Alois Riegl, *Late Roman Art Industry*, trans. Rolf Winkes [1901] (Rome: Giorgio Bretschneider Editore, 1985).

5. The phrase "the love that dare not speak its name" derives from the 1894 poem "Two Loves" by Lord Alfred Douglas, then the lover of Oscar Wilde. During Wilde's 1895 trial for sodomy and gross indecency, the prosecutor questioned him about that line of the poem; in response, Wilde delivered a now famous apologia for same-sex love. See Lucy McDiarmid, "Oscar Wilde's Speech from the Dock," *Textual Practice* 15, no. 3 (2001): 453–455.

6. Heinz Loew was at the Bauhaus from 1926–1931; he studied theater and sculpture, and he became the sculpture workshop's assistant (*Mitarbeiter*). Loew also experimented with photography alone and in collaboration with Edmund Collein. See Jeannine Fiedler, ed., *Photography at the Bauhaus* (London: Dirk Nishen Publishing, 1990), 349; and Heinz Loew and Helene Nonne-Schmidt, *Joost Schmidt: Lehre und Arbeit am Bauhaus 1919–32* (Dusseldorf: Edition Marzona, 1984). Less is known about Karl Hermann Trinkaus; he joined the Bauhaus's preliminary course in fall 1927 and the sculpture workshop in the spring of 1928. See Folke Dietzsch, "Die Studierenden am Bauhaus: eine analytische Betrachtung zur Struktur der Studentenschaft, zur Ausbildung und zum Leben der Studierenden am Bauhaus sowie zu ihrem späteren Wirken," v. 2 (PhD diss. Hochschule für Architektur und Bauwesen Weimar, 1990), 272. After creating stunning anti-war collages, including *The Big Game* (*Das große Spiel*) of 1933, he worked as an aircraft engineer at the Junkers factory in Dessau.

7. As I note in ch. 2, §175 resulted not only in arrests but also the blackmail and sometimes suicide of men who were suspected of being gay, and Magnus Hirschfeld was very active in the fight against this statute. See James Steakley, "Cinema and Censorship in the Weimar Republic: The Case of *Anders als die Andern*," *Film History* (New York) 11, no. 2 (1999): 186.

8. Christian Rogowski, "The Dialectic of (Sexual) Enlightenment: Wilhelm Dieterle's *Geschlecht in Fesseln* (1928)," in *The Many Faces of Weimar Cinema: Rediscovering Germany's Filmic Legacy*, ed. Christian Rogowski (Rochester: Camden House, 2010), 213.

9. Jonathan Katz, "The Art of the Code: Jasper Johns and Robert Rauschenberg," in *Significant Others: Creativity and Intimate Partnership*, ed. Whitney Chadwick and Isabelle de Courtivron (New York: Thames and Hudson 1993), 188–207, 251–152.

10. Jonathan Katz, "Hide/Seek: Difference and Desire in American Portraiture," in *Hide/Seek: Difference and Desire in American Portraiture*, ed. Jonathan Katz and David C. Ward (Washington, D.C.: Smithsonian Books, 2010), 14.

11. Katz, "Hide/Seek," 14.

12. Katz, "Hide/Seek," 56.

13. Anjeana Hans, ch. 5, "*The Hands of Orlac* (*Orlacs Hände*, Robert Wiene, 1924): War Trauma, Injury, and the Return to a Changed World," *Gender and the Uncanny in Films of the Weimar Republic* (Detroit: Wayne State University Press, 2014), 179–215. See also Rogowski, "The Dialectic of (Sexual) Enlightenment," 213.

14. *Different from the Others* (*Anders als die Andern*), Dir. Richard Oswald (1919). For more on this film, see Steakley, "Cinema and Censorship," 181–203.

15. Steakley, "Cinema and Censorship," 188.

16. A pioneering essay on sexuality at the Bauhaus is Ute Ackermann, "The Bau-

haus: An Intimate Portrait," in *Bauhaus*, ed. Jeannine Fiedler, trans. Translate-A-Book (Cologne: Könemann, 2006), 108–119. Issues of gender and sexuality are also thematized in many of the essays in Otto and Rössler, *Bauhaus Bodies*.

17. For more on the important role of publications in the push for homosexual emancipation, see Laurie Marhoefer, *Sex and the Weimar Republic: German Homosexual Emancipation and the Rise of the Nazis* (Toronto: University of Toronto Press, 2015), esp. 40–49, 64–79, and 64–79. On abortion and birth control as political issues in the Weimar Republic, see Atina Grossmann, *Reforming Sex: The German Movement for Birth Control and Abortion Reform, 1920–1950* (New York: Oxford University Press, 1995).

18. Marhoefer, *Sex and the Weimar Republic*, 4.

19. Magnus Hirschfeld, May 24, 1919 speech at the opening of *Different from the Others*, quoted in Vito Russo, *The Celluloid Closet: Homosexuality in the Movies* (New York: Harper & Row, 1987), 20.

20. Tirza True Latimer, *Eccentric Modernisms: Making Differences in the History of American Art* (Berkeley: University of California Press, 2017), 4.

21. Jack Halberstam, *In a Queer Time and Place: Transgender Bodies, Subcultural Lives* (New York: New York University Press, 2005), 1.

22. Alexander Doty, *Making Things Perfectly Queer: Interpreting Mass Culture* (Minneapolis: University of Minnesota Press, 1993), xv.

23. Avery Gordon, *Ghostly Matters: Haunting and the Sociological Imagination*, revised edition (Minneapolis: University of Minnesota Press, 1997/2008), xvi.

24. Eve Kosofsky Sedgwick, *Epistemology of the Closet* (Berkeley: University of California Press, 1990, 2008), 71.

25. This and previous quotation: Elizabeth Freeman, *Time Binds: Queer Temporalities, Queer Histories* (Durham: Duke University Press, 2010), 9–10.

26. Hannes Meyer, "Bauen," *Bauhaus* 2, no. 4 (1928): 12–13.

27. See Juliet Koss, ch. 7: "Bauhaus Theater of the Human Dolls," *Modernism After Wagner* (Minneapolis: University of Minnesota Press, 2010), 207–243.

28. For more on the parties, see Josiah McElheny, *The Metal Party: Reconstructing a Party Held at the Bauhaus in Dessau on February 9, 1929* (New York: Public Art Funda and Yerba Buena Center, San Francisco, 2002); and Mercedes Valdivieso, ed., *La Bauhaus de Festa* (Barcelona: Obra Social Fundació "la Caixa," 2004).

29. Klaus Theweleit, *Male Fantasies: Male Bodies: Psychoanalyzing the White Terror*, v. 2, trans. Erica Carter and Chris Turner (Minneapolis: University of Minnesota Press, 1989), 327.

30. Muñoz is here drawing on Martin Heidegger (16); on queer utopian potentialities, see José Esteban Muñoz, *Cruising Utopia: The Then and There of Queer Futurity* (New York: NYU Press, 2009), esp. the Introduction, 1–18.

31. Author unnamed, *Weimarische Zeitung*, June 13, 1924, quoted in Ackerman, "Bauhaus: An Intimate Portrait," 108. It is difficult to reconstruct whether or not any out-of-wedlock births ever occurred at the Bauhaus, but they certainly were not frequent. It is possible that the author of this polemic was thinking of Peter Keler's now-famous cradle–inspired by Wassily Kandinsky's theories of the relationships between specific shapes and colors–which was built and

exhibited in 1922; see Bernard Schulz, "Wonderful Furniture: Peter Keler's Cradle," in *Bauhaus: A Conceptual Model*, ed. Bauhaus-Archiv Berlin/Museum für Gestaltung, Stiftung Bauhaus Dessau, and Klassik Stiftung Weimar (Ostfildern: Hatje Cantz, 2009), 119–122. Dietzsch provides statistics on marriages among *Bauhäusler*; see Dietzsch, "Die Studierenden am Bauhaus," v. 2, 302–303.

32. See Morgan Ridler, "Dörte Helm, Margaret Leiteritz, and Lou Scheper-Berkenkamp: Rare Women of the Bauhaus Wall-Painting Workshop," in Otto and Rössler, *Bauhaus Bodies*, 195–216.

33. On Schneider's time as a professor in Weimar and the events that led to his flight, see Christiane Starck, *Sascha Schneider: ein Künstler des deutschen Symbolismus* (Marburg: Tectum Verlag, 2016), 28–40; and see also, Silke Opitz, "From Painter of Ideas to Sculptor of the Human Body: Sascha Schneider's Weimar Period and Sculptural Work," in *Sascha Schneider: Visualizing Ideas through the Human Body* ed. Silke Opitz (Weimar: Bauhaus Universitäts Verlag, 2013), esp. 94.

34. Hans Voelker, "Curriculum Vitae" (*Lebenslauf*), reproduced in Dietzsch, "Die Studierenden am Bauhaus," v. 2, 58–59.

35. Heike Bauer, *Hirschfeld Archives* (Philadelphia: Temple University Press, 2017), 84–86. Hirschfeld's Institute of Sexual Research also performed sex reassignment surgeries, including for Lili Elbe, the so-called "Danish Girl," subject of a recent film.

36. Bärbel Reetz, *Emmy Ball-Hennings: Leben im Vielleicht* (Frankfurt a.M.: Surkamp Verlag, 2001), 272. While little information about these events is available, Hennings, whose later family name was Schuett, was at the Bauhaus from 1928 to 1929 in the preliminary course and then the weaving workshop. See Dietzsch, "Die Studierenden am Bauhaus," v. 2, 256. A summer 1929 photograph of her by Josef Albers is reproduced in Sarah Hermanson Meister, *One and One is Four: The Bauhaus Photocollages of Josef Albers* (New York: The Museum of Modern Art, 2017), 61. See also Isabella Studer-Geisser, "Maria Geroe-Tobler, 1895–1963: Ein Beitrag zur Schweizer Textilkunst des 20. Jahrhunderts" (PhD diss. Universität Zurich, 1995).

37. The accusations appeared in the communist students' *Bauhaus* newspaper, presumably to bring them out into the open and mock them; although individuals are not named, their identities were clear for the readership of this small-circulation newspaper; "one of the leading personalities, a cruel woman [Gunta Stölzl], tries with all her might to seduce a young girl from a provincial town [Ilse Voigt], and when she does not succeed in breaking the girl's chaste resistance, she begins pursuing her with the most sophisticated means. Fortunately, however, the girl finds shelter in the arms of a sandy-haired friend [i.e. Grete Reichardt], and they swear to cleanse the house of sin with joint forces. They are assisted in these efforts by a tall, honourable man with fiery, shotgun eyes and a noble disposition [Walter Peterhans].... Isn't this delightful stuff?" Kostufra, *bauhaus* 5 (1931). Margaretha Reichardt was the main accuser and was subsequently expelled by vote of the students, only to be reinstated later. See Patrick Rössler, "Margaretha Reichardt: 1907–1984," in *4 "Bauhausmädels": Gertrud Arndt, Marianne Brandt, Margarete Heymann, Margaretha Reichardt*, ed. Kai-Uwe Schierz, Patrick Rössler, Miriam Krautwurst, and Elizabeth Otto (Dresden: Sandstein Verlag, 2019), 158–181, esp. 168–169.

38. In addition to the artists I discuss in this chapter, future research on a queer

Bauhaus could include the painter Werner Gilles, who was gay, and the Bauhaus architect Tony Simon-Wolfskehl, who was not known to have had relationships with women at the Bauhaus but spent the last fifty years of her life with Irène Demanet, the woman who hid her from the Nazis during the Second World War. See Marianne Kröger, "Tony Simon-Wolfskehl (1893–1991): Bauhaus-Erinnerungen im belgischen Exil," *Entfernt: Frauen des Bauhauses während der NS-Zeit: Verfolgung und Exil* (Munich: Edition Text + Kritik, 2012), 277.

39. On his paintings, see Mario-Andreas von Lüttichau, ed, *Max Peiffer Watenphul: von Weimar nach Italien* (Cologne: Dumont, 1999), esp. his painting of Gertrud Grunow, 18. This book's biography was completed with the help of Peiffer Watenphul's niece, Alessandra Pasqualucci.

40. Ingrid Radewaldt, "Simple Form for the Necessities of Life: The Weaving Workshop at the Bauhaus in Weimar," *Bauhaus: A Conceptual Model*, 81–84.

41. Over the lifetime of the weaving workshop, thirteen men studied there, compared to 128 women. See Patrick Rössler and Anke Blümm, "Soft Skills and Hard Facts: A Systematic Overview of Bauhaus Women's Presence and Roles," in Otto and Rössler, *Bauhaus Bodies*, 3–24. As I mention in note 22 of ch. 3, the term "women's class" seems to have been used for a relatively short period of time, from 1920–1921.

42. Oskar Schlemmer, quoted in Magdalena Droste, *Bauhaus* (Cologne: Taschen, 1990), 72.

43. *Staatliches Bauhaus Weimar, 1919–1923*, (Weimar: Bauhausverlag, 1923), 136. While this is Peiffer Watenphul's one woven work, it was so well received that a copy was made of it. Only one version is now extant, and no one, including Peiffer Watenphul himself later in his life, knows which version it is. See Radewaldt, "Simple Form," 82.

44. von Lüttichau, *Max Peiffer Watenphul*, 111–113.

45. Photography, posing, and dress up played a part in these friendships, as photographs taken over the decades document. See Grace Watenphul Pasqualucci and Alessandra Pasqualucci, *Max Peiffer Watenphul: Werkverzeichnis*, v. 2: *Zeichnungen, Emailarbeiten, Textilien, Druckgraphik, Photographie* (Cologne: Dumont, 1993), 411–420.

46. See Pasqualucci and Pasqualucci, *Max Peiffer Watenphul*, 411–420.

47. "Grotesques" of each of them were published in one of the leading avant-garde photography publications of the period, *Photographie 1931* (Paris: Arts et métiers graphiques, 1931), along with the "Grotesque" of Johanna Ey, discussed here. Max Peiffer Watenphul painted Margarete Willers's portrait in 1922. Reproduced in Rolf Bothe, Peter Hahn, and Hans Christoph von Travel, ed., *Das frühe Bauhaus und Johannes Itten* (Ostfildern-Ruit: Dr. Cantz'sche Druckerei, 1994), 97.

48. Letter to Maria Cyrenius, December 1932, cited in Peter Hahn, "Vorläufig nehme ich erst einmal alles auf: Max Peiffer Watenphuls Fotografien," *Max Peiffer Watenphul: Ein Maler fotografiert Italien, 1927 bis 1934*, ed. Peter Hahn (Berlin: Bauhaus-Archiv, Museum für Gestaltung, 1999), 4.

49. Susan Sontag, "Notes on Camp" (1964), reprinted in *Camp: Queer Aesthetics and the Performing Subject, A Reader*, ed. Fabio Cleto (Ann Arbor: University of Michigan Press, 1999), 53.

50. Sontag, "Notes on Camp," 65, 56.

51. Sontag, "Notes on Camp," 56.

52. Sontag, "Notes on Camp," 60. While her essay is foundational for scholarly analysis of this cultural phenomenon, some have critiqued Sontag's essay as having desexualized and literalized camp and for having diminished its power as a subculture by describing it to a mainstream audience. See Charles Ludlam, "Camp," in *Ridiculous Theater: Scourge of Human Folly, The Essays and Opinions of Charles Ludlam*, ed. Steven Samuels (New York: Theater Communications Group, 1993), 226.

53. This photograph is reproduced in *Important Avant-Garde Photographs of the 1920s & 1930s: The Helene Anderson Collection*, Sotheby's, London, Friday, May 2, 1997, 68.

54. These two photographs were sold by Sotheby's as a part of 234 photographs supposedly from the collection of "Helene Anderson," an invented New Woman collector of the 1920s created as a cover story by the works' subsequent owners; see Sotheby's *Important Avant-Garde Photographs of the 1920s & 1930s* (1997). Peiffer Watenphul most likely sold these photographs to Kurt Kirchbach around the time of their making, in 1929 or 1930 (email correspondence with Hendrik Berinson, Galerie Berinson, Berlin, Jan. 2011). Photo historian Herbert Molderings uncovered the truth that this was Kirchbach's collection. See "Kunsthandel: Lizenz zum Plündern," *Der Spiegel*, April 20, 1998, http://www.spiegel.de/spiegel/print/d-7867165.html. The presence of Peiffer Watenphul's photographs in this particular collection is even more intriguing, given that one of Peiffer Watenphul's paintings was also included in the 1937 Munich *Degenerate Art* exhibition (von Lüttichau, *Max Peiffer Watenphul*, 113).

55. Peiffer Watenphul sent them to Albers to thank him for his financial help after the Second World War, when Peiffer Watenphul, as a German citizen living in Italy, was unable to find work. See their correspondence in the Josef and Anni Albers Foundation.

56. Archival notes on a photograph, Bauhaus-Archiv. The text seems to be from Paul Eipper, *Die Nacht der Vogelsangs: Erzählungen* (Berlin: Reimer, 1931).

57. See for example Christopher Isherwood's recollections of a gay costume ball in Berlin and film star Conrad Veidt's regal presence there: Christopher Isherwood, "The Guardian God" (1976), reprinted in *Conrad Veidt: Lebensbilder, Ausgewählte Fotos und Texte* (Berlin: Argon/Stiftung Deutsche Kinemathek, 1993), 21–23. While there is no strong evidence to specifically link Peiffer Watenphul to a gay community, his "Grotesques" and his friendships with other gay men including *Bauhäusler* Werner Gilles and, later, Jean Cocteau, suggest queer connections. Further, he often traveled to destinations frequented by gay men including Ischia, which he first visited in 1937. See von Lüttichau, *Max Peiffer Watenphul*, 114; and Kunststiftung Poll, Berlin, ed., *Begegnungen in Arkadien: Maler auf Ischia um 1950: Eduard Bargheer, Werner Gilles, Hermann Poll, Max Peiffer Watenphul* (Dortmund: Verlag Kettler, 2013).

58. Peter Weiermair, *Wilhelm von Gloeden* (Cologne: Taschen, 1997).

59. Giovanni Battista Martini, Cristina Zelich, and Susan Kismaric, *Florence Henri: Mirror of the Avant-Garde, 1927–40* (New York: Aperture, 2015), 194–196; and Elizabeth Otto and Patrick Rössler, *Bauhaus Women: A Global Perspective* (London: Bloomsbury UK/Herbert Press, 2019), 104–105.

60. Herbert Bayer, Walter Gropius and Ise Gropius, *Bauhaus* (New York:

Museum of Modern Art, 1938), 154.

61. László Moholy-Nagy, "Zu den Fotografien von Florence Henri," *i10* (Amsterdam), no. 17/18 (Dec. 20, 1928): 117.

62. Rosalind Krauss, "Jump Over the Bauhaus, Review: *Avant-Garde Photography in Germany, 1919–1939*," *October* 15 (Winter 1980): 106–109.

63. "Photographie der Gegenwart," *Rheinische-Westfälische Zeitung*, 1929, cited in Giovanni Battista Martini and Alberto Ronchetti, "Biography," in Martini, Zelich, and Kismaric, *Florence Henri*, 197.

64. Josef Albers, letter to Florence Henri, June 24, 1929; cited in Martini and Ronchetti, "Biography," 197.

65. See *Paris Magazine* 37 (1934): 551, 558, 567. Henri's other photograph in this issue, on 542, shows a classically posed woman with her face hidden by her stylized pose. Another print of this photograph confirms that Henri airbrushed out the model's prominent pubic hair for publication. See the sales catalogue for Millon et Associés, Paris, *Suite de 16 photographies de nus, par Florence Henri et M. B. De l'artiste de variété Line Viala et du peintre Honor David* (2008), plate 11.

66. For more photographs from this series, see Millon et Associés, *Suite de 16 photographies de nus*, plates 1, 3, 5, and 7.

67. Klaus E.R. Lindemann, "Eine ungewöhnliche Frau: ein ungewöhnliches Werk," in Klaus E.R. Lindemann, ed., *Die Bauhaus Künstlerin Margaret Leiteritz: Gemalte Diagramme* (Karlsruhe: Info Verlagsgesellschaft, 1987), 7.

68. See H.P. Mühlmann, "Gemalte Diagramme," in Lindemann, *Die Bauhaus Künstlerin Margaret Leiteritz*, 37.

69. Source: R.T. Sanderson, "Viscosity-Temperature Characteristics of Hydrocarbons," Fig. 5; *Industrial and Engineering Chemistry* 42 (1949), 373; reproduced in Lindemann, *Die Bauhaus Künstlerin Margaret Leiteritz* (color plates not paginated).

70. Dietzsch, "Die Studierenden am Bauhaus," v. 2, 202. For an overview of Leiteritz's life and work, see Claudia Hohmann, *Margaret Camilla Leiteritz: Bauhauskünstlerin und Bibliothekarin* (Frankfurt: Museum für Angewandte Kunst, 2004); and Elizabeth Otto and Patrick Rössler, *Bauhaus Women: A Global Perspective* (London: Bloomsbury UK/Herbert Press, 2019), 127–128.

71. Ridler, "Rare Women of the Wall-Painting Workshop," 206.

72. Hannes Meyer, "My Expulsion from the Bauhaus: An Open Letter to Lord Mayor Hesse of Dessau (1930)," in Wingler, *Bauhaus,* 164.

73. Margaret Leiteritz, application for the position as librarian at the Institute for Gas Technology, Fuel Technology, and Water Chemistry, 1952; quoted in Lindemann, "Eine ungewöhnliche Frau," 7. She also noted that she was a "refugee class A," which indicated her flight from the post-war Soviet Zone, in which her hometown of Dresden was located.

74. Corinna Isabel Bauer gives her nickname as "Mark," in "Architekturstudentinnen in der Weimarer Republik: Bauhaus und Tessenow Schülerinnen" (PhD dissertation, Universität Kassel, 2003), 101.

75. Andreá N. Williams, "Frances Watkins (Harper), Harriet Tubman, and the Rhetoric of Single Blessedness," *Meridians: Feminism, Race, Transnationalism* 12, no. 2 (2014): 102. In a related vein, Benjamin Kahan

has provocatively asserted that "the time has come to think about celibacy"; see Benjamin A. Kahan, *Celibacies: American Modernism, and Sexual Life* (Durham: Duke University Press, 2013), 1. See also Rudolph Bell and Virginia Yans's "Introduction" to their coedited volume, *Women on their Own: Interdisciplinary Perspectives on Being Single* (New Brunswick, NJ: Rutgers University Press, 2010), 1–15.

76. Reproduced in Hohemann, *Margaret Camilla Leiteritz*, 46–47.

77. Both of these appear in Lindemann, *Die Bauhaus Künstlerin Margaret Leiteritz*, n.p.

78. In addition to his work on Johns and Rauschenberg cited earlier in this chapter, on abstraction and sexuality see Jonathan Katz, "The Sexuality of Abstraction: Agnes Martin," in Lynne Cooke and Karen Kelly, ed., *Agnes Martin* (New Haven: Yale University Press, 2010), 135–159.

79. A selection of Leiteritz's costume designs are reproduced in Heinrich P. Mühlmann, *Margaret Camilla Leiteritz: Studium am Bauhaus* (Dessau: Meisterhäuser Kandinsky/Klee, 2006), 26–33.

80. In addition to the drawing I reproduce here, the other two are available in Peter Hahn, *Junge Maler am Bauhaus* (Munich: Verlag Galleria del Levante, 1979), n.p.

81. The Al-hakawati Arab Cultural Trust has made the full text of all of the tales available on line. "The Man of Yemen and His Six Slave Girls" is in volume four: http://al-hakawati.net/en_stories/Story_subcategory/1014/Volume-4; all subsequent quotations are from this source. In the original full German translation, completed by Max Henning and published in Leipzig at the turn of the last century, "Der Mann aus Jemen und seine sechs Sklavinnen" is ch. 12 in volume VII, and available as a part of Project Gutenberg.de: http://gutenberg.spiegel.de/buch/tausend-und-eine-nacht-band-vii-10187/12.

82. Clayton Whisnant explains that, "the Nazi regime did not target lesbians with anywhere near the same intensity that it targeted gay men, but that does not mean that lesbians were unaffected by Nazi policies. Their bars, publications, and social clubs were closed down, and they were subjected to the immense pressure brought by the Nazi party on all women to conform to traditional gender norms, to get married, and to have children." See Clayton Whisnant, *Queer Identities and Politics in Germany: A History, 1880–1945* (New York: Harrington Park Press, 2016), 204; see also 229–231.

83. Claudia Schoppmann, *The Days of Masquerade: Life Stories of Lesbians during the Third Reich* (New York: Columbia University Press, 1996), 11. As Schoppmann details, Nazi officials gave serious consideration to extending § 175 to include women (9). On individual women's experiences with the Nazi criminal justice system specifically for being lesbian, information is sparse, but Schoppmann explores key cases (13–14); see Schoppmann, "The Position of Lesbian Women in the Nazi Period," in Günter Grau, ed., *Hidden Holocaust? Gay and Lesbian Persecution in Germany, 1933–45*, trans. Patrick Camiller (London: Cassell, 1995), 8–15. For a collection of primary documents, see "Discussions Concerning the Prosecution of Lesbians," in Grau, *Hidden Holocaust?* 71–84.

84. Despite the May 1933 burning of books and files from Magnus Hirschfeld's Institute of Sexual Science, until the summer of 1934, Nazi policy on homosexuality was far from resolved. One of Adolph Hitler's closest allies within the party was the openly gay Ernst Röhm, head of the SA (*Sturmabteilung,*

or Storm Battalion). Röhm was murdered during the Night of the Long Knives (June 30–July 2, 1934), and an overtly anti-gay consensus grew. For more on this complex history, see Grau, *Hidden Holocaust?*

85. Raymond Williams, "Structures of Feeling," *Marxism and Literature* (Oxford: Oxford University Press, 1977), 128–135.

86. Gordon, *Ghostly Matters*, 63. Gordon is discussing the context of Argentina, but her conceptual framework is evocative for Germany's Nazi period as well.

87. Masters' council meeting, July 11, 1922; report from Gertrud Grunow read aloud and included in the minutes. Ute Ackermann and Volker Wahl, ed., *Meisterratsprotokolle des Staatlichen Bauhauses Weimar 1919-1925* (Weimar: Verlag Hermann Böhlaus Nachfolger, 2001), 226.

88. Thomas Röske, "Sexualized Suffering: On Some Lithographs by Richard Grune," *Intervalla: Platform for Intellectual Exchange* 2 (2014): 88.

89. "Frl. Fleischmann," as she is named in the minutes. See Ackermann and Wahl, *Meisterratsprotokolle*, 224, 227.

90. Masters' council meeting, March 15, 1923; Grunow's report was again read aloud and entered into the minutes. See Ackermann and Wahl, *Meisterratsprotokolle*, 298, 301. Grunow wrote, "Mr. Grune is in the midst of a development from a youth to the masculine and its power. As a person, he is not unappealing. His apparent back and forth is due solely to the developmental period and would—with 'fixed stricter tasks,' meaning goals—quickly stop; furthermore, he will soon gain a certain stability in his development." (301).

91. Andreas Gayk, ed., *Die Rote Kinderrepublik: Ein Buch von Arbeiterkindern für Arbeiterkinder*, illustrated by Richard Grune (Berlin: Arbeiterjugendverlag, 1928). Memories of their experiences of the camp seem to have been enduring for participants; the copy that I viewed bears a Christmas, 1928 dedication "to remember the children's republic Seekamp of 1927." Sabine Hake has written of this and other such "children's republics" in relation to the active proletarian culture that was often deployed politically during the interwar period, but did not endure. See Sabine Hake, ch. 15, "The Emotional Education of the Proletarian Child," in *The Proletarian Dream: Socialism, Culture, and Emotion in Germany, 1863–1933* (Berlin: De Gruyter, 2017), 270–287.

92. Gustav Weber, ed., *Das Weltenrad sind wir! Der 6. Deutsche Arbeiterjugendtag in Frankfurt am Main und das 2. Reichszeltlager der SAJ: Auf der Rheininsel Namedy von der Junge geschildert*, illustrated by Richard Grune Kiel (Berlin: Arbeiterjugend-Verlag, 1931).

93. For this and subsequent information, I am drawing on Röske, who has published the most complete biographical information on Grune to date. See Röske, "Sexualized Suffering," 90.

94. Röske, "Sexualized Suffering," esp. 84. Grune's *Passion of Twentieth Century* series is also held in the United States Holocaust Memorial Museum.

95. Freeman, *Time Binds: Queer Temporalities*, 10.

CHAPTER 5

1. Richard Frick, "2 Bauhäusler, 2 Plakatgestalter, 2 Antifaschisten," *Typografische Monatsblätter* 69 (2001): 3.

2. Hannes Meyer, "My Expulsion from the Bauhaus, An Open Letter to Lord Mayor Hesse of Dessau," *Das Tagebuch* (Berlin) 11, no. 33 (Aug. 16, 1930): 1307; extracts rpt. in *The Bauhaus: Weimar Dessau Berlin Chicago*, ed. Hans M. Wingler, trans. Wolfgang Jabs and Basil Gilbert (Cambridge, Mass.: MIT Press, 1962), 163–165.

3. In his public announcement that he was stepping down, Walter Gropius wrote that the Bauhaus, "is now firmly established. This is indicated by the growing recognition it receives and the steady increase in the number of its students." See "Administrative Changes, 1928," in *Bauhaus 1919–1928*, ed. Herbert Bayer, Walter Gropius, and Ise Gropius (New York: Museum of Modern Art/Harry N. Abrams, Inc., 1938), 206.

4. For more on Hannes Meyer's development of the "Volksbedarf statt Luxusbedarf" slogan, see Magdalena Droste, *Bauhaus* (Cologne: Taschen, 2006), 174, where it is translated as "popular necessities before elitist luxuries."

5. Michael Siebenbrodt, "Zur Rolle der Kommunisten und anderer fortschrittlicher Kräfte am Bauhaus," *Wissentschaftliche Zeitschrift der Hochschule für Architektur und Bauwesen* 23, no. 516 (1976): 481. This article, which is based on research and interviews with living *Bauhäusler*, is still one of the most comprehensive sources on Bauhaus Communism, and I draw on it heavily here.

6. Siebenbrodt, "Zur Rolle der Kommunisten," 482–483.

7. Droste, *Bauhaus*, 199.

8. Avery Gordon, *Ghostly Matters: Haunting and the Sociological Imagination*, revised edition (Minneapolis: University of Minnesota Press, 1997/2008), 196.

9. Irena Blühová, "Mein Weg ins Bauhaus," *Bauhaus* 6, ed. Hans-Peter Schulz and Staatlicher Kunsthandel der DDR (Leipzig: Galerie am Sachsenplatz 1983), 7–9.

10. Siebenbrodt, "Zur Rolle der Kommunisten," 483. Siebenbrodt mostly does not offer specific dates, nor does he identify his sources by name. His oral history informants, looking back fifty years, may well not have remembered some details. Further, he was collecting information in the German Democratic Republic where most citizens had learned to be wary of going on the record on almost any topic.

11. Siebenbrodt, "Zur Rolle der Kommunisten," 481, 483.

12. Translation from *bauhaus* 1 (May 1, 1930), in Patrick Rössler, *The Bauhaus and Public Relations: Communication in a Permanent State of Crisis* (London: Routledge, 2014), 154.

13. For one of Ivana Tomljenović's May Day photographs from 1930, see Jadranka Vinterhalter, ed., *Bauhaus: Networking Ideas and Practice* (Zagreb: Museum of Contemporary Art, 2015), 263. See also a 1931 image by an unidentified photographer reproduced in Roswitha Fricke, *Bauhaus Photography* (Cambridge, Mass.: MIT Press, 1985), 305. The large crowd drawn to demonstrate is evidence of how charged this election was. See the call for participation put out by the head of the local KPD: Paul Kmiec, "Maiaufruf an die Bauhäusler," n.d. (late May 1931), reprinted in *Bauhaus Berlin: Auflösung Dessau 1932, Schließung Berlin 1933, Bauhäusler und Drittes Reich*, ed. Peter Hahn (Berlin: Bauhaus-Archiv/Weingarten, 1985), 28. Among the identifiable figures

in the crowd are Grete Krebs—wearing white boots—and Kurt Stolp, both of whom were in Ivana Tomljenović's politicized circle and appear in figure 5.7.

14. See Duncan Forbes, ed., *Edith Tudor-Hart: In the Shadow of Tyranny* (Ostfildern: Hatje-Cantz/National Galleries Scotland/Wien Museum, 2013) and Julia Secklehner, "'A School for Becoming Human': The Socialist Humanism of Irene Blühová's Bauhaus Photographs," in *Bauhaus Bodies: Gender, Sexuality, and Body Culture in Modernism's Legendary Art School*, ed. Elizabeth Otto and Patrick Rössler (New York: Bloomsbury Visual Arts, 2019), 287–309. Both women are also profiled in Elizabeth Otto and Patrick Rössler, *Bauhaus Women: A Global Perspective* (London: Bloomsbury UK/Herbert Press, 2019), 130–133, 172–177.

15. On Albert Mentzel's Kostufra work, see Siebenbrodt, "Zur Rolle der Kommunisten," 483. Later Rothschild-Mentzel, along with the eldest of their three children, Ruth, was murdered in Auschwitz. See Volkhard Knigge and Harry Stein, ed., *Franz Ehrlich: Ein Bauhäusler in Wiederstand und Konzentrationslager* (Weimar: Gedenkstätte Buchenwald, 2009), 154.

16. Karen Koehler, "Bauhaus Double Portraits," in Otto and Rössler, *Bauhaus Bodies*, 266–268.

17. Sabine Hake, *The Proletarian Dream: Socialism, Culture, and Emotion in Germany*, 1863–1933 (Berlin: De Gruyter, 2017), 257. See also Patrick Rössler, *New Typographies: Bauhaus and Beyond, 100 Years of Functional Graphic Design in Germany* (Göttingen: Wallstein Verlag, 2018), 179.

18. Alexander Knoll, "Dies Haus soll Waffenschmied sein," *Kulturwille: Monatsblätter für Kultur der Arbeiterschaft*, vol. 5, no. 8 (Sept. 1928), Leipzig, 168. This same issue also contains a sharp critique of the "absolute film" of Ludwig Hirschfeld Mack and other *Bauhäusler* that I discuss in ch. 1. See H.W., "Der abstrakte Film," 173–174.

19. Frick, "2 Bauhuausler," 11.

20. On the exhibition including a reproduction of the catalogue cover, see Korinna Lorz, "'foto-bauhäusler, werdet arbeiter-fotografen!' Fotografie am Bauhaus zwischen Avantgarde und Agitation," *Fotogeschichte* 127 (2013): 40–41; and Tatiana Efrussi, "After the Ball: Hannes Meyer Presenting the Bauhaus in Moscow." *Bauhaus Imaginista* 2 (2018): http://www.bauhaus-imaginista.org/articles/2083/after-the-ball. For more on Bella Ullmann-Broner and to view the first iteration of this design as a poster, see Otto and Rössler, *Bauhaus Women*, 140–145. In relation to this poster, Richard Frick points out that the Communist Party would win 13.1% of the votes in that 1930 election. See Frick, "2 Bauhäusler," 12–13.

21. For more on her work and life, see Lelia Mehulić, *Ivana Tomljenović Meller: A Zagreb Girl at the Bauhaus* (Zagreb: Zagreb City Museum, 2011), and Otto and Rössler, *Bauhaus Women: A Global Perspective*, 134–139.

22. Mehulić, *Ivana Tomljenović Meller*, 45.

23. The other film that shows the Dessau Bauhaus building is Part IV of the Humboldt Film series *How Do We Live Healthily and Affordably?* (*Wie wohnen wir gesund und wirtschaftlich?*), *The Bauhaus and Its Construction Methods* (1926 to 1928), which includes shots of the facade in its opening sequence. Others that qualify as "Bauhaus films" include one minute of footage showing an Oskar Schlemmer dance, shot in March of 1926 shortly after the school's White Party opening festivities. This fragment is held in the collection of the Bundesarchiv-Filmarchiv Berlin; see Noam Elcott, *Artificial Darkness: An*

Obscure History of Modern Art and Media (Chicago: University of Chicago Press, 2016), 220–228. An additional "Bauhaus film" is Part III of *How Do We Live Healthily and Affordably?* titled *New Living*, which shows the new Gropius residence, discussed in my third chapter. On the Humboldt films, see Jeanpaul Goergen, "'wirklich alles wurde unseren wünschen entsprechend gemacht': Das Bauhaus in Dessau im Film der zwanziger Jahre," in *Bauhaus and Film*, ed. Thomas Tode, special issue of *Maske und Kothurn: Internationale Beiträge zur Theater-, Film, und Medienwissenschaft*, 52, no. 1–2 (2011): 109–122. Parts III (https://vimeo.com/292714014) and IV (https://vimeo.com/292714585) of the Humboldt Films are available from the Bauhaus-Archiv Berlin. See Tode's volume for a number of excellent essays on Bauhaus film and new media.

24. Ivana Tomljenović, interview from 1983, quoted in Bojana Pajić, "Bauhaus in 57 Seconds," in Vinterhalter, *Bauhaus*, 118.

25. Among those identifiable *Bauhäusler* in the stills shown in figure 5.6 are building-construction instructor Alcar Rudelt (top left), weavers Grete Reichardt (top center) and Kitty Fischer van de Mijll Dekker (top right, left in second row, right in fourth row, and bottom center), and grinning metal designer Otto Rittweger (right in second row). Thanks to Sabine Hartmann for these identifications.

26. Joachim Büthe, ed., *Der Arbeiter-Fotograf: Dokumente u. Beitr. zur Arbeiter-fotografie 1926–1932/Kulturpolitische Dokumente der revolutionären Arbeiterbewegung* (Cologne: Prometheus, 1977).

27. Kostufra, *bauhaus* 12 (April 1932): 2. In the article, the students point out that the prominent use of the word "terror" on the cover is a direct reference to issue 4 of their journal, which reported on the dismissal of Communist students in 1930 (4). It is noteworthy that in this April 1932 issue as in several others (issue 3, for example), they single out Wassily Kandinsky as behind many of the actions against them (2). The cover that I reproduce is from Kandinsky's own collection, held at the Centre Pompidou in Paris.

28. On the remark and Meyer's dismissal, see Éva Forgács, "Between the Town and the Gown: On Hannes Meyer's Dismissal from the Bauhaus," *Journal of Design History* 23, no. 3 (2010): 265.

29. For more on Hannes Meyer in the Soviet Union, see Michael Siebenbrodt, "Der Bauhausdirektor Hannes Meyer als Hochschullehrer und Architekt in Moskau 1930–1936," in *"Als Bauhäusler sind wir Suchende": Hannes Meyer (1889-1954), Beiträge zu seinem Leben und Wirken*, ed. Peter Steininger (Bernau: Baudenkmal Bundesschule Bernau e.V., 2013), 35–40; and Muscheler, *Das rote Bauhaus*. Muscheler reproduces a famous photograph of members of the Bauhaus Brigade in Moscow (80).

30. Astrid Volpert, "Hannes Meyers starke Frauen der Bauhauskommune am Moskauer Arbatplatz 1930–1938," in Steininger, *"Als Bauhäusler sind wir Suchende,"* 41–54.

31. Etel Mittag-Fodor, *Not an Unusual Life, for the Time and Place*, Documents from the Bauhaus-Archive Berlin, *Bauhäusler* 3, ed. Kerstin Stutterheim (Berlin: Bauhaus-Archiv/Studio Ferdinand Ulrich, 2014), 130.

32. See Ursula Muscheler, "1930–31: Bauhaus-Stoßbrigade Rot Front," in *Das rote Bauhaus: Eine Geschichte von Hoffnung und Scheitern* (Berlin: Berenberg, 2016), 30–46. On Magnitogorsk, 56–61, 65. See also Steven Kotkin, *Magnetic Mountain* (Berkeley: University of California Press, 1997), esp. ch. 3, "The Idiocy of Urban Life," and ch. 4, "Living Space and the Stranger's Gaze," 106–145, 157–197.

33. Kristen Baumann, "Weben nach dem Bauhaus: Bauhaus-Weberinnen in den dreißiger und vierziger Jahren," *Das Bauhaus Webt: Die Textilwerkstatt am Bauhaus*, ed. Magdalena Droste (Berlin: Verlag Berlin, 1998), 43–51.

34. This was actually Bergner's second attempt to go to the Soviet Union, an indicator of how much this move meant to her. See Volpert, "Hannes Meyers starke Frauen," 41–54.

35. Lena Meyer-Bergner, quoted in Baumann, "Weben nach dem Bauhaus," 46.

36. For more on Lena Meyer-Bergner, see María Monserrat Farías Barba, Viridiana Rivera Zavala, and Marco Santiago Mondragón, "Lena Bergner: From the Bauhaus to Mexico," *Bauhaus Imaginista* 34 (2018; http://www.bauhaus-imaginista.org/articles/2485/lena-bergner-from-the-bauhaus-to-mexico). In 1936, she and Meyer left the Soviet Union amidst the beginning of the Stalinist purges; she eventually became a professor of textiles in Mexico; see also Otto and Rössler, *Bauhaus Women: A Global Perspective*, 90–91.

37. The U.S.-American Bauhaus student Howard Dearstyne recalled a strong reaction to Mies's arrival from the Communist students—who demanded that Mies exhibit his work for them to judge whether or not he was qualified to serve as director. Mies's response was to call the police. See Howard Dearstyne, *Inside the Bauhaus* (London: Architectural Press, 1986), 220–222.

38. See "M., A Swiss Architecture Student Writes to a Swiss Architect about the Bauhaus Dessau," *Information* (Zurich), no. 3 (Aug.–Sept. 1932), reprinted in Wingler, *Bauhaus*, 175–176.

39. Katja and Hajo Rose, 1932 manuscript for the *Weltbühne*, unpublished. Quoted in Droste, *Bauhaus*, 196–199.

40. Gunta Stölzl, letter from May 1931, in Monika Stadler and Yael Aloni, ed., *Gunta Stölzl: Bauhaus Master* (New York: Museum of Modern Art / Hatje Cantz, 2009), 107n45. Identified among the vandals by Stölzl and others is Grete Reichhardt; see letter to Gropius, 104.

41. For more on these incidents, see endnote 37 of ch. 4 in this book and Patrick Rössler, "Margaretha Reichardt," in *4 "Bauhausmädels": Gertrud Arndt, Marianne Brandt, Margarete Heymann, Margaretha Reichardt*, ed. Kai-Uwe Schierz, Patrick Rössler, Miriam Krautwurst, and Elizabeth Otto (Dresden: Sandstein Verlag, 2019), 168–169.

42. See two of Stölzl's letters from in May and June of 1931, in Stadler and Aloni, *Gunta Stölzl*, 107.

43. See Hans Wingler's commentary on the document: "City Council of the City of Dessau to Mies van der Rohe, Contract of October 5, 1932 Concerning the Termination of Employment," in Wingler, *Bauhaus*, 179.

44. When Iwao and Michiko Yamawaki, both *Bauhäusler*, returned to Japan in 1932, this photomontage was published with Iwao's report on the school's closing. Iwao Yamawaki, "The Closing of the Bauhaus," *Kokusai kenchiku*, Sept. 4, 1932, cited in Helena Čapková, "Transnational Networkers: Iwao and Michiko Yamawaki and the Formation of Japanese Modernist Design," *The Journal of Design History*, vol. 27, no. 4 (2014), 375.

45. For more on Otti Berger's innovations as a weaver, her flight into exile, and the path that would eventually lead to Auschwitz, see T'ai Smith, ch. 4: "Weaving as Invention: Patenting Authorship," in *Bauhaus Weaving Theory: From Feminine Craft to Mode of Design* (Minneapolis: University of Minnesota Press, 2014), 111–139.

46. See documents in Wingler, *Bauhaus*, 182–184.

47. These events are recounted in Wingler, *Bauhaus*, 564–565 and accompanied by a Nazi newspaper's account, "Haussuchung im 'Bauhaus Steglitz'; Kommunistisches Material gefunden," *Lokal-Anzeiger* (Berlin), April 12, 1933. A description of the Carnival party is in a letter from Annemarie Wilke to Julia Feininger from Feb. 21, 1933, reprinted in Wingler, *Bauhaus*, 186.

48. See "Die endgültige Auflösung des Bauhauses, 20. Juli 1933," which includes an overview and Mies van der Rohe's minutes from that final meeting; in Hahn, *Bauhaus Berlin*, 142–143. This book also provides further detail on the Bauhaus's temporary closure in April and the intervening debates through July; see "Die Polizeiaktion vom 11. April 1933" and "Die Bemühungen um eine Wiedereröffnung des Bauhauses," 127–141.

49. For more on the building itself, see Ingolf Kern, ed., *The Bauhaus Building in Dessau* (Leipzig: Spector Books, 2014), 146-147.

50. On the history of the Dessau Bauhaus building under National Socialism in addition to Kern (in previous note), see "Die Bauhaus-Gebäude in Dessau und Berlin nach 1933," in Hahn, *Bauhaus Berlin*, 152. The Dessau-Roßlau City Archives hold detailed records of the squabbles among various parties for space in the building and the modifications made to it. For more on the work of Bauhaus architects in Nazi Germany, including Gropius and Mies, see Winfried Nerdinger, "Bauhaus Architecture in the Third Reich," trans. Kathleen James-Chakraborty, in ed. Kathleen James-Chakraborty, *Bauhaus Culture: From Weimar to the Cold War* (Minneapolis: University of Minnesota Press, 2006), 139–152.

51. A postcard bearing an installation shot of the 1937 Munich *Degenerate Art* exhibition shows Klee's and Kandinsky's works on the wall; see Mario-Andreas von Lüttichau, "'Crazy at Any Price': The Pathologizing of Modernism in the Run-Up to the 'Entartete Kunst' Exhibition in Munich in 1937," in *Degenerate Art: The Attack on Modern Art in Nazi Germany 1937*, ed. Olaf Peters, (New York: Neue Galerie & Munich: Prestel, 2014), 40. Paul Jaskot finds that, although Bauhaus members were exceedingly well represented in the show, the word "Bauhaus"– the "Communist Bauhaus in Dessau," to be exact– appeared only once in the *Degenerate Art* exhibition catalogue. See Paul Jaskot, "The Nazi Party's Strategic Use of the Bauhaus: Marxist Art History and the Political Conditions of Artistic Production," in *Renew Marxist Art History*, ed. Warren Carter, Barnaby Haran, and Frederic J. Schwartz (London: Art Books Publishing, 2013), 392–393.

52. For more information on those persecuted and murdered under the Nazi regime, see "Bauhäusler in Verfolgung und Widerstand," in Knigge and Stein, *Franz Ehrlich*, 139–161.

53. Jeffrey Herf, *Reactionary Modernsim: Technology, Culture, and Politics in Weimar and the Third Reich* (Cambridge: Cambridge University Press, 1986), esp. ch. 1, "The Paradox of Reactionary Modernism," 1–17.

54. Michael Tymkiw, *Nazi Exhibition Design and Modernism* (Minneapolis: University of Minnesota Press, 2018), 41–58.

55. For examples of Tymkiw's pushback to the "critical gesture" argument, see his discussions of Cesar Klein (37–39) and Lilly Reich and Ludwig Mies van der Rohe (44) in *Nazi Exhibition Design*.

56. Arthur A. Cohen largely excuses Herbert Bayer's work for the Nazi regime;

see Arthur A. Cohen, *Herbert Bayer: The Complete Work* (Cambridge, Mass.: MIT Press, 1984), 41–42. For a highly critical counter-example, see Sabine Weissler, "Bauhaus-Gestaltung in NS-Propaganda-Ausstellungen," in *Bauhaus-Moderne im National-Sozialismus: Zwischen Anbiederung und Verfolgung*, ed. Winfried Nerdinger (Munich: Prestel Verlag and Bauhaus-Archiv, Berlin, 1993), 60.

57. Herbert Bayer was an Austrian citizen. On his life in relation to these complexities, see Patrick Rössler, "Altagsnormalität unter der NS-Herrschaft," in *Der einsame Großstädter: Herbert Bayer und die Geburt des modernen Grafik-Designs* (Berlin: Vergangenheitsverlag, 2014), 126-171.

58. For further reproductions from the *Germany Exhibition* catalogue, see Jeremy Aynsley, *Graphic Design in Germany: 1890–1945* (Berkeley: University of California Press, 2000), 204–205.

59. Sabine Weissler, "Bauhaus-Gestaltung in NS-Propaganda-Ausstellungen," 60.

60. Information on Ilse Fehling here is drawn from: *Ilse Fehling: Bauhaus Bühne Akt Skulptur: 1922–1967* (Munich: Galerie Bernd Dürr, 1990), and from the Graphic Archive of the Deutsche Kinemathek, Museum for Film and Television, Berlin.

61. Anna Teut. *Architektur im Dritten Reich, 1933–1945* (Berlin: Ullstein, 1967).

62. See Paul Jaskot, *The Architecture of Oppression: The SS, Forced Labor and the Nazi Monumental Building Economy* (London: Routledge, 1999); and Adina Seeger, "Vom Bauhaus nach Auschwitz: Fritz Ertl, Bauhausschüler in Dessau, Mitarbeiter der Auschwitzer Bauleitungen, Angeklagter im Wiener Auschwitzprozess," Master's Thesis, University of Vienna, 2013.

63. The *Bauhäusler* known to have perished at Auschwitz are: Susanna Bánki, Otti Berger, Eva Busse, Friedl Dicker, Else Rawitzer, Lotte Rothschild-Mentzel, and Hedwig Slutzky. This information comes from Patrick Rössler and the German Research Foundation project "Die bewegten Netze des Bauhauses": https://forschungsstelle.bauhaus.community.

64. See Lutz Schöbe, "'In unterirdischer Rolle': Anmerkung zu Leben und Werk des Architekten Franz Ehrlich," in Knigge and Harry, *Franz Ehrlich*, 16–20.

65. Gerd Fleischmann, "'JEDEM DAS SEINE,' Eine Spur vom Bauhaus in Buchenwald," in Knigge and Harry, *Franz Ehrlich*, 108–117. For a meditation on these gates and the history of their slogan, see Neil McGregor, "At the Buchenwald Gate," *Germany: Memories of a Nation* (New York: Alfred A. Knopf, 2015), 458–473. One Bauhaus member is known to have died at Buchenwald, Georg Calmann.

66. On the Bauhaus diaspora to the U.S., see Éva Forgács, ch. 16: "Endgame" and ch. 17: "Liberalism's Utopia," in *The Bauhaus Idea and Bauhaus Politics* (1991), trans. John Bátki (Budapest: Central European Press, 1995), 179–202; and Magdalena Droste, "Ludwig Mies van der Rohe: The Bauhaus Becomes a School of Architecture," in *Bauhaus* (Cologne: Taschen, 1991), 204–239. Pond Farm was where Marguerite Friedlaender Wildenhain taught ceramics and created community for decades. See Otto and Rössler, *Bauhaus Women: A Global Perspective*, 17–19.

67. On the impact of the Bauhaus in locations including the United States, Japan, the Soviet Union, Turkey, Israel, and India, see Bauhaus-Archiv, ed., *Bauhaus Global* (Berlin: Gebrüder Mann, 2010).

BIBLIOGRAPHY

PRIMARY SOURCES: ARCHIVAL AND MUSEUM COLLECTIONS CITED

Akademie der Künste, Archiv, Berlin.

Bauhaus-Archiv, Berlin.

Bauhaus Dessau Foundation, Dessau-Roßlau.

Dessau-Roßlau City Archives.

Documentation Center of the Art History Research Group of the Hungarian Academy of Sciences, Budapest.

Estate of László Moholy-Nagy, Ann Arbor.

Getty Research Institute, Los Angeles.

Graphics Archive, Deutsche Kinemathek, Museum for Film and Television, Berlin.

Harvard Art Museum, Cambridge, Mass.

Harvard Film Archive, Cambridge, Mass.

Jewish Museum in Prague.

Josef and Anni Albers Foundation, Bethany.

Kandinsky Library, Centre Pompidou, Paris.

Metropolitan Museum of Art, New York.

Museum of Contemporary Art, Zagreb.

Museum of Modern Art, New York.

Sächsisches Industriemuseum, Chemnitz.

University of Applied Arts Vienna, Collection and Archive, Vienna.

Zagreb City Museum, Zagreb.

PRIMARY SOURCES: PUBLISHED MATERIALS CITED

Ammann, David. *Mazdaznan Diätetik und Kochbuch*. 4th ed. Leipzig: Mazdaznan-Verlag, 1909.

Anschütz, Georg, ed. *Farbe-Ton-Forschungen, Bericht über den 2. Kongreß für Farbe-Ton-Forschung (Hamburg, 1–5 Oktober 1930)*. Vol. 3. Hamburg: Psychologische-ästhetische Forschungsgesellschaft, 1931.

Anders als die Andern. Directed by Richard Oswald. 1919. New York, NY: Kino Lorber Films, 2009.

Arnheim, Rudolf "The Absolute Film." 1925. Trans. Nicholas Baer. In Kaes, *The Promise of Cinema*, 459–461.

Bayer, Herbert, Walter Gropius, and Ise Gropius, eds., *Bauhaus 1919–1928*. New York: Museum of Modern Art / Harry N. Abrams, Inc., 1938.

Benjamin, Walter. "The Author as Producer." Address at the Institute for the Study of Fascism, Paris, April 27, 1934. In *Walter Benjamin: Selected Writings*. Vol. 2: 1927–1934, edited by Michael Jennings, 768–782. Cambridge, Mass.: The Belknap Press of Harvard University Press, 1999.

"On the Concept of History." *Walter Benjamin: Selected Writings*. Vol. 4: 1938–1940. Edited by Michael Jennings, 389–400. Cambridge, Mass.: The Belknap Press of Harvard University Press, 2003.

The Origin of German Tragic Drama. Translated by J. Osborne. London: Verso, 1977.

The Work of Art in the Age of Its Technological Reproducibility, and Other Writings on Media, edited by Michael Jennings, Brigid Doherty, and Thomas Levin. Cambridge, Mass.: The Belknap Press of Harvard University Press, 2008.

Brandt, Marianne. "Bauhausstil." *Bauhaus*, vol. 3, no. 1 (1929): 21.

"Letter to the Younger Generation." In Neumann, *Bauhaus and Bauhaus People*, 105–109.

Citroen, Paul. "Mazdaznan at the Bauhaus." In Neumann, *Bauhaus and Bauhaus People*, 44–50.

Freud, Sigmund. "Analysis of a Phobia in a Five-Year-Old Boy." In *The Standard Edition of the Complete Psychological Words of Sigmund Freud*. Vol. X, translated by Alix and James Strachey, 5–149. New York: Vintage, 2001.

Gabo, Naum. "gestaltung?" *Bauhaus*, vol. 2, no. 4 (1928): 2–6.

Gayk, Andreas, ed. *Die Rote Kinderrepublik: Ein Buch von Arbeiterkindern für Arbeiterkinder*. Illustrated by Niels Brodersen and Richard Grune. Berlin: Arbeiterjugend-Verlag, 1928.

Gropius, Walter. "Program of the Staatliche Bauhaus in Weimar" (April 1919). In Wingler, *Bauhaus*, 31–33.

"The Theory and Organization of the Bauhaus." In Bayer et al., *Bauhaus 1919–1928*, 22–31.

Grunow, Gertrud. "The Creation of Living Form through Color, Form, and Sound." In Wingler, *Bauhaus*, 69–70. Originally published in *Staatliches Bauhaus 1919–1923*, 20–23. Weimar: Bauhaus Press, 1923.

Der Gleichgewichtskreis: eine Bauhausdokument. Edited by Achim Preiß. Weimar: Verlag und Datenbank für Geisteswissenschaften, 2001.

Hanish, Otoman ZA. *Masdasnan Atemlehre*. Edited by David Ammann. Herrliberg: Masdasnan-Verlag, c. 1920.

"Reading Hieroglyphics." *Mazdaznan* 17, no. 1 (1918): 7–14.

Hildebrandt, Hans. *Die Frau als Künstlerin: Mit 337 Abbildungen nach Frauenarbeiten, Bildender Kunst von den Fruuhesten Zeiten bis zer Gegenwart*. Berlin: Rudolf Mosse Buchverlag, 1928.

Die Kunst des 19 und 20. Jahrhunderts. Potsdam: Akademische Verlagsgesellschaft Athenaion, 1924.

Hirschfeld-Mack, Ludwig. *The Bauhaus: An Introductory Survey*. Victoria: Longmans, 1963.

"Farben Licht-Spiele: Wesen Ziele Kritiken." In *Der absolute Film: Dokumente der Medienavantgarde*, edited by Christian Kiening and Heinrich Adolf, 127–138. Zurich: Chronos, 2012.

Hoffmann, Hubert. "Kontraste: Anthroposophie und Marxismus," n.d. (c. 1980s). Unpublished manuscript in Akademie der Künste, Archiv, Berlin.

Hübbe-Schleiden, Wilhelm. "Kerners Kleksographien." *Sphinx* 11, no. 61 (Jan. 1891): 48–50.

Isherwood, Christopher. "The Guardian God." In *Conrad Veidt: Lebensbilder, Ausgewählte Fotos und Texte*, edited by Wolfgang Jacobson, 21–23. Berlin: Argon / Stiftung Deutsche Kinemathek, 1993.

Kandinsky, Wassily. "Die 'Bauhausfrage,'" *Leipziger Volkszeitung*, Oct. 23, 1924. Facsimile of original full text (including omissions from the printed version) in *Wassilly Kandinsky: Unnterricht am Bauhaus, 1923–1933*, vol. 1, edited by Angelika Weißbach, 32–41. Berlin: Gebr. Mann Verlag, 2015.

On the Spiritual in Art. In *Kandinsky: Complete Writings on Art,* edited by Kenneth Lindsay and Peter Vergo, 114–219. New York: Da Capo Press, New York, 1994.

Point and Line to Plane. In Lindsay and Vergo, *Kandinsky*, 524–699.

Kmiec, Paul. "Maiaufruf an die Bauhäusler," n.d. (late April 1931). In Hahn, *Bauhaus Berlin*, 28.

Knoll, Alexander. "Dies Haus soll Waffenschmied sein." *Kulturwille: Monatsblätter für Kultur der Arbeiterschaft* 5, no. 8 (Sept. 1928): 168–169.

Koch, Adolf. *Wir sind nackt und nennen uns Du! Bunte Bilder aus der Freikörperkulturbewegung*. Leipzig: Ernst Oldenburg Verlag, 1932.

Kostufra. *bauhaus* 12 (April 1932).

Kracauer, Siegfried. "Photography." In *The Mass Ornament*, edited and translated by Thomas Levin, 47–63. Cambridge Mass.: Harvard University Press, 1995.

The Salaried Masses: Duty and Distraction in Weimar Germany. Translated by Quintin Hoare. New York: Verso, 1998.

"M., A Swiss Architecture Student Writes to a Swiss Architect about the Bauhaus Dessau." In Wingler, *Bauhaus*, 175–176.

"The Man of Yemen and His Six Slave Girls." In *One Thousand and One Nights*, vol. 4, edited by al-hakawati Arab Cultural Trust: http://al-hakawati.net/en_stories/Story_subcategory/1014/Volume-4.

Meyer, Hannes. "Bauen," *Bauhaus* 2, no. 4 (1928): 12–13.

"My Expulsion from the Bauhaus: An Open Letter to Lord Mayor Hesse of Dessau" (1930). In Wingler, *The Bauhaus,* 163–165.

Moholy-Nagy, László. "Zu den Fotografien von Florence Henri." *i10*, no. 17/18 (Dec. 1928): 117.

"Lichtrequisit einer Elektrischen Bühne." *Die Form: Zeitschrift für gestaltende Arbeit* 5 (1930): 297.

"Light: A Medium of Plastic Expression." *Broom* 4 (March 1923): 283–284.

The New Vision: Fundamentals of Bauhaus Design, Painting, Sculpture, and Architecture. Mineola: Dover Publications, 2005. Originally published as *Von Material zu Architektur*. Munich: A. Langen, 1929.

Painting Photography Film. 1925. Translated by Lund Humphries Publishers. Cambridge, Mass.: MIT Press, 1969.

Moholy, Lucia. *Moholy-Nagy Marginal Notes: Documentary Absurdities*. Krefeld: Richard Scherpe, 1972.

Nonn, K. "The State Garbage Supplies: the Staatliche Bauhaus in Weimar." *Deutsche Zeitung* no. 178, April 24, 1924. Reprinted in Wingler, *Bauhaus*, 76–77.

Orlacs Hände. Directed by Robert Wiene. 1924. Vienna, Pan-Film AG, 1924.

Photographie 1931. Paris: Arts et métiers graphiques, 1931.

Du Prel, Baron Carl. "Du Prel über den Spiritismus." *Sphinx* 1, no. 3 (1886): 215.

Riviere, Joan. "Womanliness as Masquerade." In *The Inner World and Joan Riviere, Collected Papers: 1920–1958*, edited by Athol Hughes, 90–101. New York: Karnac Books, 1991.

Röntgen, Wilhelm. "Über eine neue Art von Strahlen (Vorläufige Mitteilung)." *Aus den Sitzungsberichten der Würzburger Physik.-medic Gesellschaft Würzburg* (1895): 132–141.

Schrenck-Notzing, Albert. *Phenomena of Materialization: A Contribution to the Investigation of Mediumistic Teleplastics*. Translated by E. E. Fournier d'Albe. London: Kegen Paul, Trench, Trubner & Co., 1920.

Schwitters, Kurt. *Lucky Hans and Other Merz Fairy Tales*. Translated and Introduced by Jack Zipes. Princeton: Princeton University Press, 2009.

Soupault, Ré. "Probleme der Mode." *Die Form* 5, no. 16 (1930): 414–423.

Der Student von Prag. Directed by Henrik Galeen. Berlin, Sokal-Film GmbH, 1926.

Voelker, Hans. "Curriculum Vitae." In Dietzsch, "Die Studierenden am Bauhaus," vol. 2, 58–59.

Weber, Gustav ed. *Das Weltenrad sind wir! Der 6. Deutsche Arbeiterjungendtag in Frankfurt am Main und das 2. Reichszeltlager der SAJ. Auf der Rheininsel Namedy von der Junge geschildert*. Berlin: Arbeiterjugend-Verlag, 1931.

SECONDARY SOURCES CITED

Ackermann, Ute. "The Bauhaus: An Intimate Portrait." In Fiedler, *Bauhaus*, 108–119.

"'Bodies Drilled in Freedom': Nudity, Body Culture, and Classical Gymnastics at the Early Bauhaus." In Otto and Rössler, *Bauhaus Bodies*, 25–47.

Ackermann, Ute, and Volker Wahl, eds. *Meisterratsprotokolle des Staatlichen Bauhauses Weimar 1919–1925*. Weimar: Verlag Hermann Böhlaus Nachfolger, 2001.

Ahlfeld-Heymann, Marianne. "Erinnerungen an Paul Klee, 1923/24 and 1933." In *Und trotzdem überlebt*, 77–85. Konstanz: Hartung-Gorre Verlag, 1994.

Alexander, Zeynep Çelik. *Kinaesthetic Knowing: Aesthetics, Epistemology, Modern Design*. Chicago: University of Chicago Press, 2017.

Andriopoulos, Stefan. *Ghostly Apparitions: German Idealism, the Gothic Novel, and Optical Media*. New York: Zone Books, 2013.

Possessed: Hypnotic Crimes, Corporate Fiction, and the Invention of Cinema. Chicago: University of Chicago Press, 2008.

Apraxine, Pierre, and Sophie Schmit. "Photography and the Occult." In Chéroux and Fischer, *The Perfect Medium*, 12–17.

Aynsley, Jeremy. *Graphic Design in Germany: 1890–1945*. Berkeley: University of California Press, 2000.

Bakhtin, Mikhail. *Rabelais and His World*. Translated by Hélèn Iswolsky. Cambridge, Mass.: MIT Press, 1968.

Baki, Peeter, and Éva Bajkay. "Unbekannte ungarische Fotografinnen: Etel Fodor, Irén Blüh, Judt Kárász." In *"Von Kunst zu Leben": Die Ungarn am Bauhaus*, edited by Éva Bajkay, 322–331. Pécs: Janus Pannonius Múzeum/Berlin: Bauhaus-Archiv: 2010.

Bär, Peter. "Meta Erna Niemeyer und der abstrakte Film." In Herold et al., *Ré Soupault*, 53–63.

Barnett, Vivian Endicott, and Christian Derouet. *Kandinsky*. New York: Guggenheim Museum, 2009.

Barr, Helen. "*Cherchez l'homme!* Männerbilder in illustrierten Zeitschriften der 1920er-Jahre." In *Der Mann in der Krise? Visualisierungen von Männlichkeit im 20. und 21. Jahrhundert*, edited by Änne Söll and Gerald Schröder, 37–51. Cologne: Böhlau Verlag, 2015.

Vom Bauen der Zukunft: 100 Jahre Bauhaus. (English: *Bauhaus Spirit*.) Directed by Bolbrinker, Niels and Thomas Tielsch. Hamburg: Filmtank/Neue Visionen Filmverleih, 2018.

Bauer, Corinna Isabel. "Architekturstudentinnen in der Weimarer Republik: Bauhaus und Tessenow Schülerinnen." PhD diss., Universität Kassel, 2003.

Bauer, Heike. *Hirschfeld Archives*. Philadelphia: Temple University Press, 2017.

Bauhaus-Archiv, eds. *Bauhaus Global*. Berlin: Gebrüder Mann, 2010.

Bauhaus-Archiv Berlin/Museum für Gestaltung, Stiftung Bauhaus Dessau, and Klassik Stiftung Weimar, eds. *Bauhaus: A Conceptual Model*. Ostfildern: Hatje Cantz, 2009.

Baumann, Kristen. "Weben nach dem Bauhaus: Bauhaus-Weberinnen in den dreißiger und vierziger Jahren." *Das Bauhaus Webt: Die Textilwerkstatt am Bauhaus*, edited by Magdalena Droste, 43–51. Berlin: Verlag Berlin, 1998.

Baumhoff, Anja. "What's the Difference? Sexual Politics of the Bauhaus." In *The Gendered World of the Bauhaus: The Politics of Power at the Weimar Republic's Premier Art Institute, 1919–1932*, 53–75. Frankfurt am Main: Peter Lang, 2001.

"What's in the Shadow of a Bauhaus Block? Gender Issues in Classical Modernity." In Schönfeld, *Practicing Modernity*, 51–67.

Beckers, Marion, ed. *Photographien der Bauhaus-Künstlerin Gertrud Arndt*. Berlin: Das verborgene Museum, 1994.

Beiser, Frederick. *German Idealism: The Struggle Against Subjectivism, 1781–1801*. Cambridge, Mass.: Harvard University Press, 2002.

Bell, Rudolph and Virginia Yans. "Introduction" to *Women on their Own: Interdisciplinary Perspectives on Being Single*, 1–15. New Brunswick Rutgers University Press, 2010.

Bergdoll, Barry, and Leah Dickerman, eds. *Bauhaus 1919–1933: Workshops for Modernity*. New York: Museum of Modern Art, 2009.

Bergdoll, Barry. "Bauhaus Multiplied: Paradoxes of Architecture and Design in and After the Bauhaus." In Bergdoll and Dickerman, *Bauhaus*, 41–61.

Bernhard, Peter, ed. *Bauhaus Vorträge: Gastredner am Weimarer Bauhaus, 1919–1925*. Berlin: Gebr. Mann Verlag; Bauhaus-Archiv, 2017.

Bigalke, Bernadett. "Gesundheit und Heil: Eine ideengeschichtliche Spuren-suche zur Einordnung der Mazdaznan-Bewegungin ihren Entstehungskon-text." *Gesnerus: Swiss Journal of the History of Medicine and Sciences* 69, no. 2 (2012): 272–296.

Biro, Matthew. *The Dada Cyborg: Visions of the New Human in Weimar Berlin*. Minneapolis: University of Minnesota Press, 2009.

Blau, Eva. *The Architecture of Red Vienna, 1919–1934*. Cambridge, Mass.: MIT Press, 1999.

Blühová, Irena. "Mein Weg zum Bauhaus." In *Bauhaus 6*, edited by Hans-Peter Schulz and Staatlicher Kunsthandel der DDR, 7–9. Leipzig: Galerie am Sachsenplatz, 1983.

Boak, Helen. *Women in the Weimar Republic*. Manchester: Manchester University Press, 2013.

Boje, Walter. *Wo beginnt das Illegitime? Gedanken zur Spannweite der Photographie*. Cologne: 9. Veröffentlichung der Deutschen Gesellschaft für Photographie e.V., 1965.

Botar, Oliver. "Biocentrism and the Bauhaus." *Structurist* 43/44 (2003–2004): 54–61.

Sensing the Future: Moholy-Nagy, Media, and the Arts. Zurich: Lars Muller, 2014.

Bothe, Rolf, Peter Hahn, and Hans Christoph von Travel, ed. *Das frühe Bauhaus und Johannes Itten*. Ostfildern-Ruit: Dr. Cantz'sche Druckerei, 1994.

Bourneuf, Annie. "The Margins of the *Angelus Novus*." In Godfrey, *R.H. Quaytman*, 34–41.

Paul Klee: The Visible and the Legible. Chicago: University of Chicago Press, 2015.

"Too Many Times: On Klee's *Angelus Novus*." Lecture presented at the Second Triennial Lovis Corinth Colloquium on German Modernism "Elective Affinities / Elective Antipathies: German Art on Its Histories," Emory University, March 2017.

Bowie, Andrew. "German Idealism." In *German Philosophy: A Very Short Introduction*, 32–50. Oxford: Oxford University Press, 2010.

Boyaki, Amanda. "Alma Buscher Siedhoff: An Examination of Children's Design and Gender at the Bauhaus during the Weimar Period." PhD diss., Texas Tech University, 2010.

Braude, Ann. *Radical Spirits: Spiritualism and Women's Rights in Nineteenth-Century America*. Bloomington: Indiana University Press, 2001.

Buchholz, Kai, Rita Latocha, and Hilke Peckmann, ed. *Die Lebensreform: Entwürfe zur Neugestaltung von Leben und Kunst um 1900*. Darmstadt: Häusser, 2001.

Burchert, Linn. "The Spiritual Enhancement of the Body: Johannes Itten, Gertrud Grunow, and Mazdaznan at the Early Bauhaus." In Otto and Rössler, *Bauhaus Bodies*, 49–72.

Büthe, Joachim, ed. *Der Arbeiter-Fotograf: Dokumente u. Beitr. zur Arbeiterfotografie 1926–1932 / Kulturpolitische Dokumente der revolutionären Arbeiterbewegung*. Cologne: Prometheus, 1977.

Butler, Judith. *Gender Trouble: Feminism and the Subversion of Identity*. New York: Routledge, 1990.

Canguilhem, Denis. "Flammarion and Eusapia Palladino." In Chéroux and Fischer, *The Perfect Medium*, 235–248.

Čapková, Helena. "Transnational Networkers: Iwao and Michiko Yamawaki and the Formation of Japanese Modernist Design." *The Journal of Design History* 27, no. 4 (2014): 370–385.

Chéroux, Clément. "Ghost Dialectics: Spirit Photography in Entertainment and Belief." In Chéroux and Fischer, *The Perfect Medium*, 44–71.

Chéroux, Clément, and Andreas Fischer, eds. *The Perfect Medium: Photography and the Occult*. New Haven: Yale University Press, 2005.

Cloutier, Crista. "Mumler's Ghosts." In Chéroux and Fischer, *The Perfect Medium*, 20–28.

Cohen, Arthur A. *Herbert Bayer: The Complete Work*. Cambridge, Mass.: MIT Press, 1984.

Cohen, Deborah. *The War Come Home: Disabled Veterans in Britain and Germany, 1914–1939*. Berkeley: University of California Press, 2001.

Colini, Laura, and Frank Eckardt, eds. *Bauhaus and the City: A Contested Heritage for a Challenging Future*. Würzburg: Königshausen and Neumann, 2011.

Cox, Guy. *Optical Imaging Techniques in Cell Biology*. Boca Raton: Taylor and Francis, 2007.

Dabrowski, Magdalena, Leah Dickerman, and Peter Galassi, eds. *Aleksandr Rodchenko*. New York: Museum of Modern Art, 1998.

Davis, Melody. *Women's Views: The Narrative Stereograph in Nineteenth-Century America*. Durham: University of New Hampshire Press, 2015.

Dearstyne, Howard. *Inside the Bauhaus*. London: Architectural Press, 1986.

Dempsey, Amy. *Modern Art*. New York: Thames and Hudson, 2018.

Derrida, Jacques. *Specters of Marx: The State of the Debt, the Work of Mourning and the New International*. Translated by Peggy Kamuf. New York: Routledge Classics, 1994.

Didi-Huberman, Georges. *Confronting Images: Questioning the Ends of a Certain History of Art*. University Park: Penn State University Press, 2009.

Dietsche, Daniela. "Studien zum Bauhaus als Wirtschaftsunternehmen." MA Thesis, Technische Üniversität Berlin, 1993.

Dietzsch, Folke. "Die Studierenden am Bauhaus: eine analytische Betrachtung zur Struktur der Studentenschaft, zur Ausbildung und zum Leben der Studierenden am Bauhaus sowie zu ihrem späteren Wirken." PhD diss., Hochschule für Architektur und Bauwesen Weimar, 1990.

Dogramaci, Burcu. "Disorder or Subordination? On Gender Relations in Bauhaus Photographs." In Otto and Rössler, *Bauhaus Bodies*, 243–263.

Doherty, Brigid. "'*We Are All Neurasthenics!*' or, The Trauma of Dada Montage." *Critical Inquiry* 24, no. 1 (1997): 82–127.

Dose, Ralf. *Magnus Hirschfeld: The Origins of the Gay Liberation Movement*. New York: Monthly Review Press, 2014.

Doty, Alexander. *Making Things Perfectly Queer: Interpreting Mass Culture*. Minneapolis: University of Minnesota Press, 1993.

Downie, Louise, ed. *Don't Kiss Me: The Art of Claude Cahun and Marcel Moore*. New York: Aperture, 2006.

Droste, Magdalena. *Bauhaus: 1919–1933*. Cologne: Taschen, 1993.

"Stahlrohrstühle als Objekte medialer Bildstrategien und ihr doppeltes Leben." In *Modern Wohnen: Möbeldesign und Wohnkultur der Moderne*, edited by Rudolf Fischer and Wolf Tegethoff, 183–214. Berlin: Gebr. Mann Verlag, 2016.

Dyer, Richard. "Less and More than Women and Men: Lesbian and Gay Cinema in Weimar Germany." *New German Critique* 51 (1990): 5–60.

Edelman, Lee. *No Future: Queer Theory and the Death Drive.* Durham: Duke University Press, 2004.

Efrussi, Tatiana. "After the Ball: Hannes Meyer Presenting the Bauhaus in Moscow." *Bauhaus Imaginista* 2 (2018): http://www.bauhaus-imaginista.org/articles/2083/after-the-ball.

Eipper, Paul. *Die Nacht der Vogelsangs: Erzählungen*. Berlin: Reimer, 1931.

Elcott, Noam. *Artificial Darkness: An Obscure History of Modern Art and Media*. Chicago: University of Chicago Press, 2016.

Elder, R. Bruce. *Harmony and Dissent: Film and the Avant-Garde Art Movements in the Early Twentieth Century*. Waterloo: Wilfrid Laurier University Press, 2010.

Elsaesser, Thomas. "The Camera in the Kitchen: Grete Schütte-Lihotsky and Domestic Modernity." In Schönfeld, *Practicing Modernity*, 27–49.

Emboden, William, ed. *Kate T. Steinitz: Art Into Life Into Art*. Severin Wunderman Museum Publications, 1994.

von Erffa, Helmut. "The Bauhaus before 1922." *College Art Journal* 3, no. 1 (1943): 14–20.

Fehling, Ilse. *Bauhaus Bühne Akt Skulptur: 1922–1967*. Munich: Galerie Bernd Dürr, 1990.

Fiedler, Jeannine, ed. *Bauhaus*. Translated by Translate-A-Book. Cologne: Könemann, 2000.

Photography at the Bauhaus. London: Dirk Nishen Publishing, 1990.

"T. Lux Feininger: 'I am a Painter and Not a Photographer!'" In Fiedler, *Photography at the Bauhaus*, 44–53.

Finkeldey, Bernd. "Im Zeichen des Quadrates: Konstruktivisten in Berlin," in *Berlin – Moskow 1900–1950*, edited by Irina Antonowa and Jörn Merkert, 157–161. Munich: Prestel / Berlinische Galerie, 1995.

Forbes, Duncan, ed. *Edith Tudor-Hart: In the Shadow of Tyranny*. Ostfildern: Hatje-Cantz, 2013.

Fore, Devin. *Realism after Modernism: The Rehumanization of Art and Literature*. Cambridge, Mass.: MIT Press, 2015.

Forgács, Éva. *The Bauhaus Idea and Bauhaus Politics*. Translated by John Bátki. Budapest: Central European Press, 1995.

"Between the Town and the Gown: On Hannes Meyer's Dismissal from the Bauhaus." *Journal of Design History* 23, no. 3 (2010): 265–274.

Foster, Hal. "Fatal Attraction." In *Compulsive Beauty*, 101–122. Cambridge, Mass.: MIT Press, 1995.

Foster, Hal, Rosalind Krauss, Yve-Alain Bois, Benjamin H.D. Buchloh, and David Joselitt. *Art Since 1900*. Vol. 1: *1900 to 1944: Modernism, Antimodernism, Postmodernism*. 3rd ed. New York: Thames and Hudson, 2016.

Foster, Stephen, ed. *Hans Richter: Activism, Modernism, and the Avant-Garde*. Cambridge, Mass.: MIT Press, 1998.

Foucault, Michel. *The History of Sexuality*. Vol. I: *An Introduction*. Translated by Robert Hurley. New York: Vintage, 1990.

Freccero, Carla. *Queer/Early/Modern*. Durham: Duke University Press, 2006.

Freeman, Elizabeth. *Time Binds: Queer Temporalities, Queer Histories*. Durham: Duke University Press, 2010.

Frick, Richard. "2 Bauhuausler, 2 Plakatgestalter, 2 Antifaschisten." *Typografische Monatsblätter* 69, no. 3 (2001): 1–16.

Fricke, Roswitha, ed. *Bauhaus Photography*. Translated by Harvey L. Mendelsohn. Cambridge, Mass.: MIT Press, 1985.

Funkenstein, Susan. "Paul Klee and the New Woman Dancer: Gret Palucca, Karla Grosch, and the Gendering of Constructivism." In Otto and Rössler, *Bauhaus Bodies*, 145–167.

Gabet, Olivier and Anne Monier, ed. *The Spirit of the Bauhaus*. Translated by Ruth Sharman. New York: Thames and Hudson, 2018.

Gleiniger, Andrea. "Marcel Breuer." In *Bauhaus*, edited by Jeannine Fiedler, 320–321.

Godfrey, Mark, ed. *R.H. Quaytman: Chapter 29*. Tel Aviv: Tel Aviv Museum of Art, 2015.

Goergen, Jeanpaul. "'wirklich alles wurde unseren wünschen entsprechend gemacht': Das Bauhaus in Dessau im Film der zwanziger Jahre." In Tode, *Bauhaus and Film*, 109–122.

Gordon, Avery. *Ghostly Matters: Haunting and the Sociological Imagination*. Revised ed. Minneapolis: University of Minnesota Press, 2008.

Gordon, Mel. *Voluptuous Panic: the Erotic World of Weimar Berlin*. Expanded ed. Port Townsend: Ferrell House, 2008.

Gronostay, Walter. "Possibilities for the Use of Music in Sound Film." Translated by Alex H Bush. In Kaes, *The Promise of Cinema*, 566–567.

Grossmann, Atina. *Reforming Sex: The German Movement for Birth Control and Abortion Reform, 1920–1950*. New York: Oxford University Press, 1995.

Gruber, Helmut. *Red Vienna: Experiment in Working-Class Culture, 1919–1934*. Oxford: Oxford University Press, 1991.

Guillén, Mauro. *The Taylorized Beauty of the Mechanical: Scientific Management and the Rise of Modernist Architecture*. Princeton: Princeton University Press, 2006.

Gunning, Tom. "Haunting Images: Ghosts, Photography, and the Modern Body." In *The Disembodied Spirit*, edited by Alison Ferris, 8–19. Brunswick: Bowdoin College Museum of Art, 2003.

———. "Phantom Images and Modern Manifestations: Spirit Photography, Magic Theater, Trick Films, and Photography's Uncanny." In *Fugitive Images: From Photography to Video*, edited by Patrice Petro, 42–71. Bloomington: Indiana University Press, 1995.

———. "To Scan a Ghost: The Ontology of Mediated Vision." *Grey Room* 26 (Winter 2007): 94–127.

———. "What's the Point of an Index? Or, Faking Photographs." In *Still Moving: Between Cinema and Photography*, edited by Karen Beckman and Jean Ma, 23–40. Durham: Duke University Press, 2008.

Grau, Günter, ed. *Hidden Holocaust? Gay and Lesbian Persecution in Germany 1933–45*. Translated by Patrick Camiller. London: Cassell, 1995.

Guttenberger, Anja. "Fotografische Selbstportraits der Bauhäusler zwischen 1919 und 1933." PhD diss., Freie Universität Berlin, 2011.

Hahn, Peter, ed. *Bauhaus Berlin: Auflösung Dessau 1932, Schließung Berlin 1933, Bauhäusler und Drittes Reich*. Berlin: Bauhaus-Archiv and Kunstverlag Weingarten, 1985.

———. *Junge Maler am Bauhaus*. Munich: Galleria del Levante, 1979.

———. "Vorläufig nehme ich erst einmal alles auf: Max Peiffer Watenphuls Fotografien," *Max Peiffer Watenphul: Ein Maler fotografiert Italien, 1927 bis 1934*, edited by Peter Hahn, 1–10. Berlin: Bauhaus-Archiv, Museum für Gestaltung, 1999.

Hake, Sabine. *The Proletarian Dream: Socialism, Culture, and Emotion in Germany, 1863–1933*. Berlin: De Gruyter, 2017.

Halberstam, Jack. *The Queer Art of Failure*. Durham: Duke University Press, 2011.

Hans, Anjeana. *Gender and the Uncanny in Films of the Weimar Republic*. Detroit: Wayne State University Press, 2014.

Harrington, Anne. *Reenchanted Science: Holism in German Culture from Wilhelm II to Hitler*. Princeton: Princeton University Press, 1996.

Hau, Michael. *The Cult of Health and Beauty in Germany*. Chicago: University of Chicago Press, 2003.

Hebdige, Dick. *Subculture: The Meaning of Style*. London: Routledge, 1979.

Hemken Kai-Uwe, and Rainer Stommer, eds. *Konstruktivistische Internationale, 1922–1927: Utopien für eine europäische Kultur*. Stuttgart: Verlag Gerd Hatje; Düsseldorf: Kunstsammlung Nordrhein-Westfalen, 1992.

Henderson, Linda Darymple. "Claude Bragdon, the Fourth Dimension, and Modern Art in Cultural Context." In *Claude Bragdon and the Beautiful Necessity*, edited by Euginia Victoria Ellis and Andrea Reithmayer, 73–86. Rochester: RIT Graphic Arts Press, 2010.

———. *The Fourth Dimension and Non-Euclidean Geometry in Modern Art*. Revised ed. Cambridge, Mass.: MIT Press, 2013.

Herf, Jeffrey. *Reactionary Modernism: Technology, Culture, and Politics in Weimar and the Third Reich*. Cambridge: Cambridge University Press, 1986.

Herold, Inge, Ulrike Lorenz, and Manfried Metzner, eds. *Ré Soupault: Künstlerin*

im Zentrum der Avantgarde. Heidelberg: Verlag das Wunderhorn/Kunsthalle Manheim, 2011.

Herold, Inge. "Meta Erna Niemeyer: Studentin am Bauhaus Weimar 1921–1925." In Herold et al., *Ré Soupault*, 25–50.

———. "Ré Richter alias Renate Green und die Mode." In Herold et al., *Ré Soupault*: 65–107.

Heyden, Thomas. "Mehr Licht! Lampendesign der 'Neuen Sachlichkeit' in Deutschland." In Weber, *Die Metalwerkstatt am Bauhaus*, 98–103.

Heyman, Isabelle. *Marcel Breuer, Architect: The Career and the Buildings*. New York: Harry N. Abrams, 2001.

Hohmann, Claudia. *Margaret Camilla Leiteritz: Bauhauskünstlerin und Bibliothekarin*. Frankfurt: Museum für Angewandte Kunst, 2004.

Hoormann, Anne. *Lichtspiele: Zur Medienreflexion der Avantgarde in der Weimarer Republik*. Munich: Wilhelm Fink Verlag, 2003.

Hopfengart, Christine. "The Magician as Artist of Quotas: Paul Klee and His Rise as a Modernist Classic." In Scholz and Thomson, *The Klee Universe*, 69–80.

Hopkins, David. *Dada's Boys: Masculinity after Duchamp*. New Haven: Yale University Press, 2008.

Hövelmann, Katharina. "Bauhaus in Wien? Möbeldesign, Innenraumgestaltung und Architektur der Wiener Ateliergemeinschaft von Friedl Dicker und Franz Singer." PhD diss., Universität Wien, 2018.

Important Avant-Garde Photographs of the 1920s & 1930s: The Helene Anderson Collection. London: Sotheby's, 1997.

Itten, Johannes. *Design and Form: The Basic Course at the Bauhaus and Later*. Revised ed. New York: John Wiley and Sons, 1975.

Jaeggi, Annemarie. "Ein geheimnisvolles Mysterium: Bauhütten-Romantik und Freimaurerei am frühen Bauhaus." In Wagner, *Das Bauhaus und die Esoterik*, 37–45.

James-Chakraborty, Kathleen, ed. *Bauhaus Culture: From Weimar to the Cold War*. Minneapolis: University of Minnesota Press, 2006.

———. "Clothing Bauhaus Bodies." In Otto and Rössler, *Bauhaus Bodies*, 125–144.

Jaskot, Paul. *The Architecture of Oppression: The SS, Forced Labor and the Nazi Monumental Building Economy*. London: Routledge, 1999.

———. "The Nazi Party's Strategic Use of the Bauhaus: Marxist Art History and the Political Conditions of Artistic Production." In *Renew Marxist Art History*, edited by Warren Carter, Barnaby Haran, Frederic J. Schwartz, 382–397. London: Art Books Publishing, 2013.

Jensen, Erik N. *Body by Weimar: Athletes, Gender, and German Modernity*. Oxford: Oxford University Press, 2010.

Jolly, Martyn. *Faces of the Living Dead: The Belief in Spirit Photography*. New York: Mark Batty Publisher, 2006.

Jones, Amelia. *Irrational Modernism: A Neurasthenic History of New York Dada*. Cambridge, Mass.: MIT Press, 2004.

Kaes, Anton. *Shell Shock Cinema: Weimar Culture and the Wounds of War*. Princeton: Princeton University Press, 2009.

Kaes, Anton, Nicholas Baer, and Michael Cowan, ed. *The Promise of Cinema: German Film Theory, 1907–1933*. Berkeley: University of California Press, 2016.

Kahan, Benjamin A. *Celibacies: American Modernism and Sexual Life*. Durham: Duke University Press, 2013.

Kaplan, Louis. "Where the Paranoid Meets the Paranormal: Speculations on Spirit Photography." *Art Journal* 62, no. 3 (2003): 18–27.

Katz, Jonathan D. "The Art of the Code: Jasper Johns and Robert Rauschenberg." In *Significant Others: Creativity and Intimate Partnership*, edited by Whitney Chadwick and Isabelle de Courtivron, 188–207. New York: Thames and Hudson 1993.

"Hide/Seek: Difference and Desire in American Portraiture." In *Hide/Seek: Difference and Desire in American Portraiture*, edited by Jonathan D. Katz and David C. Ward, 10–61. Washington, D.C.: Smithsonian Books, 2010.

"The Sexuality of Abstraction: Agnes Martin." In *Agnes Martin*, edited by Lynne Cooke and Karen Kelly, 135–159. New Haven: Yale University Press, 2010.

Kern, Ingolf ed. *The Bauhaus Building in Dessau*. Leipzig: Spector Books, 2014.

Kiaer, Christina. *Imagine No Possessions: The Socialist Objects of Russian Constructivism*. Cambridge, Mass.: MIT Press, 2005.

Klee, Felix, ed. *Paul Klee: Briefe an die Familie, 1893–1940*. Vol. 2: 1907–1940. Cologne: Dumont Buchverlag, 1979.

Klein, Paul-Reza. "Der 'Phantasus' Tierbaukasten von Friedl Dicker und Franz Singer, Baukästen zwischen technischem Spiel und künstlerischem Ausdruck." MA Thesis, Universität für angewandte Kunst Wien, 2015.

Knigge, Volkhard, and Harry Stein, eds. *Franz Ehrlich: Ein Bauhäusler in Wiederstand und Konzentrationslager*. Weimar: Gedenkstätte Buchenwald, 2009.

Koehler, Karen. "Bauhaus Double Portraits." In Otto and Rössler, *Bauhaus Bodies*, 265–286.

Koss, Juliet. *Modernism After Wagner*. Minneapolis: University of Minnesota Press, 2010.

Kotkin, Steven. *Magnetic Mountain*. Berkeley: University of California Press, 1997.

Krabbe, Wolfgang. *Gesellschaftsveränderung durch Lebensreform: Strukturmerkmale einer Sozialreformerischen Bewegung im Deutschland der Industrialisierungsperiode*. Göttingen: Vandenhoeck und Ruprecht, 1974.

Krauss, Rosalind. "Jump over the Bauhaus: Avant-Garde Photography in Germany 1919–1939." *October* 15 (Winter 1980): 102–110.

Kruger, Werner, ed. *The Guestbook of Kate T. Steinitz*. Cologne: Galerie Gmurzynska, 1977.

Kruppa, Karsten, "Marianne Brandt: Annäherung an ein Leben." In Weber, *Die Metallwerkstatt am Bauhaus*, 48–55.

Kress, Celina. "Neue Akteure beim Bau von Groß-Berlin: Adolf Sommerfeld und sein Netzwerk." In *Neues Bauen im Berliner Südwesten: Groß-Berlin und die Folgen für Steglitz und Zehlendorf*, edited by Brigitte Hausmann, 29–46. Berlin: Gebr. Mann Verlag, 2018.

Kröger, Marianne. "Tony Simon-Wolfskehl (1893–1991): Bauhaus-Erinnerungen

im belgischen Exil." In *Entfernt: Frauen des Bauhauses während der NS-Zeit: Verfolgung und Exil*, 275–294. Munich: Edition Text + Kritik, 2012.

Kunststiftung Poll Berlin, ed. *Begegnungen in Arkadien: Maler auf Ischia um 1950: Eduard Bargheer, Werner Gilles, Hermann Poll, Max Peiffer Watenphul*. Dortmund: Verlag Kettler, 2013.

Lahusen, Susanne. "Oskar Schlemmer: Mechanical Ballets?" *Dance Research: The Journal of the Society for Dance Research* 4, no. 2 (1986): 65–77.

Lant, Antonia. "Haptical Cinema." *October* 74 (1995): 45–73.

Latimer, Tirza True. *Eccentric Modernisms: Making Differences in the History of American Art*. Berkeley: University of California Press, 2017.

Lerner, Paul. *Hysterical Men: War, Psychiatry, and the Politics of Trauma in Germany, 1890–1930*. Ithaca: Cornell University Press, 2003.

Lerner, Vladimir, and Eliezer Witztum. "Images in Psychiatry: Victor Kandinsky, M.D., 1849–1889." *American Journal of Psychiatry* 163, no. 2 (February 2006): 209.

Leßmann, Sabine. "'Die Maske der Weiblichkeit nimmt kuriose Formen an…': Rollenspiele und Verkleidungen in den Fotografien Gertrud Arndts und Marta Astfalck-Vietz." In *Fotografien hieß teilnehmen: Fotografinnen der Weimarer Republik*, edited by Ute Eskildsen, 272–279. Düsseldorf: Richter Verlag/Museum Folkwang, Essen, 1994.

Lindemann, Klaus E.R. "Eine ungewöhnliche Frau: ein ungewöhnliches Werk." In Lindemann, *Die Bauhaus Künstlerin Margaret Leiteritz*, 7–11.

Lindemann, Klaus E.R., ed. *Die Bauhaus Künstlerin Margaret Leiteritz: Gemalte Diagramme*. Karlsruhe: Info Verlagsgesellschaft, 1987.

Linse, Ulrich. *Barfüßige Propheten: Erlöser der zwanziger Jahre*. Berlin: Siedler Verlag, 1983.

"Ludwig Christian Haeusser und das Bauhaus." In Bernhard, *Bauhaus Vorträge*, 157–178.

Loew, Heinz, and Helene Nonne-Schmidt. *Joost Schmidt: Lehre und Arbeit am Bauhaus 1919–32*. Dusseldorf: Edition Marzona, 1984.

Long, Rose-Carol Washton. "Expressionism, Abstraction, and the Search for Utopia in Germany." In Tuchmann, *The Spiritual in Art*, 201–217.

Lorz, Korinna. "'foto-bauhäusler, werdet arbeiter-fotografen!' Fotografie am Bauhaus zwischen Avantgarde und Agitation." *Fotogeschichte* 127 (2013): 31–44.

Ludewig, Manfred, and Magdalena Droste. "Marcel Breuer." In *New Worlds: German and Austrian Art, 1890–1940*, edited by Renée Price, translated by Elizabeth Clegg, 553–556. New Haven: Yale University Press, 2001.

Ludlam, Charles. "Camp." In *Ridiculous Theater: Scourge of Human Folly, The Essays and Opinions of Charles Ludlam*, edited by Steven Samuels, 225–227. New York: Theater Communications Group, 1993.

Lusk, Irene-Charlotte. *Montagen ins Blaue: László Moholy-Nagy, Fotomontagen und -collagen, 1922–1943*. Gießen: Anabas, 1980.

von Lüttichau, Mario-Andreas, "'Crazy at Any Price': The Pathologizing of Modernism in the Run-Up to the 'Entartete Kunst' Exhibition in Munich in 1937." In *Degenerate Art: The Attack on Modern Art in Nazi Germany 1937*, edited

Olaf Peters, 36–51. New York: Neue Galerie & Munich: Prestel, 2014.

ed. *Max Peiffer Watenphul: von Weimar nach Italien*. Cologne: Dumont, 1999.

Lyford, Amy. *Surrealist Masculinities: Gender Anxiety and the Aesthetics of Post-World War I Reconstruction in France*. Berkeley: University of California Press, 2007.

"Mädchen wollen etwas lernen," *Die Woche*, April 4, 1930, 30–32.

Mahn, Gabriele. "Kunst in der Kleidung: Beiträge von Sophie Teuber, Johannes Itten, under verwandten Avangarde." In *Künstler ziehen an: Avantgarde-Mode in Europa, 1910 bis 1939*, edited by Gisela Framke, 68–77. Berlin: Edition Braus, 1996.

Makarova, Elena. *Friedl Dicker-Brandeis: Vienna 1898–Auschwitz 1944*. Los Angeles: Tallfellow/Every Picture Press, 2001.

Margolin, Victor. *The Struggle for Utopia: Rodchenko, Lissitzky, Moholy-Nagy, 1917–1946*. Chicago: University of Chicago Press, 1997.

Marhoefer, Laurie. *Sex and the Weimar Republic: German Homosexual Emancipation and the Rise of the Nazis*. Toronto: University of Toronto Press, 2015.

März, Ursula. *Du lebst wie im Hotel: Die Welt der Re Soupault*. Heidelberg: Wunderhorn Verlag, 1999.

Martini, Giovanni Battista, Cristina Zelich, and Susan Kismaric. *Florence Henri: Mirror of the Avant-Garde, 1927–40*. New York: Aperture, 2015.

McBride, Patrizia. "*Cut with the Kitchen Knife*: Visualizing Politics in Berlin Dada." In *Art and Resistance in Germany*, edited by Deborah Ascher Barnstone and Elizabeth Otto, 23–38. New York: Bloomsbury Academic, 2018.

McCarter, Robert. *Breuer*. London: Phaidon Press, 2016.

McDiarmid, Lucy. "Oscar Wilde's Speech from the Dock." *Textual Practice* 15, no. 3 (2001): 447–466.

McElheny, Josiah. *The Metal Party: Reconstructing a Party Held at the Bauhaus in Dessau on February 9, 1929*. New York and San Francisco: Public Art Fund and Yerba Buena Center, 2002.

McGarry, Molly. *Ghosts of Futures Past: Spiritualism and the Cultural Politics of Nineteenth-Century America*. Berkeley: University of California Press, 2008.

McGregor, Neil. "At the Buchenwald Gate." In *Germany: Memories of a Nation*, 458–473. New York: Alfred A. Knopf, 2015.

Mehulić, Lelia. *Ivana Tomljenović Meller: A Zagreb Girl at the Bauhaus*. Zagreb: Zagreb City Museum, 2011.

Meister, Sarah Hermanson. *One and One is Four: The Bauhaus Photocollages of Josef Albers*. New York: The Museum of Modern Art, 2017.

Metzner, Manfred. *Ré Soupault: Das Auge der* Avantgarde. Heidelberg: Wunderhorn Verlag, 2011.

Michelis, Marco de. "Walter Determann: Bauhaus Settlement Weimar, 1920." In Bergdoll and Dickerman, *Bauhaus*, 86–95.

Mittag-Foder, Etel. *Not an Unusual Life, for the Time and Place*. Edited by Kerstin Stutterheim. Documents from the Bauhaus-Archive Berlin, *Bauhäusler 3*. Berlin: Bauhaus-Archiv/Studio Ferdinand Ulrich, 2014.

Möbius, Hanno. *Montage und Collage: Literatur, bildende Künste, Film, Fotografie, Musik, Theater bis 1933*. Munich: Wilhelm Fink Verlag, 2000.

The Modern Girl around the World Research Group, ed. *The Modern Girl Around the World: Consumption, Modernity, and Globalization*. Durham: Duke University Press, 2008.

Moholy-Nagy, Sibyl, ed. *László Moholy-Nagy*. New York: Solomon R. Guggenheim Museum, 1969.

Molderings, Herbert. "Kunsthandel: Lizenz zum Plündern." *Der Spiegel*, April 20, 1998. http://www.spiegel.de/spiegel/print/d-7867165.html.

"Light Years of a Life: The Photogram in the Aesthetic of László Moholy-Nagy." *Moholy-Nagy: The Photograms, Catalogue Raisonné*, edited by Renate Heyne and Floris Neusüss, 15–25. Ostfildern: Hatje Cantz, 2009.

Montserrat, María, Farías Barba, Viridiana Rivera Zavala, and Marco Santiago Mondragón. "Lena Bergner: From the Bauhaus to Mexico." Translated by Laurence Nunny. *bauhaus-imaginista.org* (2018). http://www.bauhaus-imaginista.org/articles/2485/lena-bergner-from-the-bauhaus-to-mexico.

Morehead, Allison, and Elizabeth Otto. "Representation in the Age of Mediumistic Reproduction, From Symbolism to the Bauhaus." In *The Symbolist Roots of Modern Art*, edited by Michelle Facos and Thor J. Mednick, 155–168. Farnham: Ashgate, 2015.

Muche, Georg. *Blickpunkt: Sturm, Dada Bauhaus, Gegenwart*. 2nd ed. Tübingen: Wasmuth, 1965.

Mühlmann, Heinrich P. "Gemalte Diagramme." In Lindemann, *Die Bauhaus Künstlerin Margaret Leiteritz*, 35–37.

Müller, Ulrike. *Bauhaus Frauen*. 2nd ed. Munich: Elisabeth Sandeman Verlag, 2019.

Bauhaus Women: Art, Handicraft, Design. Paris: Flammarion, 2009.

Mulvey, Laura. "Visual Pleasure and Narrative Cinema." *Screen* 16, no. 3 (1975): 6–18.

Muscheler, Ursula. *Das rote Bauhaus: Eine Geschichte von Hoffnung und Scheitern*. Berlin: Berenberg, 2016.

Margaret Camilla Leiteritz: Studium am Bauhaus. Dessau: Meisterhäuser Kandinsky/Klee, 2006.

Muñoz, José Esteban. *Cruising Utopia: The Then and There of Queer Futurity*. New York: NYU Press, 2009.

Natale, Simone. "A Cosmology of Invisible Fluids: Wireless, X-Rays, and Psychical Research around 1900." *Canadian Journal of Communication* 36 (2011): 263–275.

Nerdinger, Winfried. "Bauhaus Architecture in the Third Reich." Trans. Kathleen James-Chakraborty. In James-Chakraborty, *Bauhaus Culture*, 139–152.

ed. *Bauhaus-Moderne im National-Sozialismus: Zwischen Anbiederung und Verfolgung*, edited Winfried Nerdinger. Munich: Prestel Verlag / Bauhaus-Archiv, Berlin, 1993.

Neugärtner, Sandra. "Utopias of a New Society: Lucia Moholy, László Moholy-Nagy, and the Loheland and Schwarzerden Women's Communes." In Otto and Rössler, *Bauhaus Bodies*, 73–100.

Neumann, Eckhard. *Bauhaus and Bauhaus People: Personal Opinions and Rec-
ollections of Former Bauhaus Members and Their Contemporaries.* Edited
and translated by Eva Richter and Alba Lormann. Revised ed. New York: Van
Nostrand Reinhold, 1970, 1992.

O'Konor, Louise. *Viking Eggeling 1880–1925: Artist and Filmmaker, Life and
Work.* Translated by Catherine G. Sundström and Anne Bibby. Stockholm:
Tryckeri AB Björkmans Efterträdare, 1971.

Okuda, Osamu. "Klee und das Irrationale." *L'Europe des esprits: Die Magie des
Unfassbaren von der Romantik bis zur Moderne,* edited by Serge Fauchereau,
92–103. Bern: Zentrum Paul Klee, 2012.

 "Kunst als 'Projection aus dem überdimensionalen Urgrund': Über den Okkult-
 ismus bei Paul Klee." In Wagner, *Esoterik am Bauhaus,* 88–107.

Opitz, Silke. "From Painter of Ideas to Sculptor of the Human Body: Sascha
Schneider's Weimar Period and Sculptural Work." In *Sascha Schneider: Vi-
sualizing Ideas through the Human Body,* edited by Silke Opitz, 76–107. Wei-
mar: Bauhaus Universitäts Verlag, 2013.

Otto, Elizabeth. "Bauhaus Spectacles, Bauhaus Specters." In *Spectacle,* edited
by Jennifer Creech and Thomas O. Haakenson, 41–74. Oxford: Peter Lang
Oxford, 2015.

 "Designing Men: New Visions of Masculinity in the Photomontages of Herbert
 Bayer, Marcel Breuer, and László Moholy-Nagy." In Saletnik and Schuldenfrei,
 Bauhaus Construct, 183–204.

 "Fragments of the World Seen like This: Photocollage at the Bauhaus." In
 Meister, *The Bauhaus Photocollages of Josef Albers,* 111–121.

 "Margarete Heymann-Loebenstein: 1899–1999." In Schierz, Rösller, Kraut-
 wurst, and Otto, *4 "Bauhausmädels,"* 121–155.

 "Marianne Brandt: 1893–1983." In Schierz, Rösller, Krautwurst, and Otto, *4
 "Bauhausmädels,"* 86–119.

 "Neue Frau oder weibliche Konstrukteur? Marianne Brandts Suche nach
 einer Bauhausidentität." In *Gespiegeltes Ich: Fotografische Selbstbildnisse
 von Frauen in den 1920er Jahren,* edited by Gerda Breuer and Elina Knorp,
 116–129. Berlin: Nicolai, 2013.

 "Passages with Friedl Dicker Brandeis: From the Bauhaus through Theresien-
 stadt." In *Passages of Exile,* edited by Burcu Dogramaci and Elizabeth Otto,
 230–251. Munich: Edition Text + Kritik, 2017.

 "*Schaulust*: Sexuality and Trauma in Conrad Veidt's Masculine Masquerades."
 In *The Many Faces of Weimar Cinema: Rediscovering Germany's Filmic Leg-
 acy,* edited by Christian Rogowski, 135–152. Suffolk: Camden House, 2010.

 "A 'Schooling of the Senses': Post-Dada Visual Experiments in the Bauhaus
 Photomontages of László Moholy-Nagy and Marianne Brandt." *New German
 Critique* 107 (Summer 2009): 89–131.

 Tempo, Tempo! The Bauhaus Photomontages of Marianne Brandt. Berlin:
 Jovis/Bauhaus-Archiv, 2005.

Otto, Elizabeth, and Patrick Rössler, eds. *Bauhaus Bodies: Gender, Sexuality,
and Body Culture in Modernism's Legendary Art School.* New York: Blooms-
bury Visual Arts, 2019.

 Bauhaus Women: A Global Perspective. London: Bloomsbury UK/Herbert

Press, 2019.

Otto, Elizabeth, and Vanessa Rocco, eds. *The New Woman International: Representations in Photography and Film from the 1870s through the 1960s.* Ann Arbor: University of Michigan Press, 2011.

Paret, Paul Monty. "Invisible Bodies and Empty Spaces: Notes on Gender at the 1923 Bauhaus Exhibition." In Otto and Rössler, *Bauhaus Bodies*, 101–122.

Parot, Françoise. "Psychology Experiments: Spiritism at the Sorbonne." *Journal of the History of the Behavioral Sciences* 29 (Jan. 1993): 22–28.

Pasqualucci, Grace Watenphul, and Alessandra Pasqualucci. *Max Peiffer Watenphul: Werkverzeichnis.* Vol. 2: *Zeichnungen, Emailarbeiten, Textilien, Druckgraphik, Photographie.* Cologne: Dumont, 1993.

Passuth, Krisztina. *Moholy-Nagy.* New York: Thames and Hudson, 1985.

Paviot, Alain. *Bauhaus Photographie.* Paris: Galerie Octant, 1983.

Peckmann, Hilke. "Abstraktion als Suche nach neuer Geistigkeit." Buchholz et al, *Die Lebensreform,* vol. 2, 65–67.

Phillips, Christopher. "Resurrecting Vision: The New Photography in Europe between the Wars." In *The New Vision: Photography between the World Wars*, edited by Maria Morris Hambourg and Christopher Phillips, 65–108. New York: Harry Abrams and the Metropolitan Museum of Art, 1989.

Poggi, Christine. *Inventing Futurism: The Art and Politics of Artificial Optimism.* Princeton: Princeton University Press, 2008.

Poling, Clark V. et al. *Kandinsky: Russian and Bauhaus Years.* New York: Guggenheim, 1983.

Potts, Alex. "László Moholy-Nagy: Light Prop for an Electric Stage, 1930." In Bergdroll and Dickerman, *Bauhaus*, 274–277.

Quaytman, R.H. "Engrave." In Godfrey, *R.H. Quaytman*, 50–61.

Rabinbach, Anson. *The Human Motor: Energy, Fatigue, and the Origins of Modernity.* Berkeley: University of California Press, 1990.

Radewaldt, Ingrid. "Simple Form for the Necessities of Life: The Weaving Workshop at the Bauhaus in Weimar." In Bauhaus-Archiv Berlin, Stiftung Bauhaus Dessau, and Klassik Stiftung Weimar, *Bauhaus: A Conceptual Model*, 81–84.

Radrizzani, Réne, ed. *Die Grunow-Lehre: Die bewegende Kraft von Klang und Farbe.* Wilhelmshaven: Florian Noetzel, 2004.

Rawsthom, Alice. "The Tale of a Teapot and its Creator." *The New York Times*, Dec. 16, 2007. https://www.nytimes.com/2007/12/16/style/16iht-design17.1.8763227.html.

Reetz, Bärbel. *Emmy Ball-Hennings: Leben im Vielleicht.* Frankfurt a.M.: Surkamp Verlag, 2001.

Ridler, Morgan. "Dörte Helm, Margaret Leiteritz, and Lou-Scheper-Berkenkamp: Rare Women of the Bauhaus Wall-Painting Workshop." In Otto and Rössler, *Bauhaus Bodies*, 195–216.

Riegl, Alois. *Late Roman Art Industry.* Translated by Rolf Winkes. Rome: Giorgio Bretschneider Editore, 1985.

Ringbom, Sixten. *The Sounding Cosmos: A Study in the Spiritualism of Kandinsky and the Genesis of Abstract Painting.* Åbo: Acta Academiae Aboensis

vol. 38, no. 2, 1970.

"Transcending the Visible: The Generation of Abstract Pioneers." In Tuchmann, *The Spiritual in Art*, 131–153.

Roberts, Mary. *Intimate Outsiders: The Harem in Ottoman and Orientalist Art and Travel Literature*. Durham: Duke University Press, 2007.

Rodríguez, Marisa Vadillo. "La Música en la Bauhaus (1919–1933): Gertrud Grunow como Profesora de Armonía, La Fusión del Arte, el Color, y Sonido." *Anuario Musical* 71 (2016): 223–232.

Rogowski, Christian. "The Dialectic of (Sexual) Enlightenment: Wilhelm Dieterle's *Geschlecht in Fesseln* (1928)." In *The Many Faces of Weimar Cinema: Rediscovering Germany's Filmic Legacy*, edited by Christian Rogowski, 211–234. Rochester: Camden House, 2010.

Röske, Thomas. "'sie wissen nicht, was sie tun': Hans Prinzhorn spricht am Bauhaus über 'Irrenkunst.'" In Bernard, *Bauhaus Vorträge*, 237–242.

"Sexualized Suffering: On Some Lithographs by Richard Grune." *Intervalla: Platform for Intellectual Exchange* 2 (2014): 80–96.

Rössler, Patrick. *The Bauhaus and Public Relations: Communication in a Permanent State of Crisis*. London: Routledge, 2014.

Bauhausmädels. Cologne: Taschen, 2019.

Der einsame Großstädter: Herbert Bayer und die Geburt des modernen Grafik-Designs. Berlin: Vergangenheitsverlag, 2014.

"Gertrud Arndt: 1903–2000." In Schierz et al., *4 "Bauhausmädels,"* 56–85.

Herbert Bayer: Die Berliner Jahre, Werbegrafik 1928–1933. Berlin: Bauhaus-Archiv/Vergangenhsitsverlag, 2013.

"Margaretha Reichardt." In Schierz et al., *4 "Bauhausmädels,"* 156–191.

Die neue Linie, 1929–1943: Das Bauhaus am Kiosk. Berlin: Bauhaus-Archiv and Kerber, 2007.

New Typographies: Bauhaus and Beyond, 100 Years of Functional Graphic Design. Göttingen: Wallstein, 2018.

Rössler, Patrick, and Anke Blümm. "Soft Skills and Hard Facts: A Systematic Assessment of the Inclusion of Women at the Bauhaus." In Otto and Rössler, *Bauhaus Bodies*, 3–24.

Rössler, Patrick and Gwen Chanzit. *Der einsame Großstádter: Herbert Bayer, Eine Kurzbiografie*. Berlin: Vergangenheitsverlag, 2014.

Russo, Vito. *The Celluloid Closet: Homosexuality in the Movies*. New York: Harper & Row, 1987.

Rykwert, Joseph. "The Darker Side of the Bauhaus." In *The Necessity of Artifice: Ideas in Architecture*, 44–49. New York: Rizzoli, 1982.

Sachsse, Rolf. *Lucia Moholy: Bauhaus Fotografin*. Berlin: Museumspadagogischer Dienst/Bauhaus-Archiv, 1995.

"Telephon, Reproduktion und Erzeugerabfüllung: Zum Begriff des Originals bei László Moholy-Nagy." Lecture presented at the Internationales László Moholy–Nagy Symposium, Bielefeld, Germany, 1995.

Saletnik, Jeffrey, and Robin Schuldenfrei, eds. *Bauhaus Construct: Fashioning Identity, Discourse, and Modernism*. London: Routledge, 2009.

Schierz, Kai-Uwe, Patrick Rössler, Miriam Krautwurst, and Elizabeth Otto, eds. *4 "Bauhausmädels": Gertrud Arndt, Marianne Brandt, Margarete Heymann, Margaretha Reichardt*. Dresden: Sandstein Verlag, 2019.

Schöbe, Lutz. "Joost Schmidt: Die sieben Chakras." In Wagner, *Das Bauhaus und die Esoterik*, 107–112.

Scholem, Gershom. "Walter Benjamin and His Angel." In *On Jews and Judaism in Crisis: Selected Essays*, edited by Werner J. Dannhauser, 198–236. New York: Schocken Books, 1976.

Scholz, Dieter, and Christina Thomson, eds. *The Klee Universe*. Berlin: Staatliche Museen zu Berlin/Hatje Cantz, 2008.

Schönfeld, Christiane, ed. *Practicing Modernity: Female Creativity in the Weimar Republic*. Würzburg: Königshausen & Neumann, 2006.

Schoppmann, Claudia. *The Days of Masquerade: Life Stories of Lesbians During the Third Reich*. New York: Columbia University Press, 1996.

"The Position of Lesbian Women in the Nazi Period." In *Hidden Holocaust? Gay and Lesbian Persecution in Germany, 1933–45*, edited by Günter Grau, translated by Patrick Camiller, 8–15. London: Cassell, 1995.

Schrom, Georg, and Stefanie Trauttmansdorf, eds. *Bauhaus in Wien: Franz Singer, Friedl Dicker*. Vienna: Hochschule für Angewandte Kunst in Wien, 1989.

Schuldenfrei, Robin. "Images in Exile: Lucia Moholy's Bauhaus Negatives and the Construction of the Bauhaus Legacy." *History of Photography* 37, no. 2 (2007): 182–203.

Luxury and Modernism: Architecture and the Object in Germany 1900–1933. Princeton: Princeton University Press, 2018.

Schulz, Bernard. "Wonderful Furniture: Peter Keler's Cradle." In Bauhaus-Archiv Berlin, Stiftung Bauhaus Dessau, and Klassik Stiftung Weimar, *Bauhaus: A Conceptual Model*, 119–122.

Schulz, Isabel. "'Märchen unserer Zeit': Kurt Schwitters als Vortragskünstler am Bauhaus." In Bernhard, *Bauhausvorträge*, 307–309.

Schuster, Peter-Klaus. "The World as Fragment: Building Blocks of the Klee Universe." In Scholz and Thomson, *The Klee Universe*, 15–24.

Schwartz, Frederic J. "Utopia for Sale: The Bauhaus and Weimar Germany's Consumer Culture." In James-Chakraborty, *Bauhaus Culture*, 115–138.

Sconce, Jeffrey. *Haunted Media: Electronic Presence from Telegraphy to Television*. Durham: Duke University Press, 2000.

Secklehner, Julia. "'A School for Becoming Human': The Socialist Humanism of Irene Blühová's Bauhaus Photographs." In Otto and Rössler, *Bauhaus Bodies*, 287–309.

Sedgwick, Eve Kosofsky. *Epistemology of the Closet*. Berkeley: University of California Press, 1990.

Seeger, Adina. "Vom Bauhaus nach Auschwitz: Fritz Ertl, Bauhausschüler in Dessau, Mitarbeiter der Auschwitzer Bauleitungen, Angeklagter im Wiener Auschwitzprozess." MA Thesis, University of Vienna, 2013.

Serner, Walter. *Letzte Lockerung: Ein Handbrevier für Hochstapler und solche die es werden wollen*. Munich: DTV Verlag, 1984.

Shaw, Jennifer. *Exist Otherwise: The Life and Works of Claude Cahun*. London:

Reaktion Books, 2017.

Siebenbrodt, Michael. "Architektur am Bauhaus in Weimar: Ideen und Pläne für eine Bauhaussiedlung." In *Das Bauhaus kommt aus Weimar*, edited by Ute Ackermann and Ulrike Bestgen, 236–254. Weimar: Klassik Stiftung Weimar, 2009.

"Der Bauhausdirektor Hannes Meyer als Hochschullehrer und Architekt in Moskau 1930–1936." In Steininger, *"Als Bauhäusler sind wir Suchende,"* 35–40.

"Zur Rolle der Kommunisten und anderer fortschrittlicher Kräfte am Bauhaus." *Wissentschaftliche Zeitschrift der Hochschule für Architektur und Bauwesen* 23, no. 516 (1976): 481–485.

Siepmann, Eckhard, ed. *Montage: John Heartfield, Vom Club Dada zur Arbeiter-Illustrierten Zeitung*, 2nd ed. Berlin: Elefanten Press, 1992.

Silverman, Dan P. "A Pledge Unredeemed: The Housing Crisis in Weimar Germany." *Central European History* 3, no. 1/2 (1970): 112–139.

Sinclair, Upton. *The Profits of Religion: An Essay in Economic Interpretation*. Pasadena: self-published, 1918.

Smith, T'ai. "The Bauhaus Has Never Been Modern." In *Craft Becomes Modern: The Bauhaus in the Making*, edited by Regina Bittner and Renée Padt, 142–152. Bielefeld: Kerber Verlag, 2017.

Bauhaus Weaving Theory: From Feminine Craft to Mode of Design. Minneapolis: University of Minnesota Press, 2014.

Sontag, Susan. "Notes on Camp." In *Camp: Queer Aesthetics and the Performing Subject, A Reader*, edited by Fabio Cleto, 53–65. Ann Arbor: University of Michigan Press, 1999.

Soupault, Ré. *Das Bauhaus: Die heroischen Jahre von Weimar*. Edited by Manfred Metzner. Translated by Beate Thill. Heidelberg: Verlag das Wunderhorn, 2009.

Frauenportraits aus dem "Quartier réservé" in Tunis. Heidelberg: Wunderhorn, 2001.

Nur das Geistige zählt: Vom Bauhaus in die Welt, Erinnerungen. Edited by Manfred Metzner. Heidelberg: Wunderhorn, 2018.

Staatliches Bauhaus Weimar, ed. *Staatliches Bauhaus Weimar, 1919–1923*. Weimar: Bauhausverlag, 1923.

Stadler, Monika, and Yael Aloni, eds. *Gunta Stölzl: Bauhaus Master*. Translated by Allison Plath-Moseley. New York: Museum of Modern Art; Ostfildern: Hatje Cantz, 2009.

Stasny, Peter. "Die Farbenlichtspiele." In *Ludwig Hirschfeld-Mack: Bauhäusler und Visionär*, edited by Andreas Hapkemeyer and Peter Stasny, 94–109. Ostfildern: Hatje Cantz, 2000.

Starck, Christiane. *Sascha Schneider: ein Künstler des deutschen Symbolismus*. Marburg: Tectum Verlag, 2016.

Steakley, James. "Cinema and Censorship in the Weimar Republic: The Case of *Anders als die Andern*." *Film History* 11, no. 2 (1999): 181–203.

Steckner, Cornelius. "Die Musikpädagogin Gertrud Grunow als Meisterin der Formlehre am Weimarer Bauhaus: Designtheory und productkive Wahrnemungsgestalt." In Bothe et al, *Das frühe Bauhaus und Johannes Itten*, 200–214.

Steiner, Rudolf. *The Early History of Eurythmy*. Translated and edited by Frederick Amrine. Great Barrington, Mass.: Steiner Books, 2015.

Steininger, Peter, ed. *"Als Bauhäusler sind wir Suchende": Hannes Meyer (1889–1954), Beiträge zu seinem Leben und Wirken*. Bernau: Baudenkmal Bundesschule Bernau e.V., 2013.

Studer-Geisser, Isabella. "Maria Geroe-Tobler, 1895–1963: Ein Beitrag zur Schweizer Textilkunst des 20. Jahrhunderts." PhD diss., Universität Zurich, 1995.

Sudhalter, Adrian. "14 Years Bauhaus: A Chronicle." In Bergdoll and Dickerman, *Bauhaus 1919–1933*, 323–337. New York: Museum of Modern Art, 2009.

Suite de 16 photographies de nus, par Florence Henri et M. B. De l'artiste de variété Line Viala et du peintre Honor David. Paris: Millon et Associés, 2008.

Suter, Hans. *Paul Klee and His Illness: Bowed but not Broken by Suffering and Adversity*. Translated by Gill and Neil McKay. Basel: Karger, 2010.

Sutton, Katie. *The Masculine Woman in Weimar Germany*. London: Berghahn Books, 2013.

Tatar, Maria. *Lustmord: Sexual Murder in Weimar* Germany. Princeton: Princeton University Press, 1997.

Temkin, Ann. "Klee and the Avant-Garde, 1912–1940." In *Paul Klee*, edited by Carolyn Lanchner, 14–29. New York: Museum of Modern Art, 1987.

Teut, Anna. *Architektur im Dritten Reich, 1933–1945*. Berlin: Ullstein, 1967.

Theweleit, Klaus. *Male Fantasies: Male Bodies: Psychoanalyzing the White Terror*. Vol. 2. Translated by Erica Carter and Chris Turner. Minneapolis: University of Minnesota Press, 1989.

Thormann, Olaf, and Katrin Heise. "Bauhaus–Kandem." In *Bauhausleuchten? Kandemlicht! Die Zusammenarbeit des Bauhauses mit der Leipziger Firma Kandem*, edited by Justus Binroth, 156–203. Leipzig: Grassi Museum, Museum für Kunsthandwerk Leipzig; Stuttgart: Arnoldsche Art Publishers, 2002.

Tode, Thomas, ed. *Bauhaus and Film*, special issue of *Maske und Kothurn: Internationale Beiträge zur Theater-, Film, und Medienwissenschaft*, vol. 52, no. 1–2 (2011).

Tóth, Edith. *Design and Visual Culture from the Bauhaus to Contemporary Art: Optical Deconstructions*. London: Routledge, 2018.

Treitel, Corinna. *A Science for the Soul: Occultism and the Genesis of the German Modern*. Baltimore: Johns Hopkins, 2004.

Tsai, Joyce. *László Moholy-Nagy: Painting after Photography*. Berkeley: University of California Press, 2018.

"László Moholy-Nagy: Reconfiguring the Eye." In *Nothing but the Clouds Unchanged: Artists in World War I*, edited by Gordon Hughes and Philipp Blom, 156–163. Los Angeles: Getty Research Institute, 2014.

Tuchmann, Maurice, ed. *The Spiritual in Art: Abstract Painting, 1890–1985*. New York: Abeville Press, 1986.

Tupitsyn, Margarita. "Colorless Field: Notes on the Paths of Modern Photography." In *Object: Photo, Modern Photographs: The Thomas Walther Collection, 1909–1949*, edited by Mitra Abbapour, Lee Ann Daffner, and Maria Morris Hambourg, 1–15. New York: Museum of Modern Art, 2015.

Tymkiw, Michael. *Nazi Exhibition Design and Modernism*. Minneapolis: University of Minnesota Press, 2018.

Valdivieso, Mercedes, ed. *La Bauhaus de Festa*. Barcelona: Obra Social Fundació "la Caixa," 2004.

"Ise Gropius: 'Everyone Here Calls me Frau Bauhaus." Translated by Jordan Troeller. In Otto and Rössler, *Bauhaus Bodies*, 169–193.

Vinterhalter, Jadranka, ed. *Bauhaus: Networking Ideas and Practice*. Zagreb: Museum of Contemporary Art, 2015.

Volpert, Astrid. "Hannes Meyers starke Frauen der Bauhauskommune am Moskauer Arbatplatz 1930–1938." In Steininger, *"Als Bauhäusler sind wir Suchende*," 41–54.

Wagner, Christoph, ed. *Das Bauhaus und die Esoterik: Johannes Itten, Wassily Kandinsky, Paul Klee*. Bielefeld: Kerber, 2005.

ed. *Esoterik am Bauhaus: Eine Revision der Moderne?* Regensburg: Verlag Schnell & Steiner, 2009).

"Zwischen Lebensreform und Esoterik: Johannes Ittens Weg ans Bauhaus in Weimar." In Wagner, *Das Bauhaus und die Esoterik*, 65–77.

Wahl, Volker, ed. *Das Staatliche Bauhaus in Weimar: Dokumente zur Geschichte des Instituts 1919–1926*. Cologne: Böhlau, 2009.

Weber, Klaus, ed. *Die Metalwerkstatt am Bauhaus*. Berlin: Bauhaus-Archiv, 1992.

Happy Birthday: Bauhaus-Geschenke. Berlin: Ott + Stein, 2004.

Wedemeyer-Kolwe, Bernd. *Aufbruch: Die Lebensreform in Deutschland*. Darmstadt: Philipp von Zabern, 2017.

Weiermair, Peter. *Wilhelm von Gloeden*. Cologne: Taschen, 1997.

Weissler, Sabine. "Bauhaus-Gestaltung in NS-Propaganda-Ausstellungen." In Nerdinger, *Bauhaus-Moderne im National-Sozialismus*, 48–63.

Weitemeier, Hannah. *Licht-Visionene: ein Experiment von Moholy-Nagy*. Berlin: Bauhaus-Archiv, 1972.

Weißbach, Angelika, ed. *Wassilly Kandinsky: Unnterricht am Bauhaus, 1923–1933*. Berlin: Gebr. Mann Verlag, 2015.

Whalen, Robert. *Bitter Wounds: German Victims of The Great War, 1914–1939*. Ithaca: Cornell University Press, 1984.

Whitford, Frank, ed. *The Bauhaus: Masters and Students by Themselves*. New York: Overlook Press, 1993.

Wick, Rainer. *Teaching at the Bauhaus*. Ostfildern: Hatje Cantz, 2000.

Williams, Andreá N. "Frances Watkins (Harper), Harriet Tubman, and the Rhetoric of Single Blessedness." *Meridians: Feminism, Race, Transnationaism* 12, no. 2 (2014): 99–122.

Williams, John Alexander. *Turning to Nature in Germany: Hiking, Nudism, and Conservation, 1900–1940*. Stanford: Stanford University Press, 2007.

Williams, Raymond. "Structures of Feeling." In *Marxism and Literature*, 128–135. Oxford: Oxford University Press, 1977.

Wingler, Hans M., ed. *The Bauhaus: Weimar Dessau Berlin Chicago*. Translated by Wolfgang Jabs and Basil Gilbert. Cambridge, Mass.: MIT Press, 1962.

Winkler, Klaus-Jürgen. *Baulehre und Entwerfen am Bauhaus 1919–1933*. Weimar: Bauhaus-Universität Weimar, Universitätsverlag, 2003.

Whisnant, Clayton. *Queer Identities and Politics in Germany: A History, 1880–1945*. New York: Harrington Park Press, 2016.

Wolffram, Heather. *The Stepchildren of Science: Psychical Research and Parapsychology in Germany, c. 1870–1939*. Amsterdam: Rodopi / The Wellcome Series in the History of Medicine, 2009.

Wolsdorff, Christian. *Eigentlich wollte ich ja Architektin werden: Gertrud Arndt als Weberin und Photographin am Bauhaus 1923–31*. Berlin: Bauhaus-Archiv, 2013.

Worringer, Wilhelm. *Abstraction and Empathy*. Translated by Michael Bullock. Chicago: Elephant Paperbacks, 1997.

Wynhoff, Elisabeth, ed. *Marianne Brandt: Fotografieren am Bauhaus*. Ostfildern-Ruit: Hatje-Cantz, 2003.

Zimmermann, Reinhard. "Der Bauhaus-Künstler Kandinsky: ein Esoteriker?" In Wagner, *Das Bauhaus und Die Esoterik*, 47–55.

INDEX